Western Civilization
to 1500

OTHER BOOKS IN THE HARPERCOLLINS COLLEGE OUTLINE SERIES

ART
History of Art 0-06-467131-3
Introduction to Art 0-06-467122-4

BUSINESS
Business Calculus 0-06-467136-4
Business Communications 0-06-467155-0
Introduction to Business 0-06-467104-6
Introduction to Management 0-06-467127-5
Introduction to Marketing 0-06-467130-5

CHEMISTRY
College Chemistry 0-06-467120-8
Organic Chemistry 0-06-467126-7

COMPUTERS
Computers and Information Processing 0-06-467176-3
Introduction to Computer Science and Programming
 0-06-467145-3
Understanding Computers 0-06-467163-1

ECONOMICS
Introduction to Economics 0-06-467113-5
Managerial Economics 0-06-467172-0

ENGLISH LANGUAGE AND LITERATURE
English Grammar 0-06-467109-7
English Literature From 1785 0-06-467150-X
English Literature To 1785 0-06-467114-3
Persuasive Writing 0-06-467175-5

FOREIGN LANGUAGE
French Grammar 0-06-467128-3
German Grammar 0-06-467159-3
Spanish Grammar 0-06-467129-1
Wheelock's Latin Grammar 0-06-467177-1
Workbook for Wheelock's Latin Grammar
 0-06-467171-2

HISTORY
Ancient History 0-06-467119-4
British History 0-06-467110-0
Modern European History 0-06-467112-7
Russian History 0-06-467117-8
20th Century United States History 0-06-467132-1
United States History From 1865 0-06-467100-3
United States History to 1877 0-06-467111-9
Western Civilization From 1500 0-06-467102-X

Western Civilization To 1500 0-06-467101-1
World History From 1500 0-06-467138-0
World History to 1648 0-06-467123-2

MATHEMATICS
Advanced Calculus 0-06-467139-9
Advanced Math for Engineers and Scientists
 0-06-467151-8
Applied Complex Variables 0-06-467152-6
Basic Mathematics 0-06-467143-7
Calculus with Analytic Geometry 0-06-467161-5
College Algebra 0-06-467140-2
Elementary Algebra 0-06-467118-6
Finite Mathematics with Calculus 0-06-467164-X
Intermediate Algebra 0-06-467137-2
Introduction to Calculus 0-06-467125-9
Introduction to Statistics 0-06-467134-8
Ordinary Differential Equations 0-06-467133-X
Precalculus Mathematics: Functions & Graphs
 0-06-467165-8
Survey of Mathematics 0-06-467135-6

MUSIC
Harmony and Voice Leading 0-06-467148-8
History of Western Music 0-06-467107-7
Introduction to Music 0-06-467108-9
Music Theory 0-06-467168-2

PHILOSOPHY
Ethics 0-06-467166-6
History of Philosophy 0-06-467142-9
Introduction to Philosophy 0-06-467124-0

POLITICAL SCIENCE
The Constitution of the United States 0-06-467105-4
Introduction to Government 0-06-467156-9

PSYCHOLOGY
Abnormal Psychology 0-06-467121-6
Child Development 0-06-467149-6
Introduction to Psychology 0-06-467103-8
Personality: Theories and Processes 0-06-467115-1
Social Psychology 0-06-467157-7

SOCIOLOGY
Introduction to Sociology 0-06-467106-2
Marriage and the Family 0-06-467147-X

Available at your local bookstore or directly from HarperCollins at 1-800-331-3761.

HARPERCOLLINS COLLEGE OUTLINE

Western Civilization to 1500

3rd Edition

Walther Kirchner, Ph.D.
University of Delaware

HarperPerennial
A Division of HarperCollinsPublishers

An American BookWorks Corporation Production

Project Manager: Jonathon E. Brodman
Editor: Robert A. Weinstein

Library of Congress Cataloging-in-Publication Data

Kirchner, Walther
 Western civilization to 1500 / Walther Kirchner. — Rev. ed.
 p. cm.
 Includes bibliographical references and index.
 ISBN 0-06-467101-1 (pbk.)
 1. Civilization, Western—History I. Title
CB245.K545 1991
940—dc20 90-56010

95 ABW/RRD 10 9 8 7 6 5 4 3

Contents

Preface

The study of history has not always meant to people what it means to them today. Perhaps at all times, curiosity has induced them to desire to perpetuate great events and noble deeds and has impelled them to write down what they witnessed. But it is only our own age, influenced by present-day attitudes, that has looked to history as a science that can reveal and explain trends underlying human life and human affairs. Whether or not history can be regarded as a science, it may well be that future generations will deprecate our efforts. Yet in the age in which we live, history serves as more than a remembrance of times gone by and of past efforts of humankind; it serves as a guide for our actions, which shape the future.

Divisions of History

Western historians have divided history into three parts: ancient, medieval, and modern. Into the chapter of ancient history fall all events up to the decline of the Roman Empire—i.e., approximately up to the fourth or fifth century A.D. Medieval history comprises the events from then until approximately the end of the fifteenth century. What has happened since constitutes modern history.

This division of history was established centuries ago and has often been challenged. Some feel that it would be more logical to divide history just as we divide our calendar,—namely, into the periods B.C. (before Christ) and A.D. (*anno domini*— "year of the Lord"). Others would prefer a division according to the main stages of mankind's rational development—as expressed by scientific interests, organization of labor, and mastery over natural forces. They suggest a first, primitive stage, which ended approximately in the fifth century B.C.; a second, higher stage, from then to about the twelfth century A.D.; a third, lasting until the eighteenth century; and the stage in which we now live, which would make up a fourth era.

Still other historians, asserting that the traditional divisions do not take most of the non-European cultures into consideration, propose still other periodizations, the purpose of which would be to make the divisions meaningful in terms of *world* history. However, dates and periods are not much

more than aids contrived to help organize an unbelievably vast amount of information so that it may be grasped and interpreted. Therefore, it may be as well to maintain the established divisions of ancient, medieval, and modern history.

This periodization has proved serviceable, at least for Western civilization. It has an inner justification insofar as it corresponds to the various stages in the growth of Western civilization. Ancient history comprises the areas around the eastern Mediterranean where the earliest high civilizations flourished. Medieval history includes all of the European continent. And modern history encompasses the whole of the globe.

Beginnings of History

More difficult than establishing generally acceptable divisions of history is the task of fixing a date for the "beginning" of history. Peculiarly enough, although we constantly move farther and farther from the earliest civilizations, we come to learn more and more about them. Remembrance may fade, but, as the work of archaeologists and historians proceeds, records (carved in stone or brick, written on pergament or tree bark, or embodied in utensils for daily use and monuments erected by ancient generations) become increasingly available.

Judging by the results of this work, we may say that the beginnings of history must lie somewhere in the fifth millennium B.C. From about that time date the earliest artistic achievements worthy of superior cultures, the first decipherable records of man's higher rational development, and the beginnings of political and social organizations that deserve to be called "states."

Can we speak of this period also as the beginning of "Western" civilization? Obviously not, if by "Western" civilization we mean the civilization of the European peoples—the Germanic, Romance, and Slavic nations. Their history begins, properly speaking, only with the medieval period, or at the earliest with the history of ancient Greece and Rome.

Yet the more we learn about ancient times, the more we come to realize that a close connection existed between Europe and earlier civilizations in Syria, Mesopotamia, Egypt, and Asia Minor. The heritage of these regions bordering on the eastern Mediterranean was strongly felt, especially in Greece, and was, indirectly, transmitted by Greece to Western civilization. We may therefore be justified in including some of the ancient Near East into an account of Western civilization.

Concepts of History

The questions of periodization of history and the beginnings of history are closely interwoven with our philosophy of history. Many different philosophies have been proposed, reflecting the optimism or the pessimism of each age in which they were conceived.

CONCEPTS OF "PROGRESS" AND "RETROGRESSION"

The most widely accepted contemporary view postulates "progress." Those who hold this view insist that mankind, or at least Western man, has developed from humble beginnings in ancient times to certain heights in the present and will continue to advance. But they have come to realize that this progress is traceable chiefly in man's rational and material life and less so in ethical and moral development.

Actually both Greek and Christian traditions have maintained quite an opposite view—namely, that retrogression rather than progress marks mankind's development. Thus the Greeks spoke of the earliest age as a "Golden Age" and considered subsequent stages as less happy; their own age they termed the "Iron Age." Similarly, Jews and Christians have put Paradise at the beginning of their story; later and present stages of mankind have brought suffering and death. Indeed, no solution exists in the Christian view until the end of man and of mankind's history with the Day of the Last Judgment. Even rationalist thinkers of recent centuries have been inclined to see primitive man as the "noble man" and have attributed to the coercion exercised by law and civilization of modern ages the blame for having morally corrupted mankind.

CONCEPTS OF CONTINUITY AND CYCLICAL MOVEMENTS

Advocates of progress and retrogression, imaginative as they are, have often ignored the facts taught by history. Wiser investigators have approached the problem on a more scientific basis. Searching the past, some of them have come to the conclusion that fundamentals have not changed in the stream of history. Men and women are what they have always been, and no more can be traced throughout history than eternal recurrence of all human aspirations and activities, without beginning, aim, logic, or meaning.

Others have maintained that mechanical or economic laws govern the path of history. Once these laws are understood, we might even be able to predict future developments.

Still others have interpreted history in terms of repetitive cyclical movements, each having its own fulfillment, and all sharing a common pattern. For, according to them, each individual civilization has a beginning, a period of maturity, and an end—like the human life cycle, which encompasses the stages of birth, growth, decline, and death. They have come to the conclusion that Western civilization itself is now declining and that another cycle will shortly supersede it.

Lastly, some thinkers have tried to combine this theory of cycles with the philosophy of progress and have insisted that there is a spiral, rather than disconnected cycles, and that the spiral shows an upward direction.

Significance of Historical Studies

All philosophies of history seem to have one thing in common: the assumption that history is not only the story of past events but that it is also a thought process in the present. Herein lies the value of history—a value that, however, can be achieved only through a scientific and sober presentation of facts and through clear and disciplined thought based on these facts. If facts are thus presented and thought thus given, history cannot fail to have meaning for our lives of today and to exercise a powerful influence upon our actions.

Selected Readings

Ardrey, Robert. *The Territorial Imperative: A Personal Inquiry into the Origins of Property and Nations* (1966)

Colinvaux, Paul. *The Fates of Nations: A Biological Theory of History* (1980)

Handlin, Oscar. *Truth in History* (1979)

Nietzsche, Friedrich. *Use and Abuse of History* (1957)

Clough, Sheperd B. *The Rise and Fall of Civilization: An Inquiry into the Relationship between Economic Development and Civilization* (1978)

Spengler, Oswald. *The Decline of the West* (1932)

1

The Earliest Known Civilizations

3200–2300 B.C.	Egypt's "Early Kingdom"
ca. 3200	Reign of Menes (First Dynasty) of Egypt
ca. 3000	Unification of Mesopotamia (Sumer)
	Development of wheel (in Sumer?)
	Development of cuneiform writing
3000–2200	Early Minoan civilization (Crete)
ca. 3000	Building of First Pyramid (Imhotep)
ca. 2800	Egyptian calendar
ca. 2650	Reign of Cheops (Fourth Dynasty) of Egypt
ca. 2600	Reign of Messanipada of Sumer
ca. 2500	Reign of Eannatum of Sumer
ca. 2350	Reign of Sargon of Akkad
ca. 2300	Reign of Pepi II (Sixth Dynasty) of Egypt
2300–2000	Time of troubles in Egypt
2200–1600	Middle Minoan civilization
2000–1800	Egypt's "Middle Kingdom"
ca. 2000	Reign of Dungi (Shulgi) in Mesopotamia
	Early Codex of Law and *Epic of Gilgamesh* in Mesopotamia

The earliest known civilizations were developed in regions to the southeast of Europe. In Europe itself Neolithic (New Stone Age) people—ancestors of the various modern races of Western civilization—appeared about 5000 B.C.;

but written data about them do not exist. It is the Near East—Syria and the fertile valleys of the Nile, Euphrates, and Tigris, and also Anatolia, not central Europe or the American continent—that furnishes us with the first indications of the historical existence of human beings.

By the time our precursors enter our field of vision in the Near East—ca. 4500 B.C.—they had progressed beyond the Stone Age. They had ceased to be dependent upon hunting and had learned to build permanent dwellings and to domesticate certain animals. They knew how to cultivate the soil, to make tools and weapons, to build ships, to fashion stone utensils and earthenware, and to weave cloth. They manufactured copper utensils (although they had not yet produced bronze), and they used gold and silver. They had developed political organizations and laws and had begun to live in towns. They owned property, produced and traded merchandise, and built ornamental altars to gods and elaborate tombs for the dead.

Records of that age are extremely scarce. One of the oldest is a seal in the form of a cylinder, with images and some "writing" on it. Its age has been estimated at about 6500 years, and it was found in Syria somewhat north of present-day Antioch. Syria was a centrally located area at the crossroads of great trade routes; it was perhaps there that the first grain was planted and the first brick made. Yet not even Syria furnishes us with much additional information. Its two great towns, Aleppo and Damascus, are more than 4000 years old, but we know nothing of their beginnings. We must therefore turn to Mesopotamia and Egypt of the fourth millennium in order to get our first glimpses of the precursors of Western civilization and the oldest known civilizations.

EGYPT AND SUMER UP TO THE SECOND MILLENNIUM B.C.

The beginnings of Egyptian and Mesopotamian history go back to the fifth millennium. In the two great river valleys of the Nile and the Tigris-Euphrates, small communities or kingdoms arose. Royal offices—based on law and exercising political, religious, and economic duties—were set up.

With the help of advanced tools and perfected techniques, the peoples of both areas learned early to control their natural surroundings to a certain extent. In both areas, they learned to exploit available resources through irrigation and canal building, to increase the fertility of the land so as to make settled agricultural life possible, and to enforce laws that would guarantee

the maintenance of these achievements and further the common welfare. They seem to have been acquainted, as early as 4000 B.C., with primitive furnaces in which iron (probably obtained from fallen meteors) could be melted and formed into utensils. They developed a calendar, which implies observation of nature, and the art of writing, which implies scholarship.

Whether or not significant and direct connections existed between Egypt and Mesopotamia at that time cannot be determined; the parallels are interesting. We know that Egypt led a fairly isolated existence. Owing to its location, it enjoyed a modicum of peace from outside disturbances, except for rare invasions from the south and still rarer attacks from Mediterranean pirates on the Nile delta. Mesopotamia, on the other hand, found itself in the midst of much action and agitation. It carried on brisk trade with distant regions, experienced much intermingling of races, and suffered from numerous invasions.

Egypt from 3500 to 1800 B.C.

Our information about Egypt becomes more detailed with the period after 3500 B.C., as the originally independent communities along the Nile began to draw closer to one another. A process of unification began, and first two kingdoms, then—by ca. 3200 B.C.— one single kingdom was formed. With it began a period, lasting for more than a thousand years, during which Egypt was to bring forth enduring monuments of a high civilization. This period is divided into two parts: the Early Kingdom (ca. 3200–2300 B.C.) and the Middle Kingdom (ca. 2000–1800 B.C.).

EARLY KINGDOM

The Early Kingdom begins with the rule of the so-called First Dynasty, founded by the mythological figure Menes (ca. 3000 B.C.). He resided in Thinis on the middle course of the Nile and is credited with having achieved the unification of Upper and Lower Egypt. Under his successors, the country increased its strength. The rulers (called pharaohs) accumulated power, reaching a climax with Cheops (or Khufu, ca. 2650 B.C.) of the Fourth Dynasty. By that time, the capital city had been moved to Memphis, close to the delta of the Nile. From Memphis, by means of rigorous centralization, the pharaohs exercised strict control over the whole country. Cheops, best known of the great pyramid builders, was hated for his regimentation and harsh exploitation of the people.

The decline of the Early Kingdom set in with Pepi II (ca. 2300 B.C.) of the Sixth Dynasty. He extended the sway of Egypt far up the Nile to the second cataract, or series of falls, of this river, but during his long rule the central authority of the pharaoh could not be maintained. An autonomous landholding nobility began asserting itself and various slave rebellions occurred. Disintegration followed.

Governmental and Societal Structure. The pharaoh was identified in earliest times with the falcon-headed sun god Horus and later with the god

Ra. He was ruler and lawgiver and possessed absolute and divine authority. As supreme landlord, he levied elaborately systematized taxes in kind and service, regulated agriculture, and exercised control over the water system, which served periodically to irrigate the land with the waters of the Nile. He ruled with the help of a steadily growing bureaucracy (consisting of nobility and priests but also numerous scribes recruited from the common people) and governors (often royal princes), who supervised the execution of the laws in the various districts or *nomes* into which the country was divided.

Most of the farmers were free—at least during the early dynasties—and possessed cattle and their own plows and hoes. Later the nobility succeeded in monopolizing much of the land and began cultivating it with the help of slaves. Yet strict class stratification did not exist: Social mobility prevented a rigid structure, and many rose from low to high estates. Women seem to have had an equable place in society; monogamy was the rule, even though the rich occasionally took several wives.

Skills and Learning. Ancient Egypt was comparatively densely populated. There were a number of towns besides Memphis, the capital. Trade and artisanship flourished. Textiles, jewelry, papyrus, glass, and metal objects of gold, silver, and copper were produced. In the schools, scribes instructed children in writing and reading, mathematics (including algebra and geometry), mechanics, astronomy, and medicine and prepared them for government service. Scholarship was also promoted. As early as about 2800 B.C., a calendar of 365 days had been invented.

A system of writing was evolved that used hieroglyphs. At first, pictures were used to represent only complete words or concepts, but later (before 3000 B.C.) they also acquired symbolic value for individual sounds. For the development of writing, Egypt profited from the availability of the papyrus plant, which provided far more satisfactory material on which to make records than stone, brick, or clay tablets, as used elsewhere, could furnish.

Art. The Egyptians have left to posterity an extraordinary artistic heritage. Paintings and masterpieces of sculpture have been found in temples and tombs. Representations on textiles, pottery, and numerous other objects of daily life bear witness to the greatness of Egyptian civilization. No general statement would seem adequate, however, to describe the art of Egypt, for the period of Egypt's artistic creations spanned more than two millennia, and notwithstanding a considerable degree of conservatism the Egyptian taste and approach to beauty changed in the course of the centuries. All one could point out by way of generalization would be, perhaps, a rather persistent trend toward large size, a very special, unvaried calm and dignity in the highly stylized representations, and the particular sense of balance conveyed by the paintings, sculptures, and architectural masterpieces of the Egyptians—their temples, columns, and tombs. There persisted throughout an element of

symbolism, which reflects the unchanged grandeur of their artistic conceptions and gives their creations a timeless character.

Among their extraordinary achievements were the pyramids. The first was constructed ca. 3000 B.C. by Imhotep, adviser, physician, and architect of the pharaoh. Others, more daring in technique, followed. Like the great European cathedrals of the Middle Ages, the pyramids, temples, and tombs probably also served economic purposes, creating work in time of need. But this objective was transcended by more important motives. The pyramids were primarily an expression of the Egyptian attitude toward life, death, and existence beyond death. They served the glorification of the divine, the exaltation of the pharaoh, and the beautification of the people's surroundings.

Agriculture, Industry, Trade, and Law. A considerable shifting and movement of populations went on. The majority of the Egyptians lived by means of agriculture. They raised wheat, barley, vegetables, and grapes, as well as cattle and fowl. Horses were unknown in the Early and Middle kingdoms. Of course, agriculture depended upon seasonal irrigation of the desert by the waters of the Nile, and the maintenance of the irrigation system was one of the chief tasks of the government and burdens of the farmer. A minority engaged in industry, mined copper on the Sinai peninsula, worked stone and made bricks, and produced cloth and articles of glass and bronze. They made pottery, adorning even simple daily utensils with lovely colors and paintings. They made writing materials out of the papyrus plant that grew on the banks of the Nile, and they produced luxury items for the small wealthy class, which lived in richly furnished mansions in the towns.

External trade does not seem to have played a large role in Egypt; exports were essentially restricted to supplying neighbors, such as Nubia. Some trade connections extended to overseas regions, including Syria and Crete. Syria was a vital source of wood, which came from the cedars of Lebanon. Since money did not exist, barter was the basis of all trade. Laws (eventually codified) regulated both trade and agriculture. A census of the land was repeatedly taken. During the first few dynasties, justice seems to have been dispensed fairly equitably to all classes, but growing stratification of society, which came with more complex living conditions under later dynasties, terminated the practice of equality before the law.

Religion. Religion permeated all phases of Egyptian life. In early times, it concerned itself less with ethics than with human fate, especially after death: hence the furnishings and splendor of the tombs for kings, queens, nobles, and the rich, and the mummification of their bodies. Religion later embraced broader aspects of the Egyptians' spiritual life and inspired literary and artistic works. Eventually the priests, who had been under the control of the pharaohs and had attended mainly to services in the temples, achieved their own political power and prominence such as their brothers in other regions often enjoyed.

The supreme Egyptian divinities were successively Horus, Ra, and Amen—all of them identified with the sun. Osiris, who represented the Nile, held a special place as judge and ruler of the dead, but myths concerning him later became intermingled with those of Horus and Ra. Isis, goddess of motherhood and fertility, was the sister and wife of Osiris. Worship of these highest gods was supplemented by veneration of lesser local deities. Many of the gods were represented as animal or part-animal forms.

MIDDLE KINGDOM

The glory of early Egyptian culture was interrupted in the twenty-third century B.C., after the death of Pepi II. Central authority broke down, partly as a result of an unequal tax system by which priestly possessions were exempted, and prolonged political troubles ensued. The nobility gained wide autonomy and the country was torn by strife among local rulers, who held the real power in the country. Invasions from the south and north, which brought the temporary loss of the Nile delta, contributed to a worsening of conditions. Devastating famines occurred and political chaos followed. Only with the Eleventh and Twelfth dynasties (ca. 2000–1850 B.C.) did peace return. Order was then reestablished by a revived strong central authority. Once more the nobles had to obey the royal will and be satisfied with serving as members of a unified administration.

Political and Economic Organization of the Middle Kingdom. In the times of the Eleventh and Twelfth Dynasties, and especially under Amenemhet III, absolutism—that is, government by one ruler whose will must be obeyed absolutely—reached its peak. The capital was moved from Memphis to Thebes, far up the Nile near the center of the country. The central government resumed control over the water supply, the lifeline of the country. Extensive irrigation projects were again undertaken. The area of arable land was extended by bringing under cultivation the desert to the southwest of the Nile delta. A canal was constructed connecting the Nile and the Red Sea, and the Nile was made navigable beyond the first cataract.

By these measures, as well as by maintaining internal order and expanding the country eastward and southward, the pharaohs succeeded in furthering trade and industry. They even tried to restore the social balance that had been upset in the time of troubles at the end of the third millennium. Although preserving the existing system of slavery, they saw to a measure of secularization, which implied the reduction of the power of the priests. They settled free people on the land, checked the arbitrariness of the nobles, and protected the craftsmen.

Cultural Organization. Culture in the Middle kingdom showed signs of what philosophers of history such as Oswald Spengler and Arnold Toynbee have considered a "mature" stage of a civilization. Artisanship, painting, and sculpture did not evince the same creative impulses that earlier ages had

brought forth. Perhaps we can trace continued perfection of workmanship (especially in the minor arts), less formalism, and greater realism, but new ideas and depth of artistic feeling seem to have been somewhat lacking.

More than before, emphasis was placed on size; and attention shifted from art to science. Mathematics and practical activities such as construction and mining flourished. Literature—another expression of a mature society—came to play a wider role. Prose stories, histories, travel accounts, and religious and secular poetry were composed, folk tales were collected, and philosophical works were written. As for religion, the god Amen came to replace Ra, and in connection with his worship, religion began to emphasize ethical standards.

Decline. Toward the end of the Twelfth Dynasty, degeneration and effeminacy became increasingly noticeable, and military prowess declined. The successors of Amenemhet III proved to be incompetent. Total collapse occurred when foreign invaders, known to history as the Hyksos, attacked the country. Equipped with horses, a resource unknown to the Egyptians, they conquered the land, annihilated the old nobility, and established their own "barbarian" government.

Sumer

A development not unlike that seen in the Nile valley took place in the lands enclosed by the Tigris and Euphrates rivers, which comprised Mesopotamia ("between the rivers"). Here too, nature favored the early growth of civilization. Probably from about 3000 B.C.—somewhat later than in Egypt—we have written evidence that the numerous small and independent Mesopotamian communities began to consolidate into one kingdom. This kingdom was dominated by Sumerians (of unknown origin) who had invaded Mesopotamia in the fourth millennium and after whom the country is named "Sumer."

Government. The early government of Sumer did not enjoy the same stability that contemporary Egypt possessed. Central authority remained so weak that individual states, such as Ur, Akkad, and Lagash, retained a large measure of independence. Their government was in the hands of local kings or priests who exercised both economic and political control, though some of them may have been elected by popular assemblies. At various times, one or the other of these local rulers overthrew the central Sumerian government. Thus at various times the kings of Ur, Lagash, Akkad, or other regions succeeded in making themselves masters of the whole area. But tensions remained and were increased by struggles over economic control, especially of the water supply and irrigation. Moreover, difficulties resulted from the steady influx of nomadic Semitic tribes. These eventually became numerous enough to impose their language upon the entire area.

Rulers. A number of outstanding rulers appeared in Mesopotamia during the course of the third millennium. There was Messanipada (ca. 2600 B.C.),

during whose reign trade flourished, reaching from the Indian Ocean to the Mediterranean Sea. Eannatum reigned about a century later. His rule originally encompassed no more than the northern parts of the country; but, being a mighty conqueror, he soon extended his sway over most of the south. Great monuments, temples, and sculptures mark the path of his victorious armies.

Perhaps the most famous ruler was a man who had risen from relatively humble origins, Sargon of Akkad (ca. 2350 B.C.). He put an end to the renewed internal strife that had preceded his reign, once more unified Mesopotamia, established firm central authority, and conquered additional territory up to the shores of the Mediterranean. His empire differed from the earlier ones in character, language, manner of dress, religious ways, and administrative bureaucratic institutions.

After his death, anarchy returned. Barbarian invasions followed, and not until about 2100 B.C. was independence restored to Mesopotamia—this time by the rulers of Ur. Rather than war, the arts of peace reigned during their rule, especially during that of Dungi (or Shulgi) (ca. 2000 B.C.). Laws were codified and enforced. New canals were built, the irrigation system was repaired, and beautiful temples were erected.

Like the Egyptian pharaohs, the authority of the Mesopotamian rulers rested upon their claim to a position equal to that of the gods. They were commanders of the army, arbitrators of all political disputes, and, indirectly, owners of all property. They controlled the irrigation system, which was the basis of Mesopotamian prosperity. Their weakness, in contrast to the Egyptians, lay in their failure to develop an effective and reliable bureaucracy. They remained dependent upon local kings, priests, and a feudal nobility—a situation fraught with danger, inasmuch as the army was composed of mercenaries who often proved to be untrustworthy.

Learning. The Sumerians studied mathematics, astronomy, and medicine. They knew how to alloy metals (adding tin to copper in order to manufacture bronze), and they worked metals into everyday utensils. By 3000 B.C. or thereabouts, they had succeeded in constructing a wheel and could use this invention to build wheeled carriages and improve the manufacture of pottery. They were skilled construction engineers and built in brick as well as stone. They developed a numerical system and worked out a correct calendar.

They also invented a system of writing called cuneiform, whose wedge-shaped signs were entered on clay tablets using reeds. They practiced a type of cuneiform writing long before 3000 B.C., but in the course of time they simplified the signs, adopted symbols for individual syllables and sounds, and eventually created a remarkable literature. Libraries were built, numerous records were kept, and engraved cylinders serving as seals for documents were produced. Among the works of literature still preserved is

the *Epic of Gilgamesh*. It contains legends of gods, kings, and heroic events, some of which show marked similarities to those recorded in the Old Testament. The *Epic of Gilgamesh* constitutes an invaluable source of information about Sumerian life, beliefs, and ethics.

Art. To judge from surviving monuments, the Sumerians were not so proficient as the Egyptians in the fine arts. Economic backwardness and scarcity of raw materials may be partly responsible for this fact. Nevertheless, their sense of beauty, their artistic genius, and their craftsmanship are attested to by numerous works. They created fine sculptures, they built elaborate palaces, temples, and graves for their kings, and their metalwork rivaled in beauty and perfection some of the best creations of ancient times. The sound of their music has, of course, vanished, but representations on monuments indicate that the Sumerians appreciated music and possessed instruments such as the lyre and the flute.

COMMERCE AND LAW

The central location of Mesopotamia favored foreign trade. Some historians believe that, at the time of Sargon, Mesopotamian connections extended as far as South America. Certainly, traders reached India, Egypt, North Africa, Syria, and Asia Minor. Lacking any type of coined money, they exchanged goods on a barter basis. They exported fine jewelry and woven goods, as well as tools, arms, and slaves. They imported metals and other necessary materials.

Law was codified at various times: A most revealing codex, which throws light on social conditions, dates back to about 2000 B.C.

Society was clearly stratified along feudal lines. The population consisted of a priestly caste, who enjoyed a privileged position, ordinary citizens, who were free, and slaves who, in the course of time, seem to have become more numerous. A sizable class of artisans and merchants existed, but the largest group were the peasants. Despite the importance of trade, agriculture formed the basis of economic life in Mesopotamia, as in Egypt.

RELIGION

In view of the dominant position of the priests, religion was bound to play an important role in Mesopotamia. Sky, sun, earth, water, and other forces of nature were worshiped. Statues of gods were made and vast pyramidal stepped buildings—known as ziggurats—were erected and adorned with temples and sculptures. Religion so permeated all Sumerian culture that the Sumerians assigned even to abstract ideas (gods, spirits, natural forces, religious concepts) a place in their daily life and in the hierarchy of society. The Mesopotamians were preoccupied with questions of immortality and resurrection, but they never reached the depths of transcendental religious thought explored by the Egyptians or the Jews.

OTHER CULTURES BEFORE 2000 B.C.

With the progress of excavations and the science of archaeology we have come to realize that by at least the third millennium, if not earlier, other advanced civilizations existed. This is true not only for Near Eastern lands, including Syria and Asia Minor, but also for at least one corner of Europe—the island of Crete at the southern end of the Aegean Sea. Available evidence indicates that Crete possessed an organized political life with powerful rulers, and that it carried on trade with Asiatic lands and Egypt. In Crete was developed a remarkable architecture, and the island's inhabitants (possessing, like the Sumerians, the potter's wheel) produced industrial as well as agricultural goods for exchange. But the artifacts so far discovered of this so-called Minoan civilization for the period before 2000 B.C. are too few to permit a description of life and arts in Crete that would add substantially to our knowledge of this ancient civilization, which can be regarded as a forerunner of our own.

In the centuries before 2000 B.C., high civilizations arose in the Near East, especially in Egypt and Mesopotamia. The West owes much to them. Writing was developed, records were kept, ships were built, division of labor was practiced, and the art of government by law, mostly of a monarchical or religious type, developed. Great creative genius and technical knowledge expressed themselves in architecture, particularly in huge structures such as pyramids and temples. Agriculture formed the basis of the economy, and domesticated animals were widely in use. Stone and iron served to fashion tools.

Selected Readings

Aldred, C. *Egypt to the End of the Old Kingdom* (1965)

Fagan, B. *The Rape of the Nile: Tomb Robbers, Tourists, and Archaeologists in Egypt* (1977)

Lichtheim, M. *Ancient Egyptian Literature* (1976)

Mertz, B. *Temples, Tombs, and Hieroglyphs* (1964)

Redford, D. *Akhenaton, the Heretic King* (1984)

Redman, Charles L. *The Rise of Civilization: From Early Farmers to Urban Society in the Ancient Near East* (1978)

Ruffle, J. *The Egyptians: An Introduction to Egyptian Archaeology* (1977)

Sandars, N. *The Sea Peoples: Warriors of the Ancient Mediterranean, 1250–1150 B.C.* (1978)

White, J. *Everyday Life in Ancient Egypt* (1963)

2

The Near East in the Second and First Millennia B.C.

2000–1200 B.C.	Hittite Empire
1950	Babylonian invasion of Sumer
ca. 1900	Early Semitic writing developed
1800–1100	Achaean, Ionian, and Doric invasions of Greece and Aegean Islands
1800–1500	Minoan culture at Peak
1792–1749	Reign of Hammurabi (Law Code) in Mesopotamia
1700–1570	Hyksos rule in Egypt
1570–1085	Egypt's "New Kingdom"
ca. 1570	Reign of Ahmose I (Eighteenth Dynasty) of Egypt
1550–ca. 1150	Babylon under Hittite rule
ca. 1490–1436	Reign of Thutmose III of Egypt
ca. 1411–1375	Reign of Amenemhet III of Egypt
ca. 1400	Crete invaded by Mycenaeans
1400–1184	Mycenaean culture
ca. 1369–1353	Reign of Ikhnaton of Egypt
ca. 1352–1344	Reign of Tutankhamen of Egypt
ca. 1300	Hebrews leave Egypt, invade Palestine
ca. 1292–1225	Reign of Ramses II (Nineteenth Dynasty) of Egypt
ca. 1247	Assyrians take and destroy Babylon
ca. 1200–800	Independent state of Phoenicians
ca. 1195–1167	Reign of Ramses III (Twentieth Dynasty) of Egypt

1184	Conquest of Troy by Achaeans
ca. 1100	Phoenician alphabet developed
1114–1078	Tiglath-pileser I of Assyria
ca. 1005–965	Reign of David of Israel and Judah
745–727	Reign of Tiglath-pileser III of Assyria
722	Israel conquered by Assyrians
722–705	Reign of Sargon II of Assyria
709	Assyrians take Babylon
705–681	Reign of Sennacherib of Assyria
668–633	Reign of Ashurbanipal III of Assyria
663–609	Reign of Psamtik I (Twenty-sixth Dynasty) of Egypt
641–586	Jeremiah, Jewish prophet
625–605	Reign of Nabopolassar of Babylon
612	Nineveh taken by Babylonians (Chaldaeans) and destroyed
604–562	Reign of Nebuchadnezzar of Babylon
586	Judaea conquered by Babylonians; Jews abducted into captivity
569–546	Reign of King Croesus of Lydia
549–529	Reign of Cyrus II of Persia
545	Cyrus II of Persia conquers Greek Asiatic settlements
539	Cyrus II of Persia conquers Babylon
536	Return of Jews from Babylonian captivity
529–522	Reign of Cambyses II of Persia
525	Conquest of Egypt by Persians
521–486	Reign of Darius I of Persia

*A*fter 2000 B.C., new peoples whose achievements have become meaningful to Western civilization enter our field of vision. History becomes more varied, more dynamic. For the fourth or third millennium, our scarcity of sources makes conditions appear static. To be sure, historical evidence may be of many kinds, consisting of written documents; engravings in stone, clay, and metal; pictorial representations; tools and other objects used in daily life and found in tombs and temples; excavated houses; and a great variety of other evidences of human life, thought, and institutions. Yet despite this multiplicity of sources, it remains difficult for the historian to gain a feeling for that evolutionary movement, that constant change, which is implied in history. Nothing "is," and everything is in the process of "becoming." From the second millennium

onward, our information is, however, more detailed, and we begin to get a true dynamic picture.

THE SECOND MILLENNIUM

The geographical area that embraces almost all the known civilizations of the second millennium forms a kind of triangle. Within it moved the civilized peoples of earlier times. The points of the triangle lie in Egypt, Mesopotamia, and Crete. Within the area appeared Babylonians, Hittites, Phoenicians, Hebrews, and Assyrians; only Achaeans or Aegeans—forerunners of Greek civilization—moved outside the triangle. But not all the cultures that developed in the second millennium were indigenous as invaders from Central Asia and Europe put their imprint on them.

Numerous migrations took place. Groups speaking Aryan, Semitic, and other tongues intermingled with native peoples and, once settled, produced works and ideas important for the Western world.

The Babylonians

Soon after the turn of the second millennium, Babylonians (so named from Babylon, the Sumerian capital they conquered) appeared. They were Amorites, a Semitic people living west of Mesopotamia, who invaded the country and, about 1950 B.C., put an end to the old Sumerian empire. The Babylonians seem to have had little culture of their own to offer, but, once established, they took over and cultivated the heritage of preceding Sumerian generations. The shattered unity of the area was reestablished, a reliable bureaucracy was instituted, and by the time Hammurabi, Babylon's greatest ruler (17th century B.C.), came to the throne, trade and agriculture once more flourished.

SOCIETY

Under the Babylonians, we find the structure of society acquiring certain feudal traits, as class stratification was pronounced. Priests enjoyed a privileged position. Having instituted a socially oriented theocracy, they acted as judges, teachers in the schools, and officials in the bureaucracy. They were among Babylon's foremost students of nature, practiced astrology, and predicted the future. They thought that they could gain a preknowledge of what was to come from an inspection of the entrails of slaughtered animals. Their superior factual knowledge, their prestige as prophets, and their status as judges and teachers gave them a position in

society that, especially after the death of Hammurabi, they could exploit for the sake of gaining political and economic power.

A second layer of society was made up by a landholding nobility. Its influence rested on its hold on agriculture, which remained the chief source of wealth in Mesopotamia and which prospered again when, owing to royal supervision, irrigation was once more introduced and the network of canals was extended. However, the nobility's control of the landed estates was made dependent upon its rendering military or administrative service to the ruler. There was a third class, the freeholders, who not only farmed their plots but also enjoyed, as in Sumerian times, factual ownership of them. The fourth and last class consisted of slaves.

INDUSTRY AND COMMERCE

Enjoying the protection of a powerful government, industry and trade regained their former importance. City life revived. The production of metal objects, weapons (swords, shields, and bows and arrows), jewelry, woven materials, earthenware, and building materials (especially brick) increased. Although coined money did not yet come into use and trade was still based on barter, elaborate business methods were evolved: "Corporations" were organized, prices regulated, and formal sales contracts were engraved on brick. Trade extended to the eastern limits of Asia and to the western parts of the Mediterranean basin.

LAW

Under Hammurabi in the eighteenth century B.C., a famous law code was drafted. It was based on existing customs and stipulations. It regulated all aspects of social life: public, professional, business, and family affairs. It divided the populace into noblemen, freemen, and slaves, setting forth the rights and duties of each class and extending the protection of the law to all—including slaves. It favored monogamy and protected the rights of women, but, in order to encourage a high birth rate, legitimized the offspring of wives other than a man's first. With the concept of strict retaliation underlying the ethics of the lawgiver, the code, though it contained some humanitarian and enlightened elements, made many crimes punishable by death.

LEARNING, EDUCATION, AND RELIGION

The Babylonians knew how to construct arches and vaults resting on high columns, and they built many ziggurats. Like all people who must sail the seas or cross deserts, they excelled in mathematics and astronomy. They introduced a 354-day calendar and divided the day into twelve hours. They studied geography and medicine. In their well-developed schools they taught writing (cuneiform), and their government supervised and regulated many scholarly activities. Their religion prescribed veneration of various gods and

goddesses, most of whom were attached to individual localities. Highest among them was Marduk, the local god of the capital, Babylon. Their religion emphasized purity of heart and a belief in immortality.

FALL OF BABYLON

The lack of a strong and independent political power at a time when priests dominated the affairs of the state proved disastrous for Babylon. Military strength declined, and the empire was weakened by attacks from north and south. About 1550 B.C., it fell prey to the Hittites and others. Using horsedrawn war chariots, the Hittites overwhelmed the Babylonian foot soldiers, who lacked the mobility and advanced techniques possessed by their enemies.

The Hittites

The Hittites were "barbarians" of Indo-European origin. In the late third millennium they had conquered large parts of Asia Minor, whence they penetrated into Mesopotamia and, subsequently, also seized Syria, then under Egyptian rule. They did not retain full control of Syria, however, but divided it with Egypt and concentrated on ruling Mesopotamia. A warlike people, they seem to have possessed little culture and contributed little more to Mesopotamia than an efficient ruling caste.

In Hittite times, Babylonian art and artisanship declined. Life became cruder, even though (as so often happens in history) the conquerors were eventually conquered by the higher civilization of the defeated people. Like other northern Aryans, the Hittites placed their main emphasis on agriculture; but they also learned to engage in industries (especially those using iron mined in the mountains of their homeland in Asia Minor) and to promote trade.

Governmental administration under the Hittites lacked some of the Oriental features that characterized Egyptian, Sumerian, and Semite governments. Kings were not regarded as gods; they had to obey the laws, and, being often mere military chieftains, were bound by reciprocal feudal obligations to their followers. Their laws were not so despotic and barbarous as those of many Orientals. Hittite rule in Mesopotamia lasted until the twelfth century B.C.

The Phoenicians

By the time of the Hittite decline, other peoples, too, had built civilizations that left a permanent imprint on later Western culture. Among these peoples were the Phoenicians. Theirs was less a united country than a group of city-states. Their history dates back to the fourth millennium, but we know little about them until the second, when they came successively under Egyptian, Babylonian, and Hittite domination. When Hittite power declined, they gained independence, which lasted, however, only until the ninth century B.C.

COMMERCE

Like other Semitic peoples, the Phoenicians excelled as traders. In this lay their significant role in history. They owed this trait largely to the geographical location and the topographical features of their country. In their narrow, mountainous strip of land on the eastern coast of the Mediterranean, they found little opportunity for agriculture. But owing to excellent seaports (notably Sidon and Tyre), they would become, toward the end of the second millennium, the foremost navigators of their time. They established colonies as remote as Cadiz in Spain, traded with Gaul and Britain (from which they imported tin), and, through their widespread activities, carried Egyptian and Babylonian civilization to many areas of the Mediterranean. Later (ca. 850 B.C.), they founded Carthage in North Africa. It is possible that in the seventh century their sailors rounded the southern tip of Africa.

GENERAL CULTURE

The Phoenicians were famous as dyers of cloth and as workers of metal; they produced fine armor, glass, and pottery, and they provided the Near Eastern empires with much-needed timber. But perhaps their chief and most lasting contribution lay in their devising, on the basis of older models, a more practical alphabet (the word *alphabet* is derived from the Phoenician) than other peoples possessed. It was composed of twenty-two letters, each representing a sound, and it proved a far more efficient tool for writing than hieroglyphs and other elaborate symbols representing whole words or syllables.

Arameans and Hebrews

Besides Babylonians and Phoenicians, two other Semitic peoples merit consideration for their contributions to later Western civilization. One were the Arameans, who lived in the area of Damascus. Just as the Phoenicians were renowned for their overseas activities, so the Arameans became famous as overland traders. They established contacts between distant parts of the world and therewith initiated cultural interchanges. Their language came to be widely spoken; as far as we know, it was also the language used by Christ.

The Hebrews' significance lies, of course, in the influence they exercised upon Western ethics and religion. Originally, they had probably been Bedouins living in the desert. In the course of the first half of the second millennium they settled in Palestine. Some appear to have migrated later to Egypt, and it is presumed that their descendants returned from Egypt and reoccupied Palestine. This country had, in the meantime, fallen to Canaanites and Philistines (from whom the name Palestine is derived).

A government of a united yet very small country was established by Saul, and therewith the Hebrew state became a power in the Near East. Saul's successor David (ca. 1000 B.C.) conquered Jerusalem, extended the borders of the country to the shores of the Red Sea, and secured the frontiers against

foreign invaders. Culturally, David's rule was important for its firm support of prevailing monotheistic trends. He, in turn, was followed by Solomon (ca. 950 B.C.), with whom came a period of peace, prosperity, cultural flourishing, building, and lively trade, but also of Oriental luxury, arbitrariness, and despotism. After his death, revolts (which had been averted during his lifetime owing to his remarkable wisdom) broke out, and the unity established in Saul's time was destroyed. Nevertheless a foundation had been laid for that body of laws and religious tenets that, in the following centuries, would be codified in the Old Testament.

The Assyrians

Egyptians and Sumerians are important primarily because of their artistic and scholastic legacy, Phoenicians and Arameans because of their economic and intellectual achievements, and Hebrews because of their religious and ethical concepts. The Assyrians, who "enter history" in the last part of the second millennium B.C., added little to these accomplishments; it is their genius as empire builders that provided the lessons for later ages.

They were related to the Sumerians, and they had settled on the lands along the upper Tigris. As early as the eighteenth century they had freed themselves from Hittite rule, and in the twelfth century they set out on a long career of conquest, gaining most of Mesopotamia. Under Tiglath-pileser I (ca. 1100 B.C.), they extended their rule westward in the direction of Syria. Though small in number and inferior in culture to their conquered enemies, they understood how to preserve a powerful commonwealth by means of harsh discipline, ruthless destruction of all opposition, constant improvement of military organization and weapons, and effective, bureaucratic administration.

The Aegeans

Recent discoveries have thrown much new light not only on the high civilizations of the ancient Near East but also on the earliest high civilization of Europe, the Aegean. Into a region comprised of southern Greece and the islands and Asiatic littoral of the Aegean Sea infiltrated Achaeans, Ionians, and Dorians, peoples about whose origins we have little information. They probably came in waves between 1800 and 1100 B.C. from the Danube region or perhaps even from areas north of the Danube. They spoke Aryan tongues, settled as an upper caste in the newly won territories, and ruled the indigenous peasants, artisans, and traders. The fusion of their traditions with those of the native civilizations laid the basis for new and original achievements.

AEGEAN CIVILIZATION

Crete, Mycenae on the Peloponnesus, Troy on the Asiatic continent (which was located close to the Dardanelles), and a number of islands formed the major centers of Aegean civilization.Their governments were generally in the hands of kings, who in some places were elected officers. Priests did not play the same role as in Sumer, in Egypt, or among the Semites. The

nobles constituted a military caste, retained considerable independence, and lived (e.g., on Crete) in well-built stone palaces. Below them on the social scale were free peasants, artisans, and merchants, but unlike Oriental cultures, these groups exercised an influence upon government through popular assemblies. The lowest class was that of the slaves, but during the early periods of Aegean civilization these were apparently few in number. Women were treated on a more nearly equal basis with men than in the Oriental countries.

Crete

Within the area of Aegean civilization, the island of Crete held a special place. The Minoan culture there reached its peak between 1800 and 1500 B.C. By then, the island was enjoying its most prosperous times. It benefited from connections with Egypt and Phoenicia—an advantage that Cretan merchants, experienced as they were in seafaring, retained for many centuries. Large towns developed, and the ruling classes lived in luxury, as demonstrated by the art treasures that have been preserved. Vast palaces were built (the most famous being that of the legendary king Minos at Knossos), which were adorned with graceful sculptures and frescoes. Skillful craftsmen excelled in making fine jewelry and beautifully decorated pottery. Music seems to have flourished, but achievements in literature were apparently insignificant. Great works in philosophy or religion from Crete are not known, and only records of business transactions have come down to us.

Mycenae

Around 1400 B.C., Crete was invaded from the Greek mainland and became part of the Mycenaean culture—named after the town of Mycenae. This culture, which lasted until about 1184 B.C. (the year now generally accepted as the date of the destruction of Homeric Troy), was the result of crossfertilization between the civilization of the Greek mainland and that of Crete and other islands in the Aegean. Mighty buildings (among which stands out the acropolis of Mycenae itself) and extravagantly furnished tombs were created. They were embellished with exquisite works of painting and sculpture and have yielded huge treasures of silver, gold, and bronze objects, such as decorated armor and jewelry. Windows and bathrooms exhibit technical proficiency. Shipbuilding, trade, and travel flourished. Mycenaean traders could be found, like the Phoenicians, anywhere from the Pillars of Hercules (modern Gibraltar) to the littorals of the Black Sea and the Persian Gulf. Mycenaean civilization also produced legends of mythical heroes, which have been transmitted to us by Greek writers. Religion (with some rites of probably northern origin) did not assume, however, forms that could contribute to the spiritual treasures of later generations.

Decline of Aegean Civilization

In the twelfth century, new invasions of Greece took place. By that time, Aegean civilization was in its decline. Overpopulation in essentially agricultural Greece had led to incessant internal strife; control of the seaways had

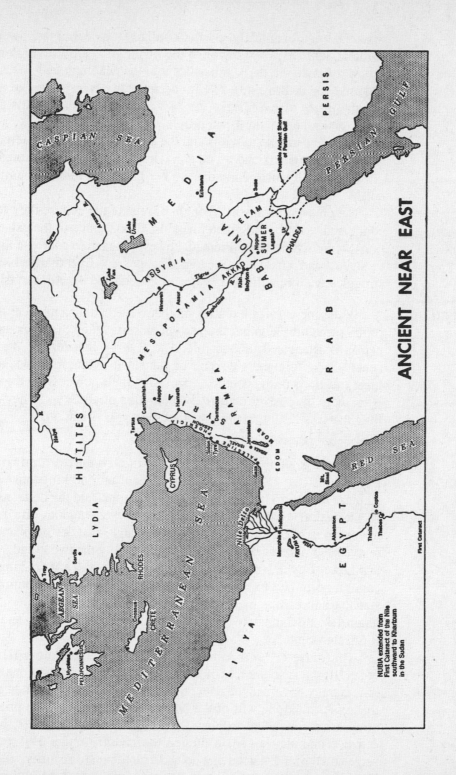

ANCIENT NEAR EAST

NUBIA extended from
First Cataract of the Nile
southward to Khartoum
in the Sudan

weakened; and, eventually, an attack on Troy ruined the manpower resources of the region. Troy, rich owing to the wealth of nearby silver mines and the control of trade via the Dardanelles into the Marmara and Black seas, was captured and destroyed (a fate it encountered several times in its history). But the losses of the Greeks (or "Achaeans," as Homer calls them) were great, and when a northern people, the so-called Dorians, arrived, the Aegeans were unable to withstand the attack and were conquered.

The Dorians attained no memorable civilization; they brought physical prowess, intelligence, and some rather primitive religious cults from the north.

They proved incapable, though, of raising the culture they found in the conquered territories to greater heights. Feudal traits in the existing institutions were strengthened; freemen, however, began to decrease in proportion to slaves, and gradually freedom disappeared. Eventually, bitter internal struggles again rent the whole area of Greece and the Aegean islands.

The Egyptians

While one civilization after another came and disappeared in the course of the second millennium B.C., Egypt, despite many disasters, continued to play a constant and unique role. The Hyksos invaders of the eighteenth century were foreigners who never gained sufficient influence to break the great traditions of the country. Exercising their power from the delta of the Nile, they could never claim the domination of all Egypt. They contributed little that was lasting to the Egyptian state or civilization.

THE NEW KINGDOM

After two hundred years, the Hyksos rulers were overthrown by Ahmose I of Thebes (ca. 1570 B.C.) and the ancient unified kingdom was revived. Ahmose restored Thebes, far south of Memphis and the delta, as the capital of the realm, and with him began the New Kingdom. He replaced the mercenaries with an indigenous army, and with its help and that of a rejuvenated bureaucracy he began to rule firmly the two kingdoms of Upper and Lower Egypt. He enforced strict obedience and, after having gained full control, he turned to external conquests. His work was continued by outstanding successors, including Thutmose III (fifteenth century B.C.), Amenhotep III and Ikhnaton (both in the fourteenth century), and Ramses II (thirteenth century).

Thutmose III and Amenhotep III. Under Thutmose III and Amenhotep III, the absolute role of the pharaohs was vigorously maintained. The bureaucracy governed the country according to established and codified law that represented the will of the pharaohs. The nobility, the priests, and the army were compelled to obey their orders. The foreigners, who as mercenaries and slaves had infiltrated the country under Hyksos rule, were settled on the land and, having gained a modicum of security, were absorbed. The frontiers of the country were pushed southward and eastward, war booty

flowed into the treasury, and lively trade relations were established with the Hittites, Phoenicians, and numerous tribes of Syria, Crete, and other regions. Luxury was once more on the rise, and the construction of monumental temples, great palaces, and splendid tombs again bore witness to the might and pretensions of the pharaohs.

Ikhnaton. The imprint of strong rulers is often such that subsequent generations direct their whole attention to preserving their work, whereby timely reforms are precluded. In Egypt, such conservatism was furthered after Amenhotep III's death by the priests of the ram-headed god Amen, who during the time of the Hyksos had come to be identified with the sun. Priests exercised steadily growing political influence.

The dangers threatening the country were, however, recognized by Ikhnaton, a pharaoh who ruled during the late fourteenth century. Sympathetic to, and stimulated by, foreign examples, which were known to him through the contacts built up in the preceding century, he sponsored radical reforms. He moved the capital northward of Thebes to Akhetaton (modern Tell-el-Amarna, halfway down the Nile toward Memphis), redivided the country, and gave up those conquests (especially overseas) that constituted a drain rather than a gain. He interested himself in the lower strata of the population, had new towns laid out, and distributed land among free peasants and serfs. He sponsored schools and learning, furthered the sciences, and inspired literary work and the fine arts, which exhibited new and original trends in the direction of greater naturalism.

He turned his attention also to questions of religion and the priesthood. He abolished the cult of Amen and, with the exception of Osiris, judge of the dead, that of the various local deities. He instituted the veneration of a single god, Aton, who was related to the former Ra, the sun disk. In doing so, he pursued the political objective of reducing priestly power and the economic aim of appropriating priestly wealth. But he seems to have been prompted also by new spiritual insights. The Aton cult tended in the direction of monotheism, and its ethics were of a higher order than were those connected with Horus and Amen.

DECLINE OF THE NEW KINGDOM

Preoccupied with such vast schemes, Ikhnaton neglected other aspects of his office. He failed to defend the frontiers vigorously enough and lost not only useless but also valuable territories. The army was allowed to deteriorate. Bureaucratic regulations superabounded, and excessive luxury and corruption spread. A dependable ruling cadre to continue Ikhnaton's work was not recruited. After his early death, disorganization and decadence set in. More borderlands fell to invaders; many of his reforms (including the cult of Aton) were abolished; and under Tutankhamen, last ruler of the Eighteenth Dynasty, the Amen priests regained their old power.

To be sure, Egypt still succeeded for another two hundred years in defending herself against outside enemies. The rule of Ramses II (1292–1225 B.C.) in particular marked a revival of Egyptian power and splendor. After concluding an alliance with the Hittites, Ramses was even able to regain some of the territorial losses. But then, beginning in the time of Ramses III of the Twentieth Dynasty (1195–1167 B.C.), the security of the country came to be again dependent upon mercenary troops. Soon thereafter, Egypt fell prey first to these hired foreign soldiers, and subsequently to successive conquerors from the outside. The New Kingdom came to an end in the year 1085 B.C.

THE FIRST MILLENNIUM

The history of the Near East in the last millennium before Christ is most absorbing in itself, but it has less immediate significance for Western civilization than do earlier periods. In the first place, Europe—through Greece— emancipated itself from Eastern influences and, notwithstanding cultural contacts with Eastern neighbors, charted a course of its own. In the second place, much of the former vitality of the East, expressed in its manifold artistic creations, was lost in the last millennium B.C.

What caused such a decline is a subject of dispute. Perhaps, after thousands of years, the Eastern civilizations had simply "grown old." Material changes, perhaps in climate or soil, may have undermined their strength. Perhaps originality and initiative had shifted to other peoples, who had learned from Eastern experiences and overshadowed their masters. Or perhaps, by sheer accident, great creative minds became scarce in the Orient.

Egypt The decline of civilization in the Near East is very noticeable in Egypt. Under the domination of Assyrians, Babylonians, and Persians, who for long periods made themselves masters of the country, few great works (judging from those that have come down to our own times) were produced. Only in the seventh and sixth centuries B.C., when Egypt had regained its independence during the Twenty-sixth Dynasty—Psamtik I and his successors—did a certain revival occur. Arts, in particular sculpture, flourished again; metal goods and pottery of considerable beauty were again created; and the study of natural sciences progressed.

The country prospered under a capable administration, and its influence was felt beyond its borders. Foreign settlers, especially Greeks, came and

contributed their share to the revival. Spiritual vigor, however, marked by originality in thought and artistic creation as opposed to imitation of old models, can scarcely be detected.

Assyria

Of somewhat more immediate interest for the growth of Western civilization than the history of the Nile valley during the first millennium is that of Mesopotamia. There the Assyrians (who after the death of Tiglath-pileser I had experienced two centuries of eclipse) once more awoke to the challenge of great tasks. In the ninth century they invaded Syria and conquered Damascus and Phoenicia; in the eighth century they captured Babylon and seized Israel. In the seventh century, while successfully defending their northern boundaries against threatening Cimmerians, they extended the southern boundary of their empire deep into Egypt. They established their capital in Mesopotamia and, after various changes, finally fixed it at Nineveh.

ASSYRIAN CULTURE

The Assyrians have not left a great cultural heritage. Schools and libraries flourished during the reigns of Tiglath-pileser III and Sargon II in the eighth century and Sennacherib and Ashurbanipal in the seventh century, but they depended upon the Babylonian religious and scholarly legacy. However, the Assyrians did develop some remarkable new forms of sculpture, especially bas-reliefs. In their animal sculptures, they evinced a realism very distinct from the geometric patterns and symbolic representations of other peoples. These sculptures and carvings have remained one of the glories of the ancient world. The Assyrians also achieved considerable technical proficiency, as evinced by the aqueducts they constructed.

ASSYRIAN POLITICAL ORGANIZATION

Of continued importance, too, was the example set by the Assyrians in the art of empire building. Constituting but a small minority in their dominions, they had to face special tasks. They solved them by force. A powerful, brutal military establishment was built up and weapons—many made of iron—were developed to perfection. Through terrorist tactics, obedience was enforced. The administration was put into the hands of harsh, efficient military governors, solely responsible to the king and drawn either from the princes of subdued nations or from the Assyrian nobility. Military measures to hold down the conquered peoples were combined with shrewd economic policies: Foreign merchants were invited into the empire; transit trade was assisted; and taxes and tolls were fixed at a moderate level so as to stimulate commerce and enrich the treasury of the king. Coins were used as a means of exchange to replace the more primitive barter system.

The Chaldaeans

The vast expansion of their dominions proved to be the undoing of the Assyrians. Having reached out too far, they could not maintain their empire.

Rebellions of individual provincial administrators were occurring. Between 650 and 520 B.C. the Egyptians, Babylonians, Persians, and other peoples freed themselves from their hated rulers. In the course of the revolts, the Assyrian towns and many of their art treasures were destroyed. In 612 B.C. Nineveh was taken by the Babylonians (or so-called Chaldaeans of Aramaic origin) and razed.

The Chaldaeans, who founded what has come to be known as the Neo-Babylonian empire, soon in turn extended their sway beyond Mesopotamia into Judaea and Syria. Their rule lasted little more than fifty years. Yet, under Nabopolassar and Nebuchadnezzar, they inaugurated an era of remarkable accomplishments. It was again a period of elaborate building. Mighty fortifications and palaces, with the famous Hanging Gardens of Babylon, were erected. New works of construction for the improvement of agriculture were built, and scientific investigations, especially in astronomy, were successfully carried through.

The Persians

The next masters of Mesopotamia were the Persians, a people whose ruling caste belonged to the Indo-European group. They defeated their neighbors, the Lydians, who had once participated with them in revolts against the Assyrians and who in the meantime had tried to build an empire of their own. They took as prisoner Lydia's fabulously rich king, Croesus. He had ruled a country extending from the Black and Aegean seas to the Mediterranean in the south and the Halys River in the east—a country of considerable culture and wealth, in which the first coined money, made of gold, was used. The Persians also defeated their other former allies, the Medes. Moreover, they subdued the Greek cities on the Aegean coast of Asia Minor. Finally, in 539 B.C., they conquered Babylon.

PERSIAN CULTURE

Thereafter, during the span of almost a century, a succession of four Persian kings—Cyrus II, Cambyses II, Darius I, and Xerxes—ruled over one of the most powerful and civilized of empires. The arts, inspired by the examples of many regions, flourished. Babylonian and Assyrian traditions were preserved. A religion first preached about 600 B.C. by Zoroaster (Zarathustra) and his disciples emerged that embodied ideas of immortality, truth, and justice. It explained the world in terms of an eternal struggle between good and evil. Zoroastrianism combined these ideas with ethical concepts that paralleled in many respects the tenets of Christianity and Confucianism, for the individual, they taught, is capable of choosing between good and evil. It became Persia's official religion.

PERSIAN GOVERNMENT

The Persian kings established their capital at Susa, not far from the Persian Gulf. Their realms extended from the borders of India to Egypt—the

latter country being conquered in 525 B.C. by Cambyses, who made himself pharaoh. As customary among most Oriental peoples, the will of the king reigned supreme. In Persia it was enforced on both land and sea by highly trained military forces and by a special bodyguard, the Ten Thousand Immortals. The empire was subdivided, and it was administered by a carefully organized bureaucracy that, at least from the time of Darius on, was subjected to strict supervision by the central government. Through traveling inspectors, who also dispensed justice, the government checked on the proper execution of the king's laws.

As opposed to the Assyrian rule by force, the Persians showed a cooperative attitude toward conquered nations, allowing them a measure of native law, their own officials, and a light tax load. Great postal roads were constructed. The canal connecting the Nile and the Red Sea was restored. A good monetary system was introduced, and a lively commerce developed. Nevertheless, the bureaucratic empire degenerated until it was conquered in 331 B.C. by Alexander the Great.

The Hebrews

The various civilizations of the ancient Near East have made lasting contributions to the Western world in the fields of art, handicraft, science, law, and government. In the area of religious beliefs (aside from Persia and the teachings of its great philosopher Zoroaster), only one people had a permanent—and, indeed, overwhelming—influence on Western civilization: the land of the Hebrews. Under Solomon's successors, the Jewish country had been first divided into two parts—Judaea and Israel—and then each part was torn by internal quarrels and by wars between the two regions.

In 732 B.C., after conquering Damascus, the Assyrians made the two Hebrew states tributaries and, ten years later, took over the entire northern region of Israel. The southern division, Judaea, was conquered in 586 B.C. by the Babylonians, and Jerusalem was destroyed. Many inhabitants, especially the rich, influential, and skilled, were abducted. Their children were not allowed to return until the coming of the Persians, who gave them permission to do so in 536 B.C.

It was just during this period of political dissolution that a unique religious codex evolved. From Elijah in the ninth century B.C., Isaiah and Jeremiah in the eighth and seventh centuries, Ezekiel and Daniel in the sixth century, to Ezra in the fourth century, a long line of great religious leaders and prophets preached unwaveringly the idea of a single god, Yahweh, a god of justice, sometimes even of mercy, who punished the sinful and rewarded those who acted rightfully and obeyed the divine law. Though constantly challenged by worshipers of foreign gods and foreign customs, they staunchly upheld monotheistic views. In the course of the centuries their teachings were written down. Eventually they formed the content of the Old Testament, which, together with Christian teachings, has constituted ever since not only

the chief code of ethics of Western civilization but also the main inspiration in Western creative arts and literature.

*D*espite *many interruptions owing to warfare and internal upheavals, Egypt and Mesopotamia (the latter with its famous city of Babylon) continued to make remarkable contributions to civilization in art, law, learning, and industry. Other peoples who were to add to the later heritage of the West, enter the historical picture after the year 2000 B.C.: Hittites, Phoenicians, Hebrews, Assyrians, Persians, and others dwelling around the Aegean Sea. Their influence was to be felt, particularly in achievements that were to nourish the emerging Greek culture.*

Selected Readings

Aharoni, Y. *The Archaeology of the Land of Israel* (1982)
Bright, J. *A History of Israel* (1981)
Contenau, G. *Everyday Life in Babylon and Assyria* (1966)
Cook, J. *The Persian Empire* (1983)
Frankfort, Henri. *The Birth of Civilization in the Near East* (1951)
Grant, Michael. *The History of Ancient Israel* (1984)
Gurney, O. *The Hittites* (1964)
MacQueen, D. *The Hittites and Their Contemporaries* (1975)
Postgate, N. *The First Empires* (1977)

3

Greece Before 500 B.C.

Wide variety distinguishes Greek civilization from almost any preceding or subsequent civilization in Europe or the Near East. Seldom has the Western world seen such a blossoming of thought and art as the tiny Greek country produced within the short span of about two or three centuries.

What accounts for the splendor of Greece? An infinity of factors must have contributed to it: the advantages of a moderate climate; the mixture of peoples; the diversity in living conditions made possible by the presence, within a small area, of mountains, plains, valleys, inlets of the sea, and islands; the inspiration derived from the beauty of land and seascape; the contacts with old civilizations; the economic opportunities afforded by a geographic location favorable to trade; and many other advantages. Yet the decisive element must have been, besides the invention of a complete alphabet, the extraordinary number of individual men and women of genius. Among scores who might be named are philosophers like Socrates, Plato, Aristotle; writers like Homer, Sophocles, Aristophanes, Sappho, Anacreon, Pindar; artists such as Phidias, Praxiteles; statesmen like Pericles,

Alexander; the historian Thucydides; and men of science like Pythagoras, Thales, Hippocrates, and Euclid.

THE POLITICAL SCENE

The political history of Greece centers primarily around two towns—Athens and Sparta—and their institutions. Other towns (e.g., Corinth and Thebes), the various islands off the coast of Asia Minor, and the colonies (e.g., Syracuse in Sicily, Tarentum in southern Italy, and Panticapaeum on the Black Sea) essentially followed the lead of the two main centers. Athens and Sparta never created empires, as the Assyrians, Babylonians, and others had built earlier, or as Rome was to establish later. It was on a very limited scale that they developed the various forms of political organization that were to become models for all future generations.

The Greek World

The Greek world comprised not only Greece proper, including Macedonia, but numerous islands of the Aegean Sea and many other, more distant territories as well. Greek colonization of these outlying parts occurred in waves, beginning in the ninth century B.C. and reaching one climax late in the eighth century and another at the end of the seventh. Connections through trade had existed earlier. The Greek colonizers, many of them Greek soldiers with experience in organizing their settlements, left their overpopulated territory to seek arable land and trading opportunities. They established settlements to the west in Sicily, southern Italy, southern France, and Spain; to the south in Egypt and along the whole northern coast of Africa; to the east on the shores of Asia Minor; and to the north around the Black Sea. In their new homes, they engaged not only in agriculture and trade but also, as in Spain or Asia Minor, in the exploitation of mineral wealth. The colonies were independent of their various mother states, but they maintained close contact with them. They spread Greek ideas and distributed Greek products abroad, gained wealth, and took back to Greece foreign ideas and foreign merchandise.

Government and Evolution of Governmental Structure

The Greeks created governments very different from Oriental despotism. Their monarchies were limited and short-lived, and even their tyrannies were moderate. A landed nobility, such as the Assyrians or Persians had evolved, did not secure a lasting hold on their governments, nor did their priests ever gain much political power. Ultimately many of their states achieved a measure of democracy.

MONARCHY AND OLIGARCHY

In the beginnings of Greek history the chief system of government was monarchical. The king represented tribal unity; he was *primus inter pares* (first among equals) within a tribe. Each tribe was based on, and derived its cohesion from, a "sense of common ancestry, common language, and common religion, a realization of common military and economic interests and a geographical proximity." The king exercised political leadership and performed certain priestly functions. Even when not actually elected by assemblies of freemen, he was generally subject to their control.

By the eighth century B.C., however, royal power had declined, for the nobles had gained control of the land (which had been under communal ownership) and had seized direction of public affairs. Soon they, too, had to share some of their new power with the commercial classes, which benefited from the fact that the geographical location of Greece was highly favorable to trade. An oligarchy based on birth as well as wealth, they took over the government.

TYRANNY

Greek political institutions underwent a further change when trade expansion stimulated the growth of industry and thereby increased not only the number of unskilled laborers (e.g., men to work the mines) but also the ranks of the skilled artisans. Soon the artisans, growing discontented with their status, joined the impoverished peasants in demanding political and social reforms. In some parts of Greece, the ensuing conflicts resulted in government by tyrants. During the seventh and sixth centuries B.C., "tyrannical" rule prevailed not only in various states of Greece proper but also in a number of colonies and on many Aegean islands. Among the famous tyrants were Periander of Corinth, Polycrates of Samos, and Peisistratus of Athens.

The tyrants were frequently wealthy upstarts. Having seized the government by illegal means and violence, they needed broad support in order to maintain themselves in power and therefore often catered to the lower classes. They enacted laws advantageous to the masses, divided estates among needy peasants (whereby they simultaneously deprived their aristocratic opponents of their chief resources), and instituted programs to encourage trade. They thus provided work for the artisans as well as profits for their merchant friends.

Dependent as they were upon commerce, the tyrants generally preferred peace to war. They took pride in the embellishment of towns, displayed pomp, and entertained their subjects with theatrical performances and games (at which valuable prizes were distributed). However, inasmuch as they ruled without a legal basis or traditional sanction, they often had to contend with bitter opposition and were driven to commit acts of brutality. Their govern-

ments rarely endured for more than one generation. Some of the tyrants were murdered or exiled. Others retained power until death, but, for lack of capable heirs, failed to establish dynasties. Eventually, the whole concept of tyranny, associated as it was with illegality and arbitrariness, took on the connotation of oppressive government.

THE CITY-STATE OR POLIS

Another form of government, the city-state (or *polis*), was to become important in subsequent Greek history. Originally, a polis constituted an "association of kinsmen," a community of houses, shops, and markets built around a fortification or a temple. But this narrow character of a polis was soon lost. The city-state expanded to include neighboring hamlets. Eventually losing much of its significance as a practical political unit, it became an ideal concept that embraced all free members of the same kinship, no matter whether they lived in the main town, in neighboring dependencies, or in far away independent colonies.

Common rights of citizenship, inherited by generation after generation, and bonds of sentiment provided a lasting link between the members of a polis. Occasionally several city-states would form a federation, choose a famous shrine at which to venerate a common deity, and under its protection seek peace among the members, cooperation against enemies, and commercial prosperity.

Two city-states, Sparta and Athens, stand out as examples of Greek governmental structure. Each made momentous contributions to Western civilization.

Sparta

Sparta was a town in Lacedaemonia on the Peloponnesus. Lacedaemonia's rugged coast provided no good harbor facilities, and Sparta's citizens depended upon agriculture. Sparta had flourished in Mycenaean times; Homer names it as the home of Menelaus and Helena. Probably in the eleventh century B.C., it had fallen to Dorian invaders who deprived the natives of the rights to the land and forced them to cultivate the soil for the benefit of the new masters. In the eighth century they extended their sway into neighboring Messenia.

Numerous revolts followed. By the beginning of the sixth century, however, the conquerors had succeeded in imposing a political system that guaranteed stability. The establishment of this system, which laid the basis for Sparta's power, has been popularly attributed to a legendary king, Lycurgus, but more probably it developed gradually. Toward the end of the sixth century, a Peloponnesian League under Spartan leadership was established.

SOCIAL CLASSES

The Spartan system provided for rigorous social stratification. The privileged ruling class (or *spartiates*), including less than a tenth of the population, was composed of descendants of the Dorian invaders. Though

divided into various groups, they were all free citizens. A second class was made up of the *perioeci*, descendants largely of the native population before the Doric invasion. They were small landholders, tradesmen, and artisans. They enjoyed rights of citizenship only in their home communities and were subject to military service.

The third, or largest, class was that of the *helots*, who belonged to the conquered peoples and had the status of serfs. They were attached to the soil, compelled to till the land and surrender to the spartiate landowners a sizable share of their produce, as well as provide auxiliary military service. They could be freed (especially for bravery in war), in which case they entered the perioeci class. A fourth class consisted of slaves, mostly prisoners of war, who, as the property of their masters, could be bought and sold.

EDUCATION

A martial spirit permeated the life of the ruling caste, the spartiates. It was instilled in them during their childhood. Infants who appeared to be physically unfit were killed shortly after birth—a practice that eventually resulted in a dangerous population shortage. At the age of seven, male children were taken from home and reared by the state. They underwent rigorous military training, were hardened to hunger and pain, and learned to share an equal, de-individualized life.

At the age of thirty, they became full citizens. Thereafter, they had to devote themselves to military and administrative service. Trade was forbidden to them as something beneath their dignity. They could marry only with the consent of the state. Not until the age of sixty were they given full freedom and permitted to become members of the Council of the Old.

POLITICAL AND MILITARY INSTITUTIONS

Sparta had two kings, who belonged to two different ancient royal houses and were chosen by lot. They acted primarily as priests and as generals of the army. Depending upon their ability, they could exercise more or less influence.

Chief political power lay with the Council of the Old, which initiated legislation and exercised supreme administrative and judicial functions. A popular assembly, composed of spartiates over thirty years of age, had the right of final approval for measures proposed by the Council of the Old. In the course of the sixth century, an elective office—that of the five *ephors*— gained importance. Gradually the ephors superseded in power the Council of the Old and even assumed the right to remove a king.

In accordance with its social and economic status, each class contributed its share to the military strength of the country. The army was a well-disciplined, heavily equipped force. It not only served in foreign wars but attended to police duties, maintaining the existing class structure and holding the subjected segments of the population in check.

ECONOMIC AND CULTURAL LIFE

The militaristic character of the state did not prevent Sparta from attaining substantial economic and spiritual achievements. Since Lacedaemonia possessed iron deposits, clay, and timber, the perioeci manufactured iron goods and a great variety of pottery and wooden articles. These products were artistic as well as practical. Trade was carried on with the Greek cities in Asia Minor and even with distant Persia. Both production and commerce were stimulated by fairs and festivals, held periodically in Sparta, which brought together peoples from many regions.

As to cultural advances, they were reflected in music and poetry. The arts of singing and dancing were cultivated. Homer's works were memorized by children and formed a basic part of a Spartan's education. Outstanding Spartan poets included Alcman, a Lydian who lived in Sparta, and Tyrtaeus.

Athens

Athens (in Attica) had the advantage of a favorable location. Excellent port facilities for overseas trade were available; the countryside was rich in grain, olives, wine, and honey; and deposits of iron, clay, and silver existed in the vicinity. Resources also included marble quarries in the homeland and gold mines in the colonies. The Doric invaders that had captured Sparta had spared Attica, which lay off the main path leading to the Peloponnesus. The Ionians, therefore, who had settled in Attica before the fifteenth century B.C. (and who were of the same race as those who inhabited the islands of the Aegean and many cities of Asia Minor), retained control of the land.

SOCIAL CLASSES

There were in Athens the usual classes—the nobility, merchants, artisans, and peasants. Slaves were proportionately more numerous than in Sparta, but it was a rather common practice for Athenians to free their slaves. In addition, there were the *metics*—foreigners welcomed to Attica for their skills or trading interests and allowed to live there permanently, though without enjoying the rights of citizens.

POLITICAL INSTITUTIONS

In early times Athens, like other Greek towns, was ruled by kings. In the course of the centuries, a well-established landholding nobility wrested control from them and reduced the royal office to a chiefly representative function—that of high priest. Men elected from the ranks of the nobility itself, called *archons*, took over the high judicial and administrative tasks. The influence of the archons, too, declined when, at the beginning of the seventh century B.C., their number was fixed at nine and their term of office limited to one year. Eventually the nobility was, in turn, deprived of its privileged status by the prosperous merchants. Despite these shifts in governmental power, landed wealth remained the principal factor determin-

ing the political status of an individual citizen and, in the course of time, was to constitute a danger to peasants and small landholders.

SOCIAL CHANGE AND REFORM IN ATHENS

The changing phases of Athenian institutions and their foundations (birth, landed property, monetary wealth) contrasted with the more static conditions of agricultural, militaristic Sparta. Various constitutions and law codes, drawn up to increase the rights of the lower strata, gave the institutions of Athens a fluidity lacking in those of Sparta.

Reforms Under Draco and Solon. Late in the seventh century, friction and social upheaval were rife. In order to stem the tide of class struggles and preserve the virtues of early times, a severe code of laws was issued under the guidance of the chief aristocrat, Draco. It prescribed the death penalty for many offenses against the status quo. Actually, we know little about Draco, even though his name has become synonymous with harsh, cruel, so-called draconian laws.

Within less than a generation, in 594 B.C., changes were introduced by Solon, who had earlier excelled as a general, merchant, and poet. Despite his aristocratic background, he sought to break the power of the landed aristocracy by limiting the amount of land anyone could own and by extending civil rights to the lower classes.

Solon divided the citizenry into four tribes (excluding metics and slaves) on the basis of the income an individual derived from the land he owned. Every citizen's status within his tribe determined the taxes he had to pay and the rank he held in the various formations of the well-trained, powerful army. Only the first of these tribes had the privilege of providing candidates to serve as archons. However, men from the three upper classes could be appointed to a newly established Council of 400. All four classes had the right to participate in the popular Assembly, which discussed matters brought before it by the Council and which elected the archons. Archonate, Council, and Assembly were supplemented by a People's Court, which supervised the administration of the archons and constituted an element of "checks and balances."

Besides making these constitutional arrangements, Solon also eased the peasants' debts, abolished enslavement for debt, and made provisions for the admittance of non-Athenians to citizenship. He promoted industry by laws furthering exports and restricting imports, encouraged silver mining, and established a uniform currency and a simplified system of weights and measures.

Reforms Under Peisistratus. Like those of Draco, Solon's reforms were insufficient to provide desired stability to the Athenian state. Within thirty years, Peisistratus (who was related to Solon) made himself tyrant of Athens. Like all tyrants, he gained power with the help of hired soldiers,

judicious bribery, and the buttressing of his authority through promoting the interests of the lower classes and filling all key offices with his merchant friends.

Yet, at least formally, Peisistratus maintained Solon's laws. He continued Solon's attacks on the old aristocracy by dividing estates. He supported the merchants by building roads, encouraging the immigration of metics and establishing colonies. He courted favor with the masses through festivals and by adorning the city with palaces and temples.

His sons, who succeeded him in power, were, however, incompetent; one was murdered (514 B.C.), and the other was expelled (510 B.C.). Even though Athens had enjoyed prosperity under Peisistratus and his sons, this revolt against the tyrants was celebrated in subsequent centuries as a testimonial to the Athenian love of freedom.

Reforms Under Cleisthenes. After the disappearance of the tyrants, the process of democratization went on. Attempts of the aristocracy to regain power were defeated. Around 508 B.C., under the influence of the statesman Cleisthenes, another reorganization took place. The four-class system based on heredity, property, and tribal connections was maintained only for purposes of taxation. Otherwise it was replaced by new divisions. These were so devised as to reduce the importance of old ties of kinship and local allegiance, to prevent a resurgence of the aristocracy, and to build among all citizens new loyalties to the state as a whole.

Citizenship rights were further extended, as every male over twenty years of age received the right to vote in the popular Assembly. The highest offices, as well as membership in the Council (increased to 500), were opened to all citizens and evenly distributed among the various divisions. Archons, members of the Council, and military leaders were chosen by lot. All offices were made subject to rapid rotation. Moreover, ostracism was introduced, whereby voters could impose a ten-year period of honorable exile on anyone whom they regarded as a threat to the existing political order.

THE SOCIAL AND CULTURAL SCENE

In the period before 500 B.C., the Greeks not only laid foundations for new types of political organizations but also struck out on economic and cultural paths of their own. Just as their political thought has retained validity for more than two thousand years, so have many of their philosophical and

scientific speculations and most of their artistic creations stood the test of time.

Perhaps it is the rationality and logic of their thinking, combined with their sensitivity and taste, that account for the merits of their work. Ionians and Dorians, homeland, islands, and colonies—they all contributed to the legacy left by Greece. Every part took pride in the contributions of any other part, thus bearing witness to the common aspirations that animated the Greek world and to the firm links that, despite the variety of traditions and institutions, bound it together.

Economic and Social Conditions

A varied and, for a long time, healthy economy, built up by an industrious and (in regard to material luxuries) not too demanding people, underlay the cultural evolution of Greece. Agricultural pursuits were of prime importance. But industrial production increased and the introduction of an advanced monetary system furthered trade as time went on. Industry and trade soon constituted, together with language and culture, the most vital link connecting the various parts of the Greek world. However, they also contributed to wars, not only with foreign competitors but also among the Greek states themselves.

INDUSTRY AND AGRICULTURE

The growth of an advanced economy was stimulated by the introduction of a monetary system. The Greeks did not rely on barter but began early, following the example of the Lydians, to mint money. Their currency consisted generally of silver coins. Their sound monetary system played a vital role in the expansion of their commerce and large-scale manufacturing. Soon the Greeks excelled in the making of fine pottery (often beautifully decorated), iron goods, bronze articles, woolen cloth, and marble. Their shipbuilding industry grew similarly. Ports were constructed and sciences necessary for seafaring were studied. Mining operations were expanded and unavailable minerals were introduced from Asia Minor, as well as from Spain, Britain, and elsewhere.

Business methods improved. Merchants organized trading companies and sponsored progressive commercial laws. Breaking the Phoenician monopoly on overseas trade, the Greeks began to export large quantities of domestic products and import other products, especially grain, fish, and raw materials. Substantial profits were derived from the slave trade.

Agriculture adapted itself to commercial needs. Since increased specialization and manufacturing made Greece, and particularly Athens, dependent upon imports and exports, and since arable land was scarce, early diversification of agriculture could not be maintained. The production of wheat, flax, barley, fruits, vegetables, and cattle (a type of production suited to a small population) had to give way to the specialized production of olives and wine for export.

SOCIETY

Increased trade was largely responsible for the shifting of governmental power in commercial centers from landholding aristocrats to wealthy merchants, from peasants to artisans. It led to a decline of conservatism and to progressive democratization.

Wherever commerce flourished, it speeded up social mobility—that is, the transfer of people from one class to another. Moreover, it contributed to changes in the status of the various classes. On the one hand, although the old aristocratic families often retained their special standing, the merchants and even the artisans came to share in various privileges. On the other hand, the conditions of peasants and slaves deteriorated. Farmers had a hard time with a growing burden of debts. Slaves (perhaps a quarter of the population) generally led an increasingly miserable existence in the mines, in the shipyards, on the farms, and in household service.

The Humanities

The same diversity characteristic of the political and social life of the Greeks was also a feature of their philosophy and art. The early great thinkers and artists (almost all of whom lived in the sixth century B.C.) were citizens of many different parts of the Greek world—products of widely differing conditions. Some of them came from Attica or the Peloponnesus; others came from the colonies. Most of the leading figures came from the Ionian islands or the Asiatic coast, where they had been in touch with Oriental traditions. Yet a feeling of unity permeated the entire Greek world, emphasized by the common treasures in art, poetry, and music.

PHILOSOPHY AND SCIENCE

The Greeks made no formal distinction between philosophical thought and natural sciences; the term "philosophy" included not merely speculative theory but practical observations and discoveries in the fields of mathematics, physics, astronomy, medicine, and zoology.

Among the greatest philosophers was Pythagoras, who was born in Samos and brought up in southern Italy. Though we possess no actual writings of his, we know that he was one of the most outstanding mathematicians of all time. He was also an eminent idealistic philosopher, who through his mystic teachings strove to reform the moral, social, and political life of his compatriots.

Three other great scientists and philosophers came from Miletus: Thales, Anaximenes, and Anaximander. Each believed that the universe is composed of a single, basic substance that they sought to identify. Thales concluded that it must be water, Anaximenes that it is air, while Anaximander decided that it is a prime, eternal, and indestructible matter that, by incessant movement, gives birth to every object and living being and to which everything returns. In the course of their speculations, all three arrived at many insights

of importance for the evolution of science. Thales' astronomical observa-
tions, for example, led to the correct prediction of an eclipse of the sun in
585 B.C. Anaximander's geographical descriptions furnished the information
required for an understanding of the size and locations of the various
countries and their distances on the globe. Other scientist-philosophers of
lasting importance included Xenophanes of Colophon and Heraclitus of
Ephesus. Like the philosophers from Miletus, Xenophanes searched for an
identification of prime matter, believing it to be earth. He speculated about
the shape of the universe, which he conceived as spherical. He also occupied
himself with religion, postulating one god—a universal deity—as opposed
to the numerous anthropomorphic deities of popular Greek worship.
Heraclitus, on the other hand, emphasized the rational character of life and
nature. He conceived all phenomena to be subject to a law, or *logos,* that is
above and in all things. He insisted that the world is in constant flux, that
there is eternal change, and that everything leads, through war or struggle,
to its own opposite and back to its original form. This theory of change was
rejected by Parmenides, most famous of the metaphysicians, who taught that
things either are or are not, but that there is no "becoming," no eternal change.

ART

The profound and noble character of Greek thought was matched by the
beauty of Greek art. During the seventh and early sixth centuries B.C., Greek
sculpture, with its stylized geometrical patterns influenced by northern
traditions, combined rhythm and strength. The paintings on Greek vases,
despite a similar formalism, evinced a special grace and simplicity in con-
ception.

The temples, too, reflected strict, mathematical thought. Yet despite the
perfection of their proportions, they did not leave the impression of ar-
tificiality but an intuitive sense of harmony. The earliest style of temples
emphasized the severe, simple Doric column; this was followed by more
elaborate Ionic patterns (which were influenced by Asiatic models) and
eventually by the light and cheerful Corinthian style. The temples were
adorned with friezes with elaborate bas-reliefs and high-reliefs. They also
contained murals, none of which, however, have survived. Though built to
honor the gods, the temples did not reach up toward heaven, like the great
Gothic cathedrals of the Middle Ages. Even when large in size, they stood
firm, close to the ground. Horizontal, not vertical, lines predominated and
mirrored the special interest of the Greeks in the affairs of the world.

LITERATURE

The same concern with worldly and human affairs shown by Greek art
helps to explain the trend of Greek literature, which flourished in an age when
nothing comparable was created by other civilizations. The Greeks were
proud of their language. It constituted a link between their widespread lands.

It also set them apart from the outside world of barbarians—people who spoke a variety of tongues *(bár-bar)*. Its sound and rhythm possess a special beauty.

The verse meters created by the Greeks set standards for thousands of years. Their lyrics, praising wine, music, and love, their epics in honor of gods, battles, and heroic deeds, and their prose describing or criticizing the events of the day enchant, inspire, and "evoke awe and pity." Transcending the immediate subject matter with which their literary works deal, they constitute eternal comments on the meaning of life and fate.

Two Homeric epics, the *Iliad* and the *Odyssey*, have come down to us from the ninth or eighth century B.C. Only slightly later, Hesiod composed his *Theogony*, a cosmogony or theory about the origins of the universe based on Greek myths about creation. The same author wrote *Works and Days,* a book containing descriptions of contemporary modes of living. Aesop's *Fables* and Sappho's and Alcaeus's lyrics probably date from the seventh century B.C. Other somewhat later Greek poets include Anacreon of Samos, famous for lyrical poetry, and Tyrtaeus of Sparta and Solon of Athens, both noted for battle hymns as well as tender songs. Most of these works possess strong individualistic traits, which distinguish them from the known literature of earlier civilizations.

MUSIC

From the myth of Orpheus, whose playing wrested concessions even from the god of the netherworld, we gain some inkling of the place music held in ancient Greece and the power it exercised on the Greek mind. Unfortunately, only a few fragments of actual compositions have come down to us. We know that the rhythms were similar to those in poetry, that choral song was cherished, that voices were often accompanied by instruments, but that polyphonic music was rarely produced. Common instruments were the lyre, the flute, the harp, and cymbals. Music was considered a fundamental part of a man's education, and it played a central role at the great Greek festivals, when prizes were given to the best musicians.

GAMES AND FESTIVALS

In their philosophy, the Greeks strove to achieve the aim of self-knowledge, *gnothi seauton*. In their arts, they sought harmony, *kalon k' agathon*. Both ideals inspired their games and festivals. These meant far more than mere amusement or sports, and more than a stimulus to trade or an opportunity for statesmen to negotiate with friends and enemies. They were expressions of the Greek view of life, of their unity, of their belief in the beauty of mind as well as body. For the duration of the games, a general truce reigned. From all parts of the Hellenic world, participants enjoyed safe conduct and found hospitality—this the most sacred obligation of a Greek citizen.

We can trace such festivals from the eighth century on. Perhaps the most famous are the Panhellenic Olympic games and the games of Corinth and Delphi. The feast days brought competition in athletics, music, dancing, and poetry. At the beginning and end of each festival, religious celebrations were held. Vase paintings, sculptures, and surviving literature bear witness to the significance of the Greek games.

Religion

The Greeks adhered to a polytheistic religion. Their gods were super-human rather than divine. There was little emphasis on ethics or morals. The religious thought of the Greeks constitutes, indeed, the one area of human experience in which subsequent ages have had little to learn from them. Only art and literature have gained from the imagination displayed by their mythology.

DEITIES

The chief deities were Zeus, Athena, and Aphrodite, most of them well known from Homer's works. Some of the traditions connected with them were handed down from Mycenaean times; others go back to Oriental precedents. With the passage of time, new gods were added, among them Dionysus, the god of wine. In addition to these gods, who were supposed to dwell on Mount Olympus, there were demigods, like Hercules, and numerous local deities. Each family honored some individual god as its special protector, and many communities were devoted to the service of a parochial god, in honor of whom the leading aristocrat performed a priestly office.

MYSTERY CULTS

A greater depth of religious experience was achieved through various mystery cults, which sprang up in the sixth century and later. In an atmosphere conducive to transcendental, supernatural speculations, the members of such cults attempted to fathom the problems of death, immortality, and transmigration of the soul and to search for the meaning and aim of life and the path to virtue. As in a number of Oriental religions, the cults included various magical rites, devoted especially to deities such as Demeter and Dionysus or even to legendary mortals such as the singer Orpheus. They were celebrated only by small groups of individuals initiated in secret ceremonies. Often the worshipers indulged not only in religious speculations but also in ecstatic and licentious rituals.

ORACLES

Greek religious ceremonies were supplemented by the practice of divination, whereby priests predicted the outcome of public or private enterprises by inspecting the entrails of animal sacrifices. Oracles were consulted, the most famous of which was that near Delphi, in central Greece. It gained a unique power in the national life because it was consulted not only in

numerous private matters (such as family problems) but also in grave political issues. A priestess (the Pythia), sitting on a tripod (three-legged stool), over the vapors of the Delphian hot springs, uttered sentences. These were induced by trances, simulated or real, or prompted by—generally rather conservative—priests of a nearby temple of Apollo. Many of the Pythia's pronouncements were enigmatic and contradictory. Yet they did influence decisions at various turning points in Greek history, such as during the Persian Wars and on other occasions.

The Greek world extended far beyond Greece proper. It penetrated into Italy and all along the Mediterranean shores, into northern Africa and into Asia Minor. In Greece itself, two centers developed, Sparta and Athens. They worked out different political systems, but both excelled through their great achievements in art, poetry, architecture, music, and education. A complete alphabet was invented, which created unequaled possibilities for intellectual pursuits and for the preservation of what great minds had devised and invented. Religious concepts were evolved in which mystery cults and oracles played a major role, and religious rites were observed in daily life as well as on special occasions—at musical and sports festivals. However, no priestly caste arose, as among the Egyptians, Mesopotamians, Hebrews, and others. Still, societal divisions were strong, with slaves serving at the bottom of the structure. Their lot was, however, not as hard as in other regions; essentially, Greek states, whether ruled by monarchs, tyrants, or "democratic" leaders, built their greatness on the efforts of freemen.

Selected Readings

Finley, M. *Early Greece: The Bronze and Archaic Age* (1970)
_____*Economy and Society in Ancient Greece* (1982)
_____*The World of Odysseus* (1965)
Hopper, R. *Trade and Industry in Classical Greece* (1979)
Page, D. *History and the Homeric Iliad* (1959)
Starr, C. *The Economic and Social Growth of Early Greece, 800–500 B.C.* (1977)

4

Greece in the Fifth Century B.C.

492–479 B.C. Greek-Persian wars

490 Battle of Marathon (Miltiades)

485–465 Reign of Xerxes of Persia

483 Aristides ostracized

480 Battle of Thermopylae (Leonidas)

Battle of Salamis (Themistocles)

479 Battle of Plataea (Pausanias)

478 Delian League founded

470 Themistocles ostracized

ca. 466 Naval battle of Eurymedon

464 Earthquake in Sparta

461 Cimon ostracized

456 Death of Aeschylus

449 Death of Cimon

447 Athens's defeat at Coronea

445 "Thirty Years' Peace" between Athens and Sparta

438 Death of Pindar

431–404 Peloponnesian War

429 Death of Pericles

428 Death of Herodotus

ca. 422 Battle of Amphipolis (Cleon)

421 Truce of Nicias

417 Death of Phidias

415–413 Sicilian expedition of Athens

406–367 Reign of Dionysius I, Tyrant of Syracuse

406 Battle of Arginusian Islands (Alcibiades)

Death of Sophocles and Euripides

405 Battle of Aegospotami (Lysander)

404 Fall of Athens

404 –403 Rule of "Thirty Tyrants" in Athens

400 Death of Thucydides

399 Death of Socrates

Before the fifth century B.C., most of the outstanding achievements of Greek civilization originated on the Ionian islands and in the Greek cities on the Asiatic shores of the Aegean Sea. During the fifth century, however, the cultural center of Greece shifted to Athens. It was there that, during the Periclean Age, architecture, literature, history, and philosophy came to full flourish. It was then that Greek culture reached its culminating glory and that noble thought turned the experience of life into a treasure for all times.

But the fifth century was also a century of strife and human anguish. It opened with wars between Greece and Persia and it closed with civil wars. It witnessed the triumph of Athenian democracy and the work of Athens's greatest statesman, Pericles. But it also brought the imperialism of Athens, its infringement of the liberties of weaker communities, its exploitation of its allies, and the ultimate collapse of its democracy. It saw the heroism of the Greeks in a struggle with an outside enemy, but also their brutality and perfidy in a struggle with each other. Like every society, Greece offered a twofold, contradictory picture.

THE POLITICAL SCENE

The reality of Greece's political life, even in the times of Greek glory, has provided the world with anything but a model for imitation. Moreover, the parochial political institutions of Greece were adapted to the needs of small city-states and hardly appropriate for countries with huge masses of citizens and for ages shaped by modern technology. In ancient Greece, a comparatively large percentage of the citizenry could play an active part in

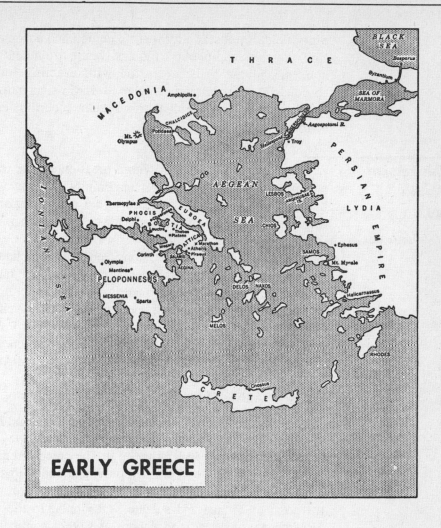

EARLY GREECE

national policies, personally contribute to lawmaking, personally take a share in the administration, and have personal access to those in power. But Greek institutions did not even adequately fulfill their purpose within the framework of Greek surroundings. The *agora*, or marketplace, was in no way similar to the serene atmosphere associated with Socrates. It was the El Dorado of slavedrivers and of dirty, loudmouthed peddlers accustomed to cheating customers. The law court, with corrupt and venal judges, was a center of perjury. The politician betrayed his country and the orator used his talents for furthering selfish aims. Women were discriminated against in

every field. Homosexuality was a common and accepted form of behavior. Noble temples and public buildings were surrounded by ugly, ill-smelling houses, and the artist entrusted with erecting inspiring monuments absconded with public funds. Even in wartime, as in the desperate struggle against Persia, the individual only seldom subordinated his interests to the common good.

The Persian Wars (492–479 B.C.)

The fifth century began with a great enterprise in the area of foreign affairs: war with Persia. The Persian Empire had grown during the preceding hundred years. It had conquered Lydia and incorporated various Ionian towns in Asia Minor and on the islands of the Aegean. The Persian king had then turned his attention farther westward and, primarily to protect his realms against possible Scythian invasions from the north, had reached out beyond the Bosporus into Europe proper—into the Danube region and into central Thrace. This second step alarmed the Greeks even more than did the subjugation of their Aegean compatriots. Many Greek city-states drew closer together. Following the example of Sparta and her Peloponnesian League, they formed other defensive alliances. Cooperation was also established between the two leading Greek centers—Sparta and Athens.

PRELIMINARIES TO WAR

The next phase in the rivalry between Greece and Persia was a revolt of the Ionian cities. Incited by the tyrant of Miletus, they rebelled, despite the fact that Persian rule was rather mild. They received naval aid from Athens but were defeated. The Persians, provoked and warned, thereupon (in 492 B.C.) again sent an army across the Hellespont, this time in order to occupy the coast of Thrace and subdue Macedonia. In the following year, they dispatched ambassadors to Athens and other continental Greek cities and demanded their submission. The envoys met with a firm refusal. Indeed, Sparta as well as Athens committed the outrage of murdering the Persian envoys, and war resulted.

Perhaps this war was not the great decision between East and West for the salvation of culture that ancient Greek and many modern writers have tried to make of it. Perhaps the battles were not so gigantic, fearful, and brilliant as they have been portrayed in Greek accounts. Perhaps many Greeks did not consider Persian rule so grave a threat. Indeed, there were numerous Greek collaborators, often whole city-states, and the Persians would probably have never attacked had they not felt sure of Greek disunity. But at least the descriptions of the struggle of small, divided Greece against mighty Persia have been an inspiration for all future generations. Countless were the acts of devotion and selfless fulfillment of duty reported to us, and ordinary citizens as well as leaders accomplished memorable deeds.

FIRST CAMPAIGN

Immediately upon rejecting Persian demands, the Athenians began to prepare for war. Under the leadership of a capable general and statesman, Miltiades, they increased their military forces, improved their tactical strength through a reform of their infantry formation (the phalanx), and entered into negotiations with Sparta for aid. When in 490 B.C. the Persians launched the expected attack, Athens was ready. Without waiting for Sparta, which was busy with a festival, they counterattacked and, in the famous battle of Marathon, completely defeated the Persians.

INTERMISSION

A ten-year pause and period of relief ensued. Revolts following the death of the great Persian king Darius in 486 B.C. and the accession of his son Xerxes delayed Persian preparations for a new invasion, which were not completed until 480. In the meantime, Athens, too, prepared anew for war. Leadership passed from the hands of Miltiades into those of two younger statesmen: Aristides, defender of old aristocratic ideals, and Themistocles, a partisan of democratic trends. Both worked devotedly, but increasingly at cross purposes, until, in 483 B.C., Aristides was ostracized. A man of integrity but of perhaps somewhat narrow views, he had advocated conservative military defenses, while Themistocles, ambitious and enterprising, had favored the risky and expensive strategy of relying for the defense of Athens upon the construction of a powerful navy.

SECOND CAMPAIGN

A second invasion by the Persians began in 480 B.C. The first encounter was at Thermopylae, a mountain pass leading into central Greece. The mighty Persian army was stopped there by a small band of Greek defenders under the Spartan king Leonidas. Together with three hundred men, Leonidas sacrificed his life in one of the most renowned battles of history. Once the pass at Thermopylae was cleared, the Persians moved on into Attica. They devastated the countryside and forced the Athenians to give up their capital, which was burned.

At this juncture the Spartans, supreme commanders on land, advocated withdrawal south to the isthmus of Corinth, but the Athenians objected and, as supreme commanders on the sea, risked a naval battle. At Salamis, they succeeded in destroying the Persian fleet and forced the Persians to retreat. The following year saw the defeat of the Persian rear guard at Plataea by a Spartan phalanx under Pausanias and another Athenian maritime victory, this time at Mycale. A number of Ionian cities were liberated. In 478 B.C. control of the straits dividing Asia and Europe was gained with the capture of Byzantium. Although no peace was concluded, this effectively ended the struggle in Europe.

Postwar Period (470–445 B.C.)

War had brought ruin to large areas of the Greek mainland. Material reconstruction, both of buildings and agriculture, proceeded quickly, but social difficulties could not be so promptly adjusted. They caused a long period of troubles in Sparta, and they led to thoroughgoing changes in Athens.

SPARTA

After the end of the Persian wars, Sparta, though spared from invasion during the war, found its institutions threatened. The danger came from two sides: from those who intended to replace the existing order by one-man rule and from others who, on the contrary, sought broad, democratic forms. Those desiring one-man rule were led by Pausanias, who, after having achieved victories in the field, aspired to make himself monarch. For this purpose he even negotiated with the former enemy. But his attempts came to naught. He was convicted of treason, and his compatriots let him starve in a temple in which he had sought refuge.

The democratic forces were also defeated. Following a terrible earthquake in 464 B.C., they instigated a revolt of the *helots* against the spartiates. With great difficulty, the revolt was crushed. Altogether it took Sparta more than fifteen years to restore the traditional order.

ATHENS

In contrast to Sparta, Athens did not maintain its existing social structure intact. As often happens, war had brought about a leveling of society, and the path of Athens led to further democratization. Significantly, this was achieved regardless of whether defenders of the aristocratic faction or protagonists of the popular forces were at the helm.

Leadership in Athens. The leading figures in Athens after the Persian wars were Themistocles, Aristides, Cimon, and, finally, Pericles. Themistocles led the work of reconstruction for almost six years, but he lost favor in 472 B.C. and eventually went to Persia, where he died, a traitor to the Greek cause. Aristides, who, having returned from exile, dominated the political scene after Themistocles' departure, died five years later and was followed in the leadership of the aristocratic party by Cimon. Cimon was a very capable man but of excessive ambition. He too was ostracized—in 461 B.C. He survived his exile and returned, but in 449 he died during a campaign that he led against Persia.

The next important figure was Pericles. He came from a leading aristocratic family and was a man of energy and ability, of broad knowledge, and of taste. A good orator, with marked demagogic talents, he allied himself with the democratic forces. To be sure, Athenian democracy remained imperfect in his time, and men of wealth and high birth kept their hold on the direction of affairs, but there was a constant drive toward broad popular rights.

Democracy in Athens. Under the leadership of these four men, a transformation of Athenian institutions took place. Citizenship rights were extended to almost all the free population, meaning that, since women, metics, and slaves were not included, about a quarter of the total population came to enjoy such rights. The voting age was lowered, and the Assembly, which met not less than forty times a year, gained in influence.

Government positions were opened to all citizens. The court system was improved. The aristocratic Areopagus, the highest court in Athens, was stripped of many of its administrative functions, and these were given to the Council. Magistrates were made liable for their acts. The practice of the state's paying officials for their services was instituted so that others besides the wealthy could hold public office. Payments were made even to those who merely attended a public festival.

Internal Policies. Public works were undertaken, such as the construction of temples and other buildings, thereby providing many of the unemployed with an opportunity to earn a living. The tax system was changed to improve the lot of the poorer classes of the population. The fortifications of the town were strengthened. A wall protecting the road from Athens to its harbor at Piraeus was completed in 479 B.C. The navy was rebuilt, and new harbor facilities at Piraeus were installed. Military bases were erected in the lands of the allies, and the power thus gained was used to promote the economic policies of the state.

Economic Policies. Athenian trade expanded. The competition of commercial towns, such as Aegina, was eliminated by force. That of others, like Corinth, was reduced by boycotts and other economic measures. Athens secured domination of the straits leading to the Black Sea, founded new colonies, such as Amphipolis in Thrace and various towns in Sicily, and settled citizens abroad. Unlike the Spartans, the Athenians pursued a policy not of self-sufficiency but of expansion. More and more of their agriculture was oriented toward serving the needs of external commerce. They concentrated on the production of wine, fruits, olives, and oil. But grain (much of which, like the necessarily large quantities of fish, came from the Black Sea region) was imported; so, too, was lumber. Exports included metals, marble, wood, and ceramic products.

External Policies. Dependence upon foreign trade and a desire for economic dominance necessitated an aggressive external policy. The period between the Persian and the Peloponnesian wars constituted an era of Athenian imperialism.

Exploiting the prevalent anti-Persian sentiments, Athens induced various Greek city-states and Aegean towns to form an alliance, the Delian League. Naturally, leadership fell to the Athenians, who soon gained almost complete control of allied policies. Although a constitution provided for proportionate rights for all members, Athens imposed arbitrary taxes, assumed jurisdiction

over the allies, and refused to grant citizenship to the peoples of the empire. In Pericles' time, the government had the funds of the League (which had originally been deposited in Delos) transferred to Athens. It soon began to use them, as if they were tributes, to finance Athenian shipbuilding programs and pay the wages of Athenian workmen. In a variety of ways, Athens exploited the League as a means of expanding Athenian economic influence.

Force supplemented persuasion and bribery whenever necessary to help Athens impose its will on its allies. Having defeated Persia's Phoenician allies in the naval battle of Eurymedon in 466 B.C., and having secured dominance in the Aegean Sea and in large areas of the eastern Mediterranean, Athens gradually extended its power into Euboea. It stationed a garrison in the town of Megara on the gulf of Corinth, seized the island of Aegina, sent troops into Boeotia, and eventually also took possession of the Chersonese.

But this ruthless expansionist policy engendered hatred, fear, and, finally, one war after another. First there came a new campaign against the Persians. It was brought to a successful conclusion when, after victories gained by Cimon, Pericles signed a peace treaty that ended Persian interference in Greek affairs. Other campaigns followed, these directed in turn against Greek sister states. They too brought some successes, as Boeotia and Phocis were subdued. But in 447 B.C., Athens suffered a grave defeat at Coronea, which induced a number of tributary towns to secede. Two years later, Pericles was forced to conclude a thirty-year truce. Athens lost some of her conquests on the continent but retained superiority on the seas and with it domination of her colonies and the Ionian islands.

Prelude to Civil War (445–431 B.C.)

The truce did not last, and Athens quickly resumed her aggressive policies. Fearing new revolts within the empire and the continued enmity of Sparta, the Athenians sought new alliances, erected new military bases, and accumulated a large war fund. They finished their main fortifications, the "long walls," which connected the city with its life nerve, the harbor of Piraeus. Pericles even attempted to have a wall built across the isthmus north of Corinth, planning to combine defensive aims with the objective of gaining control of trade in the gulf of Corinth and reducing the city itself. He also supported rebellions against Corinth.

When, in retaliation, Corinth encouraged a revolt of the town of Potidaea against Athens, Pericles attacked and defeated the Corinthian forces in battle. Such infringements not only endangered the liberty of others but also violated the truce established in 445 B.C.. When, in addition, Athens engaged in an economic boycott of the small town of Megara, Sparta (joined by Corinth, Thebes, and other Greek towns) assumed the role of defender of "Hellenic liberty." In 431 B.C., war began.

**The
Peloponnesian
War
(431–404 B.C.)**

Pericles had long prepared for war, militarily and financially. The war was bound to decide the issue of hegemony—leadership—in Greece, and Pericles seems to have welcomed rather than feared the decision. Actually, the war did decide the issue—and the decision turned against Athens.

FIRST DECADE OF WAR

The Peloponnesians started by invading Attica. According to plan, Pericles allowed the Attican countryside, which was difficult to defend, to be devastated, and evacuated the inhabitants behind the new city walls. There they could be provisioned because Athenian supremacy on the seas could guarantee the necessary import of food and supplies. The plan worked, and it is probable that new invasions thereafter would have been equally unsuccessful. But as a result of the overcrowded conditions in Athens, a terrible plague broke out in 430 B.C., which killed a third of the population. Pericles himself was a victim the following year.

During the ensuing years, Pericles was succeeded by Cleon, an able leader from the artisan class who won a number of victories. Nevertheless, the power and prestige of Athens steadily deteriorated. A loss of manpower weakened the army and the food supply became scarce. Eventually the Spartan general Brasidas inflicted on Athens a severe defeat in a sea battle off Amphipolis (in Thrace), in which Cleon was killed.

DEFEAT OF ATHENS

Following Cleon's death, the aristocratic party under Nicias gained the upper hand in Athens. This party favored peace and, in 421 B.C., succeeded in concluding a ten-year truce. But even as Greece began to recover from the ravages of war, the Athenians broke this truce, just as they had broken the truce of 445 B.C. Persuaded to do so by the brilliant but unscrupulous young aristocrat and demagogue Alcibiades, they resumed their imperialistic policies. They seized the island of Melos, which was a Peloponnesian colony. After the island surrendered, they slaughtered nearly all the defenders. Then, disregarding the warnings of Nicias, they also supported a revolt in Sicily against a regime friendly to Sparta and Corinth. Straining all their reserves, they equipped a mighty expedition and sent it to Sicily. The expedition failed in its attack on Syracuse, in which the entire Athenian army, including Nicias, perished.

In the meantime, Alcibiades had deserted to the enemy and, following his counsel, the Spartans resumed their attacks. They established a permanent base of operations in the Attican countryside, secured financial assistance from Persia, and won a number of victories. Many Attican slaves used the favorable moment to flee, and several allies of Athens deserted her cause. In the face of disaster, Athens restored oligarchic rule, deprived the lower classes of many of their rights, and welcomed, in 408 B.C., the return of Alcibiades.

His organizing ability and audacity enabled Athens to gain a few new victories. But a last great naval victory (406 B.C.) near the islands of Arginusae was followed the next year by a crushing Athenian defeat by the Spartan general Lysander at Aegospotami. The Spartans then moved on to Athens, laid siege to the city, and forced its surrender. In the name of "liberty for Greece," they destroyed its military power and defenses and reorganized its government. They installed a new oligarchic regime under thirty pro-Spartan "tyrants" and put a garrison in the town. Thus ended the war.

Reorganization in Athens

The Thirty Tyrants, led by the aristocrat Critias, ruled with brutality. They exiled or killed their opponents. Not until 403 B.C. could a revived democratic faction under a new leader, Thrasybulus, get rid of them. Even then, democracy, which had proved disastrous for Athens and the rest of Greece, was not fully restored. Nor could plans advocated by Thrasybulus for a revival of the Athenian empire be carried out, for Sparta as well as Thebes kept a close watch over the defeated enemy.

GREEK THOUGHT AND ART

Not until the fourth century B.C., when great thinkers were to appear who described and evaluated the experiences of Greece in politics, finance, and administration and who thought through the art of government and gave lasting meaning to the ephemeral (transient), not until then could the political life of ancient Greece become a treasure for all time. Greek law did not provide standards to emulate. The Greeks, unlike the Hebrews or the Romans, failed to develop—either on the basis of religious and ethical concepts or on the basis of practical precedents—a code of law that could serve as a permanent guide. Their legal decisions were arrived at individually, *ad personam*, in line with momentary trends, convictions, and judicial inquiry.

It is, therefore, to the fields of science, philosophy, art, and literature that we must turn. It is there that we find the greatness of fifth-century Greece: the evolution of the scientific concept of the "atom"; the Hippocratic standard for the medical profession; the Socratic rules of ethics and self-understanding; the perfection of the Greek ideal of harmony in art; and the achievements of the dramatists. It is through such achievements that Greece has served, uniquely, all future generations.

Science

Greek scientists of the fifth century, instead of treading new paths, carried on the search for reality and for the origin of life along the lines laid down by their predecessors. Like them, they failed to develop instruments (on which modern science is accustomed to rely) but concentrated, as before, on speculation and logical mathematical deduction rather than on observation.

MATHEMATICS AND PHYSICS

Notwithstanding the shortcomings of their methodology, the achievements of the Greeks were remarkable—especially in arithmetic, geometry, astronomy, and cosmogony. Speculating on matter and the substance of the universe, Anaxagoras, the first great philosophy teacher in Athens, formulated remarkably clear ideas about the nature of the sun. He also taught that all matter consists of an infinite number of minute particles and that a spiritual force imposes order upon their chaotic arrangement. His contemporary, Zeno of Elea, preoccupied with Heraclitus's law of eternal change, expounded the opposing belief in the world's essential stability.

A third contemporary, Empedocles of Agrigentum, in Italy, continued the search of Thales and Anaximenes for the "building stones" of nature. Instead of the oversimplified answers of his predecessors, he suggested the hypothesis that four "elements" constitute these materials and that, by alternately separating and uniting, they produce the various forms of matter. Toward the end of the century, a fourth great scientist, Democritus, took a step beyond these theories. He postulated that many different, indivisible material particles—or "atoms"—make up the cosmos and that even the soul consists of such particles.

MEDICINE

Interest in the study of nature, as reflected in these investigations, led to remarkable advances in medicine. Hippocrates (d. 377 B.C.) was the outstanding physician of the period. His great contribution consisted of his denial of supernatural causes of disease and his advocacy of the study of natural remedies. He showed the way toward scientific diagnosis of illness, and he gave expression to the highest ethics of the medical profession.

Philosophy

Speculation about the nature of the universe was followed by systematic inquiry into the nature of humanity. Empedocles, who was not only a scientist but also a teacher and a prophet, taught a religious philosophy based on belief in transmigration of the soul. More influential than his teachings were those of the Sophists; and even more significant were the ideas of Socrates.

THE SOPHISTS

The Sophists sought to gain self-knowledge and self-fulfillment. Their most outstanding exponent was Protagoras, who considered man the measure of all things. Protagoras therefore subordinated the demand for ethical behavior to the right of all people to develop their gifts and fulfill their aspirations. The Sophists later became famous for their abilities in criticism and their skill in rhetoric and shrewd dialectics.

SOCRATES

The tendency of the Sophists to fence with words and to use ingenious arguments in their logic was condemned by Socrates. The most famous of the Greek philosophers, Socrates is known to us only through the writings of others. He taught men that they should doubt unsupported statements and should develop their ability to analyze them critically. He insisted on the clarification of ideas by means of rational answers to rational questions. He searched for absolutes—for truth, virtue, beauty, and ethical standards. He emphasized the Greek ideal of self-control. He also believed in a divine principle and an unfailing inner voice that can direct our actions along the path of morality. Although devoted to the laws of Athens and serving dutifully in various civic capacities, he was accused of impiety and corruption of the youth. In 399 B.C., in his seventieth year, Socrates was convicted and forced to take poison.

Education

In the fifth century B.C., Greece had many schools. Children, especially those of the wealthy, were taught to read and write. Boys often had broad educational opportunities. They learned to recite poetry, to master at least simple problems in arithmetic, to play instruments or sing, to develop physical health and skill through sports and games, to study rhetoric, and to prepare themselves not only for a profession or trade but also for the responsibilities of citizenship.

Girls, generally, received little education beyond reading and writing, except for gymnastic training and instruction in household arts and music. Marriage was considered their goal. A woman could obtain a divorce, though, and in such a case was even allowed to keep her property. Women seldom participated in public affairs, and they had none of the privileges of citizenship. But all could attend theaters and festivals, which provided the Greeks with an important means of general education.

Arts

Much of the art of Greece has disappeared, some as recently as the era of Turkish rule in Greece. Yet quite a few original works have survived, and these, together with descriptions, architectural ruins, reconstructions, and Roman copies, give us a feeling for the beauty and majesty of fifth-century Greek art when it reached its climax. The most notable examples are the public buildings of Periclean Athens (especially the Acropolis with its

Parthenon, constructed in 447 B.C., Propylaea, and Erechtheum), the buildings around the agora, the theaters, and the town walls. These structures were built with a rare sensitivity for natural surroundings, purposeful use, and aesthetic value. The Greeks combined mathematical calculation with artistic design to give their works strength and grace and to make them live up to their ideal of harmony.

Among the supreme artists who created these works were the architects Callicrates and Mnesicles; the painter Polygnotus, whose work has, however, perished (we know of him through written tradition); and the great sculptors, who worked in marble, bronze, gold, and ivory—especially Phidias (renowned for his statues of Athena in Athens and of Zeus in Olympia), Myron (who created the "Discus Thrower"), and Paeonius (who sculpted a famous Nike, "Winged Victory"). Many of the sculptures evince a higher degree of attention to anatomical details and closeness to nature than those of earlier centuries. They do so without losing the *ethos*—i.e., the character and transcending ideal—of nature that marked the more symbolic expressions of past ages. Deep artistic feeling also distinguished Greek creations in the minor arts, such as coins and gems.

Music and Literature

Just as important as the artistic works of Greece in the fifth century B.C. were its great written works. In the preceding centuries music and literature were closely connected, but now a gradual separation of the two took place.

MUSIC

Music began to develop its own independent characteristics. A musical theory was created, scales, rhythms, and harmonies were worked out, and musical notation was invented. The range of instruments increased.

POETRY

Some of the simplicity and purity of early Greek poetry, which tended to speak directly to the listener, was lost in the more elaborate and artful works of the fifth-century poets. Yet this was the century of Pindar, most celebrated writer of odes, whose influence on subsequent ages was perhaps greater than that of any other Greek poet except Homer.

HISTORY

History was conceived in terms of both art and science. It was both subjective and objective, both a dramatic art and a cold investigation of impersonal forces, both a study of necessity and a portrayal of human character. The two foremost Greek historians were Herodotus and Thucydides. Herodotus came to Greece from Asia Minor and traveled widely, remaining only a few years in Athens. In his *Historia* ("Inquiry"), he described the Persian wars in order "that the great deeds be not forgotten." By endeavoring to find unbiased sources and maintaining an objective

attitude about his own countrymen, he hoped to teach future generations a moral lesson. His works also include accounts of his travels.

Thucydides was a native Athenian who led an unsuccessful expedition during the Peloponnesian War. He was consequently exiled, and he then wrote a history of that war. He, too, despite his admiration for Athens, retained a large measure of objectivity concerning the Athenians and their institutions, as he realized that greed and lust for power are as potent factors in the course of events as are natural forces, fate and idealism. He analyzed events scientifically, presented his story dramatically, and adorned it through the eloquence of his style. His legacy has served as a model for all later generations.

Drama

Drama flourished, as shown in the works of three great writers of tragedy: Aeschylus (*The Persians, Orestes*), Sophocles (*Oedipus Tyrannus, Antigone*), and Euripides (*Iphigenia in Tauris, Medea*). Only a few works of each have survived. The works of other dramatists of this period have been lost. Greek drama, containing some of the most beautiful lyrical passages ever written, portrays the eternal conflict between Fate and human beings. In critical or approving tones it comments on matters of the day and on eternal problems. It analyzes character, guilt, and punishment, and, like the religious festivals during which the plays were presented, it seeks to purify the souls of the listeners by evoking in them fear, awe, and pity. Its form was strictly prescribed. As a rule, a play had to exhibit unity of time, place, and action. There were no more than three actors on the stage at any one time, in addition to a chorus (reflecting the earlier close connection between music and poetry), whose task it was to comment on the meaning of events.

Greek comedy differed from tragedy in its approach, though not in its essence. Thus the greatest master of Greek comedy—Aristophanes (*The Birds, Clouds, Lysistrata*)—merely chose a lighter form to arouse in his audience the same emotions and attitudes as tragedy. Greek comedy often emphasized criticism of contemporary society. The works of Aristophanes reflect his deep insight into human behavior as it exists at all times—a universal quality that has given his comedies their permanent value, even though much of their significance for events of his time may escape the modern reader.

The Art of War

Since the fifth century B.C. was a century of conflict, it is not surprising that, while the arts of peace flourished, the Greeks also became proficient in the arts of war. Sparta, Athens, Thebes, Macedonia, and other Greek states developed their own techniques of combat. They perfected their heavily armed infantry, the phalanx, invented new formations and orders of battle, devised more efficient weapons, increased the speed and fighting power of their ships, and improved naval tactics. Moreover, they inspired every citizen

with a martial spirit and with devotion to his *polis*. In almost all states, the whole population, including alien residents, contributed, each according to his financial and professional status, to the fighting forces. Every boy was trained early, through athletics, to steel his body; and every youth served in the armed forces.

Fifth-Century Religion

Greek society, which devoted itself to rational inquiry, produced little worthy of note in the realm of metaphysical speculation. Some of the philosophers theorized that a divine power or a spirit had given order to the universe and guided its action. Just as Parmenides and Pythagoras had done in the sixth century, so Empedocles devoted himself in the fifth century to the study of questions pertaining to the soul, faith, and a divine plan. The mystery cults centered around the cycle of the seasons—fertilization, growth, ripeness, death, and resurrection. The fact that they became more widespread may indicate a certain intensification of religious feelings.

However, a transcendental or supernatural religious system was not developed, and a clergy in the modern sense was not organized. No book of religious revelation was written. The cults of the old gods of Olympus and the various local gods, the traditional religious ceremonies, and the customary public practice of divination were maintained. The oracles, such as the one at Delphi, retained their influence. A great new religious festival, the Panathenaea, was introduced, but it, too, reflected the habits of the past rather than new perspectives.

The fifth century B.C. saw the height of Greek civilization, with its lofty and enduring achievements. Owing to an outstanding military organization, on land and on the sea, as well as the devotion of the Greek leaders and citizens to their commonwealth, they overcame the persistent danger that confronted them in the form of powerful Persia. But once this external threat had been eliminated, internal rivalries led to yet more destructive warfare, and a civil war erupted between Athens and Sparta, each supported by their allies. While this catastrophe ruined the country politically, it was just at that time when the greatest artists, philosophers, educators, scientists, poets, and dramatists created their immortal works.

Selected Readings

Beazley, John D., *et al. Great Sculpture and Painting* (1932)

Claster, Jill N., ed. *Athenian Democracy: Triumph or Travesty?* (1978)

Ehrenberg, V. *From Solon to Socrates* (1973)

French, A. *Athenian Half-Century, 478–431 B.C.*(1971)

Guthrie, W. *The History of Greek Philosophy* (1981)

Hooker, J. *The Ancient Spartans* (1988)

Meiggs, Russell. *Athenian Empire* (1979)

Naquet, P. *Economic and Social History of Ancient Greece: An Introduction* (1978)

Oxford Book of Greek Verse in Translation, The (1938)

Richter, G. *A Handbook of Greek Art* (1965)
Robinson, Charles A. *Athens in the Age of Pericles* (1959)
Sachs, Curt. *The Rise of Music in the Ancient World* (1943)
Sarton, George. *A History of Science* (1952)
Zimmern, Alfred E. *The Greek Commonwealth* (1931)

5

The End of Greek Liberty (404–336 B.C.)

399 B.C.	Death of Socrates
387	"Academy" of Plato founded in Athens
385	Death of Aristophanes
377	Death of Hippocrates
371	Victory of Thebes at Leuctra
362	Battle of Mantinea: death of Epaminondas
359–336	Reign of Philip II of Macedonia
347	Death of Plato
338	Battle of Chaeronea: end of Greek independence

With the end of the Peloponnesian War and the fall of Athens, a new age in Greek history began. Greece continued to produce works of astounding beauty in architecture and sculpture (and probably also in painting and music); and it was only then, with the contributions of Plato, Aristotle, and Euclid, that Greek philosophy and science attained their highest development.

But in the political sphere, the prestige of Greece declined. Economic changes, including a great expansion in commerce and banking and the growth of a wealthy "bourgeoisie," hastened the disintegration of the society that had been able to defeat the mighty Persian Empire and that had persisted through a quarter of a century of civil war. The old simplicity in habits and manners was replaced by a love of luxury, which sapped the strength of the country. The initiative and imagination of earlier times was lost. Even where democratic institutions endured, they proved no safeguard against the domination of society and the direction of the public will by a small group of

ambitious aristocrats, rich merchants, or power-hungry professional politicians and demagogues.

POLITICAL CONDITIONS

The greatest changes in Greek political institutions occurred, necessarily, in Athens, which had been the leader of Greece in the fifth century. Sparta showed fewer signs of change. There, as so often happens, victory led to a stagnation of existing institutions rather than a healthy evolution. Thus Sparta's role as a leading power was brief. Within less than a generation, Sparta was defeated by Thebes, and less than twenty-five years later all Greece fell under the domination of Macedonia.

Eclipse of Athens

Following its defeat by the Spartans, Athens recovered rapidly in economic affairs. Agriculture in Attica was restored and improved methods of cultivation (especially crop rotation) were introduced.

As the shipping industries recovered, Athens regained the role of leading banker and trader. In fact, standards of living were possibly higher than they had been at the time of Athenian supremacy. But inflation was noticeable, class differences became more accentuated, slavery (despite the freeing of many individual slaves) increased, and social unrest was widespread. Even though social mobility made it possible for men from the lower classes to rise, many of them, disillusioned with political conditions and induced by a lack of faith and interest in local affairs, decided to leave Athens.

A new emigration movement set in, which soon spread to other parts of Greece. Thousands settled in Italy, southern Russia, Asia, and Africa. Some hired themselves out as mercenaries, and others, who had been slaves, escaped. Eventually, as the population of Athens, of Attica, and then of all Greece diminished, agricultural productivity declined —a consequence that, in a vicious cycle, led to further depopulation.

Hegemony of Sparta

With the power of Athens waning, Sparta gained hegemony in Greece. But Sparta's political heritage and provincialism did not make it fit to guide the country's political reconstruction. Handicapped by its rigid institutions, maintained without change, internal development stagnated. Overambitious generals and statesmen like Lysander and, after him, Agesilaus tried to introduce reform programs but were defeated in their endeavors.

Moreover, Sparta's foreign policy aroused apprehension and fear. Sparta engaged in expansionist maritime undertakings, insisted upon keeping garrisons in many towns of Greece, often supported oppressive oligarchic parties in the various city-states, and imposed conservative economic and social policies. In 380 B.C. the Spartans used force against rebellious Mantinea. In the same year they committed the outrage of occupying the citadel of the town of Thebes, which had supported the revolt.

In view of Sparta's ambitions various federations were formed against it. One such federation, the Corinthian League of 395 B.C. (composed of Thebes, Corinth, and Athens and supported by Persia), disintegrated in 387 B.C.; another, the Olinthian League, was broken up in 379 B.C., and a third, the Second Athenian Confederation, fell apart for fear of a renewed Athenian imperialism. Only a fourth—the Boeotian League, led by Thebes—was destined to succeed.

International Redistribution of Power

In the meantime, the decline of the whole of Greece continued until it reached a point at which the balance of power shifted to overseas territories.

SICILY

One of the areas that fell heir to continental Greece's former position was Sicily. Greek colonies there benefited from the influx of artisans, peasants, and scholars. Sicily became a great cultural center, excelling in the arts, philosophy, and science. The area also became a center of trade. Sicilian merchants competed with those of Athens and Corinth. They assumed leadership in the struggle with the Phoenicians, whose mighty colony of Carthage sought to encroach on Greek territory.

Foremost among the Sicilian towns was Syracuse. Unlike two earlier Greek colonies on the island (luxury-loving Sybaris in the seventh century B.C. and hard-working Messina in the sixth), Syracuse built a strong commonwealth. Under the able tyrant Dionysius I (d. 367) it acquired a small empire, which extended beyond Sicily into southern Italy.

PERSIA

The chief beneficiary of the civil strife in Greece was, however, not Sicily but the Persian Empire. Persia profited in three ways: Like Sicily, it could secure capable émigrés and mercenaries; it could reassert its domination over most of the Greek Ionian cities; and it could keep its traditional enemy weak. Victories won by the Spartan Agesilaus in 396 B.C. were the last important triumphs of Greece over Persia. Thereafter Persia alternated in siding for and against Sparta, thereby managing to perpetuate disunity and weakness in Greece. In 387 B.C., after one of Greece's internal wars, Persia was even accepted as an arbiter in Greek peace negotiations.

Hegemony of Thebes

No solution for Greek troubles materialized when the Boeotian League under Theban leadership defeated Sparta. Two capable generals and statesmen, Pelopidas and Epaminondas, emerged in Thebes. Owing to the courage of the former, Thebes recovered her lost citadel, and owing to the diplomatic ability of the latter, it gained the support of various small towns and an alliance with vacillating Athens. The Thebans then called a general peace conference; when this conference failed because of Spartan intransigence, they attacked and utterly defeated Sparta in the battle of Leuctra in 371 B.C.

At the head of a brilliant army trained in new military tactics, Epaminondas then successfully invaded the Peloponnesus. He dissolved Sparta's Peloponnesian League, freed the long-subjected Messenians, liberated the helots, and thus destroyed the very foundations on which Spartan power had rested. But compared with Sparta, Thebes had even less of a political program for the reorganization of Greece, which could have given permanence to Theban supremacy gained on the battlefield. The role of Thebes as a "great power" was short-lived. Athens, its perennial rival, quickly put an end to it. The Athenians formed a new Peloponnesian League and, in alliance with the former enemy, Sparta, crushed the Theban forces in 362 B.C. in a battle near Mantinea, in which Epaminondas was killed.

Panhellenism

A century of strife had thus successively brought Athenian, Spartan, and Theban leadership. But each state had individually failed to bring internal peace to Greece and to keep the country strong against external enemies. Collectively, they had likewise failed. Nevertheless, very few of the Greek leaders worked wholeheartedly for a thorough change and the establishment of a system providing for cooperation. The majority continued to uphold the ideal of each state's suzerainty. Before the forces in favor of a union could make their influence widely felt, the problem of unity was solved—but at the expense of freedom, and by an outsider, King Philip II of Macedonia.

The Macedonian Conquest

In 359 B.C. Philip became ruler of Macedonia, a country that for a hundred years had enjoyed many economic and cultural ties with Greek city-states, yet was less advanced in trade and arts. It was considered half barbarian by its southern neighbors. In his youth, Philip had spent several years as a hostage at Thebes, where he had become well acquainted with Greek ways and institutions. A capable ruler, he used the first ten years of his reign to strengthen his position in his own country and to extend his rule, not southward, but northward. In that area, and chiefly at the expense of Athenian colonies, he gained important resources by annexing harbors, mines, and agricultural lands. He then turned his attention to Greece proper.

PREPARATION FOR CONQUEST

Shrewdly, Philip took advantage of the differences between those Greeks who advocated the preservation of the traditional small, independent city-state and those who aspired to establish a federation. Despite passionate denunciations (the so-called Philippics) by the great Athenian orator and patriot Demosthenes, Philip convinced many that unity under Macedonian leadership was preferable not only to independence for individual city-states but also to a Greek federation. He gained the support of Demosthenes's great opponents Aeschines and Isocrates. With the help of lavish bribes, he acquired further adherents. By 346 B.C., Philip had secured a seat and a vote in an all-Greek Council and had been chosen president of the Pythian games.

SUBJECTION OF GREECE

Eight years later, Philip deemed the time ripe for a final blow. Sparta had been weakened militarily by the loss of manpower and population, economically by the freeing of Messenia and the helots, and spiritually by the abandonment of the old Spartan traditions. Athens was being ruined by internal strife, by Persian interference, by the Macedonian conquest of her gold mines in Chalcidice, and by the threat to her supply lines from the Black Sea. Thebes's ephemeral strength was gone with the defeat she had suffered at Mantinea. Consequently, Philip decided to strike. With his splendid cavalry and the Macedonian phalanx, its battle formation in deep ranks, he defeated the Greeks decisively in 338 B.C. at Chaeronea, shattering the league that, under the persuasion of Demosthenes, Athens had built jointly with Thebes.

He followed up his victory by a display of force as well as of generosity. He occupied Thebes, ravaged the Lacedaemonian countryside, imposed his laws, and placed governors in strategic spots throughout Greece. But he appeased Athens by granting her a favorable treaty and refrained from attacking Sparta, which had not participated in the league against him. He then formed a Panhellenic League, of which he made himself president.

Thus ended Greek liberty. Philip's rule in Greece was, however, short. In 336 B.C., within two years of his conquest, he was murdered, and it was left to his son Alexander to consummate his plans.

GREEK CULTURE IN THE FOURTH CENTURY

The German philosopher and poet Gottfried von Herder once said that "the owl of philosophy flies at dusk." Was it the dusk of Greek civilization that began with the fourth century B.C., which produced Greece's great philosophers Plato and Aristotle? Witnessing other facets of civilizations that are often considered signs of dusk or decay (emphasis on business activities and money, stress on individualism, interest in scientific instead of metaphysical and religious questions), many historians will agree with Herder. Yet so important were the Greek contributions in science (Euclid), art (Praxiteles), and oratory (Demosthenes), and so vast were the political and military achievements of Alexander the Great, that it hardly seems justifiable to regard the period after the Peloponnesian War as one of dusk or decline—notwithstanding the political collapse of the typical Greek polis, whereby democratic decision-making was replaced by that of a monarch. At the most, we may speak of that period as an age of maturity which brought a "revaluation of values."

Arts

In the fine arts, the fourth century brought greater mastery of technique and strong secular interests. Yet the old Greek sense of beauty was not sacrificed to technical skill. Nor did the Greek artists allow their creations to become mere imitations of nature or reproductions of earlier models.

PAINTING AND SCULPTURE

The two most celebrated painters were Zeuxis and Apelles. Hardly any of their works have survived, but we know that they were widely imitated by subsequent generations. Among the sculptors, the foremost were Praxiteles and Scopas. Their works exhibited not only the same charm, rhythm, and harmony that characterized those of the fifth-century masters but also a new element of animation, emotionalism, and humanism, which modified the majesty of earlier representations. Among themes depicted in their sculpture was that of the nude female body—an innovation, inasmuch as preceding generations had abstained from presenting it, in favor of the male figure.

ARCHITECTURE

The architectural works of the fourth century emphasized (in accordance with the changed tastes of a new generation) monumental size and elaborate ornamentation. Sometimes they were lacking in that harmony of proportion that was characteristic of architecture in the Periclean Age. Great examples of fourth-century architecture are few in number in Athens but more numerous on the Peloponnesus, in the Ionian cities of Asia, and in the

colonies. The Mausoleum in Halicarnassus, a new temple of Artemis in Ephesus, and Alexander's tomb in Alexandria illustrate the main trends.

Literature

The literary works of the fourth century, like the works of art and philosophy, reflect the maturity of Greek civilization. Prose superseded lyrical poetry and drama as the most important form. Aristophanes' life span extended into the beginning of the fourth century, but no new writer appeared who could match the great fifth-century authors of tragedy and comedy. Similarly, the foremost historian, Xenophon (a disciple of Socrates), can hardly be considered an equal of Herodotus nor of Thucydides. Nevertheless, in his *Hellenica*, Xenophon has given a vivid account of Greece from the point (411 B.C.) where Thucydides had left off. In his *Anabasis* he left a moving description of the spectacular retreat of ten thousand Greek mercenaries who, under his leadership, attempted to get back to the homeland after their campaigns in Persian service. Another historian, Theopompus, related in a light but critical vein the history of his contemporary Greece, interspersing his presentation with sharp political comments.

Besides these types of literature, there were numerous works of rhetoric, many of which have survived in written form. The most famous orator was Demosthenes, whose speeches, even in printed translation, still impress us with their fire, power, and persuasion.

Philosophy

The greatest achievements of the age were the writings of Plato (a disciple of Socrates) and Aristotle (a disciple of Plato). Both were interested and active in politics, and both used politics as a starting point for a broader investigation of human character, of society, of nature, and of reality beyond observable natural facts (metaphysics). Compared with their legacy, the work of other philosophical schools (such as that of the Cynics) that flourished in the fourth century was of minor significance.

PLATO AND ARISTOTLE

In the tradition of Socrates, both Plato and Aristotle taught clear, methodical, logical thinking and ethical behavior. They occupied themselves with studying the problems of virtue and beauty, justice and immortality. Plato in his *Republic* and Aristotle in his *Politics* offered solutions for the problems of organizing society so that the individual would be able to develop his capacities and society would gain peace, stability, and self-fulfillment.

Both turned their attention to ethics, aesthetics, logic, and history—indeed, to almost all areas of knowledge and experience. Of special concern to them was the inquiry into the nature of reality. Plato came to the conclusion that concepts ("Ideas") constitute reality and that the world of our senses is but a reflection of a reality beyond it. But Aristotle, who was an industrious student of nature, regarded the world around us, including both its forms and its material substance, as the reality. He compiled the studies of his predeces-

sors, classified their observations as well as his own in the fields of botany, geography, and physics, and worked on scientific methodology. He saw in reason the means for an understanding of all problems, including those of ethics. He regarded the divine power as a thought, as a moving force in the universe, as "being" in its ultimate form, and as the aim toward which everything strives.

CYNICISM

Of the various other philosophical schools, the school of the Cynics merits special attention. Organized by Antisthenes, who was also a student of Socrates, Cynicism embodied essentially negative elements: disregard for worldly goods and pleasures and for the conditions around us, and a lack of faith in any divine power. Its most famous representative, Diogenes, and his followers were sincere seekers of virtue. Through abstinence and acceptance and valiant endurance of all the vicissitudes of life, they sought to show by example how to deal with the problems of human nature.

Civil war ended at the close of the fifth century B.C., robbing the Greeks of their liberty. After a succession of further struggles for predominance among the Greek city-states, an outsider, Philip, conquered the country and linked it to his Macedonian empire. This conquest did not put an end, though, to Greece's eminence in the fields of architecture, literature, and especially philosophy, which only then reached its apex.

Selected Readings

Buchanan, Scott. *The Portable Plato* (1977)
Casson, Stanley. *Macedonia, Thrace, and Illyria: Their Relations to Greece from the Earliest Times Down to the Time of Philip, Son of Amyntas* (1971)
Cawkwell, G. *Philip of Macedon* (1978)
Crossland, John, and Diana Constance. *Macedonian Greece* (1987)
Hammond, N., and G. Griffith. *A History of Macedonia* (1979)
Mure, Geoffrey R. G. *Aristotle* (1932)

6

The Hellenistic Age

In 338 B.C., Philip of Macedonia subjected Greece; in 336 his son Alexander destroyed Thebes; in 214 B.C., the Romans engaged in the first Macedonian war; and in 146 B.C., they destroyed Corinth. These dates, spanning two hundred years, mark the path of the disintegration of the Greek commonwealth and the end of ancient Greek history, properly speaking. But the Hellenic spirit and its creative powers survived. They broadened and—consciously furthered by Alexander the Great, by Greek emigrants, Greek mercenaries in foreign service, and later by Rome—became cosmopolitan. They came to inspire the homeland, the colonies, the newly established Greek centers in the Near East, and the Roman Empire. Eventually they fused even with barbarian thought and art. The period during which this happened is the Hellenistic Age. Despite all the depth of thought and beauty of art in the times of Pericles and the relatively narrow-minded city-state, it was only in the Hellenistic Age that Greece's all-embracing influence on Western civilization was established.

ALEXANDER THE GREAT AND HIS SUCCESSORS

Politically and economically, the Hellenistic Age for Greece meant a period of almost uninterrupted warfare and violent social change. First came eleven years of conquest under Alexander the Great. Then, after his death, came thirty years of struggle for power among his successors. Finally there came the reassertion of Macedonian overlordship. But stability did not return. The populations suffered, at least within Greece herself, and economic preponderance shifted from one place to another. Athens and Sparta sank down to the level of provincial towns, and new economic centers grew up in Corinth, Ephesus, Antioch, Byzantium, and Rhodes.

Alexander the Great

Alexander was a pupil of Aristotle. Arrogant, irascible, brutal, and occasionally indulging in drunken bouts, he was yet a man of valor, strong will, breadth of vision, youthful ambition, and enthusiasm; and it is because of these traits that he has inspired generation after generation. When after his succession to the throne rebellions broke out in Greece, he destroyed as a warning the city of Thebes, which had acted as leader of the revolt, and he sold thousands from Greece into slavery. Firmly in power, and with fearful Athens not daring to act, he then turned to the unfinished plan of his father.

It was the great task for whose sake many Greeks would reconcile themselves to Macedonian rule—an all-Greek war on Persia.

CONQUEST OF THE PERSIAN EMPIRE

Within the ten years 334–324 B.C., Alexander and his well-equipped, well-led army conquered the greatest empire that had yet existed. In two battles—at the Granicus River (334 B.C.) and then at Issus (333 B.C.)—he defeated vastly superior Persian armies. He captured, though only after many long sieges and the perpetration of gross brutalities, all the ports on the eastern Mediterranean, including the famous Phoenician port of Tyre. He occupied Egypt, where he was welcomed as a liberator and made himself pharaoh. When the Persian king Darius III offered him half the Persian Empire and the hand of his daughter, he rejected the offer. He attacked anew and did not rest until, in a third great battle, at Gaugamela (331 B.C.), he had destroyed Persia's military might and captured Darius's enormous treasures. When, shortly thereafter, Darius was assassinated, Alexander ascended to the throne of the Great Kings.

From Susa, the Persian capital in Mesopotamia, Alexander then pushed his conquests even farther—into Bactria, across the mighty Hindukush mountains into Turkestan, the Caspian and Oxus regions, and on to Samarkand. He then crossed the Khyber Pass into India, defeated opposing armies there, marched along the Indus River to the Persian Gulf, then to the Indian Ocean, and finally returned to Susa.

ALEXANDER'S FAILURES

Where would Alexander's ambitions have led him had not a sudden fever prematurely claimed his life in his capital of Babylon in 323 B.C.? Would he have been able to hold together the empire he had conquered? He alienated the sympathies of his own Macedonians; his policies caused mutinies in his army, plots against his life, conspiracies which he answered with brutality and executions, and a dangerous revolutionary spirit in Greece. Judging from these facts, he seems to have lacked political acumen. He heightened Macedonian and Greek resentment by adopting Oriental manners and dress, contracting marriages first with one, then with another foreign princess, and insisting upon being shown divine honors such as those the pharaohs and Mesopotamian rulers had enjoyed.

Moreover, he showed no more than limited administrative abilities. He created no new institutions that promised permanent usefulness. He was forced to preserve Darius's imperial organization and keep Persians in high and subordinate positions. His grandiose plans for the future, sponsoring mixed marriages between Greek soldiers and barbarian women, met with no more than fleeting success.

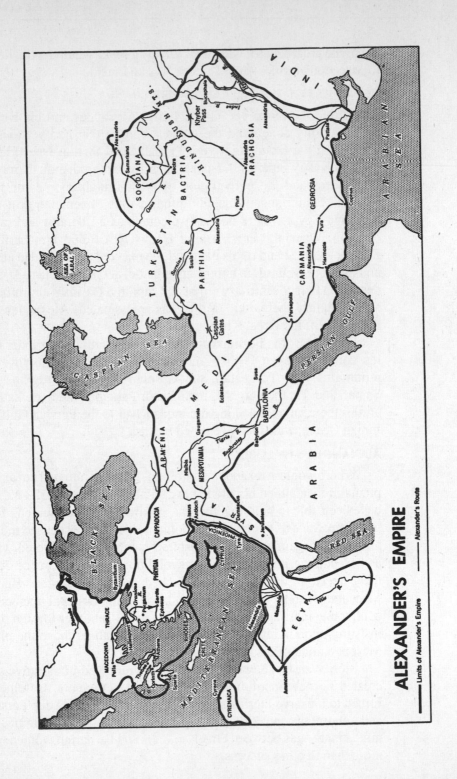

ALEXANDER'S EMPIRE

—— Limits of Alexander's Empire —— Alexander's Route

ALEXANDER'S ACHIEVEMENTS

Nevertheless, Alexander's conquests resulted in great positive achievements. Hellenic civilization was disseminated and a cosmopolitan spirit was fostered. Roads connecting distant lands were built. A common law and a common currency were initiated, trade increased, and prosperity followed in its wake. To a certain extent, the major part of the civilized Western world was welded together.

A special contribution of Alexander was his founding of more than seventy cities, over twenty of which were named after him. Geography and cartography owe much to him. Providing space and places for emigration, some of the cities, like Alexandria in Egypt, were populated with Greeks and could carry on Greek culture at a time when former centers were disintegrating.

The Diadochi

With Alexander's death, the political structure he had so recently erected broke down. Soldiers mutinied, subjected peoples rebelled, and ambitious generals, trying to succeed Alexander, began to fight among each other for the supreme position. Not until some twenty years later, after the battle of Ipsus in 301 B.C., was the basis for a new order laid.

By then the most able among Alexander's successors, called the Diadochi, had been killed. Antipater, Alexander's governor in Europe, had died; Alexander's little son had been murdered; and Antipater's successor, Antiochus, had perished. The remaining Diadochi contented themselves with partial rule, and thus—aside from a number of small semi-independent states—three large separate kingdoms emerged: Egypt, Syria, and Macedonia. Attempts by one or the other of the Diadochi at restoring the unity of Alexander's empire failed.

EGYPT

The Egyptian throne fell to the lot of a Macedonian general, Ptolemy (d. 283 B.C.). Despite much internal unrest, he and his descendants retained the crown of the pharaohs until the time of the Roman conquest. They ruled capably though harshly, assuming once more the godlike position held by the ancient pharaohs.

Like their predecessors, the Ptolemies reserved for themselves numerous trade monopolies, ownership of all landed property, control of irrigation, and regulation of industrial production. They kept many of the old laws of the land, and they saw to it that some of the ancient glory of Egypt returned. They beautified towns, built great new temples, and erected fine sculptures. They invited and protected settlers and traders who came and brought prosperity and spread Hellenic culture and in turn absorbed Oriental habits. It was preferably upon Greeks, or Hellenized Orientals, that the Ptolemies conferred administrative and military positions. Alexandria became one of

the most culturally and economically flourishing cities, not only of Egypt but of the entire Hellenized world. Through the cult of Serapis and other mystery services, Egypt even gave new religious impulses to Hellenic civilization.

SYRIA

The Macedonian general Seleucus (murdered in 281 B.C.) became ruler of the large territory extending over Asia Minor, Syria, and Mesopotamia. He, his son Antiochus, and their successors based their power on the land between the two rivers; but, like earlier dynasties, the Seleucids experienced grave difficulties in holding together the highly diversified and exposed empire. Soon its most eastern parts, Bactria and Parthia, had to be given up. Constant wars had to be waged with neighbors over the possession of Syria and Asia Minor.

Centralized governmental control as found in isolated Egypt was not achieved. The Persian subjects fought all concentration of power in the hands of the Seleucids. Further disunity was created by the Seleucids' own policy of separating the civil from the military administration in the provinces. They attempted to divide and rule, yet they fostered only disrespect for law and played into the hands of the local landholding nobility. Moreover, they, like the Ptolemies, alienated sympathies by giving preferential treatment to Greek settlers. Revolts resulted, and in the course of the third century great trading centers, such as Antioch and Pergamum, made themselves practically independent.

MACEDONIA

In Macedonia, Greece, and Alexander's other European possessions, General Antipater (d. 319 B.C.) established his own rule after Alexander's death. He had efficiently crushed (323–322 B.C.) a revolt led by Athens and known to history as the Lamian War. He abolished the remnants of Greek autonomy and installed new oligarchic regimes controlled by himself.

His successor, Antigonus (d. 301 B.C.), and Antigonus's heirs continued Antipater's policies and at no time permitted re-establishment of Greek independence nor any of the institutions of a polis. Rebellions, such as that sponsored in 251 B.C. by the Achaean League of the Peloponnesian states, were broken. Only Sparta, which finally introduced various social reforms, could maintain an uneasy autonomy. However, control of Greece did not include control of Sicily. The Greek colonies there remained independent of Macedonian rule and increasingly oriented themselves toward Carthage and Rome.

Economic Conditions Under Alexander's Successors

Despite political disruption after Alexander's death, the economy of the Hellenic world flourished. The closer connections between far-apart regions and the wider markets offered opportunities of unaccustomed dimensions to the merchants, not only in old centers, like Athens and Corinth, but especially in new ones, like Antioch, Alexandria, and Rhodes. Oriental products, luxury goods, jewelry, and spices went through their hands and were exchanged for the traditional Greek specialties—metals and metal objects, marble, agricultural products, and textiles. Shipbuilding and shipping activities reached new heights. Improved methods in banking and financial administration (which benefited from lessons learned from the Orient) stimulated production and trading activities.

Societal Conditions

Under the rule of Alexander's successors, the Diadochi and the following generation, called Epigones—a term later used somewhat deprecatingly, implying, as latecomers, inferiority—the societal structure varied greatly in the various parts of the now divided empire.

ASIA AND EGYPT

In Asia, existing institutions from the time of Persian rule were largely maintained, as Alexander had done, in order to win over the native populations. But the settlement of Greek soldiers and the appointment of Greek administrators invariably caused dissatisfaction, and numerous rebellions occurred. In Egypt, the new rulers, acting in the same way, likewise sought to preserve and imitate the political structure and even the religious customs as they had existed under the earlier pharaohs. As in Asia, they retained absolute power.

WEST

However, in the West, especially in Greece, gradual but thoroughgoing changes occurred. The polis, with its freedoms, rights, and obligations, faded. Family ties weakened, and a strict monarchical, often despotic regime was enforced. The peasantry suffered under heavier dues and duties imposed by landlords. Slavery increased with the number of prisoners obtained in the East. Thousands of Greeks emigrated. Like the soldiers who did not return, the emigrants contributed to the spread of Greek civilization and the Greek language, and a sort of Panhellenism developed. Greek and Oriental ways were mixed, and, especially in Asia, a certain assimilation resulted.

As to the Greek artisans and townsmen, they too had to carry heavier burdens, which the new rulers imposed. But merchants and upper layers of the society profited from the wealth that the exploitation of the weaker sectors of society provided.

GREEK ART AND THOUGHT IN THE HELLENISTIC AGE

Most of the Hellenic world obeyed despots and dispensed with the democratic institutions that had been the pride of Pericles and his time. Nevertheless, Greeks continued to create cultural monuments of unique value. To be sure, the art of the time has been criticized for "decorativeness," shallowness of feeling, lack of inspiration, and megalomania. Yet in the midst of barbarous struggles and political disintegration, some of the noblest works of all time were produced. The Hellenized Near East, in particular, excelled under the sponsorship of splendor-loving rulers. Where town life and commerce flourished and wealth was accumulated, the sciences, art, literature, and all other fields of learning flourished also. Likewise, the Greek colonies in the West (especially Syracuse) brought forth great thinkers and artists.

Sciences

During the late fourth and the third and second centuries B.C., rapid progress was made in mathematics and the natural sciences. A sharper separation of philosophy and science, of speculation and observation, and a new emphasis on experimentation may account for the advances that were made.

Heraclides and Aristarchus calculated the distances from the earth to the moon and sun and came to realize that the earth is round and revolves around the sun. Eratosthenes, astronomer and geographer, studied the inclination of the eclipse (the tilt of the earth), and calculated the circumference of the earth and the distance of sun and moon. He also gave descriptions of foreign lands, descriptions based on actual travel accounts that had been stimulated by Alexander's expeditions to India and Central Asia and by other ventures, some northward along the European and others southward along the African coasts of the Atlantic Ocean. Euclid, in his *Elements*, laid down fundamental principles (*axioms*) for geometry and arithmetic that have remained the basis for all geometry through more than two millennia. Hipparchus calculated, like Aristarchus, the earth's distance from sun and moon, measured the exact length of the year, and investigated trigonometric functions. Archimedes computed the value of π, stated the law of floating bodies, and invented various types of machinery. He set an example in the practical application of science.

Technical advances included improvements in the making of clocks, building of ships, and producing of armaments. Botany was furthered by the studies of Theophrastus, who, notwithstanding his metaphysical leanings, scientifically described and classified plants. Medical studies were stimu-

lated by Egyptian scholars, who placed emphasis on anatomy and research. After extensive dissection of human bodies, Herophilus observed the circulation of the blood and investigated the nervous and muscular systems. Scientific therapy replaced magic, charms, and incantations to an ever-increasing degree. Agricultural advances were ushered in by the wide application of the three-field system.

Although according to modern standards much of Hellenistic science was erroneous, its impact upon future times was immense. Owing to the eminent authority enjoyed by Hellenistic scholars, both their valid statements and their errors lived on. Both shaped Western thinking, retarding medieval and modern sciences in some directions and advancing them in others.

Libraries and Schools

With increase in knowledge came an increase in the production of books. More was written, more copied from older texts; and libraries, like the famous one at Alexandria, were founded and became centers of learning. Simultaneously, the school system was broadened. The art of reading was taught to widening circles of students, the Greek language was spread, and new fields of study were explored. Much of the teaching centered, however, around problems of style and grammar and entailed criticism rather than original thought.

Literature

In creative writing, we find less originality in form and less depth in ideas than in earlier centuries. Emphasis was placed on tradition. Although much of Hellenistic literature may have become a model for poets who lived almost two thousand years later, the artful lyrics written by men like Theocritus or Callimachus or the plays of Menander tended primarily to entertain. Often they satisfied no more than ephemeral tastes. Many of the works are full of wit, satire, and criticism. Thus Menander's portrayal of the way of life among the merchants of Athens is lively and realistic; but a tendency toward shallowness generally prevailed.

In history, too, we miss great, moving works. Alexander's expeditions furnished much material, but those who described them were only too often inclined to embellish events rather than investigate, describe, and interpret them. Not until Polybius in the second century B.C. did a historian emerge who to a certain extent returned to the scientific and artistic standards of Herodotus and Thucydides. While living as a hostage in Rome, Polybius wrote his *History*, which covers the last century of Greece before the Roman conquest. A Stoic, he composed it as a lesson in statecraft and a testimony to the inexorable progression of events.

Art

Trends similar to those in literature can be traced in Hellenistic art and architecture. A vigorous realism, perfection of technique, sober observation, and a sense for the dramatic characterize the works of art. But they were sometimes lacking in sincerity and restraint. Yet notwithstanding justified

criticisms by purists, oversolicitous of traditional Greek masterpieces with their simplicity and elegance, the great sculptures of the Hellenistic period, including the "Nike of Samothrace" and the "Laocoon," endure as monuments of a civilization providing an unending source of inspiration.

Of the great works of architecture and of painting and mosaic, unfortunately only a few, such as the altar at Pergamum with its famous frieze, have survived. But we know that, for example, the Pharos Lighthouse near Alexandria was considered a wonder of the ancient world. We also know that great progress was made in city planning, in the laying out of broad streets and parks, and in the erection of theaters and other public buildings.

Religion and Philosophy

In the midst of vigorous activity, there was, however, no evidence of creative faith. Religious beliefs were wanting. Thinking observers, aware of the signs of cultural decay, sought consolation in philosophies that led away from participation in public affairs, emphasized the need for resignation in the face of the imperfections of the world, and looked for satisfaction and self-fulfillment of the individual. Significantly, the schools of Athens, despite the city's reduced state, still functioned as leaders in intellectual pursuits.

RELIGION

With the decline of the small city-state and community, local deities had lost their meaning. Cults of family patrons were destroyed with the breaking up of old family traditions. Nor could old Olympian gods any longer fill man's religious needs. Perhaps the Orphic, Eleusinian, and other mystery cults, with their search for an understanding of creation, soul, and life after death, came closer to satisfying emotional needs, but their orgiastic and superstitious elements deterred many. Of the Oriental religions, Zoroaster's teachings could have brought a new life-giving element into the Hellenic world; but disciples of the master had perverted some of Zoroaster's original thought. Thus philosophy, with its rational approach to the problems of the world, substituted for religion.

PHILOSOPHY

Two schools of philosophy stand out: the Epicurean, founded by Epicurus in the late fourth century B.C., and the Stoic, founded by Zeno, a Phoenician, early in the third century B.C. Both were concerned chiefly with ethics, with the pursuit of knowledge, virtue, and the right way to live. The Epicureans did not acknowledge a divine power that would reward virtue. They trusted only their senses and were skeptical of people's ability to understand, to know. If they advocated justice, courage, and moderation, they did so to increase enjoyment of life and reduce pain and suffering, which are unavoidable on this earth. Since they rejected general ideas and proposed

that everyone choose his own way of conduct to fit his own needs, their teachings were later abused and led to indulgence in every available pleasure.

The Stoics, on the other hand, looked for a divine law and order. They taught that the right way to live consisted in submitting or adapting oneself to such an order and in bearing with strength and dignity what it imposes. Virtue for them meant gaining mastery of oneself, ignoring pain and pleasure, being in accord with the laws of the universe and, with the help of reason, in sympathy with other human beings.

The teachings of Stoics and Epicureans summed up the *Weltgefühl*, the world view, of the Greeks at the time the Hellenistic world merged with the Roman Empire.

*A*s part of Macedonia, Greece's role as a political leader and as a model for political institutions was over, and the Hellenistic Age followed. Its greatness is often underestimated. It brought the spread of Greek civilization to all the countries conquered by Alexander the Great, and it brought also new achievements in science and, despite later criticism, in the arts, education, and philosophy. The Hellenistic Age and the special role of Greece ended with the conquest of Greece by Rome.

Selected Readings

Austin, M. M., ed. *The Hellenistic World from Alexander to the Roman Conquest: A Selection of Ancient Sources in Translation* (1981)

Bieber, M. *The Sculpture of the Hellenistic Age* (1969)

Drachmann, A. *The Mechanical Technology of Greek and Roman Antiquity* (1961)

Grant, M. *From Alexander to Cleopatra: The Hellenistic World* (1982)

Havelock, Christian M. *Hellenistic Art: The Art of the Classical World from the Death of Alexander the Great to the Battle of Actium* (1981)

Koumoulides, John T., ed. *Hellenic Perspectives: Essays in the History of Greece* (1980)

Long, A. A. *Hellenistic Philosophy: Stoics, Epicureans, Sceptics* (1974)

Rostovtzeff, Mikhail. *The Social and Economic History of the Hellenistic World* (1941)

Toynbee, Arnold J. *Hellenism: The History of a Civilization* (1981)

Walbank, R. W. *The Hellenistic World* (1982)

7

The Rise of Rome

It is often reiterated that whereas the chief contributions of the Greeks to future Western civilization consisted in their scientific and artistic achievements, which display clarity of mind, moderation, a sense of beauty and harmony, and a love of freedom and truth, Rome's contributions were of a more practical kind. They supposedly have to do with societal structure, with government and law, with the construction of roads, aqueducts, and baths—in

general, with the ability to adapt material conditions to human use. On the other hand, an almost opposite argument can be presented: that the Greeks, with their interest in life and their application of reason to life's problems, brought forth "a (practical) rule by which we can live"; and that the Romans, with their respect for virtue and character, set up ideals for conduct regardless of material advancement. Roman history shows that the Romans were great not only for what they accomplished in the organization of society but also for what they established as the aim of human existence.

EARLY ROMAN CIVILIZATION

Unlike most important centers of antiquity (Ur, Babylon, Memphis, Thebes, Tyre, Troy, Athens, Alexandria, Byzantium) and even unlike other Italian towns (Tarentum, Syracuse, Naples), Rome was founded at a location that seemingly held little promise for future greatness. It is situated on the banks of an insignificant river, without proper port facilities on the sea, amid a not too fruitful land, and lacking special strategic advantages. Nevertheless the city grew. It came to dominate, first more highly civilized surrounding nations, then all of Italy, then most of the areas of ancient cultures, and, finally, large parts of the barbarian world. Geography, climate, trade, and religious fervor each fail to explain this astounding development. Was it "fate" or "accident," or was it perhaps the genius of individual Romans that account for Rome's rise toward eminence and empire?

Mythology and Legend

What we know of Rome's earliest development has come down to us mostly through myths supported by scant archaeological data. However, the myths have importance: Not only what *has* happened, but also what is *believed* to have happened is a force in history. Roman belief in a legendary past helped to shape the destiny of the Roman Empire, and Roman myths have provided unending inspiration for later writers, painters, sculptors, and warriors.

MYTHOLOGICAL ACCOUNTS OF EARLY ROMAN ORIGINS

According to myth, the Trojan hero Aeneas, after long travels subsequent to the fall of Troy, established a colony at Alba Longa in Latium and married a native princess, Lavinia. Twelve generations later, in 753 B.C., his descendants Romulus and Remus, once suckled by a she-wolf, founded the city of Rome.

Until 509 B.C., this city is supposed to have been ruled by a succession of seven kings, who enacted laws, established religious traditions, built temples, fortifications, and water systems, trained an efficient army, and extended Rome's borders. The mythology also includes the story of the murder of Remus by his brother; the rape of the Sabine women; the purchase of the Sybilline books, in which predictions of the future were entered; the suicide of Lucretia, violated by the son of the last of the seven kings, Tarquin Superbus; and this king's expulsion by the hero of liberty, Brutus.

LEGENDS OF THE EARLY ROMAN REPUBLIC

Stories depicting Roman life during the age of the kings continued in the legends of the early Republic. There was Horatius Cocles, who single-handedly defended a Roman bridge against invading Etruscans; Scaevola, who demonstrated to a victorious and awed enemy his and his compatriots' indifference to pain and death by stretching his hand into a tray of burning coals and seeing it charred; and Coriolanus, a haughty patrician leader, who first saved Rome from attacking enemies, then, disappointed in his expectations for gratitude, deserted to this very enemy and, finally, moved by the pleas and the pride of his old mother, returned although he knew that he had forfeited his life.

Historical Facts

What can be historically ascertained with regard to Rome's early developments is more prosaic. In the second millennium B.C., several waves of northern invaders entered Italy and occupied the rich Po Valley in the north and the fertile western slopes along the Mediterranean coast. They mixed with native populations as well as with Greeks, Celts from Gaul, Phoenicians from Asia, Numidians from Africa, and other eastern, southern, and western peoples.

VILLANOVAN CIVILIZATION

By 1000 B.C., Italy had produced a civilization named after Villanova, a town north of present-day Florence. Villanovan civilization belongs to the Iron Age, and it lasted in Italy until about the eighth century B.C. Various tribes, foremost among which were the Latins, represented this civilization. The Latins may have been the people who introduced iron into Italy. Rome inherited from them societal institutions that set models for family life and local government. They founded towns such as Alba Longa, their capital, and Rome itself. Another people belonging to the Villanovan civilization were the Etruscans. As time went on, however, they developed a culture of their own.

ETRUSCAN CIVILIZATION

Although excelling as farmers, the Etruscans also founded towns. As early as the tenth century B.C., Tarquinia and Veii had been established, and it was around these places that Etruscan civilization was built.

Industry and Commerce. Etruscan towns became famous for the manufacture of fine metal objects, weapons, textiles, and pottery. Mining activities were lively and were further stimulated when, with the conquest of the islands of Elba and Corsica (both rich in iron deposits), additional resources became available. Commerce grew accordingly. Soon Etruria became an essential trade link between the Germanic regions north of the Danube and the Mediterranean areas inhabited by Italians, Greeks, and Phoenicians.

Society and Culture. Production methods in Etruria being advanced, a considerable amount of social stratification existed. Etruscan concepts of kingship and aristocratic rule contributed to later Roman political thought. Likewise Etruscan religious customs and arts were of influence in Rome. Etruscans borrowed both religious and artistic ideas from archaic Greece but soon added their own strong individual traits. During the sixth century B.C., Etruscan art reached its first climax. At that time Etruscan work in fresco painting, sculpture, and modeling of bas-reliefs equaled the best work of other countries. Etruscan craftsmen created exquisite ornaments and jewelry.

Perhaps Etruscan literature, too, was highly developed; however, no definite statement can be made. While we can read the Etruscan alphabet, which is related to archaic Greek, we have in only a few instances succeeded in establishing the meaning of the words.

Fusion of Etruscan and Roman Institutions. Etruscan civilization lasted until the third century B.C.. Thereafter it is no longer distinguishable from that of Rome, with which it had gradually fused. From the seventh century on, when Etruscans conquered Latin Rome, Etruria and Rome were intimately linked. The mythological seven kings of Rome represent Etruscan rulers. They organized government along Etruscan tradition, which they followed when raising the military strength of the city, building water systems, and promoting commerce. Under their domination Rome grew and was adorned with temples, in which gods of Etruscan origins, such as Jupiter, Juno, and Minerva, who merged with Greek deities, were venerated. They ruled for more than one hundred years, until the Romans expelled the last Etruscan king, Tarquin Superbus, and established their independence.

This change meant at first a setback for the development of central Italy, for it not only led to two decades of war between Romans and Etruscans, who (as the stories of Horatius and Scaevola suggest) almost succeeded in reestablishing their rule, but it also brought economic and social hardships. Insecurity and loss of unity between town and back country worked to the disadvantage of both Rome and Etruria. Rome showed a sharp decline as a

trading center; Etruria was cut off from the sea at the mouth of the Tiber. In both areas, suffering and revolts ensued.

Roman Civilization at the Time of the Establishment of the Republic

When the Etruscan rulers had been driven out of Rome, a republic was instituted. Leadership fell to the patricians, a hereditary class composed of wealthy, landowning Romans of old Latin stock. The mass of the population, including all other freemen, whether peasants, merchants, or artisans, were called plebeians. Some of these were people of wealth and landed property, whose families, however, did not count among the traditional Roman gentry; others were poor. In addition there were slaves. These varied in number throughout the centuries, accounting at times for a quarter of Rome's total population.

GENS AND FAMILY

The patrician and plebeian classes were subdivided into units called gens, and a gens was composed of families. Each family was a firm entity directed by the father (*pater familias*), who exercised power over life and death of the other members, acted as priest before the family deities, administered the (originally indivisible) family property, and represented the family in gens and class. Upon him and his example depended that traditional honor and virtue that are supposed to have constituted one of the main foundations of Roman greatness.

GOVERNMENT

Upon the establishment of the Republic, executive power was vested in two annually chosen praetors (or, soon, consuls). Unlike the former kings, they did not have power over life and death. Moreover, at the end of their terms, they were held responsible for their acts. In times of grave emergency, a special official, a dictator, could be appointed who, during a six month period, could exercise absolute authority.

The fathers of the patrician families constituted an advisory body, the Senate, which had at first 300 members. The same group monopolized the important offices. All other free Romans constituted an Assembly—the Assembly of the Centuries, which debated matters of administration and of war and peace, and which served as a court of last appeal for capital offenses. It soon nominated or elected the highest magistrates and made laws. Its members were divided, according to property qualifications, into five groups. Voting was done by groups so as to guarantee the decisive influence of the wealthy, who composed the first two groups, and in this way the power in government was retained by the Senate.

MILITARY ESTABLISHMENT

Classification by group, and thus property, determined everyone's share of the military burden and his place in the army. Each unit of the army was formed collectively by a number of families. The consuls acted as commanders. Plebeians did not have access to the highest posts.

RELIGION

The family and governmental system were intimately connected with religion and permeated by religious rites. Gods and spirits (*numina: penates* and *lares*) watched over home, hearth, farm, and family, as well as over crops and over the state itself. To the priests fell both religious and state functions. Augurs, who inspected the entrails of sacrificed animals or watched the flight of birds and studied the calendar, determined favorable times for action and thus indirectly influenced policies. A high priest with life tenure (*pontifex maximus*), who enjoyed great authority, set feast days and ordered religious services. Temples were built and diverse ceremonies were invented. But, as in Greece, ethical codes of behavior or transcendental views were not connected with the Roman deities.

THE BUILDING OF THE REPUBLIC

Rome's history during the two hundred and fifty years following the end of the monarchy is one of economic growth, of social struggle within, and of expansion abroad. It is often represented as a coherent story. When compressed on a few pages, it may leave the impression that the foresight, persistence, courage, and endurance of Rome's citizens led the city on a straight path to territorial greatness and a new social order. A rather different picture, reflecting a more meaningful history, emerges when we consider the events by short spans of time. For what over a long period may appear as a straight path then turns out to be a complex process, which was never consciously planned and which might as easily have brought Rome's ruin as Rome's rise.

Rome in the Fifth Century

With the fifth century B.C., begins Rome's life as a republic. The importance of this century for Rome lies neither in territorial and commercial expansion nor in the creation of notable works of art. What is memorable is the social and political system that the Romans built, a system that was to serve them in the more than three centuries during which the insignificant city grew into the capital of a world empire.

TERRITORIAL GROWTH

Throughout the fifth century Rome carried on desperate struggles to stave off reabsorption by her neighbors. The struggles were crowned by the undertakings of the dictator Cincinnatus against the Latin Sabines and, later, those of the dictator Camillus against the Etruscan Volscians. War against the Volscians eventually brought the conquest of Veii. Owing to this success the tiny territory of Rome was enlarged—although by no more than a still smaller strip on the right bank of the Tiber. However, Rome improved thereby both its strategic position and its agricultural basis. The conquest of Veii was achieved only with the help of some of Rome's Latin neighbors, whose intention it was not only to aid but also to control any expansion of the city.

COMMERCE

With respect to commerce, too, Rome achieved little during the fifth century. As long as it had enjoyed close connections with Etruria, many foreign traders could be attracted. After it had established its independence, traders rarely found it profitable to visit the town. Reduced to a comparatively primitive agricultural economy, Rome had to begin anew attracting commerce.

SOCIAL CONDITIONS

In the sphere of social organization, the transition from a kingdom to a republic had left control in the hands of the patricians. But their power was soon challenged from two sides: by rich plebeians who had gained their wealth as traders and demanded a share in the government; and by poor agriculturists and workers who needed relief and threatened revolt.

During the long era of struggle for Rome's survival, these two groups had carried a steadily growing burden. Because of the inadequacy of land for agriculture, grain was often scarce; prices had risen as a result of the speculations of rich grain importers. Military expenses and services weighed heavily, and debts mounted because of high taxes and excessive interest rates. Enslavement for debt was rigorously enforced. Many small farms, once belonging to independent owners, passed into the hands of patricians and bankers who used slaves and grew crops for trade rather than for local daily bread. The former peasants moved to the city and added their numbers to the hungry mass of the unemployed.

POLITICAL EVOLUTION

Social differences led to political changes. Early in the fifth century, desperation drove the plebeians to leave their work and even to withdraw altogether from Rome in order to establish a new city with better living conditions. This and other subsequent rebellious moves led in the course of some fifty years to substantial political concessions by the patricians. They

admitted rich plebeians to the Senate. They allowed the election of two (later four, and then ten) new officials, tribunes, whose task it became to protect the plebeians against injustices. They also agreed to the institution of a new Assembly, the *Comitia Tributa,* in which voting took place not according to property qualifications but according to the geographical distribution of the population. This Assembly of Tribes, whose importance grew slowly, shared in lawmaking and in appointing magistrates.

Another step was taken when, toward the middle of the century, the tribunes were admitted to the deliberations of the Senate. Later they received the right to veto legislation. Eventually aides were assigned to them, called *aediles* (two of patrician and two of plebeian origin), whose tasks consisted of supervising building projects, temples, and local business activities, and of caring for public property.

Further concessions followed in the second half of the fifth century. After the introduction of the *Comitia Tributa* and the tribunate, the patricians still monopolized the consulship and thereby the executive. They even secured for themselves two new offices, that of quaestor in 447 B.C. and that of censor in 443 B.C. To the quaestor fell the task of administering military finances. The censor was charged with the supervision of public morals and with the financial administration of the city. Since the duties of the censor included assessment of the population by census every fifth year, he wielded great power, for upon the assessment depended the tax burden and the military rights, and therewith the political standing of the individual citizen. Even eligibility to the Senate depended upon assessment, since a minimum estate was prescribed for admission.

The patrician monopoly on these two offices was, however, quickly impaired by new moves. In 445 B.C., intermarriage between patricians and plebeians, long forbidden, was allowed. In 420 B.C., the quaestorship was opened to plebeians, and in 410 enslavement for debt was prohibited.

The Fourth Century

The fourth century B.C. brought a continuation of many internal trends found in the preceding hundred years. It saw further equalization of civil rights, even if the distinctions between the social strata of the population remained essentially unaltered. In external affairs, however, the new century brought a sharp change. It was then that Rome started on its road to conquest of all of Italy. A consciousness of Rome's "manifest destiny" can be traced in the thoughts and actions of the Romans at this time.

EXPANSION

The success engendered by the capture of Veii at the beginning of the century was followed by reversals. The conquest of the town had caused the desired weakening of Rome's Etruscan neighbors, but it had also conjured up new dangers. The crippling of the Etruscans, who had acted as a buffer, opened the way to invasion by Gauls, who lived in northern Italy. These

people attacked, defeated the Romans in battle on the Allia, and in 390 B.C. took the city and sacked it. At enormous expense the enemy was bought off. New invasions by the Gauls followed. Only after the lapse of another forty years could Rome respond effectively. Counterattacks were aimed northward at the remnants of the Etruscans, who had often supported the Gauls, and southward at Samnites and Latins.

The resulting wars lasted half a century and did not end until 290 B.C. They brought several bitter defeats, such as that of 321 B.C. when, during the Second Samnite War, a whole Roman army had to surrender at the Caudine Forks. Yet Rome finally subdued the Etruscans as well as the peoples of Latium and Campania and established its domination northward to the Rubicon River and southward down to and beyond the Bay of Naples.

FOREIGN ADMINISTRATION AND COLONIZATION

Rome's conquest had a multiple effect. It brought booty into Rome's treasury, gave relief to needy Roman citizens who could settle on conquered lands, and provided profits for wealthy landowners and speculators. But it also created new problems connected with the organization and colonization of the newly gained lands. For, together with land, people were acquired; their relationship with Rome needed regulation. A few received citizenship rights; many were enslaved. A large number were, by treaty, accepted as "allies." These allies were exempted from taxation and granted local autonomy, but they had to render auxiliary military service. Still others, who lived in towns of special strategic or economic importance, were subjected to "colonial" status. On them fell a major part of the tax burden. Romans, to the extent to which they were resettled, always retained their former citizenship rights.

Once incorporation had been completed, a considerate Roman administration tried to bind all elements permanently to Rome. Roads such as the Via Appia connecting Rome and Capua were built. A revitalized commerce, resulting from an economy supplementing the needs of city and back country as in Etruscan times, served to weld the commonwealth together.

INTERNAL REFORMS

Foreign enterprises and the resulting need for unity within contributed to an acceleration of the process of internal reform. A number of further changes in favor of the plebeians took place. In 367 B.C. it was decreed that one of the two consuls had to be selected from the class of plebeians. Pay was provided for military service, and battle formations were changed in line with tactical needs rather than social rank.

Laws were passed providing for reduction of debts and limiting the size of estates any individual was allowed to acquire out of the public land. Although these laws were only lamely enforced, they made it possible to resettle small farmers. Temporarily the trend toward converting agricultural

land into grazing land was thereby stopped, a trend that had rendered Rome increasingly dependent upon food imports. The concessions served not only the poor but the wealthy by reducing revolutionary pressures.

The development initiated by these laws led to a logical conclusion. The patricians had tried in 367 B.C. to counterbalance their political losses by the introduction of a new, exclusively patrician office charged with high judicial functions, the office of *praetor*. This post, too, had to be opened to plebeians before the end of the century. Likewise, the dictatorship and, finally, even priestly functions were made accessible to them.

Perhaps these concessions would have meant more had they come earlier. Reform issues often lose their meaning in the course of time, and what seems important to one generation may seem of little value to another. In Rome, too, the significance of the reform work should not be overestimated. The plebeian class was no longer what it had been, and many of its wealthy and influential members had come to share patrician interests.

Rome at the Beginning of the Third Century

Rome on the threshold of the third century B.C. thus appears as a country very different from the one that had existed at the time of the foundation of the Republic. It was different also from the one that had existed at the beginning of the fourth century. No longer just a town but a large state embracing almost half of the peninsula, Rome constituted a power that had to deal with the problems befitting a powerful state.

SOCIAL STRUCTURE

By the beginning of the third century, the patricians had lost most of their prerogatives. Yet they retained their social position, as well as many of those manifold advantages that birth, connections, education, and wealth in land and slaves could secure. They also preserved a large share of political control, since they continued to dominate the Senate and to provide the men for most of the high offices. The plebeian class had split in fact, if not in form. The provincial aristocracy, bankers, and wealthy businessmen formed one group, and they were the ones who benefited most from the rights that the political reforms of the preceding age had brought to plebeians. The other, more numerous group consisted of the small farmers, the artisans, and the poor in the city. They had gained so little that, in 287 B.C., driven to desperation by debt and misery, the plebs once more seceded from the city. They forced through a law putting final legislation entirely into the hands of the Assembly of Tribes.

The lowest segment of the population, the slaves, had likewise split. Some of the slaves, having been freed, had become "freedmen." They possessed limited civil rights; many of them had become "clients" of their former owners. Working on their former masters' lands or in their households, they enjoyed, despite continued dependence, a large measure of economic security and personal influence. In exchange, they contributed

through their work and political support to the financial and social standing and power of their masters. The other sector of the slave population had also changed in character. The influx into their thinning ranks of new slaves, drawn from the increasing number of prisoners of war, altered their ethnic and labor patterns.

Naturally, bitter antagonisms divided the various layers of the population. These class antagonisms were supplemented by new jealousies that arose between Roman citizens and non-citizens.

GOVERNMENT

Notwithstanding divergent tendencies, an elaborate governmental structure succeeded in holding the state together.

Senate. The chief influence in the state was exercised by the Senate. It had changed less than other institutions. While its members were drawn from all classes, they were always appointed from among the propertied citizens; they retained their membership for life. The Senate's legislative functions were narrowly restricted after 287 B.C. But through control of taxes, advice to the consuls, conduct of foreign affairs, and personal authority of many of its members, it continued to exercise decisive power. Rome owed most of its progress to the Senate's conservative yet wise administration and counsel.

Executive Officers. The executive power rested with consuls, praetors, censors, aediles, and quaestors—in addition to tribunes. Those aspiring to the highest ranks had to run in a fixed order through the ladder of these offices (*cursus honorum*). With the expansion of Rome and the need for executive functionaries in the provinces and armies, additional offices, such as those of proconsul and propraetor, were created. These gave an opportunity to past consuls and praetors to remain in the state service and to employ their accumulated knowledge in positions of importance. Significantly, while occasionally an able "new man" joined the ranks of the highest magistrates, it was essentially a small circle of four or five old, often rivaling families, like the Fabii and Scipios, who again and again occupied the leading offices. Together with their friends and clients, they almost monopolized the executive.

Assemblies. By 300 B.C., the Assembly of Centuries still existed side by side with the Assembly of Tribes. But the judicial and legislative powers it had possessed in early republican times had passed into the hands of the Tribes, where the weight and leverage of the higher classes were minimized. This Assembly of Tribes had become, between 338 and 287 B.C., the final instrument for lawmaking, but it had lost some of its "democratic" character. Its presidents, who generally belonged to the wealthy, exercised undue influence. Its most important elected officers, the tribunes, catered increasingly to the wishes of senators and fulfilled less and less their original tasks as defenders of the interests of the common people.

LAW

Roman law constitutes one of the greatest legacies of ancient Rome. In early times, it had been designed strictly to serve the interests of the patricians. It had been extremely severe, providing for retributive justice and for the death penalty in numerous cases. It was handed down from generation to generation through oral tradition. Only around 450 B.C. had it been codified and engraved on the Twelve Tables. With the introduction of praetors almost a hundred years later, and their assumption of many legal functions, a change had come, however. This change was speeded up when the position of praetor (and subsequently that of priest or pontiff, who also had legal functions) was opened to plebeians. Thereafter law was no longer dispensed exclusively by patricians, and praetors gradually assumed the habit of preparing opinions that judges could follow.

In assuming his office, a praetor would inform the population about the principles that would guide his opinions. These principles, influenced by changing times and keyed to changing moods of the population, served to modify the existing legal traditions, to prevent stifling conservatism, and to lay the basis for a steadily developing law concept.

The resulting *jus civile,* or civil law, set standards for the rights and property relationships of individuals and for legal procedures guaranteeing these rights. In view of Rome's growing world position, it had to be supplemented by a *jus gentium*, an international law. This *jus gentium* contained legal principles as would apply in intercourse with foreigners— foreign traders or foreign allies—whose native concepts of justice had to be taken into consideration and reconciled with those of Rome.

COMMERCE

The beginnings of a Roman *jus gentium* indicate the growing importance of Rome as an international center. By 300 B.C., this position was still insignificant in comparison with that of various contemporary Eastern trading cities. Conquest included no more than close Italian neighbors. Trade was limited, with much of it still in the hands of foreigners. Agriculture predominated in Rome's economy. Industrial enterprises were minor, and— except for some pottery, textiles, metal objects, and arms—not much was produced that could be exported. Coins as an exchange medium were introduced no earlier than 330 B.C., and even then they were only of copper and were minted abroad, in Capua. Not before 269 B.C. did Rome coin its own silver pieces.

Nevertheless, Rome's position must not be underestimated. Certainly the trade of the Phoenician town of Carthage was foremost in the western Mediterranean. A strong fleet guaranteed Carthage's safety, and its colonies on Sicily and other islands contributed to its resources and wealth. Various trade treaties between Carthage and Rome, however, of which that of

348 B.C. is indirectly known to us, bear witness to the growing commercial importance of Rome. They foreshadowed conflicts that were to redirect the path of Rome's history in the third century.

The Latins, a tribe in Italy, founded Rome only after Egypt and Sumeria had left to the world 2000 years of remarkable accomplishments. The newly established town inherited some of the civilization that the Etruscans, a mysterious tribe related to the Latins, had created. Not until about the year 500 B.C. did Rome create a state having a stable structure. There had been first a monarchy, which, however, failed to provide security and order. Then a republican government was introduced, and an aristocratic Senate held the power. In turn, and after long and bitter struggles, it had to share more and more of this power with the elected representatives of a large plebeian population. The evolution of this type of government and the laws on which it was based constitute the great achievement of early Rome. Demanding discipline and "public virtue," it provided strength and pride to a free citizenry. Supported by a strong military force, Rome could then turn to conquest, beginning its quest for control of all Italy.

Selected Readings

Banti, L. *Etruscan Cities and Their Culture* (1973)
Bloch, R. *The Origins of Rome* (1960)
Christ, Karl. *The Romans: An Introduction to Their History and Civilization* (1984)
Grant, Michael. *The Etruscans* (1981)
Grimal, P. *In Search of Ancient Italy* (1964)
Heurgon, Jacques. *The Rise of Rome* (1973)
Salmon, E. *The Making of Roman Italy* (1982)
Scullard, H. *The Etruscan Cities and Rome* (1967)
Woodhead, A. *The Greeks in the West* (1962)

8

The Flourishing of the Roman Republic

287 B.C.	Secession of Roman Plebs; Legislation in hands of Assembly of Tribes
282–275	Pyrrhic Wars
264–241	First Punic War
222	Rome incorporates Po Valley
219	Rome occupies Illyria
218–202	Second Punic War
216	Roman defeat at Cannae
207	Defeat of Hasdrubal in Spain
202	Battle of Zama (Scipio the Elder)
200–197	Second Macedonian War
192–189	Rome's war against Antiochus III of Syria
ca. 183	Death of Hannibal
159	Death of Terence
140–146	Third Punic War (Cato the Elder)
146	Destruction of Carthage
133	Acquisition of Pergamum
	End of Numantine War; Spain subdued (Scipio the Younger)
	Murder of Tiberius Gracchus
121	Acquisition of Gallia Narbonensis
	Murder of Gaius Gracchus
113	Invasion of Cimbri into Roman territories
111–105	Jugurthine War
107	First consulate of Marius

The internal political and social struggle in Rome subsided somewhat after the plebeian gains of 287 B.C. Foreign issues took precedence, and attention was focused on military efforts. Between 287 and 83 B.C., Rome gained enormously in territory, booty, and population. It was thus able to solve internal problems, to satisfy demands of poor farmers and veterans for land, and to ease debts and taxation. Indeed, the sacrifices necessitated by continuous wars seemed worth the effort—at least for the survivors in victorious Rome. Even the arts began to flourish. But success brought also a transformation of institutions, economy, and society, which raised new problems and demanded new settlements. For this the Republic was not prepared. The structure that had helped Rome survive the struggles of the third and the second centuries B.C. was, by the beginning of the first century, in the process of a complete breakdown.

THE THIRD CENTURY

The most famous and dramatic struggle in Roman history—the wars against Carthage—belongs to the third century B.C. These wars brought, with the defeat of Carthage, Roman hegemony in all of Italy and Sicily and in parts of Spain, as well as Roman domination of the western Mediterranean Sea. Victory, had, however, wider consequences than the mere acquisition of new power and territory. Rome gained a hitherto unknown feeling of its strength. It adapted itself to thinking in terms of a naval as well as a land power. It proceeded more resolutely on the path of democratization, which had proved useful during the wars. Through contact with Hellenistic civilization, it changed its daily life and aspirations.

Conquest of Southern Italy

The wars against Carthage (the so-called Punic Wars) began in 264 B.C. When the Samnite Wars had been concluded, the remnants of Etruscan power crushed, the alliance of the various Italian tribes against Rome shattered, and central Italy at a radius of about 150 miles around Rome annexed, the Romans found themselves faced with new dangers. Their advance had frightened some of their new neighbors. Particularly, Greek trading cities in southern Italy such as Tarentum saw their economy and wealth threatened by Roman competition and came to fear for their independence.

Around 282 B.C., the trading cities therefore induced Pyrrhus, king of Epirus, to cross the Adriatic Sea with his troops and attack Rome. Joined by some of the subjected Italian tribes, Pyrrhus twice inflicted terrible defeats on Roman armies. But being far from his base of reinforcements and supplies, his costly victories failed to decide the war. They only served to weaken his own position. In a third battle, at Beneventum in 275 B.C., he was defeated and forced to give up. His retreat made it possible for Rome to seize, by 265 B.C., the entire territory southward to the end of the peninsula, down to the Strait of Messina.

Conquest of Sicily

The next step consisted in crossing the Strait "for the protection of the mainland." Thus one war led to another; as long as there were neighbors, there were "threats and dangers." Crossing over into Sicily meant a struggle with Carthage.

FIRST PUNIC WAR

Friendly relations had existed between Rome and Carthage as long as they were far apart. During the Pyrrhic War, they had even been allies. But with Rome moving close to Sicily, the Carthaginians saw their commercial interests menaced. When, in addition, a rebellion of some mercenaries broke out in Sicily, they decided to station more troops on the island. This caused some Greek cities on Sicily to enter into negotiations with Rome, and in 264 B.C. the First Punic War began.

Rome first turned against Carthage's friend Hiero, tyrant of Syracuse, who was forced by the Romans' superior might to submit and join them. Then the disciplined legions, equipped with new arms to take advantage of ever-changing tactical needs, defeated Carthage's unreliable mercenary armies, led by the brilliant General Hamilcar. Even at sea Rome often proved superior. Despite reverses at the outset of the war and despite the failure of an invasion of Africa, her infant navy proved a match for that of Carthage.

PEACE

The war dragged on for more than twenty years. Finally, in 241 B.C., lack of money to pay its mercenaries forced Carthage to seek peace. It had suffered more than Rome because it depended on unimpeded commerce. Carthage had to surrender its Sicilian possessions—a loss augmented a few

years later by that of the islands of Sardinia and Corsica—and to pay a large indemnity.

With the acquisition of these islands, Rome gained control of the Sicilian grain production and the Corsican mining resources. For the time being Sicily became the foremost supplier of grain. It helped to make up for the lack of foodstuffs caused by the concentration by Italian farmers on the production of fruits, such as grapes and olives, and the raising of cattle. Moreover, Rome freed itself from trade restrictions that earlier treaties with Carthage had imposed.

Conquest of the Po Valley

After the conclusion of the First Punic War, peace was maintained for no more than ten years. Then Rome engaged in a war against the pirates in the Adriatic, who were destroyed, and thereafter against Gauls in the Po Valley. Like the Carthaginians in the south, the Gauls in the north feared that Rome with its land hunger would encroach upon their territories. Their opposition was in vain, though. In 222 B.C. the major part of the Po Valley was incorporated by Rome into the now rapidly growing empire. By 219 B.C., Illyria on the eastern side of the Adriatic was also seized.

Rivalry in Spain

Next, Rome was attracted by the wealth of Spain, rich in mineral resources and manpower. After the loss of Sicily, Carthage had concentrated on building and extending its Spanish holdings. A treaty had provided for Rome's abstention from interfering in affairs south of the Ebro River. But difficulties arose in connection with the city of Saguntum, which was allied with Rome and which Rome sought to make into a base for the expansion of its power. In order to forestall this expansion, the young Carthaginian general Hannibal, son of Hamilcar, besieged and conquered the city (in 219 B.C.). His act led to the Second Punic War.

Second Punic War

The war began with one of the most celebrated military feats in history. Hannibal, acting with great speed and determination, brought his army—infantry, cavalry, and elephants—across the Alps. Despite great losses on the way, he reached the Po Valley and there twice defeated Roman armies opposing him (in 218 B.C.).

HANNIBAL'S TRIUMPH

Marching south in the following year, Hannibal for a third time vanquished the Roman legions (at Lake Trasimene). Only the delaying tactics of the cautious Fabius Maximus Cunctator, chosen dictator by a desperate Rome, saved the city from possible ruin. But after the expiration of Cunctator's term, Hannibal crowned his career with his most brilliant triumph. At Cannae in 216 B.C., he destroyed the legions that Rome, exerting itself to the utmost, had just succeeded in raising.

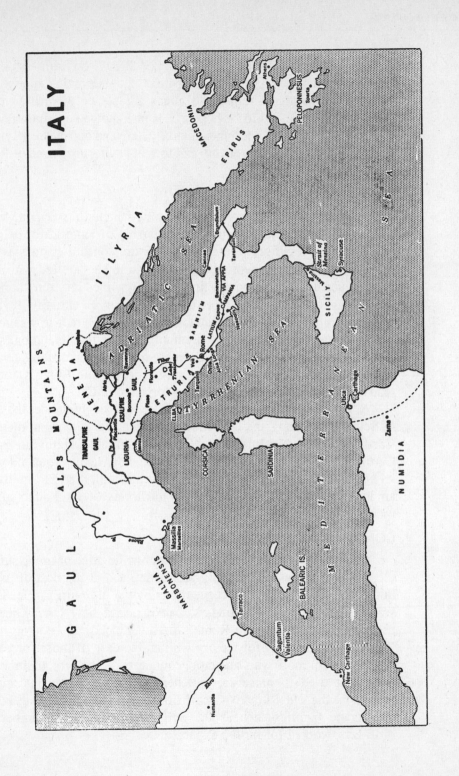

ITALY

GAUL

ALPS MOUNTAINS

TRANSALPINE GAUL

LIGURIA

CISALPINE GAUL

VENETIA

ILLYRIA

MACEDONIA

EPIRUS

PELOPONNESUS

Sparta

Athens

ADRIATIC SEA

Ariminum

Ravenna

Placentia

ETRURIA

SAMNIUM

Rome

Tiber R.

Ostia

LATIUM

Capua

Beneventum

CAMPANIA

VIA APPIA

Tarentum

Brundisium

Cannae

SICILY

Syracuse

Strait of Messina

TYRRHENIAN SEA

ELBA

CORSICA

SARDINIA

MEDITERRANEAN

Carthage

Utica

Zama

NUMIDIA

RHONE R.

GALLIA NARBONENSIS

Massilia

BALEARIC IS.

SEA

Tarraco

Saguntum

Valentia

Ebro R.

New Carthage

Numantia

Perhaps Hannibal should have marched directly on Rome as his generals advised. But, as he was far from his base of supplies and ill supported by his home government, he refused to attack the strongly fortified city. In a situation that appeared to be hopeless, Rome showed astounding firmness. It congratulated its blundering and utterly defeated consul for having risked a stand against the mighty enemy and for not having despaired of Rome, and it continued the war.

HANNIBAL'S DEFEAT

Although joined by some Italian towns including Capua, as well as Syracuse and Macedonia under the leadership of King Philip V, Hannibal made no further progress in the stage of the conflict known as the First Macedonian War. For over ten years he had to be satisfied with living off the conquered land. During this time, Rome regained its strength, raised new armies, and chose new and more capable leaders. Eventually it was able to seize the initiative and counterattack. In 212 B.C. Syracuse was retaken; in 211 B.C. Capua, and in 209 Tarentum. In 207 B.C. Hannibal's brother, Hasdrubal, was defeated in Spain; Rome regained parts of this country as a result. In 206 B.C., Philip V gave up his support and Rome's armies were ready to invade Africa. Hannibal was forced to return.

At Zama in 202 B.C., the decisive battle was fought. Under the command of Scipio (the Elder), the Roman legions, with the help of an old enemy of Carthage, King Masinissa of Numidia, defeated Hannibal and broke Carthage's resistance. Carthage had to surrender its navy, abandon most of its overseas possessions, pay another war indemnity, and forgo the right to an independent foreign policy. The territories of its Italian allies were incorporated by Rome.

CONSEQUENCES OF ROME'S VICTORY

This time Rome had bought its victory at the price of much suffering on the part of the peasants and city proletariat, and at the cost of the lives of many nobles. Considerable concessions by the old patrician leaders to the war-profiteering class of traders, bankers, and new landowners, whose capital had made possible Rome's perseverance, had become necessary. Rome also had to pay for victory with an increase of those forces at home that looked for more wars and more conquests. To be sure, there was a large party that tried to preserve, together with a homogeneous and limited dominion, the old Roman way of life. But another party, influenced by aristocratic families such as the Scipios and by large numbers of war profiteers, worked for further expansion.

THE SECOND CENTURY

Within two years of Zama, Rome found herself involved in three new wars: in the north against Gauls; in the west against rebellious Spanish peoples; and in the east against Macedonia. These wars, a logical consequence of the position Rome had gained in the third century, were all concluded victoriously. Of greater importance than the military successes, however, which were followed by additional wars between 197 and 146 B.C., was the gradual change in Roman civilization during that same period. For the first time do we encounter individuals of peace—scholars and artists—who were to contribute to the lasting greatness of Rome.

Roman Expansion

The defeat of Carthage opened the way for further action. The first step the Romans undertook was the punishment of the Gauls in the Po Valley. They had used Hannibal's invasion to rebel and join the Carthaginians. As soon as the campaign against them had been successfully concluded, the Romans sent an army to Spain in order to hold down the inhabitants there, who were likewise rebelling. The Spanish war turned out to be an extremely difficult undertaking. It started anew each time the Romans thought they had won it, and it lasted for more than half a century. The main forces of Rome were, however, directed eastward—against Macedonia, Greece, and Syria. Before the campaigns against these countries were concluded, Rome also turned once more on Carthage and destroyed the city altogether.

SECOND MACEDONIAN WAR

The first undertaking in the East was a new war against Philip. After a decisive victory at Cynoscephalae in 197 B.C., the consul Flaminius brought the conflict to a successful conclusion. The Macedonians had to pay an indemnity, reduce their army, and give up their century-and-a-half-old dominion over the Greek city-states. To the enthusiastic joy of all Greeks, Flaminius declared Greece to be "free."

SYRIAN WAR

Victory over Macedonia led to the next war, this one directed against Antiochus III, who ruled Syria and large parts of Asia Minor. Fearful that further Roman expansion would endanger his rule—and incited by Hannibal, who, chased from Carthage, had sought refuge with him—he decided to engage in a preventive war. He invaded European territory, but his efforts were in vain. Not only did he have to withdraw, but, in 190 B.C., Rome's legions crossed into Asia for the first time. Antiochus was defeated, his kingdom severely reduced in size, and parts of his lands were put under the rule of Rome's ally, the king of Pergamum.

However, none of these settlements brought peace. The Macedonians refused to reconcile themselves to the loss of Greece. The Greeks rebelled when the Romans, notwithstanding their promises of independence, continued to interfere in Greek affairs. The inhabitants of Asia Minor resented greedy Roman officials and businessmen who, abetted by Pergamum, took the place of Macedonian and Greek exploiters. Thus between 171 and 146 B.C. more wars had to be fought.

THIRD MACEDONIAN AND ACHAEAN WARS

Again Roman legions marched, devastating prosperous regions. In 171 B.C. they attacked Macedonia anew and finished by dividing the country. In 146 B.C., they made it a Roman province. In the same year, they broke up the Achaean League, which the Greek states had formed to protect themselves. They destroyed the city of Corinth, leader of the League, and imposed a heavy tribute. They also broke all resistance in Asia Minor and eventually incorporated most of the lands as provinces of the empire. In 133 B.C., through inheritance, they acquired the formerly allied Pergamum.

THIRD PUNIC WAR

But before these enterprises could be concluded, a final settlement was also sought with Carthage. Rome precipitated the Third Punic War under the pretext that Carthage had broken the existing peace when, without Roman consent, it took up arms against the provocations of Rome's ally Masinissa. With Scipio Africanus (the Younger) in command, the Romans conquered Carthage after an arduous siege in 146 B.C. Lest it ever rise again, they followed the advice of Cato the Elder, an inveterate foe of Carthage, and burned the once so mighty and prosperous town to the ground. The North African coastlands were organized as another province.

SPANISH REVOLT

The destruction of Carthage was followed by a new and long-drawn-out campaign in Spain. After subduing previous rebellions there, Rome had divided Spain into two provincial areas. But Rome continued to be bitterly opposed by the native populations. Even when Viriathus, the rebels' devoted and capable leader, was assassinated, the fight went on. Not until 133 B.C., after Scipio the Younger had been put in charge, did the Romans succeed in taking the center of resistance, the town of Numantia.

The conquest of Spain necessitated yet another campaign. In order to protect communication lines, southern Gaul (*Gallia Narbonensis*) had to be controlled. This was achieved by 121 B.C.

Second Century Economic and Social Problems Owing to the continuous warfare, considerable changes had taken place in the economic and social structure of Rome. The patricians and the Senate (*Optimates*) had reasserted their authority in spite of the reform laws of 287

B.C. Using their power cautiously, they had found themselves supported by the new capitalists, the wealthy bourgeoisie or "Equestrian class" (*Equites*), and often also by the party of the poorer sections (*Populares*). As the treasury could be filled by tribute and booty, taxes at home could be kept low. Moreover, work projects, including the building of temples, homes, roads, and aqueducts, helped the unemployed. Land in conquered territories could be made available for settlement by veterans. Equestrians were given chances to make huge profits either as tax collectors at home or a traders in conquered provinces. A young generation of ambitious politicians could find positions of influence in a widening bureaucracy. Those who had exhausted the ladder of available offices at home could continue in the service by securing newly created posts in the provinces.

But these opportunities did not solve all the problems whose settlement had been postponed during the periods of war. The conversion of individual farms in central Italy into large estates had deprived numbers of citizens not only of their livelihood but also of their independent status; it had violated their pride. Many of them moved to the city and filled it with displaced and dissatisfied elements. In debt when they lost their farms, they had to be supported at public expense.

In the meantime, the estates (*latifundia*) were populated with slave workers who were imported in increasing numbers. They were often badly abused and came to constitute another unruly element. Their desperate local uprisings frightened the upper classes. Even when freed, as many ultimately were, they constituted a source of unrest.

Civilization in the Second Century

This long period of warfare and pillaging, no less than the later periods of civil war and fearful murders, and combined with the Roman's inclination toward bloody sports and gladiator fights, have earned Rome the reputation of having been "immoral, greedy, insatiable of blood and rule." If we compare Roman history with that of the Greeks, we find the latter's history introduced by the majestic work of Homer. Even before the Greek city-states were effectively organized, we hear the voices of Sappho, Alcaeus, and Anacreon. We witness a Thales and a Pythagoras, a Hesiod and an Aesop. We stand in wonder before Doric temples and theaters; and we admire Greek festivals centering around sports, music, games, and religion.

Nothing comparable is to be found in almost five hundred years of early Roman history. Wars, social upheavals, and questions of administration and organization fill its pages. It is only between 200 and 150 B.C., after the conquest of Sicily and Greece, that we find a gentle note introduced.

LITERATURE AND ART

Around 200 B.C., under the influence of the Hellenic spirit, Rome began to promote the arts. In the preceding century, only a few books seem to have been written. Thereafter, however, Rome undertook to translate Homer, to

enact Greek tragedies, to imitate Greek authors and artists, and to create original works of lasting merit. A history of Rome was composed in epic form by Ennius. Another, in prose, was written by Cato, the foe of Carthage (who, however, in his old-fashioned admiration of Roman achievements, despised Greek civilization). Satirical, humorous, and vivacious comedies dealing with love and wine were published by Plautus and Terence. The beginnings of philosophical speculation can be noted. Greek prisoners (often enslaved) were hired as teachers. Homes and temples were built in accordance with Greek models.

RELIGION

The stirring of a more elevating religious belief took root. Narrow and primitive religious traditions connected with state, locality, and family began to broaden under the influence of the rationalism and Epicureanism characterizing contemporary Greek philosophy. New ethical standards were introduced. Despite protests of virtuous old Romans like Cato, even Oriental cults and ecstatic and immoral celebrations of Cybele and Bacchus appeared in Rome. They stimulated new trends in the arts, thought, and daily life. Religious festivals in imitation of those of the Greeks were celebrated.

LAW

Despite such stirrings, the chief cultural achievements of second-century Rome lie elsewhere. This becomes apparent through the history of Rome written at that time by a Greek prisoner, Polybius. In describing the conquest of Greece, and notwithstanding Rome's wars against his homeland and his own status as a prisoner, Polybius conveys the relief felt by many Greeks and Orientals when the legions of Rome invaded their lands. Despite all its greed and lust for blood, despite its pillaging soldiers and exploitative and rapacious officials and businessmen, and despite the imposition of harsh taxes and confiscation of land for the benefit of Roman citizens, Rome had a great deal to offer. It brought what had been missing for centuries: a measure of peace, of order, and of law.

Order and law, organization and administration, were indeed the great accomplishments of second-century Rome. They were based on the rapid and penetrating development of legal thought. Not only did the edicts of praetors and the opinions of jurisconsults, interpreting law and advising the layman, find a permanent place in the Roman system. Concepts of a higher justice and of inviolable individual rights also evolved. They were based on a *jus naturale,* or natural law, which could embrace the entire conquered world.

THE END OF REPUBLICAN INSTITUTIONS

If the Romans brought peace and order to the world they had conquered, they failed to gain these benefits for themselves. The social gap between Rome's Optimates and Equites on the one side and the Populares on the other led to violent jealousies. These were accentuated by extremes of luxury, which sapped the health and vigor of the upper classes and by the demands made upon the population for military service.

Likewise, the populations of the Italian countryside, excluded as they were from Roman citizenship, became increasingly restive. Graft and corruption spread throughout the Roman bureaucracy, and laws to check them proved ineffectual. Selfish politicians and demagogues led Rome into ever new dangerous and bloody ventures. In the provinces, wealth and independence often allowed a governor to disregard Rome's laws and use mercenary legions to exploit the conquered.

Social Upheavals

Toward the end of the period of the ongoing foreign warfare, accumulated dissatisfaction led to events at home that would constitute a decisive break in Roman history. The beginning of this sequence of events was marked by the activities of two brothers, Tiberius and Gaius Gracchus, grandsons of Scipio Africanus. They served as tribunes of the people in 133 and 123 B.C., respectively. The end came with Sulla in 83 B.C.

THE GRACCHI

To all appearances, the brothers Gracchus merely proposed a number of reforms in line with Roman tradition. In order to resettle dispossessed farmers, they demanded a limitation on the size of landholdings. They advocated the establishment of new colonies for veterans, an improvement of the financial administration, various measures against corruption, and the increase of public works. To these demands Gaius Gracchus added others for price stabilization and for abolition of the monopoly held by the Optimates on jury duty. But what gave special significance to these proposals, and especially to those of Gaius, was the fact that they were coupled with numerous demagogic demands. Among these were demands to extend citizenship rights to all Latin allies, to distribute free grain to the city proletariat, to pay the poor out of public funds, and to shorten military service.

These measures, and others that would have squandered public funds, were proposed not only for their own merits but also in order to win a personal following for the Gracchi. Perhaps Tiberius and Gaius believed that the establishment of unprecedented personal power in their own hands was necessary to carry out desired reforms. But in attempting the task, they both

infringed upon existing laws. Thus Tiberius forcibly removed his colleague in the tribunate. Both he and his brother sought to retain office after it had legally expired.

Eventually Tiberius and Gaius were both murdered, the former in 133 B.C., the other twelve years later. With them, hundreds and thousands of their followers perished.

Only a few of the measures that they had advocated survived, but the example they set had permanent significance. The entire social structure was shattered. The agrarian reform had split the ruling groups and affected the authority of the Senate, yet "democracy" had not been advanced. Tiberius and, especially, Gaius Gracchus stood at the threshold of the period that in quick succession would bring forth a rush of pretenders to dictatorial power, until the republic had perished and a monarchy was born.

MARIUS

The first in the line of aspirants to personal rule after Gaius Gracchus was a man named Marius. With him began the age when the political fortunes of Rome merged with those of a few individuals.

The offspring of a lowly family, Marius distinguished himself in military service. He participated in a war against King Jugurtha of Numidia. As Rome feared, Jugurtha was building a dominion in North Africa capable of reviving the threat Carthage had represented to Rome. It was owing to the ability of Marius, elected consul in 107 B.C., that the difficult campaign was brought to a successful conclusion. Jugurtha was captured and sentenced to be starved to death in prison.

A second opportunity to gather military laurels and reputation soon offered itself to Marius. Two Germanic tribes, the Cimbri and Teutons, invaded Helvetia, the Po Valley, and Roman Gaul, defeating one Roman army after another. The terror they spread influenced the Romans to again choose Marius as consul in 104 B.C. Against law and tradition, he was reelected during each of the succeeding four years.

The hopes that Rome put in Marius for delivering the empire from the Germanic danger were justified. He restored discipline in the army, improved its training and equipment, arranged for rewards for long-serving soldiers, and instilled them with confidence in its leader. Then in 102 and 101 B.C., he completely annihilated the two Germanic tribes in the battles of Aquae Sextiae and Vercellae. Once triumphant as military chief, Marius attacked the political problems of the day. He lacked the honesty, devotion, and political skill of the Gracchi; but he possessed what they had not had—an army.

Backed by well-trained soldiers and veterans who gave him their personal loyalty in exchange for bonuses of land or money, Marius embraced the popular cause and allied himself with political opportunists and the mob.

Resorting to violence, he undertook to overthrow the existing order. But, faced by powerful forces still devoted to republican tradition, he failed. He had proved himself unreliable. A united anti-Popular front, chiefly composed of partisans of the wealthy classes, succeeded in driving him out of office and in killing many of his adherents.

DRUSUS AND THE SOCIAL WAR

There followed a short period during which the senatorial families reasserted their leadership. Using a demagogue, Livius Drusus, they assumed the role of advocates of reform. They declared their readiness to increase their own ranks by admitting Equites to the Senate (thereby allowing these to sit on juries). They proposed to redivide the land, lower the price of grain for the poor, and accord full citizenship to Italian allies.

In the general atmosphere of corruption, party hatreds, and violence, most of these proposals came to nothing. Drusus was murdered. In 90 B.C. a terrible uprising of the disappointed Italian allies occurred, which came to be known as the Social War. The danger threatening Rome temporarily united all parties, and eventually the rebellion was suppressed. However, citizenship rights were now extended, first to those allies who had remained faithful and, toward the end of the war in 89 B.C., to all freemen from the Po River to the Strait of Messina. This measure meant little, though. Owing to the distances involved and to tactical political arrangements, the voices of the Italians did not count in proportion to their numbers.

SULLA AND THE FIRST MITHRADATIC WAR

After victory in the Social War was achieved, the Senate meant to resume its control of the state. A skillful politician, however, was already on hand who was to break the republican institutions. Cornelius Sulla, an Optimate and a member of the senatorial party, was an officer who had served under Marius in the Jugurthine War and later in the Social War.

In 88 B.C., Sulla was made consul. He secured the command against a new enemy, King Mithradates of Pontus, a kingdom on the Black Sea. Before marching against him, however, Sulla undertook to crush the popular party, for the Populares had wanted the command conferred on Marius (who had returned from exile). A bitter fight for power had resulted. In the course of the struggle, the Populares were defeated and Marius was forced to flee to Africa. Having thus eliminated the competition of the popular party and its leader, Marius, Sulla curtailed the voting rights of the Assembly and reestablished senatorial rule for the time of his absence.

He then proceeded to the East. There Mithradates had made rapid progress, finding ready cooperation among the subjected peoples of Asia Minor. Long outraged at the exploitation by Italian administrators and settlers, these peoples had, at his behest, slaughtered tens of thousands of Italians. Even Greek cities in Europe, foremost among them Athens, had

joined Mithradates. Rome was threatened with the loss of its eastern sources of wealth and its needed supplies of grain and slaves.

After a difficult and bitter four-year campaign, marked by ferocious pillaging by Roman armies, Sulla defeated Mithradates, deprived him of his conquests, and forced him and his Greek allies to pay a huge indemnity. In 83 B.C., Sulla returned to Italy.

Dictatorship and Reconstruction

During Sulla's absence, the popular party had resumed its fight under the leadership of Lucius Cornelius Cinna. Cinna was helped by dissatisfied Italians and revolting slaves. In 86 B.C., while Sulla was abroad, his arrangements for Italy were becoming undone. Marius was recalled and elected consul for a seventh time, but he died within a few weeks. Fearful violence was committed against the senatorial party, decimating the ranks of the Optimates. Thousands of slaves were given their freedom, and all limitations on the voting rights of the Italians were abolished.

SULLA'S DICTATORSHIP

Despite these events, Sulla found upon his return the situation not unfavorable to his own plans. Brutalities and disorder had alienated the sympathies of all moderate elements for the popular party. The Senate needed help. Sulla himself returned, as had Marius once, backed by an army and in the luster of recent victory. Allying himself with his old friends, the Optimates, and winning over many of the Equites and even some of the Populares through promises and bribes, he precipitated a new civil war. After ruinous fighting he took the city of Rome and had himself declared dictator. He had his opponents condemned to death without trial, and almost five thousand of them perished; their confiscated property filled Sulla's treasury and the pockets of his adherents.

REORGANIZATION

As dictator, Sulla then reorganized the government. He arbitrarily increased the number of senators and had men of his own choice appointed. He canceled the citizenship rights of former insurrectionists, reduced the authority of the consuls by restricting their powers mainly to Italy, and curtailed the powers of the people's tribunes. He improved the judicial system. Moreover, he put the provinces, through the appointment of proconsuls and propraetors, under senatorial control. He settled his veterans on land and sought to gain the goodwill of the people by festivals, bribes, and works embellishing Rome.

After three years of dictatorship, Sulla resigned in favor of the Senate. Soon thereafter, in 78 B.C., he died.

*T*o call the third and second centuries B.C. a period of flourishing in Rome is perhaps unjustified. Rome saw enormous territorial expansion: all over Italy and Sicily, into Spain, North Africa, and Greece. This occurred after a grave threat from competing Carthage had been overcome. With the total destruction of Carthage, Rome had become the invincible power of Western civilization in the whole area all around the Mediterranean Sea. While this expansion went on, agriculture improved, commerce was expanded, wealth increased, and the government efficiently carried out its duties. On the other hand, with all its laws and more or less democratic institutions (which have in many respects served as models in our times), the Romans failed to bring satisfactory living conditions to the masses of the population. As time went on, the peasantry reaped almost no benefits from Rome's "flourishing." Bitter revolts occurred, and one attack after another was undertaken by individuals, patriots, and demagogues in an attempt to overthrow the existing order. Out of the revolts emerged a dictatorship that relied for its power on the control of armies. Fearful, brutal acts were committed. But at the same time, a governmental system emerged that served for a period of transition until a new system could be worked out.

Selected Readings

Adcock, F. *The Roman Art of War Under the Republic* (1963)

Astin, A. *Cato the Censor* (1978)

Baker, G. *Sulla the Fortunate: The Great Dictator* (1967)

Balsdon, J. *Roman Women* (1974)

Boak, Arthur E., and William G. Sinnigen. *History of Rome to A.D. 565* (1977)

Brunt, P. A. *Social Conflicts in the Roman Republic* (1972)

Carcopino, Jerome. *Daily Life in Ancient Rome* (1940)

De Beer, G. *Hannibal: Challenging Rome's Supremacy* (1969)

Grant, Michael. *The History of Rome* (1978)

Harris, W. *War and Imperialism in Republican Rome, 327–70 B.C.* (1979)

Lazenby, J. *Hannibal's War: A Military History of the Second Punic War* (1978)

Salmon, E. *Roman Colonization Under the Republic* (1970)

Scullard, H. Scipio *Africanus: Soldier and Politician* (1970)

 Festivals and Ceremonies of the Roman Republic (1981)

Stockton, David. *The Gracchi* (1979)

9

The Establishment of the Empire

80–72 B.C.	Revolts in Spain (Pompey against Sertorius)
74–63	Second Mithradatic War
73–71	Spartacus rising
69	Victory over Mithradates at Tigranocerta (Lucullus)
67	Pompey destroys pirates on the Mediterranean
64	Subjection of Judaea
63	Consulate of Cicero
63–62	Rising of Catiline
63	Conquest of Pontus by Pompey
60	First Triumvirate (Pompey, Caesar, Crassus)
58–51	Caesar's conquest of Gaul
54	Death of Catullus
53	Defeat against the Parthians at Carrhae; Crassus killed
49	Caesar crosses the Rubicon and seizes Rome
48	Battle of Pharsalus; Pompey defeated, and is killed in Egypt
48–47	Caesar and Cleopatra; incorporation of Egypt
47	Caesar dictator; suicide of Cato the Younger
46	Introduction of Julian Calendar
44	Assassination of Caesar
43	Second Triumvirate (Octavius, Antony, Lepidus) Murder of Cicero
42	Battle of Philippi; Brutus and Cassius commit suicide
31	Battle of Actium; Octavius defeats Antony and Cleopatra

Although Sulla had espoused the cause of the Optimates, he probably had no illusions as to the survival chances of his reorganization attempts and the ability of the Senate to resume its former position. The times of the Republic were gone. The order in Rome was undermined by tensions resulting from overly rapid expansion, extreme economic and social inequalities, and the ambitions of men of genius who happened to live at the time. In rapid succession, the powers of the constitutional officers—consuls, praetors, tribunes, and senators—passed into the hands of individual dictators. Not until the age of Augustus was a new order created that could give stability to the commonwealth.

THE AGE OF JULIUS CAESAR

The period between 78 B.C., the year of Sulla's death, and 44 B.C., the year of Caesar's assassination, is one of almost uninterrupted civil war. Despite the grave social issues that prompted the wars, clear lines of distinction did not separate the interests for which the opposing parties stood. Public interests were mixed with personal aims of outstanding individuals; the masses followed individuals rather than ideas.

Yet during these times of turmoil, many works of lasting value were achieved. Rome's borders were expanded more rapidly than ever before. Roman and Hellenic civilization was introduced into barbarian areas, where it was to become the foundation of new civilizations. Learning and taste were promoted, along with political and military aims. The city itself was adorned with works of art that have remained its pride through two thousand years.

The Struggle for Power

Immediately following the death of Sulla, the popular party sought to destroy the work of the former dictator. It engaged in a new civil war in order to reduce the power of the Senate. While the population suffered, politicians and generals found unequaled opportunities for furthering their personal aims. Among the leaders were Sertorius, champion of the popular cause; Pompey, a former aid of Sulla; Crassus, an immensely wealthy Optimate; Lucullus, Caesar, Catiline, Clodius, and others. Gradually the struggle for power narrowed down to one between Pompey and Caesar, and finally the latter emerged victorious.

RISE OF POMPEY

Pompey's career had begun in the army under Sulla. With Sulla, Pompey had fought the Marian forces in Sicily and Africa. After Sulla's death he made himself defender of Sulla's legacy. His first opponent was the new leader of the Populares, Sertorius, a man of ability and considerable honesty, an aspirant to dictatorship like his rivals, but perhaps more in the tradition of the Gracchi than that of Marius. After a six-year struggle, which was fought in Italy and Spain, Sertorius was assassinated in 72 B.C., and the senatorial party under Pompey triumphed.

THE SPARTACUS REVOLT AND CRASSUS

The defeat of the popular party prompted another revolt. During Marius's reign, the Populares had espoused the cause of the slaves. These now armed themselves and rose under the leadership of a Thracian slave by the name of Spartacus. A new, almost unequaled danger menaced Rome. A desperate Senate raised a fresh army, put it under the command of Crassus, another adherent of Sulla, and sent it against the slaves. Only after bitter fighting did Crassus succeed in destroying the rebel troops in 71 B.C. Having achieved his purpose, however, he did not disband his legions. Instead, he marched upon Rome, fearful lest Pompey, who had likewise retained command of his forces and also moved on Rome, might seize complete power.

POMPEY AND CRASSUS

Before a clash could occur, though, Crassus and Pompey came to an arrangement—at the expense of the very Senate that had charged them with its defense. Together they forced the Senate, under the threat of arms, to allow their election as consuls for the coming year. As consuls they continued to speak in terms of earlier party slogans, to follow precedent and formally uphold existing institutions. But in reality, they established personal rule. They abolished many of Sulla's reforms and saw to a redistribution of power. Pompey in particular built up a private following among the Equestrians (for whom he secured the right of jury service) and among the masses (whom he won over by the distribution of free grain).

THE RISE OF CAESAR

The carefully laid plans of Pompey and Crassus were soon challenged by new aspirants to dictatorship: by Julius Caesar; by the ambitious lieutenant of Sulla, Catiline; by the eminent general Lucullus; and by Lucullus's brother-in-law, Clodius. Caesar soon proved the most gifted. At the beginning of his career, he had married into the Marian party and assumed its leadership. Later he had taken Sulla's granddaughter as his second wife and sought the friendship of the Equestrian order. Although his reputation, owing to his debts, dissipations, and ruthlessness in politics, was low, he had built up a large following.

The moment, however, was not yet in his favor. Not only did he lack an army to back him, but he was also bitterly opposed by the comparatively few yet influential politicians who were still devoted to republican ways, Roman traditions, and the existing order. Among them was the orator and writer Cicero, a *homo novus*, or newcomer, who had won fame in a trial against an extortionist official, Verres, and who worked for a compromise to salvage some of the former institutions. Another member of this group was Cato the Younger, stern and uncompromising heir to the ideals of Cato the Elder.

POMPEY AND THE SECOND MITHRADATIC WAR

A decision between the various aspirants was postponed because the needs of the empire demanded that attention be directed elsewhere—as usual, to foreign issues. Remarkably, the internal disruption in Rome did not make the survival of the empire impossible, nor did it even block its growth. All aspirants to dictatorship had to have behind them a victorious army and the glory that only conquest could give; thus Rome continued its vigorous pursuit of an expansionist foreign policy. First Lucullus, yet another rising star, and then Pompey were called away from the Italian scene. Mithradates, having recovered from the defeats inflicted on him by Sulla, had in 74 B.C. once more invaded various parts of Rome's Asiatic territories. In addition, pirates endangered Roman trade and communication lines. The Senate charged Lucullus with the campaign against Mithradates, and subsequently Pompey was ordered to deal with the pirates.

Lucullus achieved great military success. He defeated Mithradates at Tigranocerta in 69 B.C. and conquered the lands up to the Tigris and Euphrates rivers. But he could not turn his victories into political assets. He was recalled from the East at the insistence of Roman businessmen and provincial administrators, who resented his honest and firm rule; and thus he lost his chance. He is remembered instead for his connoisseurship of food, to which he devoted himself thereafter.

His place as commander was taken by Pompey, who had concluded the war against the pirates victoriously in 67 B.C. Within another four years, Pompey had conquered the kingdom of Pontus; old Mithradates had committed suicide; and all lands extending from the banks of the Black Sea to the Tigris River, including Armenia, Syria, and Judaea, were reorganized as either new Roman provinces or dependent kingdoms.

UPRISING OF CATILINE

For a second time, Pompey returned to Italy at the head of a victorious army (61 B.C.). He found the situation much changed. In his absence Catiline, descendant of an aristocratic family, after having failed to secure the consulship, had tried to organize a mob uprising in order to gain what he could not achieve lawfully. But Cicero, chosen consul instead of Catiline for the year 63 B.C., had uncovered the plot. He denounced the demagogic nature of the laws proposed by Catiline and, through a number of impassioned speeches, aroused the Senate. Catiline was forced to flee and, in the following year, perished in combat. Pompey thus found the Senate greatly strengthened. Even Caesar, who had been involved in Catiline's projects, had to keep himself in the background.

The First Triumvirate

Under these circumstances, Pompey decided to disband his army and to announce his return to private life. However, his action did not win him the expected applause of the Senate. He therefore approached Caesar, who for his part saw a chance to recover lost ground by allying himself with a man of Pompey's standing. In 60 B.C. a secret agreement was concluded between the two, who were joined by Crassus, whose wealth and connections recommended him to the others. Thus the First Triumvirate came into being. The three men pledged each other help in securing the most influential offices. They determined which one each should seek, which opponents should be eliminated, and which provinces should be given to whom. Their plan worked, and defenders of the Senate like Cato and Cicero found themselves, one after the other, removed from the local scene. Pompey, Caesar, and Crassus gained first the offices and then the provinces each wanted.

CONQUEST OF GAUL

As it turned out, the distribution of the provinces among the three triumvirs was of great consequence. Southern Gaul fell to Caesar, who went to the area in 59 B.C. and immediately set out to conquer the whole of Gaul. With determination and ability, he defeated Gauls, Helvetians, and Belgians. He suppressed a mighty uprising of the Gauls under Vercingetorix. He crossed the Rhine into Germany and the Channel into Britain. He opened new opportunities to Roman business interests, tax collectors, and administrators; won wealth and reputation for himself; and gained, as envisioned, the support of a personally loyal army.

The significance of his work is difficult to overestimate. Through the Romanization of Gaul, which he initiated—and by refraining from a large-scale conquest of Germany, which thus was not Romanized—he deeply influenced the future of Western civilization. In 50 B.C., he returned to Rome.

END OF THE TRIUMVIRATE

During Caesar's absence, the senatorial party had regained considerable influence. Both Cicero and Cato had returned from exile or assignment in the provinces. By 56 B.C. the Senate had succeeded in reasserting its supreme position. This induced Pompey, Caesar, and Crassus to renew their triumvirate at a conference held at Luca. But their cooperation came to an end three years later when Crassus was killed in the Battle of Carrhae against the Parthians. Thereafter Pompey once more drew close to the senatorial party. Strife soon broke out between his supporters and those of Caesar, which culminated in open and bloody street fighting. The Senate supported Pompey by creating him sole consul.

THE END OF POMPEY

Caesar, who had once more gravitated to the equestrian and popular orders, offered upon his return to disband his troops, provided that Pompey do likewise and that he, Caesar, receive the consulship for the following year. Pompey and the Senate refused. Consequently, in January of 49 B.C., Caesar, at the head of one of his legions crossed the Rubicon River, which constituted the limit of his province. He entered Italy proper.

The die was cast. The Senate declared him a public enemy, and the leaders among his supporters were expelled from Rome. But Caesar could not be stopped. Lacking troops, Pompey was forced to flee, and Caesar occupied Rome. Having seized the treasury, he promptly left again. He set sail for Spain, where he destroyed the forces assembled under one of Pompey's sons. He returned to Rome to make himself consul again. He left yet once more to attack Pompey, who had gone to Greece and had assembled an army there. In 48 B.C., at Pharsalus, Pompey was defeated. He fled to Egypt, where he was murdered before Caesar arrived.

Caesar's Rule

Caesar spent the ensuing year with Egypt's queen, Cleopatra. He subdued an uprising in Egypt and, through the queen, secured a political alliance that brought Egypt virtually under Roman control. Finally escaping Cleopatra's enchantments, he left Egypt. He annexed additional lands for Rome, gained new laurels for himself by attacking and defeating the Parthians, and reconquered the Pontus, then ruled by Mithradates' son, Pharnaces.

CAESAR'S ADMINISTRATION

In 47 B.C. Caesar returned to Rome. During his absence, his enemies had tried to rally. A republican army had been formed, but Caesar quickly destroyed it and drove Cato the Younger, the defender of the republic, to suicide. He likewise crushed an uprising instigated by the sons of Pompey in Spain. He added yet another conquest—Numidia—which was incorporated as a province into the empire. Having then distributed lands and gold among his veterans, Caesar set himself to the task of reshaping Rome's institutions.

With his power guaranteed by control of the army, Caesar had himself appointed dictator, first for ten years, later for life. He united in his own hands the powers of a proconsul, army commander, censor, tribune, and also pontifex maximus. Caesar named to administrative and senatorial positions men responsible to himself and charged them with the improvement of the administration in the provinces. He disposed of foreign spoils to improve conditions at home and had new money coined. The system of farming out taxes was curbed. He reduced the debts of ruined farmers and the government grants to the needy city population by resettling many dispossessed citizens on confiscated or conquered lands. Steps were taken to reduce slavery. He adorned Rome with majestic buildings. Caesar also ordered the introduction of a new, more scientific calendar.

CAESAR'S ACHIEVEMENTS AND DEATH

If the greatness of Caesar as a general and inspiration for the empire is generally recognized, his internal reforms—keyed to concentration of power in his own hands—are not unanimously accepted as proof of real statesmanship. Caesar knew how to please the commercial classes, the poorer sections of the population, and those non-Italians to whom he granted the rights of citizenship. But he did not solve fundamental problems in a way fruitful beyond the term of his own life. Although his government was "fair and mild," he did not, owing to his ambition and arbitrariness, reconcile the patricians and republicans. Senate and Assemblies were used by him in a purely advisory capacity and often served merely as a front. Within three years, the senatorial party avenged itself on him. Under the leadership of Brutus and Cassius, they assassinated Caesar in March of 44 B.C.

Social Scene The assassination of Caesar did not aid the cause of the Senate. The Senate could not reverse a trend that resulted from the gradual evolution of the nature of the Roman republic and that was mirrored in the economic, intellectual, and moral climate of the age. No longer could the parochial views, domestic virtue, and revered traditions of Old Rome inspire.

Wars, revolutions, proscriptions (death lists), and expansion had dissolved family ties, given women wide freedom, spread the habit of divorce, and promoted promiscuity among both sexes. They had decimated the ranks

of the senatorial group and diminished the social usefulness of existing institutions. They had increased the influence of those who, whether of equestrian, senatorial, or even freedman origin, owed their position to political shrewdness or to wealth derived not from agriculture or industry but from financial and real-estate transactions. "Conspicuous consumption" marked the lives of the upper sectors of the population, not only in the capital but also in leading provincial cities. It sharply contrasted with the poverty of the many who lived in the slums of the cities (foremost those of Rome) or eked out a meager existence on steadily diminishing peasant farms.

Cultural Scene

The crudity and brutality of the political and social arena was somewhat relieved by Rome's cultural endeavors during Caesar's time. The closer Rome's contact came to be with the East, the stronger was the East's civilizing impact felt—despite certain other influences that also came from the Orient and tended to corrupt and deprave morals and standards formerly cherished in Rome.

FINE ARTS

Architecture, sculpture, and painting were developed under Greek influence. Original creations were rare, but many Roman imitations of Hellenistic models were of great beauty. The Romans excelled in large utilitarian projects, such as city planning, the laying out of streets, the building of squares (such as *fora*—market places and squares—in Rome and in provincial towns), and the construction of aqueducts and sewerage systems (*cloaca*). Many public buildings, streets, and parks were adorned with fine monuments.

PHILOSOPHY, LITERATURE, AND RHETORIC

Writing and philosophy in Rome were likewise indebted to Greek examples. The predominant world view among the intellectuals of Rome was Epicureanism, advocating a rational life unconcerned with either transcendental aspirations or with immortality and gods, and exhorting all people to quiet enjoyment of what is within reach. This view was presented in poetic form in the *De rerum natura* of Lucretius. Lighter poetry was created by Catullus, who celebrated love and nature and who, in equally elegant style, also dealt with political issues. Many prose works were also written.

Interest in the important events of the day inspired historical works. Diodorus, Nicholas of Damascus, Posidonius the philosopher, Cornelius Nepos the biographer, Sallust, and Caesar himself composed histories of artistic as well as factual value. Whatever their ulterior motives may have been, they exhibited a historical sense that indicated a maturing spirit.

The most influential writer, if not in his own time then at least for posterity, was the great orator Cicero. With integrity and courage, Cicero, child of a corrupt age, published political speeches, letters on art and

philosophy, and works on government and law. He was a master of style. Even if, as an eclectic philosopher and transmitter of Greece's heritage, he formulated no great new ideas, he possessed wide influence owing to his genius for expressing thoughts with great clarity. He left, through the elegance of his presentation, a deep impression for over two thousand years.

EDUCATION AND LAW

The times of disruption contributed also to Rome's growth in the fields of education and law. Many who were to give distinction to Roman civilization in the subsequent Augustan Age were brought up during the civil wars. Despite the political troubles, private schools flourished under Greek educators. Law (though disregarded on the political stage) was developed further. Magistrates and lawyers, whether of high or plebeian origin, attended with care, often with genius, to judicial functions. Even while serving the interests of the propertied classes (and thereby the cause of private property), the Roman bureaucracy enriched the treasure of legal ideas and of international concepts of justice.

THE AUGUSTAN AGE

If the murderers of Caesar had hoped that upon his death the Republic could be revived, they found themselves quickly disappointed. The aims of Brutus and Cassius, leaders of the republican party, reflected neither popular wishes nor general trends. Both envisaged personal rule by an efficient administrator who would put an end to internal strife and reorganize the empire. This man emerged in the person of Octavius, eighteen-year-old relative and heir-designate of Caesar. It was he who gave peace to the commonwealth and stimulated the latent forces to new cultural achievements.

Struggle for Caesar's Heritage

Immediately upon Caesar's assassination, three pretenders to supreme power arose: Antony, friend of Caesar and consul at the time of the assassination; Lepidus, a commander of Caesar's army in Italy; and Octavius. When Antony and Lepidus joined forces, a triangular struggle followed. On one side were the republicans under Brutus and Cassius, who drew their strength from the rich eastern provinces that had been assigned to them. On another were Antony and Lepidus, who were backed by the Populares and the political friends of Caesar. Then there was young Octavius.

From the start, Octavius showed unusual political acumen. He started out by putting himself at the disposal of the Senate and even convinced Cicero that he was the man least likely to overthrow republican institutions. Then he secured the support of Caesar's veterans through lavish gifts. Next he gained the consulship for the year 43 B.C. and took up arms against Antony. Finally he reversed his course and threw in his lot with Caesar's friends.

THE SECOND TRIUMVIRATE

Before the year 43 B.C. was over, Octavius had formed, together with Antony and Lepidus, a Second Triumvirate. Combining their resources, the three immediately turned against Caesar's murderers. They issued new proscription lists, had thousands of people killed (including Cicero, at Antony's insistence), confiscated their property, and then moved against Brutus and Cassius. In 42 B.C., in a decisive battle at Philippi in Greece, the two leaders of the conspiracy against Caesar were defeated; both committed suicide.

TRIUMPH OF OCTAVIUS

After the victory, Antony stayed in the East. He reorganized Rome's unruly Oriental provinces and undertook a campaign against the still unconquered Parthians. Then he proceeded to Egypt, where he remained, falling under the spell of Queen Cleopatra.

Octavius, meanwhile, had returned to Rome. With outstanding statesmanship he managed to appease many of his enemies. By heaping on his veterans gifts—financed by confiscations of the property of his defeated opponents—he made sure that they would continue to support him. He used them to suppress any opposition and to help him counter the moves and intrigues of Antony's friends, who feared for their absent leader's position. In 40 B.C., he even concluded a new agreement with the two other triumvirs, married his sister to Antony, and had Italy and the West assigned to himself. The East was given to Antony and Africa to Lepidus. This arrangement lasted until 36 B.C., when Lepidus was removed. He had proved inefficient and of questionable loyalty during a war in which Pompey's ambitious and capable son Sextus had challenged the triumvirs.

Since Sextus had also perished in the course of the war, the fate of the empire was now left in the hands of Octavius and Antony. Their rivalry came to a head when Antony, who had continued his affair with Cleopatra, conspired with the queen in the building of an independent empire for themselves and their children. With the consent of the Senate, Octavius attacked his former colleague. In the Battle of Actium (31 B.C.), he defeated the combined forces of Antony and Cleopatra. The two escaped to Egypt, where they ended their lives and love by a double suicide, leaving Octavius in possession of Egypt and the East, as well as the West.

Reorganization of Roman Institutions

In 29 B.C. Octavius returned to Rome. Rid of opposition, he could from then on cultivate the better facets of his character, which he had had little opportunity to demonstrate while the struggle for power lasted. His earlier actions had already given hints of his qualities as a statesman, but he now appeared a changed man.

EMPERORSHIP AND INTERNAL POLICIES

Without abolishing republican forms and ways dear to the Romans, Octavius assumed, with the rank of princeps and the title of "Augustus," the functions of consul, proconsul, tribune, and pontifex maximus. He preserved the Senate but used it mainly for advice and for judicial decisions. Its membership was limited to six hundred—most of them coming from the old families and all of them required to possess a large fortune. He retained the two assemblies but reduced their share in the government to a mere formality. He reserved for himself the right to nominate consuls and other magistrates, and he created two new offices that in due time were to become perhaps the most influential: Prefect of the City and Prefect of the Praetorian (or Imperial) Bodyguard. In his hands were placed the rights to convene the Senate and preside over it, to conduct foreign affairs and make war and peace, to sponsor legislation and exercise a veto, and—most important—to command the armies.

As an imperial prerogative, he reserved for himself the control of strategically important provinces and of Egypt (of which he had made himself pharaoh). He governed these domains through his own lieutenants. The rest of the provinces were left to senatorial direction. Thus the income from large parts of the Empire went into his personal treasury and gave him enormous wealth, plus additional power. In the meantime, the state apparatus, dependent upon the Senate, decreased in size, resources, and importance. Most of the taxes were drawn from the provinces; taxes for Roman citizens remained light, consisting chiefly of those imposed on land, sales, and inheritance.

MILITARY AND EXTERNAL POLICIES

Augustus was to rule for forty-three years after his return to Rome. It was a time of restored order, law, and prosperity rather than of brilliant exploits. Military forces were kept at a minimum. They consisted of three parts: legions composed of Roman citizens who served for a long term, at the end of which they received bonuses and land; auxiliary troops of provincials; and the praetorian guard. Since peace reigned, their chief task consisted in securing the borders and helping with the pacification and Romanization of the provincial populations, which meant infiltration of the Latin language combined with Roman law and administration. It gradually expressed itself in the daily habits of the provincials, in their urbanized life, their cultural interests, and their styles of architecture.

The mineral resources of Spain were developed. Carthage was rebuilt and became anew a center of the grain trade. Egypt was secured against invaders from the south. Gaul's borders were defended. An expansion into Germany miscarried, though. Augustus suffered there his most shattering defeat: In A.D. 9 at the Battle of the Teutoburg Forest, his legions were destroyed by Cheruskans under Hermann (Arminius), and the Germanic lands beyond the Rhine and Main rivers were never incorporated into the Empire. In the East, peace was fairly well maintained. The Parthians were held back, and Judaea was quieted after an uprising that followed the death of Rome's friend Herod. Existing local autonomy and Hellenistic patterns of civilization were left unchanged.

PAX ROMANA

Thus the beginnings of a *pax romana*, a peace under Roman domination, are traceable under Augustus's rule. Large-scale commerce revived and prosperity returned. Roads were built, connecting the capital with the provinces and the provinces with one another. Seaways were made secure against pirates. Some daring highways were laid across Alpine passes.

Roman administration was considerate. Roman citizenship was extended to many regions and many individuals, who thereby acquired the rights which formerly only those from Rome as *civis Romanus* (Roman citizens) could claim. Corruption was reduced. Law schools were founded, the process of law was improved, and legal procedures were introduced in the various distant provinces of the Empire, protecting their populations. Some progress in the codification of the law was made.

Economic and Societal Structure

Economically, the Empire under Augustus became a more closely knit unit. But owing to the lack of progress in science and technology, industrial production hardly improved. It continued to be based on small-scale home industries run with the help of slaves. Nor did agricultural production in Italy itself improve. Although the interests of small landowners were better guarded, the trend toward large estates worked by slaves and producing crops for exchange with Oriental luxury goods could not be reversed. The city of Rome remained dependent upon imports, upon the productive resources of the Empire, upon tribute and spoils, and upon speculators in needed commodities. Many of these speculators were foreigners—Orientals of Syrian, Armenian, Jewish, and Greek origin.

Socially, trends as they had existed before the times of Augustus persisted. The real winner of the civil wars was the equestrian class, which had long been in the ascendancy. Membership in this class required considerable wealth, amounting to at least one-half of the fortune prescribed for a senator. Wealth gave not only decisive economic influence to the equestrian banker and financier, tax collector, and businessman. It also secured preference for positions in

the civil service. From among the Equestrians were chosen the captain of the praetorian guard and other officers close to the person of the emperor.

Artisans, also, found their lot improved, owing to peace, revival of trade, and public works. Combining in guilds, they gained a measure of security. But the senatorial group, decimated, impoverished, and distrusted as it was, gained little. While retaining rank and prestige, it saw its political influence fade. Nor was the situation of the Roman proletariat much improved. Many continued to live in poverty and want, dependent upon gifts from the public or from Augustus's private treasury, and eager to be amused by spectacles and games.

Likewise the status of the peasant masses and that of the slaves showed few signs of change. However the number of slaves who were freed steadily increased. Throughout the Empire freedmen played an important role as clerical workers or as supervisors and agents for state, private business, and landed estates.

Cultural Progress

In such an atmosphere, a new generation grew up. Cultural interests evinced in the stormy period of civil war were broadened. Wealthy individuals, uncreative themselves but attracted by peaceful arts, found satisfaction in sponsoring artists and scholars. Augustus himself and his friends Agrippa and, especially, Maecenas assumed the role of patrons of cultural endeavors.

FINE ARTS

During Augustus's reign, public and private buildings of great splendor were erected. A new forum, theaters, temples, and fountains, inspired by Hellenistic tradition, were built. Sculptures were produced to decorate homes, streets, and halls; numerous imposing busts were created. The famous *Ara pacis* with its lovely reliefs was erected, made of marble, as were so many Augustan structures.

LITERATURE

Poets and writers composed surpassingly fine prose works and verse, even when they imitated Greek models. Horace's *Odes*, Ovid's *Metamorphoses*, and Virgil's *Aeneid* mark the zenith in Roman creative literature. Many of the works were written in a patriotic vein, glorifying Rome, praising her ancient virtue, extolling present times, and advocating her mission. However, their real merit lies in the beauty of form in which great thoughts are expressed, meaningful throughout the ages. Livy wrote a famous history of Rome from its beginnings, which has at least in parts survived. In the field of geography, the main contribution came from a Greek, Strabo.

PHILOSOPHY AND RELIGION

The inner uncertainty of the age was, however, evinced by the state of philosophy and religion. Pessimistic trends predominated. Faith in the traditional gods, which Augustus tried to revitalize, was lacking. An appeal was

made by thinkers, whether in the Stoic or the Epicurean tradition, to bear with dignity whatever fate brought, to try to keep aloof from vulgar passions and, if possible, to enjoy what each day offered. Virtue and lofty moral standards were seldom manifested. In the very family of Augustus, who did his best to further such values, they remained conspicuously absent. A similar atmosphere prevailed in Roman society throughout the Empire. Mystery cults connected with excesses such as Egypt, Persia, and Greece knew continued to spread. But Jesus had been born in Judaea, and His teachings were to seal the doom of all the beliefs and cults nurtured by Roman philosophers and the emperor.

Augustus died in A.D. 14.

After Rome's century-old order had broken down, the new one was brought about by outstanding men who were not only skillful generals who based their authority on the armies they commanded but who were also able statesmen. They ruled, not as dictators, but as monarchs. They preserved—at least in name—some of the traditional institutions: foremost that of the Senate, which acted, if no longer as the deciding power, then as an important advisory body. The old Roman virtues largely disappeared; the wealthy people reigned, and the poor people, especially the agriculturalists, gained little while losing political influence and liberty. A flourishing of art, literature, law, and philosophy (eclectic, as in the works of the much admired Cicero) occurred, inspired by and derived from the great thinkers and artists of Greece. Vast conquests in northern Europe, Africa, Egypt, and the Middle East enlarged the empire.

Selected Readings

Adcock, F. *Marcus Crassus* (1966)

Alföldi, Geza. *The Social History of Rome* (1985)

Baker, G. *Sulla the Fortunate: The Great Dictator* (1967)

Chisholm, K., and J. Fergusun. *Rome, the Augustan Age: A Source Book* (1981)

Cowell, F. *Cicero and the Roman Republic* (1948)

Gelzer, E. *Caesar: Politician and Statesman* (1968)

Gruen, E. *The Last Generation of the Roman Republic* (1974)

Huzar, E. *Mark Antony: A Biography* (1978)

Lefkowitz, M. and M. Fant. *Women's Life in Greece and Rome* (1982)

Mommsen, Theodor. *A History of Rome* (1958)

Rowell, M. *Rome in the Augustan Age* (1962)

Scullard, H. H. *From the Gracchi to Nero: A History of Rome from 133 B.C. to A.D. 68* (1982)

Seager, R. *Pompey: A Political Biography* (1980)

Stockton, David. *Cicero: A Political Biography* (1971)
 The Gracchi (1979)

Yavetz, Z. *Julius Caesar and His Public Image* (1983)

10

Imperial Rome

14–37 A.D.	Reign of Tiberius
17	Death of Livy
	Death of Ovid
37–41	Reign of Caligula
41–54	Reign of Claudius
43	Britain becomes a Roman province
54–68	Reign of Nero
64	Fire in Rome; persecution of Christians
65	Death of Seneca
69–79	Reign of Vespasian
70	Destruction of temple in Jerusalem by Titus
79–81	Reign of Titus
79	Eruption of Vesuvius; death of Pliny the Elder
81–96	Reign of Domitian
98–117	Reign of Trajan
101–106	Dacian Wars
114–117	Parthian Wars
117	Death of Tacitus
117–138	Reign of Hadrian
ca. 120	Death of Plutarch
130	Death of Juvenal
131–134	War against the Jews; destruction of Jewish state
138–161	Reign of Antoninus Pius
ca. 140	Death of Suetonius
ca. 160	Ptolemy, the Geographer

161–180 Reign of Marcus Aurelius

180 –193 Reign of Commodus

193–211 Reign of Septimius Severus

199 Death of Galen

211–217 Reign of Caracalla

222–235 Reign of Alexander Severus

228 Death of Ulpian, the Jurist

230 Death of Tertullian

249–251 Reign of Decius

249–250 Persecution of Christians

253 Germanic (Gothic) invasion of the Empire

254 Death of Origen

258 Death of St. Cyprian

270 –275 Reign of Aurelian

Rome had found a solution for her political problems. Under a monarchy instead of a democratic system, order was reestablished; civil wars came to an end; dispensation of justice was improved; and the burdens of government and taxation were more equitably distributed. The Empire began to prosper under a system of government that had logically developed out of, yet was in contrast to, Rome's earlier institutions. This new system did not change during the first century A.D. In the second century, it brought the Empire to its climax. Rome's commonwealth reached its largest extent. Its populations could live under a system of law that, even though favoring Roman citizens and among these the wealthy classes, made it possible for all to gain a measure of security. They could share in the advantages of a worldwide trade and attain a considerable amount of self-expression. While art and scholarship did not reach the heights they had attained in Greece, these too bore rich fruits. Only after more than two hundred years—in the third century—did reverse trends set in that foreshadowed the collapse of the Empire.

THE FIRST CENTURY A.D.

Upon the death of Augustus, Rome's monarchical structure, which seemed so dependent upon the character and ability of the great emperor, did not break down. To the contrary, monarchy was firmly implanted. Every ruler contributed a share to the steadily rising authority of the emperors, whether he was raised to his dignity by birth or by army or praetorian guard, and whether he lived until a natural death or, as in the case of seven out of ten emperors, death by assassination or suicide claimed him. Therefore, neither the vicious stories of palace intrigues, murder, and debauchery in the imperial households, nor even the accounts of the excesses of the Roman rabble crying for bread and entertainment (*panem et circenses*) should be taken as the real story of the Empire. It survived and grew because its new institutions served the needs of the times and because sufficiently large sectors of the population derived profit from its existence and maintenance.

The Emperors

The rulers of the Empire captured the imagination of generation after generation; their colorful personalities left a strong impact upon history. Augustus's successor was his stepson Tiberius (A.D. 14–37), a conscientious and capable administrator and excellent general. His later years were poisoned by his own suspicious nature and marred by acts of cruelty inflicted chiefly on those suspected of the slightest disloyalty. He was followed by Caligula (37–41), cruel and half mad; Claudius (41–54), incompetent, yet attractive and cultured; and Nero (54–68), half insane and cruel like Caligula. Dignity was restored to the imperial office by Vespasian (69–79), who followed three short-lived rulers and who again brought order into the administrative and military services. The short reign of his generous and peaceable son Titus (79–81) was an unfortunate one because of plagues, fires, and a disastrous eruption of Mount Vesuvius. Finally there came Domitian, a despot who knew how to rule efficiently. Under him, the deification of the emperor, initiated by Caesar and Augustus and advanced by Caligula and Claudius, was furthered. Assemblies and Senate, which Vespasian had still respected, were stripped of almost all their prestige and power.

Under several of the emperors—Claudius, Nero, and Domitian—women, whether wives, daughters, or mistresses of the rulers—wielded considerable influence. They took a hand even in the making and unmaking of various emperors.

Imperial Administration

The emperors ruled with the help of the bureaucracy, in which Equestrians and freedmen played the chief role. The former filled most of the important official posts. The latter, dependent as they were upon the

personal favor of the emperor, could be trusted with his personal service and with high offices in the palace. Many proved to be able administrators, who merited credit for holding the Empire together and providing efficient and honest government.

EXTERNAL POLICIES

The Empire continued to grow. Revolts in Palestine, Britain, and Gaul were suppressed, and new provinces like Cappadocia, Judaica, and Britain were organized. Britain, the major part of which was conquered under Claudius, was protected by a wall (*limes*) against possible inroads from Scotland. Under Domitian, Rome's borders were expanded into Wales. Some conquests were also made in eastern Europe along the course of the lower Danube. Wherever armies were stationed in conquered countries, they contributed to the Romanization of the region. Only Germany north of the Main River withstood Roman pressure. New attempts at conquest were halted under Tiberius, and the frontiers were stabilized along the Rhine and the upper Danube.

INTERNAL POLICIES

Foreign expansion was matched by internal improvements. Tiberius, Vespasian, and Domitian successfully built up the treasury. The administration of public and imperial funds, left to competing agencies by Augustus, was considerably centralized. Citizenship rights were given to Spaniards and other non-Italians. Domitian attempted a number of agricultural reforms to improve the conditions of the poor farmers. Trading activities recovered and towns prospered. New large public works were undertaken; building activities flourished. Additional aqueducts were constructed during Claudius's reign. If Augustus had taken pride in the creation of marble palaces, temples, and theaters, great architectural undertakings were carried on likewise by his successors. Soon the pattern set by Rome was imitated in the smaller cities of Italy, in southern Germany and Gaul, and in Greece, Egypt, and Asia Minor.

Cultural Scene

Arts and literature flourished in first-century Rome, even if few decisive departures or innovations in style can be traced. Innovations took place, however, in the area of religion: In particular we see an interest in transcendental beliefs unknown in most periods of antiquity and a new approach to ethical concepts and human conduct.

FINE ARTS

Building activities were vigorous. Numerous villas and palaces were erected in and around Rome, among them the gigantic *domus aurea* of Nero. Other building projects were carried out in the provinces. Beautiful mosaics and frescoes were designed to adorn these buildings, whether

public or private. Some have been preserved owing to the eruption of Mount Vesuvius in A.D. 79, which, by burying the towns of Pompeii and Herculaneum, claimed them for posterity. Fine statues were sculpted, most of them still imitating Greek style or copying Greek models outright, but some showing original Roman concepts and excelling through a straightforward realism.

LITERATURE, PHILOSOPHY, SCIENCE

Literature, philosophy, and the sciences were consistently enriched by contacts with lands conquered by Rome. Lucan excelled in poetry, and a later much-cherished figure, Petronius, contributed satirical stories mirroring life in Roman society. Flavius Josephus, a Romanized Jew, wrote a history of the Jews. Celsus and others made scientific contributions in medicine, law, and agriculture. Pliny the Elder composed a natural history comprising a summary of the knowledge of his time.

Outstanding among philosophers was Seneca, teacher and adviser of Nero during the emperor's better early days, though later his victim. This statesman, philosopher, and tragedian carried on the Stoic tradition. In the midst of a society craving the vulgar entertainment afforded by races, circuses, and gladiatorial contests, he emphasized that a virtuous life and an ethical attitude in the pursuit of public obligations and personal relations constitute the aim of the wise. While abstaining from broad transcendental speculations, he sought a solution for overcoming the inescapable evils of this world.

RELIGION

In some respects Seneca's thoughts contained seeds found also in Christian ethics. Actually the official religious beliefs as well as the philosophy of the time were as incapable as ever of attracting the sophisticated minds of the learned. They could satisfy neither the yearnings of those in search of a meaningful faith nor the emotional needs of the masses.

Paganism. Worship of traditional Roman gods and of the emperor was required of everybody as a matter of devotion and service to the state. This not very demanding worship failed, of course, to meet the longings of the many who were searching for a more meaningful faith and for a guide to an ethical life. Some resorted, therefore, to teachings reflecting no more than crude superstitions. Others sought satisfaction through mystical cults aimed at purification from sin and a blessed immortal life. Widespread among the religions thus adopted was Mithraism, which, following the teachings of Zoroaster, explained the world in terms of an eternal struggle between light and darkness, good and evil.

Other faiths that became popular in Rome were the imported religions of Isis and of Cybele. Like the rites of Dionysus, they were often connected with orgies condemned by state authorities (who were anxious, as in

Vespasian's or Domitian's times, to improve morals). But they appealed to a dissolute, cynical, and superstitious society.

Judaism. More consequential than paganism was Judaism. Owing to their exclusiveness, and their ethnic as well as religious segregation, the Jews played a twofold role—both secular and religious. In the secular sphere, Judaism was important because, as traders and financiers, the Jews exercised considerable influence on the economy of Rome and because, as members of a kingdom of their own, they offered bitter political resistance to their integration into the Roman Empire. Though they had been subjected, after their return from Babylon, to Persians, Macedonians, Syrians, and Egyptians, they had never reconciled themselves to foreign rule. In the second century B.C., under the leadership of the house of Maccabaeus, they had gained independence and preserved it for approximately a century. But in the time of Pompey, they had become subject to Roman rule.

For a time, the wily policies of Herod the Great and his successors prevented new struggles for independence. But in the reign of Caligula, a revolt shook the country again, only to be followed, after its suppression, by another in Nero's time. This second revolt was not crushed until A.D. 70. Under Vespasian, Jerusalem was destroyed by Vespasian's son Titus; the Jewish religious treasures were brought to Rome.

However, the other aspect of Jewish opposition to Rome—the religious aspect—persisted. At no time could the monotheistic creed of the Jews be reconciled with Rome's religious tenets, nor with the Hellenistic spirit that permeated Rome's society. Even after being deprived of their state, the Jews set themselves, through their religion, apart from other nations. Moreover they held fast to a hope for a Messiah, who would fulfill their religious longings as well as liberate them from political domination.

Under the circumstances, Judaism failed to provide that element for religious renewal for which the Roman world seemed ripe. It was the teachings of Jesus of Nazareth, whose public career began and ended under the reign of Tiberius, which were to initiate a new age in the religious development of the Romans.

Christianity. In contrast to the parochial views of the Jews and the close connection between the Jewish people, their state, and their traditional law, the Christians early on adopted cosmopolitan tendencies, and this made it possible for their faith to spread widely. In men like Paul of Tarsus they found capable and devoted missionaries. Others, like Saint Sebastian (an early martyr), furthered their cause by showing their willingness to sacrifice their lives for it. And others worked for it anonymously as humble and loyal followers. Christian teaching flourished particularly in the eastern provinces of the Empire. It was there that, in the second half of the first century A.D., through the writing of the Gospels and through the institution of rituals such as baptism, a historical tradition was established.

Despite Roman tolerance, the relationship of the young Christian sect with the Roman state suffered from the start. Christians were disliked because of their connection with the hated Jews and because of their refusal to perform such duties toward the state as emperor-worship and service in the army. A number of violent actions against them, which claimed many victims, were undertaken. Sometimes such persecutions were caused by spontaneous popular movements. Sometimes they were sponsored by a government that sought to punish the sect for lack of devotion to the state. Most ill-famed among the persecutions was that in the time of Nero in A.D. 64, when the Christians were falsely held responsible for a devastating fire in Rome. A less spectacular but more extensive persecution occurred under Domitian.

THE SECOND CENTURY

The following century is a time of the "good" emperors and "benevolent despotism." During this time, both the political and cultural trends initiated during the first century persisted. Only toward the end of the century did they begin to take a new direction.

The Emperors

The most famous emperors during the second century, several of whom were of foreign origin, were Trajan (98–117), Hadrian (117–138), Antoninus Pius (138–161), and Marcus Aurelius (161–180). Except for Trajan, they were not, as were earlier emperors, the creatures of revolting armies nor of praetorian guards. Nor were they of the Senate, which in any case had retained a formal right of confirmation. Each of them was appointed by his own predecessor. They were men devoted to their task and capable as generals and administrators. Hadrian was an untiring traveler, who personally supervised the execution of law. He and Marcus Aurelius were interested in art and philosophy.

Imperial Administration

The organization of the Empire had been so successfully fixed by the beginning of the second century that there was no need for major institutional changes. A peaceful, organic refinement of existing patterns took place. It led to greater centralization and, as a result, an increase in the imperial bureaucracy. The efficiency of the administration was improved. Perhaps the only important change lay in the direction of a more active foreign policy. This was to bring a further enlargement of Rome's boundaries.

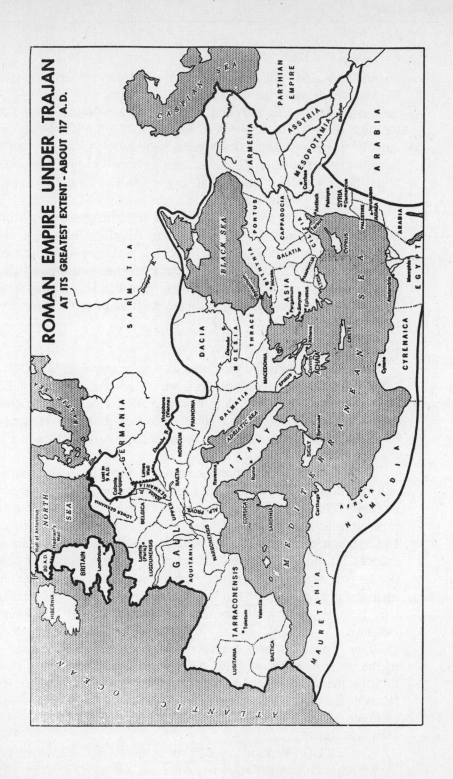

ROMAN EMPIRE UNDER TRAJAN
AT ITS GREATEST EXTENT - ABOUT 117 A.D.

EXTERNAL POLICIES

In the time of Trajan and Hadrian, the Empire reached its vastest extent. It expanded beyond the Danube into Dacia (modern Romania), into the northern parts of England, and into Arabia, Mesopotamia, and Armenia. Revolts, such as still occurred in Judaea and in the Black Sea area, were quickly suppressed. Imperiled borders were provided with strong fortifications, walls, and castles. Parthians and Germans were held in check. Additional roads were built and postal services were instituted, connecting the new provinces with the capital.

As a whole, the *pax romana* reigned and remarkably few troops were needed to maintain it. Only under Marcus Aurelius did serious difficulties arise on the borders of Parthia and Dacia. It was only in the time of his son Commodus (180–193 A.D)—the first emperor to be assassinated after almost a century of peace in the imperial households—that a shrinking of the empire occurred. It was then that a few Danubian conquests had to be given up to invading German tribes.

INTERNAL POLICIES

In the newly included provinces as well as the older ones, Roman law, administration, language, and culture were vigorously supported. Benefiting from the many links, including common institutions, law, customs, commerce without barriers, and cultural connections, the Hellenizing and Romanizing process accelerated. A feeling of unity developed throughout the Empire.

Organization. The provinces remained formally divided into senatorial and imperial domains, although in actuality they were all under the emperor's direction. The emperor knew how to counterbalance the power of senatorial proconsuls and propraetors by the appointment of Equestrians as procurators and commanders of his legions. The legions were made up of volunteers who enlisted for long-term service. Many of them were natives or colonists of border provinces who, by enlisting, became Roman citizens. Cities sprang up in the areas of northern Europe that Rome had occupied. Local autonomy was, however, more and more restricted and eventually was found only in the towns.

Law. In legal affairs, as elsewhere, centralization progressed. The will of the emperor alone was law. Neither the ancient nor those newly risen families that the emperor appointed to the Senate exercised effective influence. Executive power rested with the magistrates responsible to the emperor. Among them were men of all ranks: senators, Equestrians, freedmen, and slaves.

This efficient bureaucracy was strengthened by a steadily refined legal system. Specially qualified jurists collected and codified the existing body of judicial decisions and worked out important additions. An imperial court

of appeal was created. Ideas of a supreme "unwritten" law applicable to all men (*jus naturale*) became more widely accepted. These ideas had a humanizing effect—reducing the use of torture, easing the burdens of slavery, and advancing concepts of the fundamental inviolable rights of the individual.

Finance. Finances were handled with greater care than in earlier periods. However, a consolidated treasury system, such as modern times have found indispensable, was never worked out. Imperial and state treasuries derived income from tributes, from sale of monopolies, from special levies, and from taxes. Taxation became more universal. Land, sales, and inheritance taxes and tithes were levied not only upon conquered nations but also on Roman citizens. Yet despite a decline in income from booty, the burden remained moderate. The system of collecting taxes through tax farmers was continued, to the detriment of the treasury. A decrease in corruption could only partly make up for the costs of the bureaucracy and the inefficiency of the system.

Commerce. Under a firm rule and within the wide and diversified area covered by the Empire, commerce could develop rapidly, even though modern forms such as corporations and joint-stock companies were little developed in ancient Rome. Throughout the age of the "good" emperors, the currency in gold coins remained stable. Not until Commodus's reign did debasement start.

Mining of iron and coal was encouraged in Spain and Britain as well as in Danubian regions. Production of building materials and handicrafts flourished in many regions. Oriental products were imported from India and even China; textiles, jewels, and spices were brought to the less-developed West. Amber from the Baltic and furs from Scythia became coveted luxury items for Rome's wealthy citizens. Construction of houses, roads, and bridges contributed to creating work, trade, and prosperity.

Yet in the second century, as in preceding centuries, large-scale industrial production failed to develop. Technological improvements remained few. Especially in the Empire's western regions, industries provided for no more than bare necessities. Indeed, economic activities served mainly local needs and not the broad market that the large empire could have offered. This had an adverse effect even on the political administration.

Society

In contrast to the fact that social conditions under the "bad" emperors of the first century had ushered in an age of greatness and peace in the second century, certain undercurrents during the reign of "good" emperors—discernible to the historian only in retrospect—augured less well for the third century. Disasters like the plague, which struck the West during the reign of Marcus Aurelius and again under Commodus, were perhaps less ominous than the persistent adverse changes in societal structure.

UPPER CLASSES

The trend toward greater social and economic inequality continued. Extreme poverty, which was widespread, contrasted with the extreme luxury of the few. Among the upper classes, family life, already undermined in late republican times and the Augustan age by a high rate of divorce and immorality, continued to disintegrate. Women like Augustus's daughter Julia, his granddaughter Agrippina, and Nero's mistress Poppaea had set bad examples that were widely imitated in the second century. The population increased and urbanization took place. Yet a middle class with stern morals and a concept of duty did not develop, as has happened in parallel situations in other ages and regions. More and more, the upper classes allowed political responsibilities to be absorbed by the imperial court, put up with whims and intrigues of the government, and contented themselves with the fulfillment of lucrative bureaucratic functions.

LOWER CLASSES

Among the lower classes, both in town and in country, conditions deteriorated. Independent farmers decreased in proportion to the total number of the peasantry. Though some of them improved their lot, the majority of the country population, as well as the city proletariat, suffered gravely. Not enough grain was produced to feed their increasing numbers—partly because of soil exhaustion and continued trends toward large luxury estates. More doles had to be distributed to humor them, and more feasts and circuses were sponsored.

Slaves, who had carried part of the economic burden, became scarce as soon as the Empire ceased to expand. In their place there grew a class of tenant farmers who held an intermediate position between the free peasants, who owned their plots, and the slaves. Tenant farmers, who as such were free, cultivated the large estates or *latifundia* of the rich. But as early as the second century, certain restrictions were imposed on their freedom of movement, foreshadowing the later evolution of serfdom.

Cultural Scene To many who study the rise and decline of civilizations, Roman literature and art in the second century also bear witness to increasingly ominous undercurrents. Instead of new creative endeavors, the practice of merely collecting and cataloging data prevailed. Interest in historical records and in the sciences increased and tendencies toward imitation of traditional patterns and styles dominated in the arts. These leanings were consciously encouraged by such partisans of Hellenism as the emperor Hadrian. Yet some works were created, particularly in literature and in architecture, that do show an independent spirit and an original approach to problems of artistic expression.

FINE ARTS

Since little has been preserved of Roman paintings, Rome's creative artistic endeavors are judged mainly from the numerous works of sculpture and architecture that have survived. They followed, as earlier, the tradition of the Hellenistic era. Yet the architecture also shows a measure of emancipation from Greek models. The Colosseum, the Circus Maximus, the Tomb of Hadrian, and numerous villas point to the ability of the Romans to combine daring engineering techniques, including broad and high arches and mighty roof constructions. They possessed a sense of proportion and beauty that defied the temptations of mere size and utility. Most of the emperors paid attention to the beautification of their cities, especially in Rome. There, in addition to traditional public buildings, were erected triumphal arches, victory columns, and baths that belong among the most outstanding monuments of ancient times.

LITERATURE AND SCIENCE

The literature of the second century, written in both Latin and Greek, was comparatively rich and still excelled through purity of style. Works of poetry and fantasy were less outstanding than those written in prose and concerned with rational and scientific investigation. Tacitus composed a Roman history in the time of the emperors, his *Annals* and his *Germania*, which provided not only information on facts, conditions, and characters of the past but also thought and judgment about affairs in general. Plutarch wrote his *Lives* with their sharp character studies, and Suetonius, almost a generation later, his *Lives of the Twelve Caesars*. Among the poets, the outstanding figures were Juvenal, Apuleius, and Lucian, famous for their satirical descriptions of contemporary society.

In the sciences, the works of two men were unequaled in importance and—regardless of the many erroneous views they also held—remained basic texts for more than a thousand years. Galen, a sober student of anatomy and physiology, wrote medical treatises, laid down principles of therapy, and evolved a system of medicine. Ptolemy, a mathematician and astronomer, described the geography of the earth and drew a picture of the cosmos. Ptolemy's writings also included treatises dealing with cartography, musical harmony, and optics. Works of other authors included discussions of agriculture, engineering, and other scientific topics.

PHILOSOPHY

Epicureanism and Stoicism remained the chief philosophical schools of the age. Toward the end of the second century, however, a certain disintegration of both these schools of thought occurred. Some of their adherents, especially among the intellectuals, turned increasingly to Cynicism. Others embraced Neo-Pythagoreanism and Neo-Platonism, which combined concepts of virtue and Stoic forbearance with transcendental and mystic views

about the soul and the supernatural. Still others became increasingly receptive to the new Christian sect.

The best-known philosopher of the second century was the emperor Marcus Aurelius. His *Meditations* (composed in Greek) commend Stoic virtue and resignation to one's fate. They also demand an active humanitarian attitude, which expresses itself in deeds of compassion and helpfulness for the unfortunate, the weak, and all who suffer.

RELIGION

Most important for the future of Western civilization was the evolution of the Christian Church during the second century A.D. The Gospels and other sacred writings were put into final form. A Christian moral code evolved. Some of the early Church fathers—among them Polycarp of Smyrna—appeared. A Church hierarchy began to evolve, necessary to accommodate the growing number of adherents. Bishops were appointed to enforce established rules. Rites such as communion were introduced, the principles of priesthood were established, and other traditions were initiated. Missionary activities broadened. These activities became more successful as Greek and other philosophies began to affect Christian thinking, which began to be more acceptable to the educated upper classes of Rome.

Essentially, the unity of the Empire, its well-being and resultant tolerance, favored the growth of the Christian Church. Christianity may have been more suspect than other religion because of its own intolerance toward other creeds, its vigorous proselytism and effort at winning adherents, and its social, rather communistic tenets. Yet few obstacles were put in its path so long as its members fulfilled the obligations of the Roman citizen or subject.

Nevertheless, some persecutions occurred. Those under Trajan and Marcus Aurelius were of local origin and resulted from personal grievances. A more widespread persecution took place under Hadrian, brought about by a new revolt of the Jews, with whom the Christian sects were often still identified. The Jewish uprisings, led by Bar Cocheba, were crushed and, through the dispersion of the Jews, an end was put to the remnants of their state. The Christians, however, found themselves exposed to vigorous, apparently centrally directed attacks.

EXTERNAL AFFAIRS

The defense of the Empire turned out to be increasingly difficult. Parthian inroads ceased when the Persians conquered Parthia in the second quarter of the century, but the Persians themselves became a new menace. They revived their empire, imbued it with a remarkable new culture, pushed Roman legions back, and reduced Rome's status in the East. Small states, such as that of Palmyra in Asia Minor, made themselves virtually independent. German and Dacian invasions in Britain and Gaul as well as Helvetia and the Danubian lands also brought losses of territory. Not until the reign of Aurelian (270–275), who reduced Palmyra to obedience and established a safe boundary in the Danubian region, was the process of decay stopped so that revival seemed possible. Still, the third century ended with a net loss of territory.

INTERNAL CONDITIONS

More serious than the external problems were the internal ones. Law and order were no longer maintained; piracy and highway robbery increased. Attempts at enforcing justice by comparatively responsible governments under Septimius Severus (193–211), Alexander Severus (222–235), and Aurelian (270–275) were unsuccessful.

Despite measures for collecting taxes more effectively and distributing the burden more equitably, and despite steps to encourage industry and business, the decay of public life, morals, and order progressed. Inflation and debasement of the currency ruined the treasury. Confiscations of property undertaken with almost every change of ruler could not restore the financial strength of the government. The military forces became undependable. Foreign soldiers, settled on lands near the borders, could no longer be trusted, and attempts at reform, like those under Septimius Severus, brought no lasting improvement. A declining birth rate and plagues (a particularly severe one occurred in 251) contributed to depopulation. Laborers became scarce and production declined. Metals needed for coinage and for industry were mined in decreasing quantities, while purchases of luxury goods from the East drained existing resources. The growth of cities and of urban civilization was checked.

In agriculture, slave labor became too expensive, and more and more slaves were freed. Yet freedom no longer conveyed the advantages of earlier times because the status of all free peasants deteriorated. The number of those who voluntarily gave up their independence and became tenants (*coloni*) on imperial or privately owned large estates steadily increased. The trend toward serfdom accelerated.

THE THIRD CENTURY

With the end of the second century A.D., began the period of decay of the Roman Empire. Decay was evident in the internal structure: in the debasement of the office of the emperor, the weakening of the economy, the deterioration of morals, and the failure of justice. Externally, it was seen most in the shrinking of the Empire. As at all times, there were many diverse forces at work. Even in a period of decline, however, there were many achievements that were equal to those from the age of Rome's greatness. Many individuals demonstrated creative ability, did their duty, and led irreproachable lives. Actually, the Empire displayed a remarkable power of resistance.

The Emperors

The reign of Marcus Aurelius's son Commodus, a tyrannical and dissipated ruler, marked the transition from an age of peaceful and conscientious emperors to an age of arbitrary and incompetent men. The authority of the ruler was steadily weakened under Commodus's successors. The Senate, the wealthy, and the educated suffered under their arbitrariness and jealousy, while the masses increased their demands for circuses and free distribution of grain.

Most of the emperors gained their offices through bribery or, as in the first century, were products of the legions or the praetorian guard. Put into office by the various armies, in which many barbarians served and where each army could have its own candidate, they remained dependent upon the support of the army. They demanded godlike treatment, yet they were deposed and murdered by the very same schemers who chose or elected them. They followed each other in quick succession, sometimes ruling less than a year. Several of them came from Asia and Africa and governed the Empire not from Rome but from the provinces.

Their withdrawal from Rome, as well as their provincial origin, emphasized a change in the political balance. Rome's prestige and influence were lessened. Emperors of barbarian origin appointed other barbarians to the highest positions, while the Senate came to include numerous non-Italian members.

Imperial Administration

Third-century Rome was unable to deal successfully with administrative problems. The situation worsened when, under the vicious Emperor Caracalla, citizenship rights were extended to every subject of the Empire. This step was the ultimate consequence of the mixing process that had marked the path of the Roman Empire since the days of Julius Caesar. Far from strengthening cohesion and unity, it only served to weaken Rome in the face of internal and foreign dangers.

Civilization

Secular culture of the third century produced little that later generations have considered great treasures. Neither in building, art, science, and literature, nor in philosophy do we find works of supreme achievement or men reaching out for new horizons. Only in the field of religion were there any outstanding figures who effectively combined thought and action.

EDUCATION, PHILOSOPHY, AND LAW

A number of schools were founded, but a basis for a sizable new educated class was not laid. Metaphysicians, Neo-Platonists, and Neo-Pythagoreans continued to dominate philosophy with their teachings. But even the best among them, such as Plotinus, did not add substantially to earlier insights. History in the traditional style was written by Dio Cassius and a few minor authors. Rome's great legacy in law was enhanced. New schools of law were founded, and practical and theoretical knowledge were reconciled. Eminent jurists emerged with Papinian and Ulpian; both served as praetorian prefects, the former under Septimius Severus, the latter under Alexander Severus. Both were able to set an example in applying legal talent to practical political and administrative work.

RELIGION

A feeling of doom seems to have dominated the atmosphere of the third century A.D. However, it is impossible to say to what extent such a feeling actually pervaded the thinking of the masses, or even that of the educated classes. A relationship between the climate of opinion in the third century and the progress of Christianity existed. The more depraved the world and its politics appeared, the more people turned away from the affairs of this world and sought consolation in religion with its mysteries. And the stronger the desire became for purification and cleansing, the more effectively was the ground prepared for Christianity.

The answers that Christianity offered to an apparently hopeless situation satisfied many of the longings of the day. Persecutions, such as that under the emperor Decius (249–251), far from exterminating the Christians, only served to strengthen them, both spiritually and politically. And the devotion of the members of the Church, many of whom accepted a martyr's death, won thousands of adherents to their cause.

Among the most famous churchmen of the time was Tertullian (d. ca. 220), who took a vigorous part in the developing struggles over Christian dogma and who left numerous pastoral writings. Origen (d. 252), a great teacher first in Alexandria, then in Caesarea, continued the polemics of Tertullian, explained the Bible, and promoted biblical scholarship. Cyprian (d. 258) occupied himself with doctrinal questions (such as baptism) and with institutional problems.

Simultaneously with the interpretation and propagation of their faith, the Christians carried on the development of their worldly organization. They strengthened discipline among the members of the Church by conferring larger powers on the bishops and by enforcing a more formal training for the priesthood. They also extended their organization to remote regions—to Abyssinia and Britain, Nubia and Gaul, Persia and Spain.

Rome under the emperors saw its greatest expansion—from the borders of Scotland deep into Africa, from Spain to the borders of Persia and the Black Sea. Peace was enforced by military might as well as by law, and commerce was vigorous. But the exploitation of the provinces both by the central authorities in Rome and by local administrators was ominous. The right to Roman citizenship—i.e., to be a civis Romanus—*was, step by step, extended to non-Italians, and the legions and praetorian guard began to elevate non-Italians to the throne. Ever more luxuries were coveted by the Roman upper classes, while the conditions deteriorated under which peasants and laborers existed. Everywhere, the empire showed, despite external glory, strong indications of decay. Toward the end of the second century* A.D., *its territorial possessions began to shrink. Its financial situation became ever more precarious. Its military forces began to exercise a less decisive influence, and, owing to the plight of the masses, depopulation set in. Little of lasting cultural significance was produced, and, despite occasional suppression, the number of Christians with their own standards in worldly as well as religious affairs increased.*

Selected Readings

Birley, A. *Marcus Aurelius* (1966)

_____*Septimius Severus: The African Emperor* (1972)

Burford, A. *Craftsmen in Greek and Roman Society* (1972)

Brun, Andrew R. *The Government of the Roman Empire from Augustus to the Antonines* (1952)

Davenport, Basil. *The Portable Roman Reader* (1977)

Duncan-Jones, R. *The Economy of the Roman Empire* (1982)

Grant, Michael. *Nero* (1970)

_____*The Twelve Caesars* (1975)

Millar, Fergus. *The Emperor in the Roman World* (1977)

_____*The Roman Empire and Its Neighbors* (1967)

Pomeroy, S. *Goddesses, Whores, Wives, and Slaves: Women in Classical Antiquity* (1976)

Rostovtzeff, Mikhail. *Social and Economic History of the Roman Empire* (1957)

Seager, R. *Tiberius* (1972)

Watson, A. *The Law of the Ancient Romans* (1970)

Webster, G. *The Roman Imperial Army* (1969)

11

The End of
the Ancient World

In many respects, the Ancient World lives on today. As a historical period, however, it came to an end in the fourth century A.D. with the dissolution of the ancient Roman Empire. As a social phenomenon, "decline and fall" has received so much thought and so many interpretations that no single view will satisfy. Certainly the traditional concept that Rome, owing to inner decay, loss of faith, of "virtue," and of creative genius, was doomed to death seems as little acceptable today as the concept that the Roman world and population had reached a point of biological exhaustion. With equal justification one can argue that Rome was doomed in the first century B.C., a century of economic disruption, population decline, social anarchy, corruption, and debauchery,

when a foreign, Hellenistic spirit inundated it. Yet the first century B.C. was followed by an unequaled flowering of Roman civilization, while nothing similar occurred in the fourth century A.D. No more than a temporary revival materialized, which began with the reign of the emperor Diocletian.

THE POLITICAL AND ECONOMIC SCENE

During the last phase of the Roman Empire, while it still embraced both East and West, the ancient world again produced remarkable personalities. Several rulers of great ability occupied the throne, such as Diocletian, Constantine, and the short-lived Julian the Apostate. A number of excellent ministers, advisers, and other officials, often of barbarian origin, were available. But human genius was not enough to counterbalance the forces of disintegration that pervaded the social and economic scene. Nor was Roman strength sufficient to stem the flood of external attacks that vigorous and fresh peoples, just emerging from barbarism, launched upon the very Rome that they themselves cherished and considered their teacher. The glory of the city of Rome itself faded. It ceased to be the seat of the emperors; the Senate became a mere municipal office. Magnificent buildings, with which the emperors still embellished the city, reflected no more than past grandeur.

The Reign of Diocletian

Diocletian (284–305) was the first of the great emperors during the last stages of the Empire. An Illyrian by birth, he was a man of energy and vision, who restored order and brought about a recovery of trade and an improvement of agriculture. He even abandoned Rome as the capital and chief seat of government and built himself a great palace in the eastern city of Nicomedia.

DIOCLETIAN'S ADMINISTRATION

Diocletian surrounded himself with capable advisers and governors and promoted men on the basis of merit. Though at the price of an oversized bureaucracy, he reorganized the administration of the Empire. He divided the provinces into smaller units, which could be supervised by special officers appointed from four new central seats of government. He saw to it that, as much as possible, uniform laws superseded the many existing local privileges. Notwithstanding well-meant but unduly strict government interference—e.g., abortive maximum-price and other stifling laws—a measure of prosperity and confidence returned.

MILITARY AND EXTERNAL POLICIES

During Diocletian's reign, revolts broke out in many outlying provinces—in England and Gaul, in Egypt and Libya. Great efforts were expended to subdue them. Frontier defenses were subsequently strengthened, and soldiers ready for action were settled along the borders. Strict discipline was kept among them, and a new self-respect and authority entered into the officer corps. Yet the power of the officers was limited. They were carefully supervised by civilian officials so as to preclude such military influence in the central government as praetorian prefects and generals had exercised earlier.

DIVISION OF THE EMPIRE

Diocletian's most important decision concerned a division of the supreme power in the Empire. Two emperors with the title "Augustus" were instituted to rule jointly, one in the West and the other in the East. As one of them, Diocletian chose for himself the Eastern division. Each Augustus was given a "Caesar" as his deputy and successor; the rule of two subdivisions was assigned to them. Each Augustus and each Caesar chose a capital of his own. All four assumed a halo of divinity; nobody could approach Diocletian personally without prostrating himself.

The Reign of Constantine

Having made these reforms and having ruled for twenty years, Diocletian, old and tired, together with his co-Augustus, abdicated in 305; the two Caesars succeeded them. But within a few years of Diocletian's death, new civil wars broke out between the new Augusti and their Caesars. The wars lasted for ten years and did not end until one of the successors, Constantine, had defeated all contenders. Constantine eventually reunited the four parts of the Empire and made himself emperor of the entire realm.

CONSTANTINE'S ADMINISTRATION

Son of one of Diocletian's Caesars, Constantine had risen to the command of the legions in Britain and Gaul. Having gained the Caesarship with their backing, he defeated various rivals and, in 312, met his most powerful adversary near Rome in the Battle of the Milvian Bridge. Victory gave him the city and rule of the West. A few years later, he attacked the Eastern Augustus and defeated him. By 324 he had achieved his ambition to become sole ruler.

As such he continued many policies of Diocletian. He encouraged economic growth by protecting trade, but he raised the taxes and further enlarged the bureaucracy. In order to strengthen his sole and absolute rule, he reserved for himself command of all military forces and revised the provincial divisions, introducing still smaller units than had been instituted under Diocletian. As his seat of government, he chose a new capital, which he founded in the eastern parts of the Empire on the site of ancient Byzan-

tium. It was named Constantinople. Like Rome he had it adorned with mighty buildings and made it the center of cultural life. Soon it also became the center of economic life in the empire.

CONSTANTINE'S RELIGIOUS POLICIES

Aside from political reunification, Constantine also reversed another of Diocletian's most important policies—that toward the Christians. Diocletian had staged one of the most cruel persecutions against them. Constantine decided to win them over to his side. It would be erroneous, though, to see in his decision no more than political calculation. In an age of uncertainty, religious motives and fear of the wrath of an unknown god played perhaps as decisive a role as diplomacy. In 313, soon after the Battle of the Milvian Bridge, through the Milan Decree, Constantine granted toleration to the Christians. He subsequently restored their confiscated property, accorded them tax advantages, permitted Church jurisdiction, and even made them grants and paid them subsidies. It is unknown at what time, if at all, he himself became a Christian and was baptized.

COUNCIL OF NICAEA

Regardless of personal religious convictions, Constantine laid claim to supreme overlordship of the Church, as of every other institution in the Empire. For this reason, he presided in 325 at one of the greatest events in the history of the Christian Church: the Council of Nicaea.

Ever since a Christian dogma had been worked out, there had been "heretical" groups within the Christian community that declined to accept one or another article of faith. Among them were Ebionites, Gnostics, Manichaeans, Nestorians, and Donatists. In Constantine's time, a controversy arose over the question whether God and Christ were identical or merely similar. The two contending parties were led by Bishop Athanasius and Bishop Arius, respectively. Anxious to see unity preserved everywhere within the Empire, Constantine called a general council. Although the West was represented by only six churchmen, the old and weak bishop of Rome not being among them, some three hundred bishops and churchmen assembled. A number of questions were discussed, including the marriage of priests, the finances of the Church, and the feast days. But the main decision concerned the acceptance of Athanasius's views and the condemnation of the Arian position. Thus was established the Nicaean Creed, which has remained to this day the accepted creed of almost all branches of the Christian Church.

Final Division of the Empire

Constantine died in 337, and new struggles arose immediately upon his death. Economic and political interests as well as differences in customs, language, and attitudes increasingly alienated the Western part of the Empire, with its tradition of sternness and law, from the Eastern, where Oriental pomp

and despotism reigned. Although some emperors still succeeded in asserting their overall power, a division into an Eastern—ruled from Constantinople—and a Western—ruled from Rome—Roman Empire became final with the death of the emperor Theodosius in 395.

Economic Disintegration

In the meantime, the Empire's economic position had further disintegrated. Diocletian's reforms had borne little fruit. Price regulations had been ineffective in restoring production. Tax collection remained unsatisfactory owing to continuing corruption. Social divisions were not diminished. Nor did Diocletian's successors succeed in restoring a balanced economy. Rich landholders and bankers grew even richer in times of disaster; the middle class could not recover under the burden of heavy taxation and inflation; and the farmers and tenants continued to suffer.

Constantine contributed to worsening their situation when, in order to raise agricultural production, he promulgated laws requiring a peasant not to leave his land. Thereby a formal step in the direction of the introduction of serfdom was undertaken. Outlying provinces, weighed down by the financial demands imposed on them to alleviate the bankruptcy of the government, no longer derived benefits from being subject to a central authority. Centrifugal forces increased, as this central authority, which could not even rely any longer on the loyalty of armies, steadily weakened. Every part tried to achieve greater economic self-sufficiency. Small-scale industrial and agricultural production for local use helped not only to diminish trade but also to reduce the interchange of ideas and lessen common interests. They led to a more primitive organization of life. Towns declined and cultural achievements became fewer.

THE CULTURAL SCENE: TRIUMPH OF THE CHRISTIAN CHURCH

At the time Constantine published, in 313, his toleration edict, perhaps no more than one out of every ten inhabitants of the Roman Empire had been a Christian. By the end of the century, whether for the sake of faith or of material advantage, a vast majority belonged to the Christian Church—a church, though, which, if not subject to the state, had at least to cooperate with it. It is therefore not surprising perhaps that during the last phases of the ancient Roman Empire, most of the creative cultural forces came to center around the Christian Church. Hellenism and pagan arts, literature, rhetoric,

and law became instilled with a Christian spirit. The absorption of Neo-Platonist trends by Christian thinkers helped to increase the impact of Christian views. The Church was deprived of its official status during a brief interlude in the time of Julian the Apostate (361–363). However, Christianity soon recovered its privileged place and continued to dominate the cultural scene in the Empire.

Problems of Church Organization

With official recognition of the Christian religion and with the mass of the people turning to it, the Church was faced with the necessity of integrating millions of new members. For this purpose, additional bishoprics were founded and the training of the clergy was broadened. Moreover, since the possibilities for gaining adherents abroad were vastly enhanced, missionary activities were intensified.

But inner and outer expansion brought numerous difficulties. In an organization increasingly concerned with institutional arrangements and other worldly affairs, rivalries came to the fore. Occasionally bloodshed occurred. The Western Christian Church and the bishop of Rome—Rome being the only "apostolic see" in the West, i.e. a bishopric founded by an apostle—claimed primacy over all others. The Western Church thus became gradually alienated from the great Eastern centers of Christianity, with sees including Jerusalem, Alexandria, Antioch, Constantinople, and Ephesus. The split between the two divisions was sharpened by economic jealousies and by the conflict of opposing attitudes: the mystical leanings and asceticism of the East, implying renunciation of all pleasures of life and well-being for the sake of reaching, spiritually, a higher state, and the rationalism and emphasis on discipline in the West. Moreover, not only did the teachings of Arius, condemned at Nicea, continue to be disseminated and Arianism continue to spread, especially in the East, but also new heresies appeared.

Therefore, a second great ecumenical council was held in 381 at Constantinople. It settled some problems, successfully stemmed some pagan Oriental influences, and yielded a definitive statement on a disputed dogma concerning the provenance of the Holy Ghost. But peace was not established, and divisions within the Church organization persisted.

Christian Culture

In the face of growing tensions, or perhaps stimulated by them, a considerable number of great thinkers emerged, both in the East and West. Although most were churchmen, among those who were not was Ammianus, who served under Julian the Apostate and who wrote a history of Rome to bring Tacitus's account up to the fourth century. Among the churchmen, the most notable members belonged to the Alexandrine school of Christianity. In the preceding century, this school had become the distinguished heir of

the classical tradition in thought and literature cultivated so long in Alexandria.

SCHOLARSHIP AND ART

Among the great scholars of the fourth-century Alexandrine school were Eusebius of Caesarea, adviser to Constantine, who became famous for his interpretations of dogma and for his Church history; Gregory of Nyassa, the foe of Julian's anti-Christian, Neo-Platonic policies, who excelled as an orator and a priest; and John Chrysostom, for a while patriarch of Constantinople, likewise one of the great preachers and Bible scholars.

Early Christian art flourished alongside early Christian learning. It too continued the style of classical times, and it too used classical models for new purposes. Christian artists transformed established artistic patterns to fit the needs of Christian architecture. They adapted the Roman basilica for use in Christian worship. They followed the existing technique in the art of making mosaics and painting frescoes to represent Christian motifs and express Christian thought. They bent the realism of late pagan representations to suit their own transcendental views, and they created new symbols while using pagan designs. Their impact was such that they began to influence secular art as well. Indeed, during the fourth century were created many beautiful palaces, villas, triumphal arches, and tombs in Constantinople as well as in Rome and other cities.

MONASTICISM

The growing involvement of the Church in worldly tasks strengthened a movement that was to become one of the most important forces in the Church: monasticism. Whether it was for the sake of leading unblemished lives that people sought to retire from the rush and temptations of the world, whether they simply sought refuge from the material dangers threatening them in a state of disorder, or whether they tried to forget disappointments that had shattered their private lives, many men and women, lay people rather than regular clergy, embraced the monastic ideal. Solitary preparation for a life in the hereafter was not unknown to other religions, and the ascetic ideal had attracted Christians as early as the first century A.D. In the third century, it had inspired men such as the famous hermit St. Paul of Thebes. But it was only in the fourth century that asceticism came to full flourishing with St. Anthony (d. 356).

In order to avoid excesses, however, leaders in the Church took a stronger hand toward the end of the fourth century in regard to those who were fleeing worldly responsibilities. They demanded greater discipline among those given to the ascetic ideal and came to view the life of a monk within a monastic community as preferable to the solitary life of a hermit. St. Basil of Caesarea established definite rules for monastic life, and these have survived in the East. In the West, too, regular cloisters were erected and

eminent churchmen like St. Ambrose supervised their organization and supported their growth.

COLLAPSE OF THE EMPIRE

Despite the spread of a new faith, despite the appearance of great men of thought and action, and despite the gradual adaptation to new economic patterns, the collapse of Rome could not be prevented. It occurred finally with the breakdown of the defense system. In the East, the Persians attacked with success. The emperor Julian the Apostate, who rushed to the aid of the Eastern provinces, died during this campaign. In the North, inroads were made by the Germanic tribes. For five hundred years, attacks had been launched by them: but it was only in the fourth century A.D. that they succeeded in pushing into the heart of the Empire. Hard necessity forced them. An Asiatic tribe, known as the Huns, had crossed into Europe in 375 and invaded their territories, depriving them of their liberty and means of sustenance. Under the impact of this attack, a large Germanic tribe, the Goths, living on the northern shores of the Black Sea, had to leave their homelands. The western Goths, called the Visigoths, who had previously been allied with the Romans, therefore sought refuge within the Roman empire and, with the permission of the emperor Valens, crossed the Danube. They found a hostile reception from the local Roman authorities and fighting broke out. The Visigoths moved on, but were opposed by Roman legions commanded by the emperor Valens himself. In the Battle of Adrianople, in 378, he was defeated and killed. While the Huns pushed deep into central Europe, the Visigoths occupied Roman lands. Soon other tribes were forced to move in turn. People after people were uprooted, and finally the complexion of the entire European world was changed. What happened has later been called the "Migration of the Peoples." Rightly can this migration be considered the decisive event that ushered in a new age—the Middle Ages.

In many ways, the Roman tradition survives today. But the political unit, the empire, collapsed in the fourth century A.D. It was divided into Eastern and Western sections. The city of Rome decayed and Constantinople took the lead. The most decisive development was the recognition of the Christian faith as the state religion. With it, new forces, new concepts, and new ideals conquered Western civilization and found expression in the arts and institutions as well as in daily life.

Selected Readings

Barnes, T. *The New Empire of Diocletian and Constantine* (1982)

Birley, A. *Septimius Severus: The African Emperor* (1972)

Bowder, Diana. *The Age of Constantine and Julian* (1978)

Bowersock, G. *Julian the Apostate* (1978)

Brown, P. *Augustine of Hippo* (1967)

_____*The World of Late Antiquity: A.D. 150–750* (1971)

Burckhardt, Jacob. *The Age of Constantine the Great* (1989)

Burns, T. *A History of the Ostrogoths* (1984)

Frend, W. H. *The Rise of Christianity* (1984)

Grant, Michael. *The Climax of Rome* (1970)

Grant, R. *Augustus to Constantine: The Thrust of the Christian Movement into the World* (1970)

Kelley, J. *Jerome: His Life, Writings, and Controversies* (1975)

MacMullen, Ramsay. *Christianizing the Roman Empire* (1984)

_____*Soldier and Civilian in the Later Roman Empire* (1963)

Randers-Pehrson, J. *Barbarians and Romans: The Birth Struggle of Europe, 400–700* (1983)

Thompson, E. A. *Romans and Barbarians: The Decline of the Western Empire* (1982)

12

Barbarians, Christians, and Moslems (375 –741)

378–395 A.D. Reign of Emperor Theodosius

381 Council of Constantinople

395 Final division of Roman Empire

410 Sack of Rome by Visigoths

420 Death of St. Jerome

429–534 Vandal Kingdom in Africa

430 Death of St. Augustine

440–461 Reign of Pope Leo I, the Great

449 Angles and Saxons Settle in England

ca. 450 St. Patrick in Ireland

451 Council of Chalcaedon

Defeat of the Huns on the Catalaunian Fields

452 Invasion of Italy by the Huns

471–526 Theodoric, King of Ostrogoths

476 End of West Roman Empire

481–511 Reign of Clovis, King of Franks

486 Battle of Soissons: Franks conquer Gaul

489 Ostrogoths begin conquest of Italy

507 Visigoths in Spain

527–565 Reign of Emperor Justinian of the East Roman Empire

529 Pagan Academy of Athens closed

534 Justinian's Law Code completed

End of Vandal Kingdom in Africa

543 Death of St. Benedict

553 End of Ostrogoth Kingdom in Italy

568 Invasion of Northern Italy by Lombards

590–604 Reign of Pope Gregory the Great

610–614 Reign of Emperor Heraclius of East Rome

622 The "Hegira"; flight of Mohammed from Mecca to Medina

626 Defeat of Persians by Heraclius

632 Death of Mohammed

636 Moslems conquer Syria

Death of Isadore of Seville

638 Moslems conquer Jerusalem

643 Moslems conquer Egypt

649 Moslems conquer Cyprus

664 Synod of Whitby

687–714 Pepin of Heristal, Mayordomo of the Frankish Kings

698 Moslems seize Carthage

711 Moslems cross Gibraltar into Europe

713 End of Visigoth rule in Spain

714–741 Charles Martel, Mayordomo of Frankish Kings

717–741 Reign of Leo III, the Isaurian, in East Rome

Iconoclasm

732 Battle of Tours and Poitiers; retreat of Moslems

The Middle Ages (375–1492) were for a long time regarded as the "Dark" Ages—a thousand years of superstition and intellectual stagnation. This long era of world history was so regarded at least by the leading thinkers of the eighteenth century, the so-called Age of Enlightenment, who held the view that only in their time had the "light" of reason begun to shine again. Modern research has revealed, however, that the "darkness" that appeared to have dominated the Middle Ages should be credited to the ignorance and conceit on the part of eighteenth-century "rational" philosophers and historians rather than to any real lack of cultural contribution during the period.

As knowledge about medieval times has increased, the period of true darkness has decreased. First, a century and a half of early Renaissance (from l350 to l492) must be subtracted. Next the thirteenth century has to be eliminated, the "greatest of centuries," as J. J. Walsh has called it in a book

of the same title, followed also by the twelfth century, another "renaissance," as C. H. Haskins has shown. The period of darkness recedes further in the light of a tenth-century Ottonian and a ninth-century Carolingian cultural flowering. Finally, no more is left in darkness than the era from 375 to 800. Yet the fifth and part of the sixth centuries have also been found so full of significant events and meaningful and thought-enriching contributions to Western civilization that today, at the most, the period from 550 to 750 remains to be characterized with some justification as the "Dark" Ages. Perhaps even this period can be so termed only because of our meager knowledge or our different attitudes, not because of a lack of cultural achievement.

THE BARBARIANS

The Age of Darkness supposedly started with the disintegration of the Roman world, after barbarian Germanic tribes had attacked and overthrown the Empire. Yet no definite borderline can be drawn between the Roman and barbarian worlds. For centuries, Germans had been trained in and assimilated by the Roman Empire. By the fourth century, some had gained the highest political and military posts in Rome. Others, having adopted Roman ways, had rejoined their tribes to spread Roman customs and culture among them. Thus Rome's disintegration was in reality a slow process of fusion. The Germans brought with them ideas of freedom, human worth, individual independence, free elective government, and democratic law, ideas alien to the Oriental autocracies. They added these traditions to the cultural heritage of Rome.

Migration of the Germans

The migration of the Germanic peoples, which began around 375 and was brought on by the invasion of the Asiatic Huns, accelerated the fusion process. As the Huns advanced and devastated one region after another, tribe after tribe was put to flight and sought refuge within the confines of the Roman Empire.

THE GOTHS

The first of the migrants who pierced the Roman defenses had been the Visigoths. After defeating the emperor Valens at Adrianople in 378, they were ceded territory within the Empire's borders. They settled down but remained satisfied for a short time only. After a few decades they sought richer lands and, led by their able king Alaric, attacked Italy. The Western

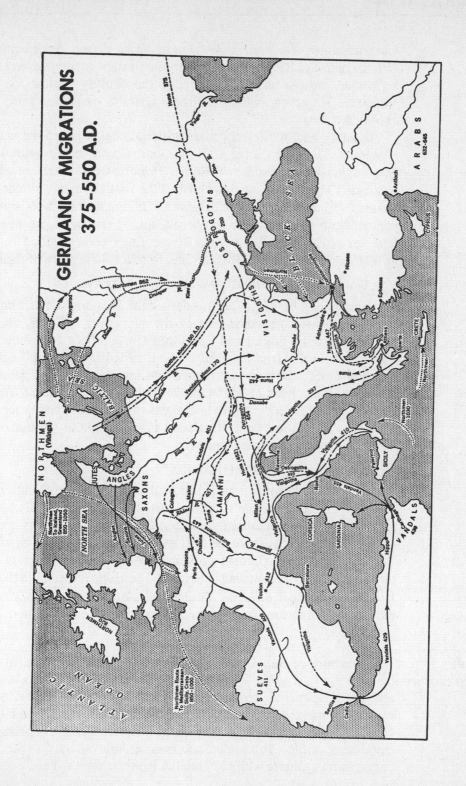

GERMANIC MIGRATIONS
375-550 A.D.

Roman Empire was at that time ruled by an inefficient emperor, Honorius. Actual control of Italy rested with Honorius's minister and adviser, Stilicho, a German, who successfully defended the country against the invading Visigoths. However, in 408 Stilicho, a victim of palace intrigues, was executed.

Disunity and inefficiency after Stilicho's death paved the way for the Visigoths. They conquered Italy, sacking Rome in the year 410. (The emperor no longer resided in Rome. Honorius had taken up his seat in Ravenna.) They might have established the first Germanic kingdom in that country if Alaric had not died. Deprived of his leadership, the Visigoths were compelled to withdraw into southern Gaul. There, in accordance with the terms of a treaty with the Western Roman Empire, they settled in Aquitaine as *foederati* (allies) of the Romans and founded a kingdom of their own.

VANDALS, BURGUNDIANS, ANGLES, AND SAXONS

Next among the Germanic invaders of the Western Roman Empire came the Vandals. Accompanied part of the way by the Suevi, the Vandals migrated through France and Spain into North Africa and settled there in 439. From North Africa they sailed into the Mediterranean, pillaging Sicily and Rome (455). Burgundians moved into southeastern Gaul (later France); Alamanni took areas of southern Germany and Switzerland. Angles and Saxons moved from the North Sea coasts into Flanders and, after subduing Celts, Picts, and Scots, into England (449). Unable to withstand their assaults, the Roman defenses crumbled.

ATTILA AND THE END OF THE HUNS

In the meantime the Huns, led by Attila, the "scourge of God," plundered and then collected tribute from the northern provinces of Eastern Rome. Having pushed through partly vacated Germanic lands, they reached the center of Gaul in 451. There their advance was finally stopped by a combined Western Roman and German army under Aetius, which defeated them in a terrible battle on the Catalaunian Fields. The Huns retreated to their base in Hungary, whence in 452 they invaded Italy. But eventually they returned to their Asiatic homeland or were assimilated by indigenous Eastern European populations.

End of the Western Empire

A century of Hun inroads and Germanic migrations brought an end to the Western Roman Empire. Deprived of much of its territory outside Italy and unable either to repel the invaders or to maintain law, order, and prosperity, the government of the Empire in the West collapsed. In 476 the German leader Odoacer put an end to all pretenses by deposing the last emperor, Romulus Augustulus, and making himself Italy's ruler. Thus the once-glorious empire with its capital at Rome ceased to exist.

The Ostrogoths

Odoacer ruled for thirteen years. But in 488, at the behest of the emperor at Constantinople, the Ostrogoths attacked Italy in order to reconquer it for Eastern Rome. The Ostrogoths, who at the time of the Hun invasion had evicted the Visigoths from their homes, had later themselves been forced to leave the Black Sea shores. In 451 they settled for a time in the Danubian and Dalmatian parts of the Eastern Empire. It was from there, led by their king Theodoric, that they invaded Italy. Odoacer had to retreat into the fortress of Ravenna, where, during negotiations, Theodoric had him assassinated.

Once victorious, the Ostrogoths established their own virtually independent rule. They were Christians, for Bishop Ulfilas (d. 383) had converted them to the Christian faith (in its Arian form) while they had lived on the South Russian steppes. They used a Bible translated into Gothic, and a manuscript of their Bible is still preserved in Upsala, Sweden.

The Germanic peoples and the Romans differed in creed, race, and tradition. Nevertheless, Theodoric, residing in Ravenna as did Honorius and Odoacer before him, built a model kingdom in Italy. He maintained law and order, displayed tolerance toward the Catholics, and protected property rights. He saw to it that Goths and Romans, each group following its own traditions, could live peacefully side by side and even intermarry. He preserved intact Rome's legal institutions, built monuments after Roman and Byzantine models, and took an interest in Roman philosophy. Towns declined, but agriculture revived. The Latin language continued in use. Theodoric encouraged trade, skilled crafts, and agriculture; and he entered into alliances with neighboring kingdoms.

The Franks

At the same time, another Romanized Germanic kingdom was being put together in Gaul. Early in the fifth century, northern Gaul had been conquered by the Franks, who had defeated a Roman army at Soissons in 486. Then, under their king Clovis (a brutal but efficient leader who died in 511), they had extended their rule over the entire country.

Clovis became a "Catholic" Christian, like most people in the Western Roman Empire, instead of adhering to the Christian ritual proposed by Bishop Arius, which was condemned by the Council of Nicea and which various Germanic tribes had adopted. He thus avoided religious tensions in the newly conquered land. He shrewdly secured political backing from the Gallic clergy. Like Theodoric, he adopted many features of the Roman administrative system. But he used his own Germanic counts (*comites*, or "companions") as advisers and military officers, and he published a code of German laws.

Since ample land was available for agriculture in Gaul, the settlement of the Franks was easier than that of the Goths in Italy. A fusion of Germanic and Roman ways of living, marked by frequent intermarriage, occurred in

Clovis's realms to a greater extent than in Ostrogothic Italy. The Roman heritage remained stronger in the south, whereas Germanic influences prevailed in the north and east.

Extinction and Survival of Germanic Kingdoms

Of all the Germanic states created within the borders of the old Roman Empire, only the Frankish kingdom was able to consolidate itself. Each of the others disappeared after a brief existence. In the course of the sixth century, the Vandals were defeated and their whole kingdom annihilated by the armies of the Eastern Roman Empire (534–553). The Ostrogothic state suffered a like fate under Theodoric's successors, who had failed to maintain the peace, prosperity, and tolerance established by the great king. After adversity and hardship had spread throughout the country, a Byzantine army, sent to reconquer Italy, attacked. After twenty years of war it defeated the Ostrogoths and drove out the survivors (555–562).

The Visigoths, expelled from southern Gaul by the Franks in 507, migrated to Spain. Though they maintained themselves there for about two centuries, their state, too, found a violent end when conquered by Moslems. Various other Germanic tribes were assimilated by native populations. The Angles and Saxons remained in isolated Britain but created no cohesive state or unit. Instead, petty kingdoms incessantly warring upon each other arose.

Only the Franks survived. As Catholics they had strong support from the Church, which they repaid with grants of land, privileges, and rights of jurisdiction. Thus, notwithstanding the incompetence and disunity of Clovis's descendants—the Merovingian Dynasty—and the political division of the land into nearly autonomous entities such as Austrasia and Neustria, the Frankish kingdom not only survived but even expanded to the east and south.

Economic and Social Life

Although the creation of a political foundation for a new Roman-Germanic civilization was in itself an event of major significance, its immediate effect on economic and social conditions was limited. With the disappearance of slavery as it had existed in Rome, social relationships changed in character. Only in a few areas was the landowning nobility replaced by Germanic conquerors. In most areas, property rights were respected, and the Roman system for the cultivation of land was preserved without change. The military system of Rome adapted itself to Germanic ways. The system of taxation was seldom disturbed, although, with the coming of the Germans, there was perhaps more emphasis on local administration of financial affairs. Most of the Roman laws were kept in force and were only gradually influenced or supplemented by Germanic laws and customs. These latter emphasized personal loyalties and kinship instead of abstract legal concepts, written codes, and courtroom procedures, such as those that had been worked out by Rome through the centuries.

Literary and Artistic Life

Literature and art of the late fourth, fifth, and sixth centuries bear witness to the strength and persistence of the Roman heritage and to the comparative weakness of early Germanic contributions. One of the most prominent writers of the age was the Roman Boethius (one-time friend of Theodoric and well versed in classical scholarship), who is most famous for his *Consolation of Philosophy*. He wrote the book in prison after falling into disgrace. Others were the historians Cassiodorus, who had also served Theodoric and who wrote on political and educational developments; the Eastern Roman Procopius, who described the Gothic wars; and Gregory of Tours, who composed his *History of the Franks*.

In addition to their philosophical interests, Boethius, Cassiodorus, and others like them pursued the study of languages. Influenced by the literary accomplishments of the Eastern Empire and the Roman Church, they translated classical literature. Some of them used classical writings as a means of promoting Christianity. They compiled Christian legends and *Lives* of saints. Poets of real merit, however, were few.

From the Eastern Empire and the Church, the West drew inspiration also in the fine arts. Many of the chief contributions in art were made in church architecture. Famous basilicas were built, their interiors adorned with beautiful mosaics, and some of the finest that survived may be seen today in Ravenna, in northern Italy.

EASTERN EMPIRE AND CHRISTIAN CHURCH

The invading barbarians left much impact, especially upon the political organization of Europe, but they were not so destructive as had been feared by those who had anxiously witnessed their coming. In many localities, old ways persisted and existing institutions were only slowly modified through a process of gradual evolution. The Byzantine Empire and the Christian Church were especially potent factors preventing too radical innovations.

The Byzantine Empire

After the final division of the Roman Empire toward the end of the fourth century, its eastern regions, in contrast to Western Rome, regained their former importance. When in 476 Odoacer deposed Romulus Augustulus in Ravenna, he did not hesitate to recognize the formal overlordship of the Eastern Roman emperor. Subsequent Germanic kings, as well as Roman bishops, followed his example. Nevertheless, despite its imperial authority, its comparative wealth, and its vigorous intellectual life, the East did not

attempt to control the West's political and cultural affairs until the reign of the emperor Justinian (d. 565). It was he who led the Byzantine Empire to new greatness. Owing to the great productive capacities of the Byzantine realms, Constantinople, with the multiracial character of its population and its broad outlook, became a center of art, artisanship, and manufacturing. Great wealth was accumulated.

With the help of his wife, the shrewd and brutal Theodora (who had been a circus actress), and that of able generals such as Belisarius and Narses, Justinian succeeded in defending the Empire's borders in the east and north. He reincorporated the African and Italian territories seized by the Vandals and Ostrogoths, respectively, and even a part of Visigothic Spain. Thus he restored that unity of the Mediterranean world that was necessary for both the vigorous expansion of trade that took place and the survival of culture. Moreover, by establishing a firm personal regime and a powerful, though burdensome, bureaucracy, and by reasserting the emperor's political authority over the Church, Justinian laid the basis for that absolute dominion of the Byzantine rulers over political and Church affairs of the East that became know as Caesaropapism.

The most lasting contributions of Justinian's age were made in the fields of art and law. The Byzantine style, heir to classical tradition and influenced by the Orient, was brought to perfection. Representative of the Byzantine style was the Christian basilica, a church building of simple, severe exterior. It consisted generally of three naves, or aisles, with the central one larger and higher, and lighted by clerestory (clear-story) windows. A vaulted, semicircular projection of the nave, an apse, was soon added to give the interior the form of the cross, and the roof was often crowned by a dome. One of the great examples of Byzantine architecture is the Church of Santa Sophia in Constantinople, built in Justinian's time.

In the decorative arts, the Byzantine style excelled through its mosaics depicting mainly religious topics. Representations usually appeared on a golden background. The human figure was realistically presented, though seldom with individualistic features. In the course of subsequent centuries, icons, ivories, enamels, miniatures, and book illustrations of unusual perfection were created in the same Byzantine style.

A code of law, the *Corpus Juris Civilis*, was created. It had been derived from collections of imperial edicts and the precedents established through the ages by jurists' opinions. This code, along with its *Digest*, became not only the foundation of Justinian's own legislation but also a basic part of modern law.

Christian Church

The fifth and sixth centuries witnessed outstanding achievements in the Christian Church. But lust for power increased, as did worldliness, intrigue, corruption, insincerity, and oppression. The by-then unchallenged position

of the Church affected the spirit within its organization. Much of the dogma had been formulated earlier and standards of scholarship had been established. Most of this was achieved by men who lived in the eastern parts of the Empire and belonged spiritually to the East. They worked out a more or less final form of the liturgy, but no definite rules about celibacy of the clergy, advocated by many, were drawn up.

In the West, the most famous thinkers and workers of the Church appeared only in the late fourth and fifth centuries. At that time, the organization of the Roman Church was perfected. Pope Leo the Great (440–461) formulated the doctrine (the Petrine doctrine) that to the Roman bishop, as successor of the Apostle Peter, belonged supreme rights and final jurisdiction within the Church. Able leadership, secular wealth, and eminent theologians supported the claim.

THE FOUR DOCTORS OF THE CHURCH

The West could take pride in Ambrose, archbishop of Milan (d. 397), called the first "doctor" of the Church and one of its foremost statesmen. He was a devoted advocate of Church rights and supremacy, as well as tolerance and Christian forgiveness, which he courageously demonstrated when in the face of the emperor himself he defended those who deviated from accepted Church teachings, so-called heretics, against imperial coercion and punishment. His contemporaries admired his vigorous sermons and his theological writings. His hymns became a permanent contribution to Church service.

Jerome (d. 420), another of the doctors of the Church, was a rather violent participant in numerous fundamental disputes on faith. He insisted on strict obedience to the teachings of the church. He himself helped to shape Church dogma. In numerous letters and other writings, he defended, propagated, and interpreted this dogma. Having studied the classical authors, his scholarship enabled him eventually to produce the Vulgate, a Latin translation of the Bible from the Hebrew and Greek, which is still in use as the basic text of the Roman Catholic Church.

The third and most famous of the Church doctors was Augustine, bishop of Hippo (d. 430), who had been a dissipated youth but had reformed to become a militant supporter of the Church, seeking its purification and expansion. He was influenced by Ambrose. Following Jerome's example, he had also become fully conversant with the works of the great pagan writers. Augustine wrote three outstanding works: the *Confessions*, the *Retractions*, and the *City of God*. In these he defended papal supremacy and therewith the right of the pope in Rome to make final decisions. He denounced heresies and warned against Nature as the temptress to sin. He described man's futile endeavors in his earthly city and his destination in the "other world," the City of God.

He was a firm proponent of monasticism. He aided missionary activities; under his influence St. Patrick went to Gaul and Ireland to convert the pagans there. The founding of monasteries in Ireland by St. Patrick initiated two centuries of cultural eminence that Ireland would never again attain.

The fourth doctor of the Church, who lived more than a hundred years later, was Gregory the Great (d. 604). Like Augustine, he was converted to Christianity during his adult years and devoted himself to the strengthening of the Catholic Church and the papacy. He started as a monk and became pope in 590. In that capacity he showed himself to be one of the most able administrators in the history of the Church. He was widely respected for his firm leadership. Like Leo the Great, he insisted on the supreme authority of the popes within the entire Christian Church.

He is famous for his piety, teachings, and writings (*Dialogues, Pastoral Care, Homilies*). He contributed to the clarification of dogma as well as to the music, compositions, and liturgy (Gregorian chant). He promoted missionary activity and the founding of hospitals and schools. It was he who sent another St. Augustine (a monk) into England and missionaries into France and Germany.

MONASTICISM

Monasticism had developed rapidly after Augustine. Its foremost representative was Benedict of Nursia (d. 543). By the sixth century, monastic life was in need of reform. Monasticism had been the pretext for a large number of men and women, including many wealthy persons, to simply enjoy a quiet, carefree life. Others had done so to gain "merit" before God by practicing extreme asceticism. Such an extreme case was that of the "pillar saint," Simeon the Stylite (ca. 450), who claimed to lead a life pleasing to Christ by sitting for many years on top of a column.

As he observed these sterile practices, Benedict became aware of their danger to Christian standards (it was easy for a hermit to succumb to worldly temptations). On the basis of earlier precedents, he introduced at his monastery of Monte Cassino a general rule for life in monastic communities. For each monk this rule prescribed celibacy, poverty, and obedience to his superior in the monastery, the abbot; prayer; and manual labor such as cultivating the land, caring for the sick, and building monasteries (*ora et labora*: Pray and work). A vow of "stability" forbade the monk ever to return to secular life. The rule spread to all parts of Christendom. Under the influence of Cassiodorus (d. 575), scholarly activities were soon added to a monk's tasks, and monasteries became the greatest cultural force. They maintained this position throughout much of the Middle Ages.

CHURCH-STATE RELATIONSHIP

During the fifth and sixth centuries, the Western Church increasingly emancipated itself from state influences. The Roman bishop steadily raised the position of his see. At the Council of Chalcaedon (451), Leo the Great had gained recognition for Rome's primacy within the whole Christian Church. Since no emperor resided in Rome, none could claim the superiority of imperial power. Neither Alaric, Clovis, nor other powerful Germanic kings could effectively interfere with the pope's functions. Only Theodoric among the Germans and only Justinian among the Eastern Roman emperors kept a measure of control over the Roman administration. But after Justinian's death, the popes, through their worldly temporal, or secular, power over the city of Rome, built a foundation on which were based their future claims for complete independence and superior position in world affairs.

THE RISE OF ISLAM

By the end of the sixth century the great Germanic migrations were over. The Lombards were the last tribe to seek new homes. Under their king Alboin, they invaded northern Italy in 568. They confined the Eastern Roman administration, which had functioned there since the expulsion of the Ostrogoths, to the so-called Exarchate of Ravenna. They established in the Po Valley a kingdom of their own, which prospered for over a hundred years. But new storms threatened the West—though from a different direction— when, with the birth of Islam, powerful new leaders and conquerors emerged in Asia.

Origins of Islam Islam, "submission to God," was the name of a new religion that originated with Mohammed (569–632). He was an Arabian who was inspired by the teachings of Persians, Jews, and Christians as well as by his own visions. He had come to profess one God and, as his prophet, to preach a life of righteousness on earth and to promise eternal bliss for the pure after death. He combined this faith with belief in a predestined fate for man, whose life and death were completely in the hands of God. His thoughts were set forth in the *Koran*, a collection of pronouncements published posthumously. The Koran requested all to love their neighbors and to be helpful and devoted; it included locally applicable rules for eating, drinking, marriage, political activity, and other aspects of social conduct.

Spread of Islam

Coming as it did at a time of renewed religious agitation, Mohammed's work was taken up with enthusiasm and devotion. It was carried on by such extremely capable disciples as Abu-Bekr, Oman, and Othman. They gained not only a religious following but also political leadership among the roaming tribes of Arabia. Then, motivated by economic forces as well as religious enthusiasm, they started on a road of conquest abroad. Moslem armies took Syria in 636, Jerusalem in 638, Mesopotamia in 640, Alexandria in Egypt in 642, Cyprus in 649; Persia and other countries followed. The Islamic faith spread rapidly as far as India and China.

The Moslems and the Eastern Roman Empire

Islam offered a serious challenge to Christian Europe. After Justinian, the Byzantine Empire had quickly lost its briefly regained strength. Internal disruptions had weakened the frontier defenses. Dangerous attacks on the empire were launched by the Mongols, Slavs, and, especially, Persians. Only in 626 had Heraclius (d. 641), a capable emperor, succeeded in stemming the Persian tide and in repelling Mongolian and Slavic assaults. But his victorious efforts had exhausted the resources of the empire; nor could he reconquer all the lost territories.

Consequently, ten years later, when the Moslems in turn launched their attack, they were able to defeat the Byzantine armies, although they were ultimately stopped before crossing into Europe. Constantinople held out, its strong strategic position and its wealth saving Europe from a new Eastern invasion. But the danger remained. Vicious, intriguing, and dissolute emperors did little to lessen it, until, in 717, Leo III (the Isaurian) came to the throne.

Leo strengthened imperial authority, augmented the ruler's autocratic, divine position, reorganized the government, and had the law codes revised. He emphasized his supreme rights even in Church affairs, challenged the position of the Roman popes, and supported the so-called iconoclastic movement, which condemned the use of religious images. His administration saw the revival of commerce, the expansion of the grain and textile trades, and the further development of the jewelry and other industries. Even though debauchery, despotism based on Oriental models, and incompetence returned with his successors, a firm basis had been laid whereby it became possible for the Byzantine Empire to resume its place as Western civilization's eastern bastion.

The Moslems and Western Europe

No such bastion existed in the West. Western Europe was divided. Italy was split in many parts. Populations in many formerly prosperous areas declined and impoverishment increased in Rome, as well as in numerous other towns. In Spain, Visigothic rule was effective in the northern and central regions, but there was no such firm control in the south. The Frankish kingdom was a battleground of competing lords and ambitious women.

Clovis's successors became known for their immaturity, inefficiency, and laziness as *rois fainéants* (do-nothing kings). Assassinations bedeviled their regimes. The early Merovingians had possessed vast resources, including gold. Their connections with Byzantium and the East had been close, and lively trade was still carried on in the Mediterranean basin. But with the conquests of the Moslems and their domination of Mediterranean trade routes, large-scale commercial activity, and with it the coining and use of money, almost ceased in Western Europe.

These economic difficulties helped to unsettle the social order and weaken the West militarily so that it was unable to stem the Moslem advance. Kings no longer enjoyed the prestige that had its roots in the traditional Germanic relationship between a leader and his followers—a relationship of trust. Nor did they possess that unlimited authority that the emperors could claim in Rome and Byzantium. They had to rely on the increasingly independent groups of nobles who gave them sustenance, advice, and support in war. But in return, these had to be accorded a role in the king's household. In most cases, they had to be given royal grants of land for their use. Though morally obligated to serve the king, they often rejected their end of the bargain.

Moslem Conquests in Africa, Spain, and France

Under the circumstances, the Moslems found little opposition when their armies reached the lands around the western Mediterranean. Advancing along the North African coast, they seized Carthage in 698. Thereafter, from nearby Tunis, they dominated not only the eastern but also the western Mediterranean sea lanes. In 711 they crossed the Straits of Gibraltar and conquered most of Spain, including Visigothic areas in the north and east. By 732, their advance forces had reached the center of France. Only then were they stopped.

Long weakened by disunity, the Franks would have been unable to offer much resistance had it not been for the fact that, in 687, Pepin of Heristal, who had been serving the Merovingian king as adviser and mayor of the palace, had assumed virtual control of the kingdom. Pepin had reunited its various parts, checked the unruliness of the independent nobles, strengthened the bonds with the Church, and regained prestige and support. Pepin's illegitimate son, Charles Martel (714–741), who had succeeded his father in the office of mayor of the palace, defeated the Mohammedans. After a battle (in the area between Tours and Poitiers in the year 732) in which the reorganized forces of the Franks, making effective use of their newly built-up cavalry, demonstrated their power, the Moslems retreated to the Pyrenees.

Soon thereafter the united stand of the Moslem realms was abandoned as competing rulers established independent regimes in Spain, Egypt, and Mesopotamia. Thus the danger to Europe passed.

Cultural Decline in the West

During the period when the East witnessed the regeneration of political and religious life connected with the rise and conquests of Islam and the flourishing of Byzantine culture, the Western world showed few lasting cultural achievements. Isidore of Seville's (d. 636) survey of the sciences and ethics of his age was an outstanding achievement of that era. Yet it can serve also as evidence of the remarkably low level of the contemporary state of knowledge.

Some more significant contributions to Western civilization were made in religious thought and art. Irish monasteries and monastic schools flourished. The production of copies and translations of early Christian writings, often beautifully illuminated, raised the level of Christian scholarship. Inspiration flowed from Ireland to England, where Canterbury and Jarrow became notable centers of learning. A gifted writer emerged in the person of Bede (d. 735), who wrote numerous religious works, of which the best known is his *Ecclesiastical History of the English People*. The Irish and the English carried on a brisk missionary activity, during the course of which Winfred (St. Boniface) became famous as apostle of the Germans in Thuringia and Bavaria. (He was martyred in 754.) But not until the age of Charles Martel's successors did intellectual endeavors spread broadly and begin to reflect a genuine revival of civilization in the West.

Western civilization in the Middle Ages was built on three pillars: the classical, the Christian, and the Germanic heritage. A fourth factor was the Moslem world, after the conquest of North Africa and Spain had brought closer ties with the West. The classical age left a powerful, permanent imprint on all areas of thought, philosophy, art, language, communications, and law. Christianity replaced abandoned beliefs, satisfied the profound metaphysical longings of the age, gave hope to the poor, and constituted a creative power in the political, social, and cultural spheres. Germans contributed a new vigor to an old civilization and instilled fresh concepts of honor, loyalty, and freedom, which set limits on the powers of kings and emperors and discredited the concept of human slavery. The Mohammedans, with their own religious fervor, represented a challenge. They effected a change in economic patterns prevailing in the Western world, brought knowledge of new products, and enriched Western civilization through their medical advances, technical skills, and learning. Under the impact of these forces, Western civilization came to encompass, far beyond the Mediterranean region, all of Europe.

Selected Readings

Campbell, J. *The Anglo-Saxons* (1982)

Gabrieli, F. *Muhammed and the Conquests of Islam* (1968)

Hillgarth, J. N. *The Conversion of Western Europe, 350–750* (1986)

Jones, Tom B. *In the Twilight of Antiquity* (1980)

Knowles, David. *The Evolution of Medieval Thought* (1964)

Morey, Charles. *Early Christian Art* (1955)

Musset, L. *The Germanic Invasions: The Making of Europe,* A.D. *400–600* (1978)

Ostrogorsky, G. *The History of the Byzantine State* (1968)

Richards, J. M. *The Popes and the Papacy in the Early Middle Ages, 476–752* (1979)

Talbot Rice, D. *The Dark Ages:The Making of European Civilization* (1965)

Tierney, Brian, and Sidney Painter. *Western Europe in the Middle Ages, 300–1475* (1978)

Wallace-Hadrill, J. M. *The Barbarian West* (1967)

13

The Early Feudal Age (741–1000)

751	Pepin the Short becomes King of the Franks
754	Donation of Pepin (Papal States)
768–814	Reign of Charlemagne
774	Conquest of Langobard Kingdom by Charlemagne
775–815	Expansion of Carolingian Empire into Bavaria, Saxony
795–816	Reign of Pope Leo III
800	Charlemagne crowned Emperor
809	Death of Harun-al-Rashid (Baghdad)
825–870	Viking invasions of Ireland and England
827	Moslems establish themselves in Sicily
843	Treaty of Verdun; division of Carolingian Empire
845	Vikings attack Frankish Kingdom
858–886	Patriarchate of Photius in Constantinople
862	Vikings (Northmen) in Russia; Rurik in Novgorod
ca. 862	Introduction of Christianity among Slavs (St. Cyril and Methodius)
870	Treaty of Mersen; Charlemagne's Empire redivided
871–899	Reign of Alfred the Great in England
885	Vikings at the gates of Paris
906	Magyar invasion of Central Europe
910	Founding of Cluny Monastery
911	Viking rule of Normandy (Duke Rollo)
919–936	Reign of Henry I (of Saxony) in Germany
936–973	Reign of Otto the Great in Germany

The period from 375 to 741, described in the preceding chapter, is considered by some historians as a part of ancient times. Thus the Belgian historian Pirenne has suggested that the Middle Ages did not "begin" until the eighth century. Contemporary students of history may accept Pirenne's suggestion, or they may prefer to date the start of the Middle Ages as early as 375. They may choose another intermediate date, such as the year 476, which is often used, since it marks the end of the Western Roman Empire. In any case, Pirenne has correctly pointed out that during the period from 375 to about the middle of the eighth century Roman imperial concepts, classical scholarship, the spirit of early Christianity, and especially the commercial organization of the Roman Empire still prevailed widely. It may also be held that the new epoch in history began with the rise of Islam and Arab dominance in the eastern Mediterranean, rather than with the organization of the Germanic successor states on the soil of the old Roman Empire. By the time of the advance of Islam and the Arabs, however, the world of the Middle Ages had clearly emerged.

FORMATION OF THE CAROLINGIAN EMPIRE

The region in which ancient cultural institutions had flourished differed geographically from that in which medieval culture was to blossom. The medieval world included central and northern European territories far beyond the limits of the Roman Empire, but it did not comprise many of Rome's eastern and non-European possessions. This new world—"The West"—was not organized as a unit ruled from a center like Rome, even though the Church formed a universal link. Nor was it dominated by the

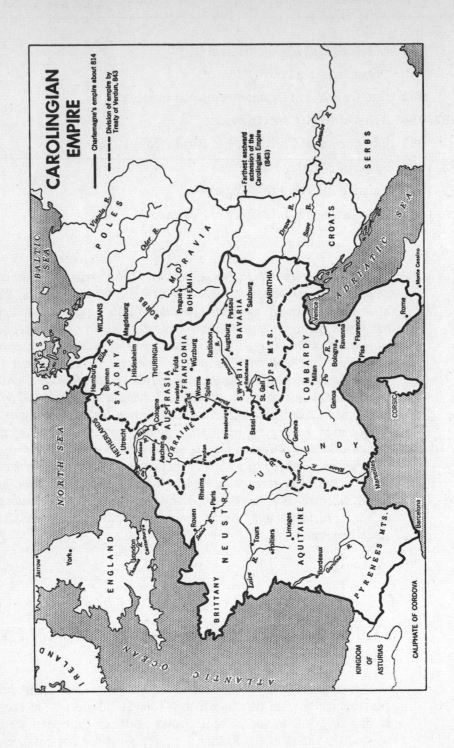

CAROLINGIAN EMPIRE

——— Charlemagne's empire about 814

━ ━ ━ Division of empire by
Treaty of Verdun, 843

Farthest eastward
extension of the
Carolingian Empire
(843)

IRELAND

ATLANTIC OCEAN

NORTH SEA

BALTIC SEA

DANES

ENGLAND

Jarrow•

York•

London•
Canterbury•
Thames R.

NETHERLANDS

Utrecht•

BRITTANY

NEUSTRIA

Rouen•
Seine R.
Paris•
Rheims•
Tours•
Loire R.
Poitiers•
Limoges•

AQUITAINE

Bordeaux•
Garonne R.

PYRENEES MTS.

KINGDOM
OF
ASTURIAS

Barcelona•

CALIPHATE OF CORDOVA

WILZIANS

Hamburg•
Bremen•
Elbe R.
Hildesheim•
Magdeburg•

SAXONY

THURINGIA

Cologne•

AUSTRASIA

Aachen⊙
Maas R.
Verdun•
Meuse R.
Metz•

LORRAINE

Rhine R.
Frankfort•
Fulda•
Worms•
Spires•

FRANCONIA
Würzburg•

Strassbourg•

Basel•

B U R G U N D Y

Lyons•
Geneva•
Rhône R.

Marseilles•

POLES

Vistula R.

Oder R.

SORBS

MORAVIA

Prague•
BOHEMIA

Ratisbon•
Danube R.
Augsburg•
SWABIA
St. Gall•

ALPS MTS.

BAVARIA
Passau•
Salzburg•

CARINTHIA

Drave R.

Save R.

CROATS

Danube R.

SERBS

ADRIATIC SEA

Venice•

LOMBARDY

Milan•
Po R.
Genoa•
Bologna•
Pisa•
Ravenna•
Florence•

CORSICA

Rome•

Monte Cassino•

imperial idea, revived first by Charlemagne in 800 and again by Otto the Great in 962. Instead, the new world was based on local, territorial units, which slowly amalgamated to form larger political entities or nations. Most of the peoples showed some Germanic traits and ways of life. These were modified by Christian views and standards and by Roman legal and cultural tradition.

"Feudal" institutions flourished. They were not founded on despotic rule, circumscribed law, or economic power derived from extensive capitalistic undertakings. Instead, they were based on the vague authority of the heads of Christianity (the German emperor and the Roman pope), on the leadership of numerous kings and dukes, on a great variety of local legal customs, on honor as the link between ruler and follower, and on land as the basis of wealth and social status.

The Carolingians

After the death of Charles Martel, his son Pepin the Short became mayor of the palace. He put an end to the Merovingian Dynasty and had himself anointed king by St. Boniface, who acted in the name of the pope. Pepin thus established the so-called Carolingian Dynasty. His rule emancipated the Frankish kingdom from the old Roman system of government and marked the triumph of northern (Germanic) ways.

REIGN OF PEPIN

Pepin's main objective was to reestablish royal prestige and power. For this purpose he chose the Church as his ally. Profiting from religious and political rivalries that strained the relations between the pope and the Eastern Roman Empire and forcing the pope to seek Pepin's support, he followed a policy of close cooperation with the Church. By means of the so-called Donation of Pepin, he ceded to the pope the Exarchate of Ravenna, which he had conquered from the Lombards after the latter had driven out the last remnants of the Byzantine garrisons. In exchange, he secured through the pope not only the support of the Frankish clergy (which he was then able to use to counterbalance the influence of the Frankish nobility), but also far-reaching control of the clergy itself.

Under Pepin, all classes had to make regular contributions to the military and administrative service. The borders of the Frankish kingdom were extended into the Lowlands, Lombardy, and the Pyrenees.

CHARLEMAGNE

Pepin's son, known to history as Charlemagne (768–814), continued his father's policies. A towering figure in history, an energetic leader, a wise politician, a clear-minded and enterprising though brutal and dissolute ruler, he reestablished a western empire.

External Policies. Charlemagne put an end to the Lombard kingdom and made himself its ruler, expanding it far into Italy. He fended off the Avars (another Eastern invader) and gained control of Bavaria and the area that would later become Austria. He fought the Moslems beyond the Pyrenees, where he conquered Barcelona. After long and bloody wars he extended his realms deep into northern Germany by defeating the Saxons under Vidukind, then converting them or killing them off. Along the Elbe River and elsewhere, he next established *marches* (frontier districts) under special *margraves*. They were his local administrators and responsible directly to him. He maintained peaceful contacts with the Eastern Moslem world and arranged for embassies and the exchange of gifts with the famous caliph Haroun al Raschid (d. 809) in Baghdad, at whose court the sciences and arts flourished. Similar relationships were developed with the Byzantine Empire.

Relations with the Church. In 800, Charlemagne was crowned emperor by Pope Leo III—a new dignity for the Frankish king, who eventually succeeded in having his new position recognized even by the Byzantine emperors. The act of coronation inaugurated, or at least implied, a dubious relationship between emperor and pope. Later popes derived from this act a claim to spiritual superiority over future emperors, whereas Charlemagne's successors derived from their imperial position the emperor's traditional claim to sovereignty in Church as well as worldly affairs. This question of imperial-papal relations was to remain a key political issue throughout the entire medieval period. In Charlemagne's time, owing to the strength of his personality and the low state of the papacy, there was no doubt as to the emperor's final authority.

Internal Policies. In internal affairs, Charlemagne continued the policies of his father. He autocratically supervised the Church in the Frankish kingdom, appointed bishops and abbots, and endowed the Church with lands. He used the clergy and its missionary work, especially in Germany, as instruments in the extension of his political authority. He held the nobles in line but often called upon them, as well as upon the clergy, for advice in connection with state policy. He dispensed justice with a firm hand, even though he did not act as lawgiver—aside from issuing edicts (*capitularies*) for specific purposes. General laws were based primarily upon the traditions of each locality.

His domains were carefully administered. He appointed counts and margraves to govern the various parts of his realms, designated members of his household as civil servants, and often sent royal messengers or *missi* (in pairs, consisting of one layman and one clergyman) to supervise the execution of the laws. They had to report to him both orally and in writing about conditions in his lands.

Charlemagne reorganized the military forces, obtaining recruits through the service of all free men in his realms. Like his grandfather, he devoted special attention to the cavalry. He chose Aachen, in Germany, as the site of his chief residence. At his palace there he arranged for the organization of schools to supplement the educational institutions administered by the Church.

In contrast with these achievements, however, there was little progress in commerce and finance. An economy based on agriculture and designed to meet primarily immediate everyday needs of each locality was a principal obstacle. Money remained scarce. The silver coins that were minted had merely local, temporary value. No central tax and treasury system could be introduced. Without adequate sources of income from taxes, even so powerful a ruler as Charlemagne had to obtain necessary funds mainly from the income of his own domains and to seek to supplement it by a few traditional general levies, such as highway tolls.

DIVISION OF CHARLEMAGNE'S EMPIRE

Charlemagne's personality left an indelible stamp on future generations, but his empire failed to survive. It was divided among his three grandsons. In the treaty of Verdun (843) they split it into three segments: (1) the region comprising central and northern France and extending eastward to about the Meuse River; (2) the region comprising most of central and southern Germany from the Rhine eastward; and (3) the intermediate region, stretching northward into the Netherlands and southward into Italy.

Upon the death of the eldest of the grandsons, a new treaty was drawn up (at Mersen, in 870) whereby his lands, consisting of the intermediate strip, were divided between the two surviving brothers. These treaties were of fundamental importance, for modern France and Germany, with their differing languages and diverging customs, evolved from them. The center region, partitioned at Mersen, has remained subject to influences from both sides and constituted for a long time an object of strife between the Germans and the French.

The Carolingian Renaissance

More lasting than Charlemagne's political work was the impact of learning and the arts in his time. In monasteries and palace schools, during the Carolingian renaissance, classical texts were once more studied, theological problems pondered, books collected, and manuscripts copied. This work was aided greatly by the development of a minuscule handwriting, which made possible a new, faster, and more legible method of writing. Beautiful books and psalters—manuscripts containing collections of psalms—created in monastic centers such as St. Gall, Rheims, and Fulda, were illuminated and illustrated with delicate paintings and exquisite miniatures. Many have been preserved to this day.

The direction of the interests of the Carolingian scholars may account for a certain lack of originality, yet there was enormous progress in the intellectual life compared with preceding periods. This progress extended also the field of education. The curriculum of the seven arts—the *trivium*, comprising grammar, rhetoric, and logic; and the *quadrivium*, consisting of arithmetic, geometry, astronomy, and music—found its first practical application. New patterns of instruction emerged, even though the traditional idea of strict disciplinary training of mind and body (including the practice of systematic floggings) remained an integral part of the medieval educational method.

Scholarship was highly prized. Among the Christian scholars, teachers, and writers at Charlemagne's court were Paul the Deacon, who composed a *History of the Lombards*, and Walafrid Strabo, who wrote theological commentaries. Alcuin (d. 804) contributed, among other theological works, to an improved version of the Bible, and Einhard (d. 840) composed a *Life of Charlemagne*.

Under the influence of the Byzantine style, architecture, painting, and handicrafts improved. Remarkable churches were erected in Italy, western Germany, and southern France. In the Rhineland and Lorraine, splendid gold, silver, ivory, and enamel works were created. Soon the Carolingian revival had repercussions in many parts of the Western world. Carolingian schools and arts and crafts were widely imitated, and they stimulated cultural advances in Anglo-Saxon regions, from which they had once drawn inspiration. The scholarly contributions of Johannes Scotus Erigena (ca. 850) are an example of the cultural progress achieved since the time of Isidore of Seville. They foreshadowed in some respects the major trends of theology and philosophy in the twelfth century.

VIKING INVASIONS AND THE REORGANIZATION OF EUROPE

During the ninth and tenth centuries, new invasions endangered the cultural progress of the West. The assaults came from all sides. From the south, Moslems began the conquest of Sicily (in 827) and a few years later plundered Rome. From the east, a new power, the Magyars, had arisen and begun to threaten the West. Most important, from Scandinavia in the north, a new great Germanic migration started, that of the Northmen or Vikings.

The Vikings

Hardy, bold, and restless, the pagan Vikings or Northmen (Norsemen) excelled as seafarers, traders, and warriors. Their pillaging expeditions, primarily along the coasts of the British Isles and Ireland, the Netherlands, France, Spain, and North Africa, extended as far as the shores of Greenland and America, and eastward into the lands of the Baltic, Finnish, and Slavic peoples. Since no defenses against seaborne invasions had been set up anywhere, the Vikings swept forward without difficulty. They sailed rivers into the interior of each region. Crossing Poland and Russia via the Vistula, Duna, Dnieper, and Volga rivers, they reached the Black and Caspian seas. Crossing the Frankish kingdom via the Seine and Meuse rivers, they reached as far as Burgundy.

They plundered and destroyed everything in sight but eventually were tamed and absorbed by the higher civilizations with which they came into contact. Settling on lands ceded to them by the defeated peoples, they were soon converted to Christianity and fused with the native populations. In this way they—later called Normans—settled in Normandy (911), within feudal France; in Anglo-Saxon England north of the Thames (870); and in Russia (862). Under the leadership of Rurik and his associates, they founded the first Russian state in recorded history.

France

Wherever the Vikings settled, they changed the political institutions of the country. In France, Charlemagne's successors were unable to drive them out, nor could they insure the safety of their realms by paying tribute. The Vikings occupied extensive areas far beyond the borders of Normandy. Their presence strengthened the tendencies toward feudal decentralization. The king's government was weakened and thus the nobles saw a chance for challenging royal prerogatives. Seeking the widest autonomy, they did not even hesitate to engage, upon occasion, the support of the Viking enemy.

In vain did the kings try to counter their efforts by buying the services of some of the nobles with the help of gifts of royal land (*demesne*) and then playing these nobles against others. The surrender of royal lands only served to diminish still further the strength of central authority. Dissolution of the realm resulted, and differences between northern and southern France in language, tradition, and law were accentuated.

Trade and commerce again declined, individuals grew more and more insecure, and living standards remained at a low level. The fine arts and scholarship deteriorated.

Only toward the end of the tenth century was a new period ushered in when the last of the inefficient Carolingian rulers was replaced as king of France by Hugh Capet (d. 996), count of Paris. Hugh initiated the Capetian line of kings. He stopped the alienation of royal lands and introduced a measure of stability in government by establishing the tradition of primogeniture—i.e., the automatic right of the firstborn to inherit the lands

and position of his father instead of seeing the property divided among himself and his brothers.

This procedure of inheritance eliminated the weakening effect that the nobles could often exercise by making recognition of a dead king's successor dependent upon his granting them broader privileges once in power. But even under Hugh Capet, effective royal authority remained limited to his own domains around Paris. Feudalism, with its politically divisive and economically retarding influences, reached its full development.

England

In England, the effect of the Viking invasions under Danish leadership proved more disruptive than in France. Despite its Christianization, the island had not become politically united. Indeed, Christianization had at first caused additional differences between the eastern (Anglo-Saxon) and the western (predominantly Celtic) parts. These differences had not been settled until 664, when a Church assembly, a synod, in Whitby established standards acceptable to both.

But even then, political integration had not made much progress. Not until the ninth century brought closer commercial and religious connections with the continent was a strong regime created. This was accomplished by the Saxon king Alfred the Great (d. 899), who succeeded in asserting his authority over the major part of the country and provided leadership for its cultural progress. His work had, however, no lasting effect. When the Northmen invaded the country, its newly gained unity was shattered. After Alfred's death the Danes obtained control over most of central England north of the Thames. To be sure, some of the Danish possessions (the Danelaw) were reconquered by the Anglo-Saxons in the middle of the tenth century and royal control over the local nobility was restored. But this did not bring stable government. Shortly after the year 1000 the Danes, strengthened by reinforcements from their homeland, regained the initiative, and the struggle for power was resumed.

Spain

In Spain, too, the Norse invasions impeded Western civilization. Viking assaults put a stop to the progress of the Christians in their continued efforts to expel the Moslems from the peninsula. By 834, the Christians had nearly reached the center of Spain, had taken Burgos, and had begun the process of organizing monarchies based upon Western concepts. But the invasions compelled them to concentrate upon self-defense and prevented the recovery of further territories.

Russia

As in the west, so in the east, the Northmen shattered the old regimes and thus necessitated the creation of new political systems. Tribes with different racial backgrounds inhabited the plains and forests of what was later to become Russia. Their political institutions were primitive; they were often the prey of invaders from the north or east: The Goths, Huns, Avars,

Norwegians, and Swedes had invaded the country. In the seventh and eighth centuries the Norwegians and Swedes had settled along the great waterway of the Volga and begun trading with the Moslems.

After the middle of the ninth century, Christianity infiltrated from the south as a result of the activities of St. Cyril and Methodius, the "apostles of the Slavs," who had devised an alphabet for the Slavic language. From that time on, cultural relations, particularly those with the Byzantines, supplemented commercial relations with the Scandinavians and Moslems. But a Russian state, properly speaking, seems not to have come into being until the Northmen, under Rurik, arrived in Novgorod in 862. They established their political sway along the great trade route connecting the Baltic and the Black seas by way of the Dnieper River. Soon Kiev became its capital. By 988, one of the Norse rulers, Vladimir I, had accepted the Christian faith and enforced it throughout his realms.

Central Eastern Europe

During the tenth century, in addition to Russia, certain other Christian nations were formed in eastern Europe. Poland, inhabited by Slavs and centering around the upper Vistula, emerged as a state under Miesco I. Hungary, where remnants of various eastern invaders (including the Huns and Magyars) had mixed with indigenous populations, also achieved statehood.

The German Empire

While the regions in the east and west of Europe were being transformed by the Norse invasions, the central area of the continent remained largely untouched by them. In Germany and Italy, the two main forces of the Middle Ages—empire and papacy—evolved.

RENEWAL OF THE EMPIRE

In Germany, the last Carolingian rulers proved to be as weak as those of France. They could hardly hold their own in wars against the nobles and clergy, who ruled powerful duchies such as Saxony, Franconia, and Swabia or large bishoprics such as Mainz and Cologne. But in Germany, even earlier than in France, the dynasty died out. The great lords, following an old Germanic tradition, elected a new king from their midst. This elective system has remained in force throughout time. They chose Henry the Fowler (919–936), duke of Saxony, whose family was destined to retain the crown for a hundred years.

Henry I brought new authority and dignity to the royal office. He achieved peace at home, continued the work of eastern colonization, and successfully defended the German frontiers. He left a well-ordered kingdom to his son Otto the Great (936–973), who became one of the great rulers of the nation.

In 962 Otto, taking Charlemagne as his model, had himself crowned emperor. He reinstituted the "Roman Empire," or, as it later came to be called, the "Holy Roman Empire." Thenceforth, for almost a thousand years, the office of emperor remained in the hands of German kings. The desire to maintain the empire may have diverted their attention from domestic affairs and national interests for the sake of international and imperial aims. As emperors, Otto and his successors were drawn into a preoccupation with Italian policies and problems. Yet the concept of an imperial authority (as a worldly sword) corresponded with the spiritual authority of the papacy. Such a world view was in harmony with the religious feelings of the age and reflected the climate of political opinion. Moreover, the close relationship between Germany and Italy immensely nourished the cultural life of both areas and contributed to some of the outstanding achievements of Western civilization.

NATIONAL AFFAIRS

Otto the Great continued Charlemagne's work in other respects as well. He expanded his territories eastward, spreading Western Christian civilization and at the same time protecting Europe from new assaults by Oriental invaders. In the decisive Battle on the Lechfeld, in 955, he defeated the Magyars, who had plagued Germany with their attacks since the times of Charlemagne. He occupied Bohemia and extended his realms southward along the Rhone Valley. He maintained close relationships with the Byzantine Empire, even to the extent of arranging for his son and successor, Otto II, to marry a Byzantine princess.

At the same time, in domestic affairs, he concentrated on building up the military and economic power of his hereditary duchy of Saxony, thus increasing the resources at his command and making it possible for him to suppress numerous rebellions. He then redistributed the conquered lands, assigning many of them to relatives or to loyal princes of the Church. The supervision of the Empire he entrusted to officials (counts, margraves, and *missi*, as in the court of Charlemagne) appointed by himself. He retained control over the papacy (even deposing two of the popes), enforced reforms in the Church, and firmly supervised all ecclesiastical affairs in Germany. Cultural endeavors were encouraged, and thus the Carolingian renaissance was followed by an Ottonian renaissance. Like Charlemagne, Otto the Great sponsored schools and promoted learning and scholarship. Beautiful manuscripts, jewelry, and book illustrations (reflecting the influence, as in earlier times, of Byzantine models) were produced by craftsmen in the Rhenish regions and in southern Germany.

The Church

During the period that saw the rebirth of the Empire and the restoration of its prestige, disorganization was prevalent in the Church. During the tenth century the Church exercised an all-pervasive influence on daily life, doing

much to shape the education and culture of the time. But in many regions, lack of discipline, of devotion, and of piety interfered with the fulfillment of its tasks. Among the higher clergy were many who primarily sought possession of land, economic power, and jurisdictional rights. Churches and church endowments were often handed over, as if they were fiefs and feudal rights, to laymen from the nobility. These used them for ends that contradicted the proper ones of the Church. Monasteries again served as places of refuge where the wealthy lived in luxury and idleness, instead of seeking salvation. It was in the face of such trends that, in the course of the century, a reform movement started within the ranks of the Church. It became known as the Cluniac reform movement.

WEAKNESSES IN CHURCH ORGANIZATION

The decline in the affairs of the Church had manifold roots. Wealth corrupted the morals of many of its servants. Popes and bishops paid more attention to political than to spiritual duties. Simony—the purchase of clerical offices—affected the choices of many high-ranking officials. Moreover, noble birth opened the way to such positions as bishop and abbot, which could provide land, wealth, and prestige to those younger sons of the nobility who could not secure a fief.

Intrigues among the nobility in Rome and at the Curia—the administrative body of the Church—made good government in the Church impossible. Finances remained in constant disorder. The tithes, consisting of a tenth of the income of the common people and originally intended for the maintenance of the Church, were generally collected by the landed nobility, who financed religious activities in their own territories and paid something to the bishop but then kept the balance for themselves. Clergymen resorted to such means of bolstering Church power as forging documents (e.g., the Donation of Constantine and the False Decretals), that purported to justify the popes' worldly authority in Rome and their dominion over all Church affairs and appointments. Popes enforced their worldly authority by threat of excommunication and other religious penalties.

Moreover, the status of the Church was endangered by a rift between the Western and the Eastern hierarchy. It had begun in the course of the seventh and eighth centuries over the question of religious images, which the iconoclasts wished to see banned. The rift had come to a first climax in the ninth century, when the Eastern Roman Emperor Basil I (867–886) and his powerful patriarch, Photius of Constantinople, sought to bring about complete independence of Constantinople from the popes. Although this rift was temporarily healed after the death of Photius, tension persisted.

REFORM MOVEMENT

Christian devotion lived on, however, in spite of worldliness. It lived on in the hearts and deeds of innumerable individuals; thus a mighty reform movement grew. This reform movement centered around the cloister of Cluny, which was founded in 910 and which established daughter houses in many regions.

The Cluniac monks, led by devoted abbots, adhered strictly to the rule established by Benedict. They sought to purify the morals of churchmen and to improve the conduct of ecclesiastical affairs. In this they were aided by the emperors and a number of lesser princes, who, out of conviction as well as for political reasons, favored reform. Notably Otto the Great's grandson, Otto III (d. 1002), who made his distinguished teacher Gerbert of Rheims pope (Sylvester II), led the way to a revival of a true Christian spirit. Inspired perhaps by the Caesaropapism in his mother's native Byzantium, he tried to conduct his imperial office in this spirit. Thus, owing to the efforts of practical-minded leaders and the influence of Cluny, a spiritual revival eventually occurred that brought the Church, during subsequent centuries, to the peak of its power.

Europe in 1000

By the beginning of the second millennium, Europe appeared to be quite different from what it had been in the age of Charlemagne. The Church was making progress toward reform and new prestige. Monasteries as well as palace and cathedral schools provided centers for study, where Latin served as the common language. Chronicles were composed there, the main source for our present-day knowledge of events, social conditions, climate, famines, and epidemics. A spirit of otherworldliness permeated thought and written works, distinguishing Western medieval civilization from that of both classical and modern times. States that were to become the nations of the modern world (France, Spain, Germany, England, the Scandinavian countries, Russia, Poland, and Hungary) began to emerge. European civilization was no longer on the defensive but at the beginning of an age of expansion. The foundations for a great intellectual and artistic development had been laid.

Political conditions were gaining in stability, population was increasing, and commerce was being revived. Economic activities were coming to embrace manifold industrial pursuits and no longer centered almost exclusively in agriculture. Craftsmanship was improving, and industries, such as those making textiles, armor, cloisonné (enamel work), and silver and gold vessels, were expanding. New iron, silver, and salt mines were opened, and their products were efficiently processed. The tenth century witnessed the rise of Italian towns such as Milan, Venice, Genoa, and Pisa. North of the Alps, German and French towns such as Cologne, Mainz, Verdun, and Lyons gained in importance.

FEUDALISM

Feudalism as a form of social organization reached maturity in the ninth and tenth centuries. It is not unknown to other civilizations at a certain stage of their economic evolution. In the West, it assumed a special form as a political system built on an economy involving land tenure and personal service. Some of its roots can be traced to late Roman times, when slaves were gradually acquiring a new status as tenants. Other roots can be traced to the times of the great migrations when peasants, in order to achieve security, offered their personal services to a lord who would defend them.

Certain characteristics of feudalism derived from Germanic traditions, as, for example, the custom of German kings, lords, or lesser nobles of taking into their households and supporting a number of friends who were obligated to serve them loyally in the government and in time of war. In this way a type of social organization emerged wherein one segment of the population assumed responsibility for government and military defense against external enemies, while the other segment provided a livelihood for all by tilling the soil.

Feudal "Pyramid"

As time went on, the social organization, by which the various parts of society were interconnected, each with its own rights and duties (*feudal nexus*), developed in such a way that it resembled a pyramidal structure. At the top was the king and below him, as *vassals* and *subvassals*, were the nobles (including the dukes, counts, barons, and knights). The base consisted of the peasants, who made up perhaps 90 percent of the population. Inasmuch as a rigid hierarchical pyramid never developed, however, transition from one step of the pyramid to another was not uncommon.

The system allowed numerous exceptions for reasons of tradition, geography, fortuitous circumstances, and economic necessity. Yet as a rule, every person had specific work to do in conformity with the class (or estate) into which he or she was born. Since all were responsible only to the one immediately above them in the pyramid, with whom a personal direct relationship connected them, general allegiance to the person at the top of the pyramid, to the "government" or the "nation," did not develop. Nor could rulers dispose directly of the services of vassals (or peasants serving their own vassals), except within narrow, customary, or specified bounds. In the case of the nobility, this personal relationship was strengthened by an oath of fidelity.

VASSALS

The duties of the nobles (the vassals) were many. Vassals were obligated to serve their overlords for a specified time during the year; to help in case of war (e.g., to be on hand, fully armed, mounted, and accompanied by a stipulated number of men); to make certain payments upon special occasions (e.g., by presenting gifts on certain feast days); to give counsel when called upon; to act as judge; and to offer hospitality to their overlords and court for a given period each year. In exchange, vassals were given land, a *benefice* (later, a *fief*), which could be held in trust, if not by virtue of property rights. From about the tenth century on, vassals could leave their land to their sons—generally the firstborn. But the heir had to assume the duties connected with the possession of the fief. If a family died out, the land *escheated* (reverted) to the overlord, who would either keep it or entrust it to another vassal as a reward for services.

The obligations of the vassals to their overlords—and ever since the time of Charles Martel, military duties constituted the predominant obligation—were regulated by some kind of personal contract, which presupposed reciprocity. Personal and territorial rights were interwoven, for the use of land and the performance of service could not be separated. Often a vassal would hold lands or fiefs from several overlords, in which case he would owe service to each. Conflicting duties, especially in times of war among the lords, became so burdensome that ultimately the concept of a *liege lord* developed, to whom primary service and allegiance were due.

As a whole, mutual relationships rested upon a feeling of honor, which derived from the early Germanic leader-companion relationship, and emphasized rituals, such as performing homage, by which a man acknowledged himself a vassal of a lord; swearing fealty, which meant faithfully serving his lord; and being knighted. Not to live up to one's duties as a vassal was considered a disloyal act. Inasmuch as the whole system was based on personal relationships and mutual trust, disloyalty constituted the greatest dishonor. It was punished by forfeiture of the vassal's fief to his lord.

Nevertheless, disloyalty was common. Kings and other overlords consistently increased their economic demands and attempted to enlarge their judicial and military rights. Vassals tried to gain privileges and immunities —exemptions from certain duties and taxes—and to reduce the number of their obligations. Vassals especially desired lands (known as *alodial* lands) that they could fully own and control in their own right, free and clear of the service obligations usually involved in the use of feudal lands.

PEASANTS

Just as the estate of the noblemen had its rights and duties, so had the estate of the peasants. They did not own the soil they tilled, nor could they sell it, any more than a vassal could sell his fief. But they enjoyed perpetual

use of the land. Likewise they had a right to use common woods for fuel and building materials, pastures for their cows, oxen, sheep, and horses, and streams for fishing. They generally collectively worked the land belonging to a fief. A share of the harvest had to be surrendered to the lord, who was also entitled to a share of the working time of each peasant so that his own lands (his demesne) would be cultivated and so that roads and bridges would be kept in passable condition. On rare occasions, instead of contributing their personal services (*corvée*), the peasants were allowed to make payments in money or goods.

Furthermore, the peasants or their wives had to help in the lord's household as servants and artisans, spinning and weaving, and as musicians and painters, and to accompany him in military campaigns. They had to pay various kinds of fees whenever certain events occurred (e.g., a marriage or death in the lord's castle or the peasant's household). The total burden imposed on a peasant varied with geographic conditions, fertility of the soil, regional customs, and the personal character of his lord. Generally, the lot of average peasants was hard. The absence of other productive forces in the early medieval economy meant that the full weight of the economic burden rested almost completely upon their shoulders.

SERFS

Most of the peasants in Germanic lands had originally been free men. During the great migrations they tended to sink down to a level similar to that of the Roman tenants. A leveling process took place, which was speeded up by the fact that the uncertainties of the times made the peasant prefer protection by a lord to complete freedom. Subsequently, the obligations placed on the peasants, combined with their economic weakness, plunged many of them in various parts of Europe, and especially in Western Europe, into deeper dependency.

Eventually, to compel them to fulfill their duties, the peasants' movements were more and more restricted by those who wielded the sword. Neither peasants nor their children were then allowed to leave the land to which they belonged. They became "attached" to it in perpetuity; they became *serfs*. As such, they gradually came under the jurisdiction of their lord. Even if obligations and fines were regulated by custom, or in some cases by a written law, the lack of legal recourse against a lord's decision left them subject largely to his whims. The lord's rights extended also to economic monopolies, such as milling and using common pastures, and might go as far as to include the imposition of capital punishment.

Not all peasants became serfs. Until the twelfth century, especially in Germany, many enjoyed a greater or lesser degree of freedom. In regions like Scandinavia, serfdom hardly developed at all.

Church and Towns

Besides the two major segments of the population ("those who defend" and "those who labor with their hands") there were others, who were, comparatively, small in numbers. They included the clergy ("those who pray") and the craftsmen, traders, and unskilled servants, carriers, and other laborers. The Church adapted itself to feudalism by obtaining possession of lands, levying tithes, and supplying the necessary services through its own vassals and serfs. Feudal towns, however, had little opportunity to develop under the restrictive social system. The towns that did expand often came into conflict with the controlling authorities.

Living Conditions

With a lack of scientific, medical, and technological progress, which generally depends upon the growth of towns (and particularly a division of labor), life for knights and nobles, as well as for peasants, was hard and dangerous. Living conditions were primitive. Food was often scarce, owing to the widespread use of the two-field system (one field under cultivation, the other pasture), which severely curtailed crop production. Industrial output was insignificant. There were sharp distinctions among the classes, but differences in living standards were somewhat less pronounced than in other ages—in Roman, for example, or in modern times—when a variety of luxuries were available and people had money to pay for them.

Chivalry, the conventional form of behavior that gradually developed, imposed burdens upon the nobles. The honor of a knight required valor in tournaments (often quite dangerous affairs), generosity toward enemies (even if tempered in practice by a view toward economic gain through ransom and spoils), proficiency at hunting, and the like. It also required faithful service to the overlord, who could not otherwise have fulfilled his own duties as administrator of justice and protector of all persons under his jurisdiction.

Castles were rarely to be seen before the late ninth or early tenth century. The manorial system was only slowly developing. Manors were fortified residences of nobles that became focal points around which workshops, churches, schools, and markets were built. They constituted centers for an advancing civilization. Often the lord, instead of supervising matters himself, appointed an official to whom he delegated administrative responsibilities. In many such instances, the lot of the peasant was harder than it would ordinarily have been on a small farm.

Expansion of the Economy

Stimulated by a growing population, by Western expansion into thinly inhabited lands, by deforestation in many regions so as to clear space for working the land, and owing to the acquisition of new knowledge, economic activities increased gradually, albeit slowly. Agriculture remained of chief importance. Rye, wheat, barley, hemp, beans, fruits, and wine were the chief crops. Forest products, such as wax, honey, berries, animals, and timber,

contributed to nourishment and clothing. Better use was made of water energy to lighten burdens. Heavy wheels were provided for plows, and harrows and scythes eased the work of harvesting. Cattle raising remained uncommon. The invention of the horse collar made possible the wider, more effective use of horses instead of oxen.

Internal trade, often hindered by tolls on bridges and roads, remained comparatively insignificant, except on the local level. Since the use of coined money was rare, most trade was conducted by barter. Nevertheless, long-distance trade increased somewhat—on land along the great salt routes from central Austria, Germany, and western France and Portugal, or following the rivers. On the sea, trading activities flourished in the Baltic area, where new markets were developed, and in the Mediterranean region, where rich Byzantium and the Near East beckoned. Northmen built improved types of ships and thus, besides great inland marketplaces like Prague, Kiev, Regensburg, and Cologne, major ports began to prosper. Among the leaders were Genoa, Barcelona, Wisby, and Novgorod; subsequently also Venice, Ragusa, and Marseilles.

Feudal Fragmentation

The feudal system as a whole, varying as it did from region to region and from generation to generation, indicates the high degree of local independence that generally prevailed. Each domain or territory belonging to a lord, and even each manor, was designed to constitute, economically and politically, an almost self-sufficient unit. Since each vassal cherished his autonomy, conflicts of interest between his lord and overlords—especially kings—often developed. The overlords were always eager to integrate the various individual domains into their own larger holdings. This endeavor led to a perpetual struggle between the forces of centralization and those of fragmentation.

The conflict began as early as Carolingian times and continued as the noblemen tried to retain their independence against the attempts of emperors, kings, dukes, and other great lords to impose their will. Charlemagne had used the *missi* system for enforcing his administrative orders. Later German kings achieved a degree of centralization through the appointment of officials and clerks who in time became known as *ministeriales*. Ministeriales served only the king, upon whom they depended for their livelihood and from whom they derived their power and administrative authority. Basing their authority neither on right by birth nor on possession of a fief, they found themselves outside the customary feudal hierarchy and constituted a nascent bureaucracy. In other countries, a similar officialdom subsequently came into being. Thus adjustments were made that enabled the feudal system to serve the common needs of the people for centuries.

*F*eudalism, as it had developed by the year 1000, was not a theory or an ideology; it was the practical answer of the age to the needs for organizing society under altered circumstances. It varied from country to country and itself changed with time. It refers to the relationship between lord and vassal and—in what has been termed manorialism—the relationship between nobleman and peasant. Through intertwining connections (the feudal nexus), it embraced all layers of the population in every political, economic, judicial, and military aspect. Even the Church adapted to its premises. During the early stages of feudalism, various Western European countries, partly under the common roof of the "Holy Roman Empire of the German Nation," began to be formed. In Eastern areas the Byzantine Empire supplied such a pattern for a common roof; but there, too, individual countries emerged.

Selected Readings

Bloch, M. *Feudal Society* (1961)

Brooke, C.N.L. *Europe in the Central Middle Ages, 962–1154* (1964)

Bullough, D. *The Age of Charlemagne* (1965)

Einhard, *Two Lives of Charlemagne* (tr. L. Thorpe, 1969)

Ganshof, François. *Feudalism* (1952)

Geary, Patrick J. *Before France and Germany: The Creation and Transformation of the Merovingian World* (1988)

Hodges, R. *Dark Age Economics* (1982)

McKitterick, R. *The Frankish Kingdoms under the Carolingians, 751–987* (1983)

Pirenne, Henry. *Mohammed and Charlemagne* (1939)

Reynolds, S. *Kingdoms and Communities in Western Europe 900–1300* (1984)

Sawyer, P. H. *Kings and Vikings* (1982)

Smyth, A. P. *Warlords and Holy Men: Scotland, A.D. 80–1000* (1984)

14

Beginning of a New Millennium (Eleventh Century)

1015–1054	Reign of Yaroslav the Wise of Russia
1016–1035	Reign of Canute the Great in Denmark and England
1035	Establishment of Kingdoms of Aragon, Castile, and Leon in northern (Christian) Spain
1037	Death of Avicenna
1039–1056	Reign of Emperor Henry III (House of Franconia)
1042–1066	Reign of Edward the Confessor in England
1046	Synod of Sutri; beginnings of Cluny Reform of Papacy
1049–1054	Reign of Pope Leo IX
1054	Schism between Orthodox and Catholic Churches begins
1055	Turks capture Baghdad
1056–1106	Reign of Emperor Henry IV
1059	Establishment of College of Cardinals for Papal elections
1066	Battle of Hastings; conquest of England by Normans
1066–1087	Reign of William the Conqueror of England
1071	Normans seize last Byzantine Holdings in Italy
1072–1091	Normans conquer Sicily
1073–1085	Reign of Pope Gregory VII
1077	Incident of Canossa
1081–1086	Domesday Book compiled
1081–1118	Reign of Emperor Alexius Comnenus of Constantinople

1084 Normans seize Rome; Pope Gregory VII flees

1085 Conquest of Toledo by Christians in Spain

1086 Carthusian Order founded

ca. 1088 Origins of University of Bologna

1095 Council of Clermont (Pope Urban II)

1096–1099 First Crusade

1098 Founding of Cistercian Order

1099 Capture of Jerusalem by the Christians

Modern concepts of science, of natural causes and laws, were alien to medieval ways of thinking about nature and human destiny. No wonder then that many in the tenth century, living in an intellectual climate of superstition and ever fearful of wondrous events to come, seem to have taken the Scriptures literally and to have looked forward with trepidation to the close of the millennium since the birth of Jesus. But the year 1000 passed and still the world had not ended, the Last Judgment Day had not come, great catastrophes had not occurred—nor had a new plunging comet appeared or a widely devastating pestilence.

The first century of the new millennium began uneventfully. It brought a continuation of old conditions as well as slow changes toward something new. The two great powers (the Empire, centering around Germany, and the papacy, centering around Rome) had jointly attained predominance, but now they began to drift apart and entered an age of conflict. The minor kingdoms in Western Europe, especially France and England, gained in stability. To be sure, in England an equilibrium was achieved only after the island had been subdued by Norman conquerors. Christianity completed its victorious march into the border areas of Europe. It embraced Scandinavia and most of the Slavic East; it also made headway in Moslem Spain.

Trade and commerce improved, marked by a gradually expanding agricultural production, turning wastelands into cultivated land and increasing trade of the towns. Literary and artistic activities multiplied. Before the century was over, the first university had been founded. The restoration of its intellectual and economic strength made it possible for the West to spread its enriched culture not only into adjacent European territories, but also, through the crusades, into Asiatic lands that had been lost to Christianity ever since the rise of Islam.

THE POLITICAL SCENE

In the course of the eleventh century, three spectacular events occurred that have retained a special hold on the imagination of posterity: the Battle of Hastings (1066), the dramatic incident of Canossa (1077), and the First Crusade (1096–99). Of more lasting significance than these isolated events, however, was the common trend, notwithstanding the crusade, toward political diversity. Despite the renewal of the Empire under Otto the Great and the regained authority of the Church under the impact of the Cluniac reforms, cohesion among the European peoples diminished steadily. Separate states were organized, and the historian concerned with the Middle Ages has to deal with them individually.

Empire and Papacy (1002–1056)

Early in the eleventh century, the Saxon line of kings and emperors died out. Following established custom, the German nobility convened on an open field near Mainz to elect a new king. Their choice was Conrad, duke of Franconia (who became Emperor Conrad II). Like its Saxon predecessors, the Franconian house was destined to rule for about a century. During this period, the danger of foreign invasions lessened, but internal rivalries increased. Particularly, a conflict between emperor and pope developed that constituted a serious peril to European civilization.

GERMANY

From the last Saxon emperor, pious and able Henry II, who founded the majestic cathedral at Bamberg, Conrad II (d. 1039) inherited amicable relationships with the clergy. He did his best to remain on good terms with them and followed Henry's practice of using clerics as his advisors and administrators. On his first expedition to Italy, he was crowned emperor by the pope, in the tradition of his Saxon predecessors. He reasserted those imperial prerogatives that under his weaker predecessors had lapsed. In order to provide greater stability to the imperial status, he promoted the system of primogeniture. This policy enabled his son, Henry III, to achieve a prestige that was not to be surpassed by any monarch throughout the Middle Ages.

Henry III's empire extended from the Baltic Sea to Rome, from Flanders to Hungary. His influence was felt throughout Europe. In the West, he dominated northern and central Italy and acquired important territories along the Rhone River. In the East, he became the overlord of Hungary, Poland, and Bohemia. He put up fortresses along the borders of the Empire to protect it from invasions. He held the feudal nobility in check by assigning many administrative duties to ministeriales solely responsible to himself. Deeply religious, he kept in close touch with the conduct of Church affairs and promoted reform measures in this field.

The extent of his power and influence in religious matters is shown by the fact that at the Synod of Sutri (1046) he was able to depose three popes and choose a fourth to replace them. Within the short period of three years thereafter, he witnessed the elevation of a pope advocating the Cluniac reform, namely Leo IX, to the Roman see. But in 1056, in the midst of his varied activities, the young emperor suddenly passed away, leaving a mere child as his heir and successor.

ITALY

During the reigns of Conrad II and Henry III, Italy gained new political importance. At the beginning of the eleventh century, the country consisted of many subdivisions subjected to a variety of rulers: Byzantine governors in the South (where they maintained themselves after being expelled from the Exarchate of Ravenna); popes in the center; emperors in the North; remnants of the Lombards in the mountains; and Moslems in Sicily. Further fragmentation occurred when, in the first quarter of the eleventh century, Viking "Normans" also succeeded, after decades of pillaging raids, in gaining a foothold in Italy and in carving out a dominion of their own.

But conditions changed in the second quarter of the century. As Arab power declined, some of the lands occupied by Moslems were reconquered. Northern Italian towns, owing to revived trade in the Mediterranean, gained in strength, independence, and prosperity. Order was brought to the affairs of Rome through the joint efforts of Cluniac reformers and emperors. The ambitious Roman nobility, which had long fought for supremacy in the city and for dominance over the papacy, was relegated to a lesser role. Competent, effective government was restored. A rejuvenated Italy became an important asset in the struggle for international power and prestige. Its new significance in world affairs became apparent when Henry died and his young son Henry IV (1056–1106) ascended the throne.

Empire vs. Papacy

The accession of Henry IV marks the beginning of a two-hundred-year struggle for supremacy between Empire and papacy. From the outset of this contest, the popes held advantages such as they had not enjoyed for centuries. As workers for religious and social reform, they had regained spiritual authority; a purified Church meant enhanced prestige for them. They had succeeded in strengthening their ecclesiastical independence by enforcing the rule that popes should not be chosen by the emperor and other worldly powers, but canonically, as the Scriptures prescribe. Within a few years after Henry III's death, the authority to elect a pope was vested in a college of cardinals. The emperor retained only the right of confirmation of the election, and the Roman nobility, clergy, and people that of approval. This latter right was more or less a formality.

The popes had further increased their political independence by means of an alliance with the Norman invaders. They no longer treated them as enemies but as vassals and used them against the Roman nobility, the Byzantine armies, and, especially, the emperors. Indeed, although Leo IX (whom Henry III had installed as pope) and his successors were German by origin, they turned against the emperors. The struggle reached its first climax during the tenure of Pope Gregory VII.

GREGORY VII

Gregory adhered to the Cluniac reform movement and demanded supreme authority in all Church affairs. His program embodied that of the Cluniac reformers with regard to elimination of simony, strict observance of celibacy by all the clergy, and the abolition of *lay investiture*: the right of lay lords to participate, as they had done, in the choice of bishops, abbots, and other churchmen whose functions included the rule over lands and estates. It also meant the pope's right to invest such churchmen not only with their spiritual but also their secular authority and to demand homage, loyalty, and feudal dues from them. To achieve his ends, Gregory appointed a group of *legates* who had to supervise the entire administration of the Church in the pope's name. This program led necessarily to conflict—the more so as Gregory VII was an intelligent, ambitious, and strong-willed man, whose policies envisaged worldly as well as spiritual power.

CANOSSA

As Emperor Henry IV grew to manhood, he developed an independent mind and showed himself to be just as ambitious as Gregory. Soon Gregory clashed with him over the question of investiture. Each insisted on his right to nominate and install bishops, and, after bitter recriminations, the emperor ordered the deposition of the pope. The pope's answer was to excommunicate the emperor. This act played into the hands of Henry's vassals, who had been awaiting an opportunity to take revenge for a severe defeat they had suffered at his hands in an earlier rebellion. Resenting Henry's arbitrary rule, they promptly deserted him. In midwinter, the emperor was forced to cross the Alps to Canossa and submissively seek absolution and forgiveness from the pope.

The Canossa incident (1077) has remained famous in history as a symbol of extreme humiliation. But its practical effect was different from appearances. The act of submission turned into an eventual victory. Freed of the ban of excommunication (the pope could not refuse pardon to a penitent Christian), Henry promptly gained control over the rebellious German princes and then resumed the struggle with Gregory. Again the pope used the weapon of excommunication, but this time to no avail. In vain did Gregory seek the help of the Normans under their able duke Robert Guiscard. Gregory was forced to flee while Henry took Rome and once more ordered

the pope's deposition. Although the Normans eventually reconquered the city (and pillaged it), Gregory did not return and in 1085 died in exile.

THE FINAL YEARS OF HENRY IV

The emperor survived Gregory by more than twenty years, continuing his unceasing struggle against the papacy and the feudal nobility. Soon the rebellious nobility was joined by members of the emperor's own family: first by his elder son, then by his second son and successor, and finally, after a disastrous second marriage, by his new young wife. By the end of the century Henry had to give up Italy. Even in Germany he found few supporters. Only the growing urban communities, which he had had the foresight to favor throughout his reign, remained loyal. But their support was not sufficient to maintain his position. In 1106 he was forced to flee the country. He was again excommunicated and died shortly thereafter without receiving a Christian burial—which was not arranged until weeks later.

France and England

France and England, having no imperial rights, aims, or pretensions, did not become involved in such serious conflicts with the popes. Since the issue of investiture was not so important to them, their rulers could focus their attention on internal questions.

FRANCE

No single political event stands out in French history during the eleventh century. The country remained divided into numerous duchies and counties, such as Normandy, Aquitaine, Burgundy, and Flanders, each enjoying a large measure of independence. Central power and royal authority were restricted mainly to the king's demesne. Economic progress was slow.

ENGLAND

In England, however, many changes took place. Early in the century, recurring Danish invasions had given the Danes control over the major part of the country. A measure of stability was not restored to the country until the reign of King Canute the Great (1016–35). Canute reorganized the administration, appointed sheriffs to enforce the law, maintained peace, and allowed the Church to carry on its work without opposition. But he had to pay a tribute, called the Peter's Pence, to the Church.

Norman Conquest. Seven years after Canute's death, Edward the Confessor, who had been reared in France and was a friend of the Normans, ascended the throne. When he died, leaving no heirs, a struggle over the right to inherit the throne of England followed. The chief contenders were Harold, who assumed the throne, and William, a Norman. In 1066 William set out to enforce his rights and pretensions. From Normandy he crossed the Channel with a large fleet (depicted, along with subsequent events, in the famous Bayeux Tapestry). In the Battle of Hastings, William defeated and killed

Harold, whose forces had been exhausted by a victorious campaign against Scandinavians who had simultaneously invaded from the North.

Norman Administration. The Norman Conquest was of lasting significance. Once established as king, William distributed English lands as fiefs among his Norman nobles, built castles, reduced many peasants to serfdom, and spread the feudal customs of his native land. Yet he also preserved English laws and traditions. Moreover, he endeavored to prevent feudal fragmentation and saw to it that Anglo-Norman barons did not gain the same independence enjoyed by lords on the Continent.

In 1081, William ordered a survey and evaluation of the land and cattle. This survey constituted, for the eleventh century, a rare instance of thorough royal supervision and economic statistical investigation. The results were incorporated in the Domesday Book, which provided a basis for uniform tax levies.

Relations with the Church were peaceful. The archbishop of Canterbury at the time, Lanfranc, was a scholar of distinction, who displayed tact and wisdom and cooperated with the king. William did not challenge the Church's right to independent ecclesiastical courts. In fact, Gregory VII's investiture struggle had few repercussions in England, at least until the reign of the Conqueror's son. At that time Lanfranc's successor Anselm raised the issues of Church autonomy and lay investiture.

The relations between the Anglo-Saxon and Danish inhabitants and the Norman conquerors, especially the ruling class, were at first tense. But by the time Henry I, William's third son, came to the throne in 1100, intermarriage and mixture of Danes and Normans, originally forbidden, were rapidly progressing.

Spain

On the Iberian peninsula, the struggle against the Moslems was resumed after the Norman invasions had ended. The progress of the Christians was slow, however, for their forces were divided. Numerous principalities, often fighting each other, then existed, such as Aragon, Castile, Leon, Navarre, and Portugal. On the other hand, Moslem strength was also divided. The Moslem rulers of Spain, residing in Cordova, had fallen out with the caliph in Baghdad, and their own lands were similarly disunited. Eventually the Christians began to win the upper hand, especially after they had consolidated their holdings and after Castile and Leon had formed a union in 1037. By 1085, with the capture of Toledo, Christian rule had been extended beyond the center of the peninsula.

The Moslems made up for their decline in political power by means of a marked increase in their economic and cultural influence. Some of their agricultural methods, such as terracing, irrigation, and the cultivation of vegetables and flowers unknown in Europe, spread to Western countries. Their commercial, banking, and credit systems, their advances in the textile

industry, as well as their skill in making jewelry, cutlery, and glassware, began to give their remaining Spanish possessions an importance for Western civilization that their military and political exploits had never had. Moreover their knowledge of physics, chemistry, mathematics, and, particularly, of medicine fertilized the Western mind in areas to which it had given scant attention. However, the example they set in tolerance—in permitting religious groups (Christian or Jewish) other than their own—was not imitated by the West.

Northern Europe

In Scandinavia, the migrations of the Northmen ended during the eleventh century. In that century, too, after long resistance, the Christianization of Denmark, Sweden, and Norway was completed. The three countries were rapidly integrated with the European medieval world. Feudal institutions, however, did not take root there to the same extent as in France, Germany, or England. In particular, serfdom never gained the same importance in the north that it had attained elsewhere.

Eastern Europe

The eleventh century saw the rule of three eminent men in Eastern Europe: King Stephen, King Boleslav I, and Yaroslav the Wise.

Stephen (d. 1038) was a king of Hungary. Famous for his piety—a quality for which he was later canonized—he established close collaboration with the Roman Church. He introduced feudal institutions, contributed to the westernization of his country, and raised Hungary to the status of an eminent power in Eastern European affairs.

Boleslav I (the Brave; d. 1025), king of Poland, started this country on the road to political importance and also tied it to the West. He too promoted Catholic influence. He was responsible for a long series of aggressive wars. He led attacks on one neighbor after the other—Russians, Czechs, Germans, and Magyars. After his death, these attacks brought a breakup of his kingdom and the subjection of Poland itself to imperial vassalage. However, it was largely due to the efforts made in his time that the country was established as an independent Slavic realm.

Yaroslav the Wise (d. 1054) was a ruler of the grand duchy of Kiev, which comprised early medieval Russia. In bitter fratricidal wars, in which he and his brothers fought among themselves, he won the throne of his father, Vladimir. Despite the fact that he was of Norse descent and relied largely on Scandinavian advisers and troops, he promoted Slavic national customs. Repulsing invading forces from east and west, he vigorously carried on the work of political stabilization at home. A code of laws was completed during his reign. Kiev became a prosperous center of lively commerce with Byzantium and the Orient. Commercial relationships and dynastic connections with Scandinavia, Germany, England, and France were also maintained.

Yet, owing to distance, to differences in traditions, and to Byzantine influences, close ties with Central and Western Europe were not established. In fact, the gap widened when the tension between the Eastern and Western Christian churches (a tension dating back to controversies about icons and to the political rivalries during the reign of Patriarch Photius) led in 1054 to a new split, and Russia adhered to the Eastern, or "Orthodox," Church.

ECONOMIC, SOCIAL, AND CULTURAL CONDITIONS

The sequence of great invasions and depredations of Europe by Huns, Magyars, Moslems, and Northmen had contributed its share to a deep decline of economic conditions in Europe. In the eleventh century, the economy of the continent began to improve markedly in comparison with the low level of activity in the preceding eras. Similar progress was achieved in the creative arts. The Ottonian renaissance was carried forward into the eleventh century, and beautiful and increasingly appreciated art treasures were created. Architects and artisans did outstanding work. Exceptional skill was developed in jewelry and leather crafts, in book binding, and in book illustration and illumination of manuscripts. New advances were made in classical scholarship, philosophy, and literature.

Business Enterprise

As the political system of the Middle Ages approached maturity, the spirit of commercial enterprise began to spread. Towns increased in number and size. Some industries, especially those engaged in textile production, expanded. Aided by the central location of its harbors, the profits derived from its shipping industry, and the business sense of its merchants, Italy became a leader in a variety of business undertakings.

Merchants in towns north of the Alps likewise improved their business methods. Instead of providing solely for local needs, they too sought wider markets. Iron, copper, silver, tin, salt, and wine, as well as manufactured goods such as armor, were shipped abroad. Silver was coined in increasing quantities. Important mining centers arose in Germany (the Harz region, Bohemia, and Tyrol), northern Sweden, England, and elsewhere. Feudal lords accorded better treatment to traders within their territories, promoting fairs and markets from which they derived profitable taxes and tolls.

Agricultural Enterprise

Not only trade and industry but also agricultural production increased as a result of the growth in population, the practice of intensive cultivation, and an increase in the acreage of arable land through clearing of forests and colonization of Eastern European regions. Foodstuffs were in greater demand because brisk commerce had enriched the townspeople. Some of the money that thus became more freely available flowed into the hands of peasants as well as into the coffers of the landed nobility.

Social Organization

As early as the eleventh century changes in some aspects of the social system under feudalism began to occur. The interests of the nobility, formerly preoccupied with military and governmental functions, were broadened to include commercial activities. In trade, greater specialization and division of labor took place. Since goods could be produced in larger quantities, new wants and needs were created. A different type of urban society emerged, whose impact was to be felt in the following century.

Economic changes also affected the social status of the peasants. In some regions they appear to have attained higher standards of living or to have succeeded, without affecting the essential institutions of feudalism, in reducing their burdens. In other regions, the peasants found it possible to change the relationships to their lords and to lease land from them instead of working for them. In still other areas, where improvements were too slow in coming, at least some of the peasants found ways of escaping bondage by illegal means; they moved to newly colonized regions where they would be free.

Scholarship and Literature

The concentration of population in the towns and the diversified activities of the townspeople stimulated cultural endeavors. In the time of the Carolingian renaissance, cultural work, aside from that of the palace schools, had centered mainly around monasteries and churches. This trend continued. But more of the eleventh-century cultural achievements came from outside ecclesiastical institutions.

ECCLESIASTICAL CONTRIBUTIONS

The Cluniac reform movement had a stimulating effect on scholarship. The monks wrote many new Lives of Saints and a number of historical chronicles. A musical notation system using lines and spaces was invented. It made possible a consistent musical tradition and served to improve standards of performance. In philosophy and classical learning, some famous teachers and scholars appeared. Among them were Gerbert of Rheims and, later in the eleventh century, Lanfranc and Anselm of Canterbury. Anselm, like Scotus Erigena, is often considered one of the forerunners of *scholasticism*, although he himself insisted that a Christian scholar cannot rely on logical thinking but must depend on faith and the teachings of the Church. The Latin works of Boethius and other classical writers were studied, and a developing interest was shown in Arab achievements.

SECULAR CONTRIBUTIONS

The revival of sciences, literary activities, and arts, which took place outside the ecclesiastical field, is evinced by poetry on topics of love, epics dealing with heroic deeds, and legal writings. In contrast with the slight evidence of achievements in literature during the tenth century and earlier (among these achievements was the classic epic *Beowulf*, dating back to the eighth century) we find numerous secular works dating from the eleventh century. They include the famous early southern French *chansons de geste* (songs of heroic deeds and chivalry), composed not in Latin but in the language of the region, the vernacular. The *Chanson de Roland*, though existing versions were written down somewhat later, was also created in the eleventh century. From the same period date parts of the *Anglo-Saxon Chronicle* and certain of the Arthurian tales and other legends.

Studies of Roman law, especially of Justinian's *Corpus juris civilis*, were revived. As these and other "higher" studies were added to the traditional schoolwork circumscribed by the seven arts (the trivium and the quadrivium), their influence was gradually felt all over Europe. It was in connection with the study of Roman law that one of the most significant cultural developments occurred—the establishment of universities. The university provided a regular meeting place for outstanding teachers and mature students. They organized themselves into a closely knit community in order to be able to pursue their studies in freedom and to be protected against disruptive outside interference. Bologna in Italy, which lays claim to having possessed, around 1088, the "first" university, excelled in the teaching of law.

The Arts

The early eleventh century brought the Ottonian renaissance to full flowering. Germany under the Ottonian (or Saxonian) emperors held the leading place in this artistic reawakening. "Schools" of art flourished in Trier, Fulda, Hildesheim, Cologne, and, especially, the island of Reichenau in Lake Constance. They emphasized a Christian spirit rather than any secular feudal or classical tradition.

Notwithstanding the continuing influence of Byzantine culture, an original quality of aesthetic expression developed in these centers. A transcendental element prevailed, contrasting with the more lifelike, sometimes even impressionistic trends of the Carolingian renaissance a hundred years earlier. This quality can be traced in the illuminated manuscripts, the elaborate book covers, and even the handwritten state documents drawn up at the time. Later in the century, these art centers slowly declined.

ARCHITECTURE

In architecture, the eleventh century saw the Romanesque style fully matured. During its early stages in the ninth century, it had rivaled the Byzantine style. The latter persisted in Western Europe deep into the eleventh century, as shown by St. Mark's in Venice with its extraordinary mosaics. But by that time the Romanesque, inspired by the Italian basilica, had become the decisive expression of Western artistic trends.

Romanesque churches, most of them the work of now unknown masters, represent some of the noblest achievements in the arts at any time. These churches are beautiful in proportions. The exteriors are often severe, with plain and heavy walls, small doors, and small, high windows. The arches are simple and rounded. A separate bell tower is often found next to the church. On the whole, the designs were appropriate to the way of life in southern countries, beckoning worshipers out of the hot, noisy, bright, busy marketplace into the serene, cool, peaceful atmosphere of another world. But the Romanesque style—somewhat modified to suit different climates (often requiring special provisions for air and light)—spread also to regions north of the Alps, notably northern France, Germany, Scandinavia, and England. Some of the Romanesque churches were adorned with frescoes. Beautiful sculptures or bas-reliefs can be found both on the outside and the inside walls.

The Romanesque style was also used for secular structures. Stone castles, which appeared in increasing number, were built in this style. Simultaneously, the style's influence was reflected in the minor arts and crafts.

RELIGION AND THE FIRST CRUSADE

Perhaps owing to the reforms within the Church and the new devotion they engendered, a strong religious fervor became evident toward the end of the eleventh century. It showed itself in the building of numerous churches, in the appearance of great preachers, and in revived missionary zeal. It was expressed in literature, in the scholastic work of the monks, and in mystical writings bearing witness to the inwardness and warmth of faith. It can be traced in the arts, in the loving care with which sacred books were copied and adorned, and in the craftsmanship applied to objects of worship. It was reflected in the regained esteem and authority of the popes, as well as in the reforms effected among the old monastic orders and the establishment of new ones.

New Monasticism

The religious fervor that led to the founding of new monastic orders was akin to that which had inspired hermits in early Christian times. In contrast to the organizational concepts of the existing orders (which had been so often misused to serve secular purposes), the hermit's ideal of solitary devotion to God was one of the driving forces behind the establishment of new orders, such as those of the Carthusians and Cistercians.

The Carthusian monks, named after their first house in Chartreuse, France, accepted the Benedictine rules in their strictest form. They gave up all worldly possessions (in which they recognized the greatest danger to the Christian Church). They lived almost like hermits, restricted themselves to vegetarian fare, and devoted their lives to silent meditation, prayer, and physical work.

The order of the Cistercians, or gray monks, was also founded in France—in Cîteaux, in 1098. But the Cistercians moved to regions distant from cultural centers and, setting up numerous retreats, became famous as colonizers in Eastern Europe. Along with the Christian faith they disseminated knowledge about Western methods of cultivating the soil. Eventually they possessed no fewer than seven hundred monasteries. They too prescribed the habit of silence, manual work, simplicity, and vegetarianism. They also sponsored missionary schools and encouraged the teaching of arts and crafts.

Crusading Spirit

In a still more spectacular manner than through the founding of new monastic orders, the religious spirit of the age was demonstrateed by a mighty enterprise, a war for the conquest of the Holy Places in Palestine, known as the First Crusade.

In addition to religious enthusiasm, other motives inspired the Crusaders. Nobles were interested in conquests so that they could acquire lands for fiefs. Knights hoped for adventure, glory, and spoils. Popes hoped to extend the area subject to their authority and to gain the increased prestige that they needed for their struggle against the practice of lay investiture. People in the towns hoped the Crusade could bring them new trade connections, Oriental goods, and profits. To many individuals, the Crusade meant escape from pestilences, dangerous neighbors, or personal problems.

Yet there was also a deep religious feeling. There was the hope of gaining forgiveness of sins, of securing salvation by means of an undertaking pleasing to God, of promoting Christianity and protecting pilgrims to the Holy Land against infidels (though their ill-treatment by Moslems was certainly exaggerated), and of converting the Moslems.

The Moslems and the West at the Time of the First Crusade

The time seemed favorable for a successful crusade, for the Moslems were divided. In the course of the eleventh century, the Seljuk Turks had gained domination over large parts of the Moslem world. They had conquered Baghdad, and in 1071 they had gained another great victory. At Manzikert, they had defeated the Byzantine forces and seized large parts of the Eastern Roman Empire.

But once established, the Seljuk emperors had begun to promote the arts of peace. Under Malik Shah (d. 1092) they had devoted themselves to city building, trade, scholarship, poetry, and science. His reign had been the age of the wise statesman Nizam-al-Mulk; of great geographers and historians following in the tradition of al-Masudi of the tenth century; of Hakim Omar Khayyam, the "Voltaire of the East," author of the *Rubaiyat* who won fame as a scientist as well as a poet. Commerce and industry flourished.

The prospects for a successful crusade that the temporarily peaceful orientation of the Moslems seemed to offer were enhanced when, owing to the dissatisfaction among the Moslems with Seljuk rule, new dissensions occurred after Malik's death.

Eastern Rome and the West at the Time of the First Crusade

The time seemed favorable also in view of conditions in the Byzantine Empire. In 1094 its emperor, Alexius Comnenus, had suggested to the pope a joint campaign against the Turks. Byzantium could pride itself on its trade and commerce, its arts and scholarship, and its possession of the most efficient governmental administration in Europe (one of its emperors, Constantine Porphyrogenitus, had himself written a distinguished treatise, *On the Administration of the Empire*). But its military power had long been in decline.

Even against a divided Moslem world, the forces of Constantinople alone seemed too weak. Alexius realized this, but he had good reason to expect help from the West. Not only did he know that the West was interested in preserving his empire as a buffer against the Moslem danger; he could also lure the Italian cities with promises of great trade advantages in Constantinople.

Alexius could also hold out hope to the popes for a reunion of the Eastern Orthodox and the Western Catholic churches. This last issue was of special importance, for the break that had occurred only forty years earlier, in 1054, did not, at the time, seem final. Then, at the height of the Cluniac reform movement, papal ambassadors had in their zeal once more excommunicated a patriarch of Constantinople, the Greek Cerularius. Negotiations with him about controversial dogma regarding baptism, the provenience of the Holy Ghost, the use of leavened or unleavened bread at communion, the celibacy of the clergy, and, especially, the primacy of the popes had broken down. But the popes had never given up hope of seeing the East return to the Catholic fold, and Alexius took advantage of their expectations.

First Crusade

The emperor's call for a crusade released the accumulated fervor. In response to his pleas, Pope Urban II (1088–1099), at the Council at Clermont in southern France, addressed one of the most famous and eloquent religious orations to the throngs assembled there. He exhorted them to take up the cross and deliver Christianity from the Turkish danger. He ordered a suspension of all feuds in Europe on pain of excommunication.

His call was heeded by French, Germans, English, and Normans. The thousands participating in two abortive preliminary expeditions, motivated by enthusiasm and desire for plunder, were followed by a main body under Norman leadership, bent on conquest and salvation. Merchants from Genoa, Pisa, and elsewhere traveled in their wake.

The Christian armies reached Constantinople, where a treaty with Alexius was negotiated. Since the Western army was unexpectedly overwhelming, the emperor was only too anxious to get rid of them, and he promised to make Byzantine fiefs of all the lands the knights could conquer.

The Crusaders then proceeded. In 1097 they took Nicaea. Advancing further, despite immense hardships and losses, they successfully stormed Jerusalem in 1099. To the joy of Christendom, a Christian kingdom was founded. It became a fief of the pope. The Norman Godfrey of Bouillon (soon followed by Baldwin I) was crowned king of this new Western feudal state. The Christian kingdom was soon gravely endangered by internal jealousies, by attempts of the nobles to cut out independent principalities or fiefs for themselves, and by the greed of knights and traders and their brutality toward the Moslems. Nevertheless, it was to last almost one hundred years.

At the first great Church council, in Nicaea in 325, the Roman emperor had presided. Byzantine emperors thereafter had, under caesaropapism, controlled church affairs. Ever since the reign of Charlemagne, German "Holy Emperors" had exercised a dominating influence. Henry III had deposed and appointed popes. With Gregory VII in the middle of the eleventh century, the Western church succeeded in breaking the secular hold over it, without achieving, however, a reverse papal domination over the secular rulers. These dual aspirations involved bitter struggles, with the popes often siding with the nobility in the various countries, who likewise fought subjection to imperial or royal supremacy. This struggle, which involved all layers of society, was, from the side of the Church, supported by a vigorous internal reform and purification movement, whereby faith in the Christian Church could be renewed. This spiritual renewal made possible a great common undertaking of the European world, which found itself faced by new conquests launched by Turks in the Near East: a war or "crusade" aimed at regaining the Holy Places in Palestine. Its success, crowned by the taking of Jerusalem, opened the way for new contacts and interest in the East and numerous possibilities for expanded commercial activities.

Selected Readings

Brand, C. M. *Byzantium Confronts the West* (1968)

Douglas, D. C. *The Norman Fate* (1976)

Erdmann, C. *The Origin of the Idea of the Crusade* (1935)

Fuhrmann, H. *Germany in the High Middle Ages c. 1050–1250* (1986)

Holmes, George. *The Oxford Illustrated History of Medieval Europe* (1988)

Kennedy, H. *The Prophet and the Age of the Caliphates* (1968)

Lawrence, C. H. *Medieval Monasticism* (1984)

Payne, Robert. *The Dream and the Tomb: A History of the Crusades* (1984)

Riley-Smith, Jonathan. *The Crusades: A Short History* (1990)

Runciman, Steven. *The First Crusade* (1980)

15

Flourishing of the Middle Ages

1180–1223 Reign of Philip II Augustus of France

1181 Submission of Henry the Lion to Frederick Barbarossa

1187 Sultan Saladin conquers Jerusalem

1189–1193 Third Crusade

1189–1199 Reign of Richard the Lion-Hearted

1190–1197 Reign of Emperor Henry VI

1198 Frederick II of Hohenstaufen becomes King of Sicily

Death of Averroes

1198–1216 Reign of Pope Innocent III

Only in recent times have studies revealed the complexities and the breadth of achievement of the twelfth century. In fact, a great deal of additional research, especially in economic history, will be required to gain a valid picture of that age. To past historians, the century seemed to lead to the heights of feudal development. In reality, there were many symptoms of feudal disintegration. Some of the patterns of political organization (indispensable in earlier times), of kingship, and of knighthood, had become largely ornamental by the twelfth century. Knightly ways were now more praised than practiced. As so often throughout history, theory and ideal were developed only when practice waned. The estate of the bourgeoisie (the burghers or townspeople) played a role steadily increasing in importance. Although papal power rose and religious concepts permeated all endeavors of Western peoples, their scholarship, art and architecture, laws, politics, and everyday life—even attitudes toward religion—changed as worldliness and wealth increased.

POLITICAL SCENE

The twelfth century witnessed a change in the political balance of power of Europe. Territorial lords—the kings of countries such as Sicily, France, England, or Denmark, and the dukes of large principalities in the German Empire or in Flanders and Aquitaine—gained strength in comparison to both the emperors and the popes. Likewise the bureaucracies, which were developing rapidly everywhere, increased their influence. Perhaps most important, growing towns that could defy lesser lords and even challenge the

greater ones were becoming significant factors in political affairs. Townspeople, with their ambitious aspirations, made their weight felt. They redirected the political evolution of Europe in regard to both internal and external issues. They speeded up the decline of the lower nobility, helped to strengthen the power of kings and central authorities, and promoted Western culture's eastward expansion deep into pagan and Moslem lands.

The Empire

During the twelfth century, the Franconian line of kings and emperors died out and the family of Hohenstaufen came to the throne. With it began, not only in Germany and Italy, but also in other countries, the most dramatic period in medieval history. It is marked by important events, great personalities, and astonishing cultural achievements.

CONCORDAT OF WORMS

After the death of Emperor Henry IV, the main problem facing his successor, Henry V (d. 1125), last of the Franconians, was that of settling the issue of investiture. This was done in 1122 by means of the Concordat of Worms. It stipulated that the emperor would abandon the right of investing his bishops with the symbols of their spiritual office—i.e., the ring and *crozier* (staff). The Concordat was a compromise that reflected a gain for the papacy, even though, in effect, the emperors still retained the authority to determine the personnel of the bishops' offices, the *episcopacy*. It affected the imperial relationship to the German nobility, for it encouraged the nobles to persist in their opposition to central imperial power. Henry V was not the man to counter this trend successfully. In any case, he died soon after the Concordat had been concluded.

BEGINNINGS OF HOHENSTAUFEN RULE

Consequently Henry's successors, Lothar of Supplinburg (d. 1137) and Conrad III, the first Hohenstaufen emperor (d. 1152), inherited extremely difficult problems. Neither of them could regain full authority over the German princes. Both at least maintained imperial rights in Italy more successfully than had Henry, and both expanded the empire eastward. Lothar, in particular, encouraged colonization in the Slavic and pagan lands and promoted the extension of European culture. The advanced economic standards of the western German towns, their concepts of law, and their spirit of freedom were introduced in the less developed regions east of the Elbe and the Oder.

REIGN OF BARBAROSSA

The second Hohenstaufen emperor was Frederick I Barbarossa (1152–1190). The Hohenstaufen family, which ruled for about a century, produced three outstanding emperors: Frederick Barbarossa himself, his son Henry VI (d. 1197), and (in the following century) his grandson, Frederick II (d. 1250).

Barbarossa was a man whose wisdom, energy, and ability deeply impressed his contemporaries. At least temporarily, he settled the struggle over supreme authority in Germany in favor of the imperial crown, emerging successful from a long and dramatic contest with his rival, Henry the Lion of the House of Guelph. Henry the Lion was one of the great eastern colonizers, a farseeing statesman who founded and promoted towns and trade. He was less interested in imperial policies in Italy than was Barbarossa.

Churchmen and traders led the way eastward, drawing after them settlers for towns and for the new agricultural regions, which were won by deforestation. Feudal lords were attracted who seized and held political power. Christianity was spread, along with Western feudal ways. Various counts, margraves, and others set out to gain dominions, to which peoples from the West moved. They drained marshes, constructed roads and bridges, and built towns. Owing to this expansion of Western civilization, later very important regions became part of the empire, such as Brandenburg with the town of Berlin and Saxony with the town of Meissen.

But Henry the Lion was also a rebellious leader who fought bitterly for the independence and power of the territorial princes. Eventually Barbarossa reduced him to obedience and restored firm imperial authority over all Germany. He declared a general peace of the land and enforced it with the help of ministeriales, whom he selected from his entourage and upon whom he relied (like earlier strong rulers) instead of on the nobility or Church. Laws were also efficiently enforced; infringements on imperial prerogatives were no longer tolerated. Barbarossa, moreover, continued the policy of extending German influence eastward into former Slavic lands, to which he invited prospective settlers.

Towns were allowed free constitutions. Magdeburg Law, originally drafted for the great central German town and residence of the Magdeburg archbishops, was accorded to them. Providing for broad immunities and self-government, it constituted one of the most important legal contributions of the Middle Ages.

Outside Germany, Barbarossa secured Burgundy as a fief. He was less successful in his Italian policies. Not only did he face the opposition of several popes who feared his power and resented his claims to a God-ordained worldly leadership; he also became involved in interminable conflicts with the growing towns or communes of northern Italy. When he attempted to secure complete imperial authority in Lombardy, a number of wars resulted. After shifting fortunes had ended in his severe defeat at Legnano, he was compelled in 1183 to allow the towns a large measure of self-government.

Only in southern Italy did his policy become profitable, for he succeeded in marrying his son Henry to the heiress of the kingdom of Sicily and southern Italy. This kingdom was governed by Normans, who, under Robert Guiscard's brother Roger, had driven out the remnants of the Moslem forces as well as the Byzantine troops. A model feudal state, it had become under Roger II (d. 1154) the dominant Mediterranean power and a cultural center, which inherited much from the Byzantine and Moslem civilizations. By means of Henry's marriage, the German emperors gained not only control over southern Italy and large parts of the Mediterranean but also a counterweight against papal power.

HENRY VI

Barbarossa drowned in 1190 while on a crusade, but his work was carried on. Henry VI, his son, diligently pursued his father's policies. By fully exploiting his power over Germany, northern Italy, and his wife's inherited kingdom in southern Italy and Sicily, he secured for the Empire a status superior to any it had held since the regime of the Franconian Henry III. But events after the premature death of Henry VI, comparable to those after the parallel early passing of Henry III, ended this era of accomplishment. The prestige and power of the emperorship were largely destroyed during the minority of Henry VI's son and eventual successor.

France

While the German kings in their role as emperors devoted their attention to great international tasks, the French kings concentrated on more modest objectives. Very painfully and slowly, the process of centralizing power in the hands of the royal court and counteracting feudal disintegration went on. With great difficulty, Louis VI (d. 1137) and his able adviser, Abbot Suger (d. 1151), held the lesser nobility in check and, ingeniously, even imposed their will occasionally upon the greater lords. Royal prestige and authority were based upon firm control and economically sound exploitation of the royal domain, accomplished with the help of a bureaucracy created along the lines of the German ministeriales. These officials were ordered to take over military command posts, to perform a variety of administrative duties, and to collect taxes. At Paris, Louis established his court, his *curia regis*.

During the second half of the century, Louis VII tried to continue this administrative system and increase the royal authority. But he was so handicapped by internal rivalries and continuous wars with England that he could not even maintain the status quo. Moreover, in 1152 he made the mistake of having his marriage to Eleanor, heiress of Aquitaine, annulled for lack of male heirs. Thereupon Eleanor married Henry II of England. This added the military strength and economic resources of Aquitaine to those of England, while France was weakened. Subsequent wars against England brought several major defeats, losses of considerable territories, and, in the wake of defeats, rebellions of the nobility. Not until Philip II Augustus,

Louis's son, came to the throne in 1180 did the political fortunes of France begin to improve.

England

The political achievements of the French monarchy were less significant for the future of Western civilization than the political ideas and institutions originating in England. The isolated position of this recently conquered country, the preoccupation of its rulers with their continental territories, its mixed populations and diversified traditions, and its economic needs all contributed to a unique political development.

HENRY I

With Henry I (d. 1135) the consolidation of a bureaucracy began. It counteracted feudal decentralization by strengthening the position of the royal court *(curia regis)* as the supervisor of law enforcement and the final tribunal for appeals. It administered the royal treasury through a new institution, called the *exchequer*. Henry restored peace with the Church; conflicts had developed late in the eleventh century when a struggle over the question of investiture had led to the expulsion of Anselm, the archbishop of Canterbury. Henry recalled Anselm, and a compromise on the investiture question (along the lines of the Concordat of Worms) was reached.

HENRY II

Years of anarchy followed upon the death of Henry I. But an unruly nobility with ambitions for local autonomy could not block the long-term trend toward consolidation and pacification. New advances in this direction were made under Henry II (d. 1189), who stands out as one of the most important of medieval English rulers. He required heavy financial contributions from the nobility as well as from the townspeople and vigorously enforced his will. By allowing individuals to substitute *scutage*, or monetary payments, for their personal services, he enriched his treasury while relieving many nobles of tasks unwillingly and poorly performed. He rebuilt the bureaucracy organized by Henry I. He also revived the *curia regis* as the main agency of government, on which he could rely in his frequent absences during the wars against France. While demonstrating his authority over local officials, he nevertheless promoted a measure of self-government and responsibility on the local level.

The common law gained wide respect. A jury system for indictment in criminal cases came into general use along with assizes (county courts) to render decisions in disputes over landed property. In line with a precedent set by Henry I, final appeals to the king's judges were allowed, so that legal procedures replaced a resort to arms as a means of settling controversies. Thus the twelfth century saw a rapid development of English concepts of law. They were to influence the future development of legal systems far beyond the borders of England.

At first Henry, seeking good relations with the Church, tried to secure the help of the clergy in his attempts to reorganize the institutions of the country and his resultant struggles with the barons. But later he tried to bring the clergy as well as the barons under his sway. In 1164 he issued the Constitutions of Clarendon, which reaffirmed royal authority over churchmen. When he also claimed jurisdiction over clergymen accused of crime, he became involved in a bitter controversy with his former chancellor, Thomas à. Becket, then archbishop of Canterbury, who rejected this claim. The archbishop was murdered, an act that Henry (who was at least indirectly responsible) seems to have repented of, although his repentance was not so deep as to stop him from enjoying the political advantages derived from this method of eliminating opposition.

Henry extended his realm into Wales, Ireland, and Scotland. Through his marriage with Eleanor of Aquitaine and through other marriage alliances in his family, he acquired extensive additional fiefs, especially in France, and he successfully defended them against the French and other enemies.

RICHARD THE LION-HEARTED

Misfortunes beset Henry II in his later years, and when the old king passed away, many of the achievements of his regime vanished with him. He had come to realize how frail were the foundations upon which he had built. The barons, who had gained many privileges and immunities during the disorders prior to his accession, had revolted. Moreover, their example had been followed by his own sons, whose ambitions had been encouraged by Eleanor and who, knowing too little about statecraft, had fought their father as well as one another.

In the course of the wars the eldest son of Henry perished. Thus the second son, Richard I (d. 1199), known to history as the Lion-Hearted, ascended to the throne when Henry died. Richard promptly began to waste England's military resources on crusades, reckless campaigns in France, personal luxuries, and gifts to friends. When his quarrelsome nature involved him in exploits that ended with his capture and imprisonment in Austria (on his way home from the Third Crusade), the country had to pay a huge ransom for his release. In fact, only after the city of London was pawned to the German emperor was Richard liberated. Meanwhile his absences had benefited the country. At such times England was left undisturbed to develop the institutions that had been wisely created by his predecessors.

Spain and Portugal

In Spain during the twelfth century, the power of the Moslems declined. Internal dissensions among them enabled the Christians to expand their holdings on the Iberian peninsula. Between 1139 and 1179, the area of Portugal was organized as an independent kingdom.

Eastern Europe

A number of important developments occurred in eastern Europe. Of lasting significance among them was the steady eastward advance of Western civilization.

THE BALTIC REGIONS

The Germans and Scandinavians brought Christianity, feudal institutions, and economic development to the peoples around the Baltic Sea. Swedes conquered Finland, Danes invaded Estonia, and Germans advanced into Slavic territory beyond the regions between the Elbe and Oder rivers. The Germans also sailed across the Baltic to establish themselves in Livonia, south of the Finnish gulf. Everywhere the Western peoples extended the areas under cultivation and founded cities. Thus by the end of the twelfth century, Western civilization had embraced the entire continent (with the exception of Lithuania, which retained its independence and pagan worship) up to the borders of Russia and the Byzantine Empire.

RUSSIA

During the same century, drastic changes occurred in Russia. Under a wise and humane prince, Vladimir Monomachus (d. 1125), Russia had recovered from incessant strife within the ruling family. But after his death, civil wars broke out anew. These coincided with a number of other adverse developments, including invasions by neighboring countries from the east, rapid loss of the timber resources of the Kiev region through deforestation, and a steady reduction of trade. All of this undermined the strength of the state.

In the second half of the twelfth century, the vigorous urban civilization of Kievan Russia began to decline. More and more people emigrated, northeastward and southwestward. By the end of the century, Kiev had ceased to be the capital. The once prosperous region, now depopulated, fell into decay and was partly absorbed by Western neighbors.

The grand dukes moved from the Dnieper to the upper Volga basin—i.e., from the Slavic center to a region largely inhabited by Finnish tribes. An almost entirely new, more primitive commonwealth was built there around Suzdal and, later, Moscow. This new state, being remotely situated, bore less resemblance than the preceding Kievan Rus to other European nations, with which it maintained but little contact. Only the town of Novgorod near the Baltic shores preserved through trade a significant link with the West.

The Papacy

Despite the gradual formation of individual nations with their own objectives and aspirations, the feeling of a community of interests among the Western peoples persisted. This sentiment was furthered by the common Church represented by Rome. Eager to preserve their independent status in Rome, the popes had definite local interests. These involved them in conflicts with the emperors, with the kings of the Western European

countries, with factions among the Roman nobility, with their desperate subjects who again and again resorted to revolts, and at times even with their own allies and vassals, the Normans in Sicily.

But political considerations were always intertwined with broad religious aims and with the international tasks of the Church. At least during the second half of the century, popes such as Eugenius III, Adrian IV, and Alexander III understood how to maintain the dignity of the papal see, its position vis-à-vis the emperors, and its duties toward all of Western Christendom. They checked the renewed tendencies toward worldliness and corruption, combated the still prevalent evil of simony (i.e. selling and buying of church offices), and, at the Third Lateran Council of 1179, took vigorous measures to improve the morals of the clergy. The system of electing popes was revised so as to avoid schisms. The leadership of Cluny came to an end with the death, in 1157, of Cluny's last great abbot, Peter the Venerable. However, the spirit of reform lived on and the monastic movement continued to show signs of strength. High standards in theological scholarship were maintained as outstanding and devoted churchmen set examples of a truly Christian life.

Second and Third Crusades

The twelfth century brought two new Crusades. The First Crusade having achieved the goal of liberating Jerusalem, the Second Crusade was precipitated when, in 1144, the Turks conquered Edessa, a town in Asia Minor. They thereby cut the communication lines between the strife-ridden kingdom of Jerusalem and the European countries. Responding to the persuasive urging of St. Bernard of Clairvaux, the German emperor and the French king took up the cross and led their armies to the rescue. In 1149 their enterprise ended in a fiasco.

Thereafter conditions in Jerusalem (which, because of a lack of local resources, depended upon open trade routes) further deteriorated. The Knights Templars, Hospitalers, and other organizations that had been founded to protect the homeland and defend the pilgrims en route did not suffice to meet any serious challenge. Within a few decades such a challenge was posed by Saladin, a Moslem general and statesman as gentle and gallant as he was energetic and capable. He reunited the divided Moslem East under his banner. In 1187 he defeated the Christians in a fierce battle at Tiberias and conquered Jerusalem.

The news of the fall of the city shocked the Christian world. Its three mightiest rulers, Emperor Frederick Barbarossa, King Philip Augustus of France, and Richard I of England, promptly reconciled their differences and decided to hurry to the aid of the fallen kingdom. The Church raised funds through the sale of many of its valuables. The towns equipped ships and provided needed goods and the Third Crusade got underway.

Unfortunately, Barbarossa was drowned on the journey, Philip and Richard quarreled, and the holy places were not recovered. In 1191 the whole effort had to be given up. The crusaders had conquered only the Mediterranean port of Acre in Palestine. Since the generous Saladin granted the Christian pilgrims free access from Acre to Jerusalem, the port could from then on serve both as exchange place for European and Oriental wares and as gateway to the Holy Land.

THE CULTURAL SCENE

With the twelfth century, Western culture entered upon a period of flowering. Closer contact with the Moslems in Asia, Sicily, and Spain contributed to the splendor. Western people's philosophy of life had slowly changed. In early Christian times, Church fathers, such as Ambrose and Augustine, had been distrustful of "reason" because it did not further man's salvation. In the twelfth century, however, even though beliefs in all kinds of magic and other superstitions survived, reason became the chief instrument of Western intellectual and cultural activities. It enriched the scholarly disciplines, politics, and the arts. Unavoidably, it also brought new dissensions.

Religious Activities

The influence of reason was most pronounced in the area of theology, around which all other studies centered. Reason altered the trend of theological studies; it encouraged doubt. This emphasis called to the fore all the vital forces in the Church, which, in response to the challenge, reached new heights of achievement. New monastic orders were founded; mystic movements directing men toward inwardness were strengthened; and Church institutions of lasting significance were created.

SCHOLARSHIP

Among the great Church writers of the twelfth century were Peter Lombard, Roscellinus, Hugh of St. Victor, and John of Salisbury. They were *schoolmen* who taught a younger generation to use the tools of reason for doctrinal investigation. Such approach was intended to help resolve contradictions in the writings of the Church fathers and affirm and strengthen faith. Other scholars included the historians Ordericus Vitalis (*Ecclesiastical History*), Otto von Freising (*The Two Cities*), and William of Malmesbury (*Chronicle of the Kings of England*). But the two outstanding figures were Bernard of Clairvaux (d. 1153) and Peter Abelard (d. 1142).

Bernard was a strict man of deep devotion and purity of life. He composed treatises on Church dogma, baptism, and immaculate conception. Yet he was less a schoolman than a great preacher and influential Church organizer. He sponsored the Second Crusade. He fought for the election of popes of high moral standards. As a mystic who insisted on the orthodoxy of all Church dogma and traditions, he devoted his life to the task of inspiring and purifying the whole Church body.

Abelard was a man of very different character and mindset. His name is familiar to many for his love affair with Héloise and its sad consequences, described in his *History of My Calamities* and in the *Letters of Héloise*. He was a rationalistic thinker, an inspiring teacher, and a preeminent schoolman who followed in the steps of Roscellinus. His major contributions to Western culture consisted of the philosophical ideas embodied in his work *Sic et Non*.

With his keen intellect, he analyzed apparent contradictions in the theology of his time and in the writings of past great churchmen. Doubt, he insisted, would lead to inquiry, inquiry to truth. And though he never thought of challenging the Church, doubt led him into conflict not only with St. Bernard but also with other interpreters of Church traditions and eventually brought official condemnation of his writings.

MONASTICISM

Two new monastic orders were formed during the twelfth century: the Premonstratensians in 1120 and the Augustinians about two decades later. Designed mainly to include in their membership the canons, or clergymen, who were assigned to cathedrals and performed the duties of priests, both orders not only contributed to the spiritual work of the Church; they also helped extend papal power and made a significant contribution to the maintenance of religious devotion among the people.

HERESIES

Church life was stimulated also by the impact of nonconforming religious thought. Among non-conformists, we find two particularly significant groups. One was represented by those who believed in the simple, humble, and human ways of early Christianity. The other was represented by those who believed in the possibility of establishing direct contact with the divine. At all stages in the development of the Church, there had been many who wanted to revive the earliest Christian ways.

In the twelfth century, the most important group of this type were the Waldenses (followers of Peter Waldo). They opposed the worldliness of the papacy and Church abuses such as simony, as well as some dogmas of the Church, such as the traditional concepts of the Virgin Mary, the sacraments, and the saints.

Similarly, throughout Church history there had been many Christians who sought a direct mystical experience of God and therefore devoted themselves to the individualistic service of Christ. Nonconformists of this type went to extremes in religious meditation. In their search for God they found it possible to dispense with that part of the Church that served as mediator. Among these nonconformists was Joachim of Flora, who elaborated a concept of world history based on mysticism.

Universities

The spirit of independent inquiry and of unorthodox theological investigation was greatly furthered by the establishment of additional universities. The most important became those of Paris and Oxford, both of which soon grew to enormous size. Rich and poor were admitted both to the faculty and to the student body. The goal was preparation for professional life; conclusion of studies was marked by the conferring of degrees. The universities taught theology, philosophy, law, and medicine. They enjoyed such privileges as tax exemptions and autonomous jurisdiction, which were accorded by popes, kings, and princes. Some (masters' universities) came under the administration of professors, others (students' universities) under that of students.

The influence of the universities was immense. They fostered doubt and inquiry, which led to scholarly achievement. They stimulated the entire educational system of the existing monastic, cathedral, palace, and—later— municipal schools. The number of those learning at least reading, writing, and some elements of the seven arts increased. In the twelfth century, although England apparently possessed comparatively few laymen with scholarly training, France, Germany, and especially Italy possessed considerable numbers.

The influence of universities was felt in Church affairs and in the political realm. Masters and students, for their own protection, and for the purpose of gaining increased privileges, organized fraternities similar to guilds of artisans. Constituting a state within the state, they often participated in local politics and became a formidable threat to existing social institutions.

Universities benefited greatly from Arabic studies of Latin and Greek and from Arabic interpretations of Euclid, Ptolemy, Hippocrates, and Aristotle. The Western students studied Arabic advances in medicine, mathematics, algebra, astronomy, geography, and mapmaking. They became acquainted with the works of great men such as the philosopher Averroes and the geographer Idrisi.

Arabic influence spread outside the universities, too, as the West learned much about fine arts from the richly ornamented handicrafts and architecture of the Moslems. It also learned to imitate their agricultural methods and industrial work, particularly their textile and steel manufactures. Western

people adopted Arabic words, such as *cotton, check,* and various astronomical terms. Most important, they learned to use Arabic numerals, including the zero, and methods of computation. They derived some useful information even from Moslem pseudo-sciences and superstitions. In political affairs, they applied some of the methods of Oriental despotism. And they became more luxury loving, more cosmopolitan, in everyday life.

Law

In addition to theology, philosophy, and medicine, the universities came to excel in the field of law. Canon law was reinterpreted and codified. Gratian (ca. 1140) gained lasting fame for his publication of the *Decretum,* a collection of Church laws with a commentary. Secular law was also reinterpreted. The Justinian law code was analyzed, and many of its concepts were adopted.

Cruel and superstitious ordeals, which had been used to prove the guilt of the accused, became less and less acceptable. Even though cruel punishments, including torture, continued in use and in some cases even increased, the ordeals were replaced by more adequate methods of determining guilt. However, practice varied widely in the method of investigation and in the punishment of crime. Both investigation and punishment still depended to a large degree upon the birth and rank of the accused person. Yet considerable progress was made, particularly in England, in making legal procedures more uniform and punishment more humane.

Court Life and Literature

Throughout the twelfth century, learning and art remained closely interwoven with, and often subject to, theology. But cultural endeavors along secular lines increased as well.

In this development France excelled. At the courts of the highborn, notably at the court of Eleanor of Aquitaine, educated men and women frequently gathered. A gentler spirit, furthered by the growing veneration of the Virgin Mary, pervaded society. Women played a more respected role. Poetry and music embellished court life; feudal courtly ways were idealized.

Younger sons of the nobility, who lacked a fief or a Church benefice and thus had no solid station in life, occasionally turned to intellectual endeavors and made their living by entertaining the great lords. As troubadours or wandering knights, they sang of chivalrous tournaments at arms, of the deeds of ancient heroes defying a stern fate, of the beauty of nature, and of women and courtly love. They recited heroic tales, as in olden times, and they composed new tender lyrics.

They supplemented Latin poems with those in the vernacular and works for oral recital with written compositions. In France, Chrétien de Troyes wrote about the eternal love of Tristan and Iseult (Isolde). Other troubadours sang new *chansons de geste*, and the *Song of Roland* found its final form. Courtly ways spread to other countries.

In Germany, *Minnesänger*, counterparts of the troubadours, appeared: Walther von der Vogelweide created his undying lyrics; and the powerful moving *Nibelungenlied* was composed. England contributed romantic tales about King Arthur and his knights of the Round Table. Everywhere there were wandering students who composed serious and tender songs, as well as raucous and libertine (*goliardic*) verse. Though sometimes mixed with Latin, they were written in the vernacular French, German, and Italian. Minstrels and *Spielmänner* entertained not only the noble and rich at their courts but also the common people at fairs and marketplaces.

Aside from epic and lyric poetry, numerous prose works, both in Latin and in the vernacular, originated in the twelfth century. Their value has only gradually come to be appreciated. Besides legends of the saints, these prose works included stories about classical heroes, especially Alexander the Great (who was often transformed in character and placed in a Christian medieval setting) and about the Greeks besieging Troy. Books were also written on numerous subjects ranging from the various sciences and pseudo-sciences to hunting and history. Chronicles of noteworthy events were compiled.

Music

Recitations of poetry were generally accompanied by music, in which instruments (harps, lyres, and horns) supplemented the voice. Partly under the influence of folk songs, the mighty *unisono* Gregorian chant (vocal music without instrumental accompaniment) developed vigorously. In addition to this one-voice music, polyphonic music, music with many voices, began to evolve. Like so many other cultural accomplishments, the most notable musical achievements originated with the Church. Some of the most beautiful liturgical and choral compositions of all time were created.

Arts

In the arts, there were few new departures, but accomplishments along traditional lines were manifold and impressive. Medieval artists did not aspire to originate new forms but preferred to do creative work in accordance with long-established values and patterns. The Romanesque style continued to dominate architecture. Churches in this style were built not only throughout the West but also in eastern Europe. Romanesque influences spread as far as Novgorod and Suzdal in Russia. As architects again gained increased mastery of technical problems, they built churches on the largest scale the West had seen since classical antiquity. This trend toward large dimensions indicated, perhaps, a certain decadence, a certain lack of ability to give new significance to traditional forms of artistic expression. During the second half of the century, a new style—the Gothic—emerged. Nevertheless, a beauty seldom achieved still characterized twelfth-century Romanesque church architecture, a beauty that cannot be described in words but must be seen and experienced in reality.

Painting of miniatures also continued to flourish. Artists decorated books with exquisite illuminations. Pictures created in the style of Byzantine icons enriched the treasures of the West.

Social Conditions

The vigorous intellectual activity of the twelfth century was both the cause and the effect of wide societal changes. Courts, especially in Western Europe, became centers of art and general culture as well as of military undertakings and law. Rulers and vassals, townsmen and even peasants, developed new character traits. Christianity began to shape their moral standards; law, their daily actions; sciences and arts, their manners, customs, and aspirations.

THE NOBILITY

The outlook on life of many strata of the nobility seems to have changed swiftly during the twelfth century. Although courage was demanded of the knight, as always, and loyalty to his overlord remained the basis of his social position, the concept of a contractual relationship between lord and vassal was no longer meaningful. The code of chivalry with its ceremonies began to become an empty gesture. These changes were more pronounced in some regions than in others. But everywhere noblemen seem to have turned to new objectives in life. Thus the owner of a manor might be more concerned about the work of his peasants and the prosperity of the countryside. He might take a greater interest in the type of tools used for the cultivation of his fields and try to improve his breed of cattle. He might favor the planting of new crops and the use of the three-field system. Although commercial activities still did not seem quite "honorable" among the nobles, the lords did, nevertheless, increase their participation in trade. They often attempted to derive extra income from new methods of taxation. Many were inspired to adorn and beautify their surroundings.

A pronounced change also occurred in the military sphere. Many more castles, with heavy towers and walls and wide moats, which were easy to defend, were constructed. Castles remained uncomfortable, primitive, dank, and unhealthy, but they did provide a large measure of security. Heavy plate armor (worn over the coat of mail, which consisted of interlocking metal rings), though costly to manufacture, gave the knights protection in battle and reduced the importance of valor. Fighting became more of a business. The collection of ransom from a fallen foe instead of killing him or chivalrously sparing his life became the objective. Casualties among the nobility were relatively few.

THE BURGHER

An increase in wealth, and thereby in power, was not limited to the nobility. The townsman—the burgher—also knew how to enjoy wealth and power. With progress in agricultural methods and steady improvement in the

production and distribution of food, the number of towns multiplied. They sprang up not only on old Roman sites but also in newly colonized regions, in central England, northern and eastern Germany, Scandinavia, Hungary, and Russia. Towns were built near castles or cathedrals, and on trade crossroads, rivers, or inlets of the sea. They gained additional importance and prestige if they harbored a university or sponsored fairs to which visitors from afar traveled.

The towns were peopled by freemen—artisans, merchants, and day laborers—as well as former serfs who had escaped from the land to which they had been attached. Once in town, a serf found shelter and asylum, for towns needed additional hands. At the end of a definite period (often "a year and a day"), serfs legally gained their freedom. The burghers came to constitute an important third estate, distinct from the clergy and the nobility. They built high walls and gates around their towns to protect them from aggressive lords. To insure safe transportation on the highways, the traders traveled heavily armed, prepared to deal with robbers.

Soon some of the lords began to realize that the towns, even though their power made them somewhat independent, could offer important advantages as a source of needed revenue. They therefore granted the town populations exemptions from labor services and gave them charters, privileges, and jurisdictional rights. In exchange, they demanded payment of customs and other taxes or fees. Towns were thus enabled to find a place in the feudal hierarchy.

Life in town was in some respects easier than life outside. Not only did the burghers find better protection, but they also obtained a more efficient government and more equitable justice. They enjoyed a more luxurious, cultivated way of life, notwithstanding the price they had to pay in terms of noise, overcrowding, dirt, fires, pestilences, and similar causes of discomfort and danger. Municipal government was, of course, in the hands of the most prosperous burghers, who tried to exercise control for their own benefit. Social stratification was rigorous. Clear differences existed between the wealthy merchant, the typical artisan, and the unskilled laborer (or carrier). The latter's living conditions remained pitiable. Possession of money became a criterion for rank.

In Italy, with its comparatively ancient towns, the twelfth century saw the development of primitive forms of capitalism. Despite Church prohibitions, there were vigorous money markets, where money changers exchanged the silver and gold coins of the various provinces at a profit and where money lenders provided loans for interest. Speculation in real estate was common, and various forms of financial activities supplemented industrial and agricultural activities as a source of income. Christian bankers began to rival Jewish ones. The lives of the Jews, who relied largely upon activities such as money changing and lending and on trade, became more

precarious. Numerous persecutions of Jews occurred in England, France, and other European countries.

Political control in the towns was mainly in the hands of the guilds, which had been organized to protect property rights. Beginning with guilds of merchants, these protective organizations were gradually extended to embrace all the crafts. They regulated working conditions, standards of production, retail trade, and taxes. They provided insurance and support in old age and sickness and care for widows. They organized social life. They prescribed the artisan's path of advancement from apprentice to journeyman to master. The rank of master was reserved for those socially acceptable craftsmen who could demonstrate proficiency in their trade.

THE PEASANT

Social changes also affected the peasants. Towns offered opportunities for work and enabled some peasants to leave the manorial lands. They could then avoid compulsory labor service and free themselves of serfdom. Others would find a haven of comparative freedom in recently deforested areas brought under cultivation and in newly colonized regions (particularly in eastern Europe) in which the lords could not claim ownership of all the available land. The flight of many peasants from the land to which they were attached forced the lords to ease the burdens on those who remained (e.g., their service obligations could be converted into payments in kind). Therefore they too gained in freedom.

The life of the peasant was also made easier by technical innovations, such as wind and water mills (reflecting the growing rational and inquisitive spirit of man), the horse collar (which had actually been used on a restricted scale in the tenth century), and heavier plows. Moreover, expanding markets increased the peasants' income by providing new outlets and raising prices of agricultural products. Thus at the dawn of the thirteenth century, the peasants, though still carrying the main burden, had in many regions improved their economic position.

During the twelfth century, Frederick Barbarossa succeeded in restoring imperial authority. In various parts of Western Europe, kings likewise gained in strength. They all endeavored to replace part of the services of the nobility with those of the bureaucrats—i.e., appointees of their own, whether ministeriales, bailiffs, or others. Basic feudal loyalties weakened. The influence that the Church and, on the secular side, growing towns exercised worked in the same direction toward weakening the feudal nexus. Education through secular and Church schools was widened. Besides a rapid extension of commercial activities, a renaissance of secular thought occurred that permeated scholarship and arts. This cultural flourishing was, however, well within the framework and atmosphere of the religious spirit of the times,

which, notwithstanding superstitions and belief in devils and gremlins, governed daily habits as well as all extraordinary achievements of the mind.

Selected Readings

Arnold, B. *German Knighthood, 1050–1300* (1985)

Benson, Robert L., and Giles Constable, eds. *Renaissance and Renewal in the Twelfth Century* (1982)

Brooke, C. N. L. *The Twelfth Century Renaissance* (1969)

Davies, N. *God's Playground: A History of Poland* (1981)

Ennen, E. *The Medieval Town* (1979)

Hallan, E. M. *Capetian France: 987–1328* (1980)

Jones, Charles W. *Medieval Literature in Translation* (1950)

Jordan, K. *Henry the Lion* (1986)

_____*The Letters of Abélard and Héloise* (1974)

Leyser, K. J. *Medieval Germany and Its Neighbors, 900–1250* (1983)

Morrison, K. F. *Tradition and Authority in the Western Church* (1969)

Munz, P. *Frederick Barbarossa* (1969)

Oman, Charles, W. *A History of War in the Middle Ages* (1953)

Power, Eileen. *Medieval People* (1952)

Reuter, T. A., ed. *The Medieval Nobility* (1978)

Reynolds, S. *Kingdoms and Communities in Western Europe, 900–1300* (1984)

Vlasto, A.P. *The Entry of the Slavs into Christendom* (1970)

Von Grunebaum, Gustave E. *Medieval Islam* (1953)

16

The "Greatest of Centuries" (Thirteenth Century)

1202	Founding of Order of Livonian Knights (Brethren of the Sword)
1204	Death of Maimonides
1202–1204	Fourth Crusade; capture of Constantinople by Crusaders
1209–1213	Albigensian "Crusade"
1212	Children's Crusades
1213	England becomes Papal Fief
1214	Defeat of Emperor Otto IV at Bouvines
1214–1250	Reign of Emperor Frederick II
1215	Fourth Lateran Council
	Founding of Dominican Order
	Magna Carta imposed by Barons on King John of England
1223	Tartar invasion of Russia
1226–1230	Establishment of Teutonic Knights in Prussia
1226	Death of St. Francis
1226–1270	Reign of King Louis IX of France
1229	Emperor Frederick II regains Jerusalem
1231–1233	Permanent organization of Catholic Inquisition
1237–1240	Tartar conquest of Russia
1240	Defeat of Swedes on Neva River
1242	Defeat of Livonian Knights on Lake Peipus
1248	Christian Spaniards take Seville
1248–1254	Seventh Crusade
1256–1273	"Interregnum" in Germany

1259 Rise of Hanseatic League

1261 End of Latin Empire of Constantinople

1266 Charles of Anjou becomes King of Sicily

1270 Eighth Crusade; death of St. Louis

1271–1295 Marco Polo's travels in Asia and China

1272–1307 Reign of Edward I of England

1273–1291 Reign of Emperor Rudolf of Habsburg

1274 Death of Thomas Aquinas

Second Council of Lyons

1280 Death of Albertus Magnus

1282 Sicilian Vespers

1285–1314 Reign of Philip IV of France

1291 Beginnings of Swiss Confederation

Fall of Acre, last Christian Bastion in the Holy Land

1292 Death of Roger Bacon

1294–1303 Reign of Pope Boniface VIII

1295 "Model Parliament" convoked in England

The great eastward colonizing movement of the West was brought to a halt in Asia during the twelfth century and in Europe during the first half of the thirteenth. But the undiminished vitality of the West continued to appear in so many other ways that some historians have spoken of the thirteenth century as the "greatest of centuries." Individuals who left a deep and permanent stamp on Western civilization appeared in the political and religious arenas, as well as in the great universities and among the artists, poets, and scholars. The idea of a universal Church triumphed. Europe, combining its classical heritage with Catholic Christian tradition, reached a crowning point in its intellectual and artistic evolution.

THE UNIVERSAL CHURCH

By the beginning of the thirteenth century, the Catholic Church had grown into an organization possessing both spiritual and worldly power. The Church enjoyed many advantages. But it also had to deal with numerous vexing problems—the same kinds of administrative, political, and foreign issues confronting most of the European governments. Throughout much of the thirteenth century, the Church was fortunate in that the popes were men who combined a conception of their religious duties with an ability to administer effectively a large and oftentimes worldly, secular institution.

Age of Innocent III

When the century began, Innocent III (d. 1216) was at the helm of the Church. Elected in 1198 at a youthful age, he became one of the most famous popes of all times. Like Gregory VII, he was perhaps more of a statesman than a churchman.

INTERNATIONAL CHURCH AFFAIRS

Innocent III vigorously built the worldwide authority of the Church. He acted as the arbiter in the struggle between the Hohenstaufen (Ghibelline) house and the Guelph family for possession of the throne. Innocent first helped to raise the Guelph Otto IV, Henry the Lion's son, to the imperial throne. But later he defeated Otto IV with the help of the French, replacing him with his ward, the Hohenstaufen Frederick II. The pope interfered in French policies of state, insisting that the French king Philip Augustus take back a rejected wife. He imposed his will through an interdict on the whole French country, by which nobody in all of France could receive the sacraments or Christian burial.

By means of interdict and excommunication, he forced King John of England to acknowledge papal rights in matters of clerical appointments. Contrary to John's wishes, he raised Stephen Langton to the see of Canterbury. Not only was John forced to yield, but he also had to acknowledge the pope's overlordship. England thus became a papal fief for almost a century and English kings had to pay feudal dues to the popes.

Innocent also intervened in political struggles on the Iberian peninsula. Again he made use of interdicts to enforce his decisions. He succeeded in making the popes feudal overlords of Castile as well as of Sicily.

CHURCH ADMINISTRATION

Innocent owed many of his successes to his able administration of the papal realms. He achieved what most worldly rulers in their own countries strove for in vain: the establishment of a central governing authority that was the only final source of political power. Innocent applied the monarchical

principle within the Church. He obtained recognition of supreme appellate jurisdiction for the papal see, secured control of clerical appointments in imperial and other lands, and, like Gregory VII, exercised supervision of all Church business through a corps of legates. He succeeded, at least for a time, in suppressing all interference by the Roman nobility and by foreign powers in the affairs of the papal states. His insistence on careful collection of dues and tithes (despite the fact that part of these often went to local lords) increased the revenues of the Church. Competent administration of the funds in turn increased the power of the popes.

FOURTH LATERAN COUNCIL

With equal forcefulness, Innocent III made final decisions in spiritual matters. In 1215, he convened a council at the Lateran and imposed his wishes in matters of ecclesiastical discipline. He settled debatable questions about dogma, including controversies about the sacraments. He decreed that no new monastic orders must be founded. He introduced measures to regulate the position of the Jews in society, opposing their financial practices. He organized a campaign against the leading group of heretics, the so-called Albigenses.

HERESY

The Albigenses (or Cathari) were pious men and women who had adopted some tenets of the Manichaeans, who believed that not a single God but two powers, good and evil, reigned in the world. Like Peter Waldo's followers, the Waldenses, the Albigenses condemned worldly property and many of the mores and customs (such as marriage) that constituted the foundation stones of Church and society. They became a popular group in southern France.

Innocent III tried to win them back to the fold by peaceful means, but these failed. In 1209 he sent a "crusading" army under a papal legate to destroy them with fire and sword. When lords like Simon de Montfort, who coveted their lands, joined these efforts, most of the sect was destroyed. The survivors were dragged before an ecclesiastical tribunal. Entrusted with the task of "saving" the sinner and protecting the Church, the tribunal tortured them into confessing their "guilt." The convicted Albigenses were then handed over to the civil authority, which condemned them to loss of property, exile, or death.

INQUISITION

The system of inquiring into the faith of those who were suspected of heresy was organized in 1233 into a permanent institution under one of Innocent's successors, Gregory IX. It was a system applied occasionally in earlier times by local ecclesiastical courts and used broadly and harshly in Innocent III's time against the Albigenses. This institution came to be called

the Inquisition. It was a tribunal, charged with inquiring into the Catholicity of the views held by individuals suspected of heresy. Nonconformists were to be punished with penance or excommunication. But since no clear division existed during the Middle Ages between the duties of spiritual authorities and those of worldly rulers, Church action generally implied state action. Consequently, condemnation by tribunals of the Inquisition (often the result of confessions obtained through torture) meant the infliction of the most severe penalties by state authorities. Punishment ranged from confiscation of property to imprisonment, exile, and burning at the stake.

FOURTH CRUSADE

Several crusades were sponsored by Innocent III. Soon after he became pope (in 1198), the Fourth Crusade was undertaken. The death of Saladin in 1193 had revived the hopes of the Christian world; religious fervor still existed. Prayers were offered for the success of the crusade. Almost a third of the Church income was set aside for it. Jewish money lenders were forced to cancel debts and interest, and merchants were warned against providing the Moslems with supplies. But all was in vain, for the crusade, begun in 1202, was destined to end in failure.

When the armies assembled in Venice, funds were already exhausted and the crusaders, in order to secure transportation, had to submit to conditions imposed by Venice with the aim of gaining profits rather than saving souls. The Venetians demanded that the crusaders first conquer the Christian town of Zara, an Adriatic seaport that was a commercial rival of Venice. This the crusaders did.

After proceeding from Zara, they were diverted a second time from their aim when a claimant to the Byzantine throne persuaded them to attack Christian Constantinople. The Byzantine Empire was in a state of disintegration and internal discord. The conquered Balkan Slavs had risen against it, while the Turks assaulted it from the east. The Italian towns of Pisa, Genoa, and Venice used it as a battleground on which their own commercial interests were advanced.

The crusaders yielded to temptation. They besieged and conquered Constantinople. The pope reconciled himself to this act with the thought that the members of the schismatic Greek Orthodox Church might be brought back into the Catholic fold. While the road to the Holy Land was forgotten—except by pillaging knights and soldiers in search of relics that could be turned into money—a Latin Empire of Constantinople was founded. Baldwin of Flanders became its emperor, and Frenchmen and Venetians seized the provinces. The great city of Constantinople itself was ruined. It lost its place as the foremost market on the East-West trade routes. Venice secured the benefits of its remaining commercial functions.

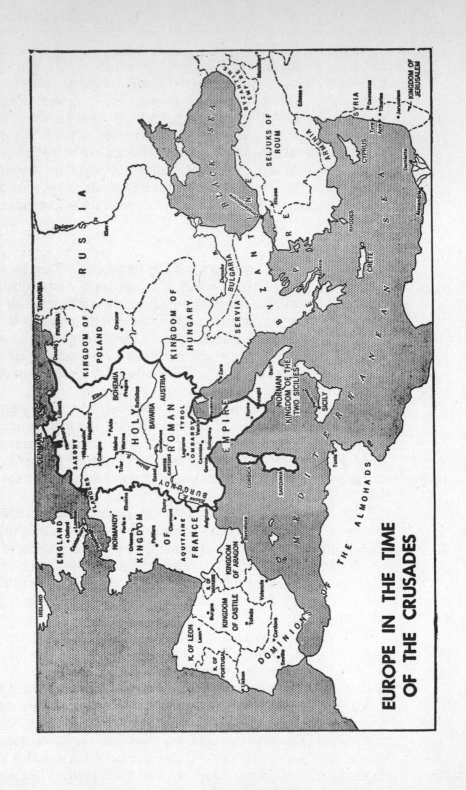

EUROPE IN THE TIME
OF THE CRUSADES

CHILDREN'S CRUSADE

The Fourth Crusade was followed by the strange enterprise known as the Children's Crusade. This represented an attempt to compensate for the sins and failures of the adults who had not recovered the Holy Land. Innocent children, it was hoped, would succeed. Thus in the year 1212, long columns of boys and girls (French children led by a boy of twelve named Stephen and German children led by a boy of sixteen named Nicholas) marched from their native lands through European countries, over the Alpine passes, and down to Mediterranean ports. Even the sick and crippled joined the procession.

But the crusades, which had begun in an atmosphere of unhealthy, psychopathic rapture, ended with thousands dying en route. Other thousands were sold by Christian and Arab shipowners into Moslem slavery. Innocent III promptly started preparations for another Crusade but died before they could be completed.

Successors of Innocent III

Innocent's ability to promote the political influence of the Church proved in the long run to be a danger to the papacy itself. He had established a precedent for future popes to attempt tasks extraneous to the proper functions of the Church. Nevertheless, for more than half a century, his successors managed to maintain the dominant position gained by Innocent. They kept the Church's monarchical structure intact, and they enforced their jurisdictional rights. They also brought the conflict with the imperial house of Hohenstaufen to a successful conclusion. The danger posed to the papal states by the union of Germany and Sicily by virtue of Henry VI's marriage with a Norman princess was ended.

Innocent's successors failed, however, in their efforts to regain the Holy Land through crusades, just as Innocent had failed. They likewise did not succeed in their attempts to turn the capture of Constantinople (in 1204) into a real victory. The Orthodox patriarch, who had moved from that city to Nicaea in order to remain independent, continued to refuse, despite pressure from Rome, to submit to the authority of the papal see. In 1261 the Latin Empire itself collapsed. The Greeks under Michael Palaeologus reconquered Constantinople, the Byzantine Empire was revived, and the patriarch resumed his work in the capital.

New Monastic Orders

The stirring events outside the Church and the devotion engendered by the activities within it led to the founding of new monastic orders. Innocent III, disregarding the ban on new monastic orders issued by the Fourth Lateran Council, had eventually allowed their organization. The new orders were the Franciscans, the Dominicans, and the Carmelites.

ST. FRANCIS AND ST. DOMINIC

The Franciscan Order was founded by St. Francis of Assisi (d. 1226). Son of a wealthy merchant, he gave up all worldly ambitions, "married Lady Poverty," and preached the gospel of love. Followers—later called friars minor—gathered around him. Like St. Francis, they lived in complete poverty and begged for their daily bread (for this reason they were known as *mendicants*). They devoted their lives to comforting the poor and the ill and aided the needy through love and deeds. The spirit of compassion with all the world is most beautifully expressed in Francis's *Little Flowers* and his "Canticle of the Sun."

The Spaniard St. Dominic was Francis's counterpart. Although he possessed little of Francis's gentleness and childlike innocence, he shared the same intense desire to serve the Christian cause. As a priest, he devoted his life to preaching and missionary work. In order to spread the Christian faith he encouraged learning and worldly knowledge.

THE ORDERS

The Franciscan and Dominican friars, as well as the Carmelites, founded no cloisters. The Dominicans devoted themselves to intellectual endeavors. Through sternness and discipline of mind and body, they soon became, like their founder, outstanding teachers and preachers. They also came to be the leading agents of the Inquisition.

The Franciscans, in contrast, became known for their simple, loving, and tender methods. They were little concerned with the widespread cultural work that monks belonging to traditional orders pursued through their artistic, scientific, legal, and classical studies. They did not stress educational, agricultural, and political work. Living unattached, they preached to the poor and helped and nursed all supplicants.

Unfortunately, the standards of the great founder were not long maintained. The Franciscans amassed wealth and sank rapidly into idleness. To forestall conflicts with the official Church, which approved neither of the luxurious life of many of the Franciscans nor of the opposition of others to all worldly possessions, the Franciscan rule of complete poverty was changed by Francis's disciple and biographer Bonaventura (d. 1274). A limited ownership of property was officially permitted to the order. This trend was opposed by some, who seceded and were later called Spiritual Franciscans. In accordance with the ideals of the founder, these friars not only adhered to "Lady Poverty" but also favored mystical tendencies, which eventually caused many of them to be branded as heretics. Such deviations from ecclesiastical policy did not, however, prevent the Franciscans, Dominicans, and Carmelites from serving Church and papacy admirably for hundreds of years.

THE EMPIRE AND THE NATIONS

Developments in the thirteenth century showed clearly how much the political world had progressed beyond the feudal concepts of the tenth and eleventh centuries. A new age dawned. It was foreshadowed by men like the Hohenstaufen emperor Frederick II and the French kings Philip Augustus and Saint Louis and by institutions and events such as the interregnum in Germany and the signing of the Magna Carta in England. Law represented by bureaucracies triumphed over vague concepts of honorable relationships between the various estates or classes as promoted by a feudal nobility.

The Empire

As so often in the history of Germany, the transition from one stage of development to the next was abrupt. During the last two decades of the twelfth century, the Empire had reached a new apex of its power. It dominated the entire center of Europe as far south as Sicily. Then, after less than half a century, it declined so rapidly that it became powerless. For almost twenty years no emperor at all could gain recognition. When the Empire was revived, it resembled the old Empire more in form than in content. Yet in the meantime, the house of Hohenstaufen had produced in the person of Frederick II one of the most remarkable, inexplicable figures of the Middle Ages.

FREDERICK II

Henry VI's son Frederick II (d. 1250) had grown up in Sicily, where Christians, Mohammedans, Byzantines, and Jews lived side by side; where peoples, languages, and cultures had mixed, and where sciences and arts as well as different religions flourished. Frederick learned from these varied cultures and grew to be a man of extreme independence of mind. He hardly fitted into the age in which he was born. He became a skeptic, an individual thinker said to have rejected all religions as frauds, a willful and brilliant ruler, a poet, and a scientist. As a freethinker he tried to organize society and build a state on a rational basis. He wrote a book on birds and studied animals and human races with detached curiosity. He is justly known as *stupor mundi*, "the amazement of the world." But his work was out of tune with the spirit of the age. It is not surprising that before he died (in 1250) what he had created was already crumbling.

ITALIAN AND GERMAN POLICIES

After the death of Henry VI, Pope Innocent III, who feared the combined might of Germany and Sicily, attempted to separate the two areas. He tried to achieve this aim by securing the election of the Guelph Otto IV as emperor. His plan failed, for Otto (d. 1218) was as insistent on the German emperor's

rights in Italy as any Hohenstaufen. The pope himself therefore turned eventually to Frederick II, who had become king of Sicily. After Otto had suffered, in 1214, a severe defeat at the hands of the French, Frederick could not be prevented from gaining as well the German throne.

Frederick spent only a few years in Germany. He allowed the administration and jurisdiction there to slip into the hands of the princes and great lords. These nobles gained the right to leave their fiefs as an inheritance to their children without regard to the services implied and to decide matters of taxation without consulting the emperor.

In the meantime, Frederick focused his attention on Italy and Sicily. In northern Italy he sought, though with inconclusive results, to revive full imperial authority over the Lombard towns. In southern Italy he successfully built a modern bureaucratic, centralized government with an efficient and well-balanced tax system. His plans were astonishingly modern in their conception, and his achievements were great, even though they hardly survived him.

SIXTH CRUSADE

During most of his lifetime, Frederick was handicapped by incessant strife with the popes, who excommunicated him no less than five times. The main conflict began in 1228 when, after many delays, Frederick set out upon the crusade he had long promised to undertake. This crusade had become the more urgent as the Fifth Crusade, which had attempted to reach Jerusalem via Egypt, had ended in failure in 1221. Although under the ban of excommunication because of his delays, Frederick proceeded. And it was he, the excommunicated emperor, who succeeded where fervent Christians had failed. Through diplomacy, not through valor, he acquired Jerusalem from the Egyptian al-Kamil and made himself its king. The West was to retain the Holy City until 1244. After his return, his struggle with the popes continued, the principal issue being control over northern Italy and Sicily. It was not solved in Frederick's lifetime.

FREDERICK II'S SUCCESSORS AND THE INTERREGNUM

Frederick's heirs were unable to continue his work, and in 1268, after many reversals, the house of Hohenstaufen died out. Its last member, Conradin, a young grandson of Frederick, was decapitated by order of a French duke, Charles of Anjou, who had seized the kingdom of Sicily during Conradin's minority. In the meantime, Germany remained without an emperor.

Though various foreigners laid claim to the crown, no final election took place, and thus, in 1254, an *interregnum*, a period without emperor or king, of almost twenty years ensued. As a result the medieval concept of emperorship was undermined. Ecclesiastical and lay princes as well as imperial towns were able to stabilize their independent power. Because of the international

tasks of the emperor Germany had always tended toward decentralization, and now during a period when there was no emperor these trends grew stronger.

FRANCE

During the thirteenth century, as in the twelfth, political developments in France took a course very different from that in the Empire. While both areas gradually abandoned feudal institutions, Germany and Italy moved in the direction of a multiplicity of independent units dominated by great lords or oligarchies of rich burghers. France moved in the direction of a centralized state under the authority of the king.

PHILIP AUGUSTUS

During the reign of Philip Augustus (d. 1223), who came to the throne in 1180, centralized authority over the vassals was strengthened. The forces of disruption, which had prevailed under his father, Louis VII, were checked. Philip revoked many of the privileges that had been granted by Louis to the great nobles in exchange for their support against England. Moreover, fiefs that were escheated—or had been forfeited—were not allotted to new vassals. Whenever possible, Philip kept them as his personal domains to increase his revenue. He created *bailiffs* and *seneschals*, who administered the lands for him and dispensed his justice. He used the income to hire troops, which were often put under the command of the seneschals. Not only minor lords, but the great ones as well, had to acknowledge his supreme authority.

Cautious in financial affairs and intent on increasing his resources, he turned also to vigorous persecutions of Jews. Philip Augustus energetically, though not always successfully, carried on the war against England. When after the death of Henry II and Richard the Lion-Hearted, John of England refused to acknowledge the right of the French king to superior jurisdiction in English possessions in France, Philip declared all these possessions forfeit. He occupied Normandy, Anjou, and Artois. Shrewdly using Church approval to weaken his enemies, he successfully defended himself against England, as well as against England's German ally, Otto IV, whom he decisively defeated at Bouvines in 1214.

ST. LOUIS

Philip's work was continued by his grandson Louis IX (1226–1270), who was canonized because of his kind, chivalrous, and deeply religious character. He prevented the great nobles, who had begun to use the same effective political strategy as the king himself, from again becoming too powerful. Bailiffs, *enquêteurs*, or *missi* were appointed to build the prestige of the royal court. Justice was dispensed more honestly. Roman law was studied, and the *parlement*, a permanent institution charged with deciding final appeals, supplanted law courts formerly attached to the king's household. Louis secured peace within his realms by promulgating a truce of God, which

forbade all feuds for certain periods during the year. In the same spirit of moderation, he also promoted peace with England, giving up some of the territorial gains won by Philip Augustus.

SEVENTH AND EIGHTH CRUSADES

It was in Louis's time that the mighty movement of the crusades, which had spanned two centuries, came to a close. The so-called Seventh Crusade was led by Louis in 1248, four years after Jerusalem had been reconquered by the Moslems. But on the way, while passing through Egypt, Louis was captured and had to be ransomed at inordinate cost to the French. The Eighth Crusade in 1270 was also undertaken by Louis. It got no farther than Tunis, where Louis died. Not long thereafter, the last Western stronghold in the Holy Land, the fortress of Acre, was captured by the Moslems.

England

In England, as in France, central control grew stronger in the course of the thirteenth century. But in England the monarchy aspired to centralization and the nobility itself furthered this. For, during the long absences of the kings on their campaigns in France and elsewhere, it was able to reap the advantages of centralization.

JOHN AND THE MAGNA CARTA

The incapable Richard the Lion-Hearted was followed on the throne by his brother John, who was more able, though arrogant and much disliked for his brutality. His power and prestige, at first enhanced by the determined exercise of his royal prerogatives, suffered after he met with military defeats in France and with opposition from the Church. His position was further weakened when, in order to carry on his undertakings abroad, he increased his monetary demands on his English vassals.

The barons, supported by Archbishop Langton, revolted and coerced him, in 1215, into signing the *Magna Carta*, This document (which the pope later declared not binding) stipulated that the barons should not be tried except by their peers, that they should not be arrested arbitrarily, and that without their consent they should not be subjected to any levies, excepting the customary ones. The Carta in no way replaced feudal concepts with modern democratic ideas. Indeed, it enhanced and reaffirmed the barons' feudal rights. Its significance lies in the fact that it subsequently enabled various groups and classes of the population to appeal to the principles it embodied—especially those encompassing "due process of law." What had been granted the barons could also be asked for by others.

HENRY III

The Magna Carta, instead of bringing peace, led to new civil strife, which continued under John's successor, Henry III (d. 1272). Since Henry's long reign was a weak one, the nobles went on sharing the governmental powers

with the king. But a change was foreshadowed, for gradually the middle class began to make its voice heard in politics.

Spain

Owing to Spain's continued preoccupation with the Moslems, Spain's political role in European affairs remained limited during the thirteenth century. The struggle against the Moslems entered a new stage, though, when after a brief revival of Moslem strength a lasting decline set in. As a result, the kingdoms of Castile, Leon, Aragon, and Portugal, despite continued violent strife, were able to expand further. In 1234 the Spaniards took Valencia and, in 1248, Seville. Before the century was over, they reached the southern shores of the Iberian peninsula and began to turn their attention to overseas territories. They seized the Balearic Islands and placed an Aragonese prince on the throne of Sicily in 1282. They thus laid the basis for future maritime greatness.

Eastern Europe

From the time of Charlemagne on, Western civilization had progressed eastward—starting on the Rhine and reaching successively the Elbe River, the Oder, the Vistula, and finally the Baltic Sea up to the Finnish gulf. During the course of the thirteenth century, Western political expansion eastward came to a final standstill.

THE BALTIC AREA

The Christianization and colonization of the Baltic lands had been carried on by Germans, Danes, and Swedes. In order to acquire new agricultural lands and new fiefs, they had sought to conquer additional territories. In the time of Innocent III and his successors, the papacy had supported this drive in order to expand Rome's authority. It aimed at reuniting with the Catholic Church not only "schismatic" Orthodox Greeks in Constantinople but also Orthodox Slavs in Russia. The Order of the Teutonic Knights, which, like the orders of the Templars and the Hospitalers, had been established to protect the Holy Land, was charged with the task, and its activities were transferred to the Baltic region.

While the Teutonic Knights were colonizing and Christianizing Prussian lands on the lower course of the Vistula river, another order, the Brethren of the Sword, which had itself established at the mouth of the Duna River, colonized Livonia. Simultaneously, the Danes and Swedes were expanding their possessions in Estonia and Finland. Wherever knights and missionaries went, merchants followed. But in 1240, a halt was called to Western progress. In the great battles of the Neva (1240) and Lake Peipus (1242), the Russians, led by young Alexander Nevsky, defeated the Swedes and Germans. The Western nations had to give up their plans for further territorial expansion.

RUSSIA

At the very time, however, when Russia was successfully defending itself against the Catholic West—and shortly thereafter also against the aggressive pagan Lithuanians—another great Eastern invasion began. The Tartars, under the leadership of Genghis Khan, moved westward after conquering much of Siberia and China. In 1223 they crossed into Europe and defeated the opposing Russian forces. Russia was temporarily saved from subjection by the opportune death of Genghis Khan.

Deprived of his leadership, the Tartars retreated, only to return in 1237. By 1240 all Russia was at their mercy, and only with difficulty were they stopped at Germany's borders. Europe proper was saved, but for more than two hundred years Russia remained under Tartar rule. Although Tartar control was limited—the Tartars concentrated on levying tribute, drafting Russians as soldiers, and occasionally plundering the countryside—it had a lasting effect on the entire Western world. It recalled the dangers to which the West had been exposed by successive waves of Mongolian conquerors—Huns, Avars, Magyars, Tartars—and enhanced a feeling of common destiny. On the other hand, it tied Russia more closely to the East, helped to promote the power of the subservient Moscow granddukes at the expense of western Russia, and slowed the cultural growth of the conquered lands.

COMMERCE AND SOCIETY

In the thirteenth century the homogeneity of society was weakened. In the past, the agricultural economy had been rather similar in all regions of the West. Now differences became more pronounced. Population growth and the development of industry and commerce speeded up the changes. The specialization of labor increased, stimulated by the growth of towns.

Towns

Towns flourished throughout Europe. In the past, towns had generally tried to fit themselves into feudal social and economic patterns. But, owing to their own dynamics, they undermined feudalism and emphasized values alien to a feudal society. These changes occurred even though only a small fraction of the entire population lived in towns. Few towns had more than 50,000 inhabitants. Often even important ones had as few as two to ten thousand. Most of them were under oligarchic city governments.

In Italy, Milan, Venice, and Genoa were the leading centers of trade. Florence became a center of textile manufacturing. Siena, through its connections with the popes, became a banking center. In Spain and Portugal, the seaports of Barcelona and Lisbon flourished. In France, Marseilles, Lyons, and Paris became important merchant communities, as did London, Bristol, and York in England. In the Netherlands and Germany, Bruges, Ghent, Lübeck, and Danzig gained fame as seaports, Frankfurt and Cologne became known for their fairs, and Nürnberg gained a reputation for its manufactures. In Bohemia and Poland, Prague and Cracow prospered.

Because of their wealth, some of the towns were able to secure almost complete independence. They hired their own soldiers and sailors and joined to form leagues, thus gaining political power superior to that of many princes. Among the leagues were the Lombard League in northern Italy and the Hanseatic League of northern Germany. Both received wide privileges from worldly and ecclesiastical lords. As the towns grew in wealth and power, the burgher gained prestige. Social differentiation, though increased between rich and poor, decreased between nobles and merchants, and intermarriage between these two classes became common.

Commerce

Lack of source material makes it difficult for the historian to get a reliable picture of the importance of retail trade in the thirteenth-century economy. Communications were slow. It may be conjectured that retail trade remained comparatively insignificant, since most of the population continued to live in the country and provided for its own modest needs. Only in urban centers, such as those of northern Italy, could it have played a major role.

International and overseas trade, however, can be traced through a study of the documents in the archives of many commercial towns. Historians have shown that in the period of the crusades, shipping, exchange of commodities, and financial institutions had received strong impulses. Links then established with the East remained after the failure of the crusades.

Trade in one area stimulated trade in others, so that mercantile activities increased far more rapidly than did agricultural activities. Merchants saw to it that highways and seaways were kept safe from robbers and pirates. Money was coined in increasing quantities. Prices rose, and so did production. Transactions on credit became common. Business loans became available, despite the opposition of the Church to taking interest (which was branded as *usury*); such loans acted as a further stimulus to business.

Numerous trade routes connected the various parts of Europe. To guarantee their safety was one of the major problems of the burghers. Some of the most important extended from Venice or Milan across the Alps to southern Germany and either down the Rhine to the Netherlands or via Nürnberg, Lüneburg and Lübeck to Scandinavia. Others extended via Prague or Leipzig to eastern Europe. Still others extended from Genoa or Marseilles into the

interior of France, up the Rhone River into the Champagne, and on to the Netherlands and England. There were two great trade routes to the Orient, one from the Italian ports via the Mediterranean either to Egypt or to the Crimea and from these intermediary stations overland to Persia and India; the other ran from German ports, especially Lübeck, via the Baltic to either Riga and Reval in Livonia or to Novgorod in Russia, and from these places overland to Smolensk, Moscow, and possibly down the Volga to the Caspian Sea and Persia. By crossing Asia even distant China was accessible to the thirteenth-century traders.

In many foreign cities the Italians established *fondachias*, the Germans *comptoirs*, or staple-and-exchange centers. Most famous were those of the Italians in Constantinople, Alexandria, and Kaffa (southern Russia), and those of the Hanseatics in Bruges, London, Bergen (Norway), and Novgorod.

European merchants exported cloth, armor, horses, quicksilver, copper, herring, and salt. They imported furs, timber, tar, honey, and wax via the Baltic, and precious stones, spices, drugs, and dyes, as well as silk, cotton, and metal objects via the Mediterranean. Because of the higher standards of the Eastern world, the trade balance was in its favor. The West was forced to make up the difference through the export of gold or silver.

Society

Commercial expansion contributed to shifts in the relative importance of the feudal classes. These shifts primarily affected the nobles and the townspeople, and to a lesser extent the peasant class.

THE NOBILITY

The nobles remained the most important class, but they found their monopoly in offensive arms threatened. Technological advances rapidly altered the art of warfare and traditional concepts of chivalry. Moreover, the prospering towns could, with their increasing wealth, build up a military might of their own and fend off encroachments by the nobility. Many nobles tried to make up for their losses by taking on administrative duties and securing high government posts. Others expanded their commercial activities as producers of agricultural goods and as entrepreneurs in mining and industries.

THE CLERGY

Despite an increase in papal power, the clergy as a whole lost some of its status. Its position was adversely affected by the conflicts between national governments and papacy. It was also affected by the growth of monarchical strength whereby some of the privileges—and tasks—of the Church were absorbed; by a loss of jurisdictional rights in various regions; and by problems arising from the difficulty of reconciling worldly ambition and competitive economic enterprise with the tenets of Christianity. Only to

a limited extent was it possible for these losses to be compensated by the widening of the clergy's educational functions and influence.

THE BURGHER

The townspeople gained more than any other class from the changes that were taking place during the thirteenth century. They amassed wealth, which bought them influence. They enjoyed amenities and entertainments not available elsewhere. In exchange for aiding the monarch in his struggles with the nobility and providing the major portion of his tax revenue, they were accorded additional rights. Soon they, too, began to occupy important administrative offices. Moreover, in a world where money came to be essential, they had the means to pay for luxury goods and services. Those who profited most were not the producers and artisans, but the merchants. They were the ones who controlled the funds. They employed the artisans and reaped the profits of business.

THE PEASANT

During the thirteenth century, the economic and social condition of the peasants was somewhat better than in preceding or subsequent centuries. In many regions, the process of liberating the peasants from the obligation of feudal services continued. Numbers of them escaped and found refuge in towns, where workers were needed and where, as a rule, they would gain freedom, since, according to a proverb of the time, "town air makes free."

In other regions, the status of the peasants did not change because lords of manors turned to commercial farming and could not dispense with their serfs' labor. Yet their peasants were often better rewarded for their work, and better care was taken of them in order to secure larger harvests and profits.

Travel

The entire medieval period is characterized by travel. Streams of pilgrims flowed from Scandinavia, England, Germany, France, and Hungary to the Christian shrines in Jerusalem, Rome, and Compostella in Spain. Journeymen crisscrossed European lands. Kings and courts moved from one castle to another. Scholars and students taught and studied in university after university. Knights, soldiers, musicians, and magicians traveled from court to court and from fair to fair. Increased trade added new groups of travelers. On trips lasting for years they crossed endless seas, steppes, and forests.

The most famous of the distant journeys was that of the Venetian Marco Polo, who spent twenty years with the Tartars and the Chinese. The Franciscan friar Orderic Pordenone and Louis IX's ambassador Guillaume Rubriquis visited the East. Missionaries such as John of Plano Carpini were sent by the pope to Russia and Tartary. John of Montecorvino (d. 1328) became the first archbishop of Peking in China.

SCIENCES AND ARTS

Nineteenth-century historians emphasized the unity of medieval thought and culture, as contrasted with the variety of modern civilization. Later research, however, has revealed an infinite variety in thirteenth-century Western culture as well. Advances in the scientific study of nature were made in an age when belief in magic and witchcraft was common. The Christianization and humanization of legal and political concepts were furthered in an age of brutality and growing disregard of honor and loyalty. A measure of classical scholarship was reintroduced without, however, giving up the emphasis on early Christian ways and traditions. Economic standards based on otherworldly concepts and feudal conditions existed side by side with standards reflecting a materialistic outlook and a spirit of commercial enterprise.

The age was full of contradictions, as every age is. No single encyclopedic work—or *summa*—written during the thirteenth century to summarize all contemporary knowledge and views actually succeeded in doing so. Each of those works reflected the prevailing theological point of view, which came increasingly under attack by new forces.

Science

The Western world's intellectual horizon was greatly enlarged as a result of such external factors as travel and war and such internal factors as ideas and individual genius. Evidence of this enlargement can be found in the numerous scientific works that reveal a more profound understanding of nature than was revealed in any earlier work produced in Europe since classical times.

New knowledge gained—though this was often pseudo-scientific—was combined with knowledge inherited from Arabs and Greeks. Geographical studies appeared. They were based on reports by recent travelers as well as on descriptive writings by the Greek Ptolemy or by Idrisi and other Moslem writers. Astronomy, algebra, botany, and zoology were studied. New textbooks on these subjects were written. Aristotle's scientific works were edited and explained by scholars who used not only Greek but also Arab sources such as the works of Avicenna and Averröes (d. 1037). Robert Grosseteste wrote commentaries on the Arab works. Albertus Magnus composed a compendium of knowledge about many scientific subjects. Roger Bacon, in his *Opus Majus*, discussed the methods and results of rational investigation. Other notable compendia or summas were written by Alexander of Hales and by Vincent of Beauvais. They included not only theological investigations but also commentaries on classical philosophy and studies of nature and social institutions. There was progress in medicine, following the teachings of the Jewish scholar Maimonides. The study of herbs and their

healing qualities was emphasized, and some improvement was made in therapy.

Many technological advances were made in the fields of optics and chemistry. Methods of papermaking were improved. Gunpowder was developed. Instruments such as the compass, the magnifying glass, and the chemical clock were invented or adapted from models devised by other civilizations. Agricultural implements such as the scythe, iron plow, and horse harness were increasingly used. Iron ore and iron tools became more important in production.

Scholasticism

Economic necessity as well as intellectual curiosity led to the establishment of many schools. While the guilds took over systematic training in trades, the universities encouraged intellectual endeavors. New universities were founded, the most important being those of Naples, Salerno, and Padua. The number of students increased everywhere. Students devoted themselves principally to the study of theology or philosophy. The achievements of "Scholasticism" became one of the great glories of the age.

REALISM AND NOMINALISM

Scholasticism was built upon the heritage of ancient Greece and early (patristic) Christianity, as taught by the Church fathers in the first few centuries. It attempted to reconcile faith with reason; it sought salvation through both. The "schoolmen" subordinated their reasoning to tradition, revelation, and the teachings of the Church. Nevertheless, they weighed the contradictory statements of earlier authorities in the attempt to solve, with the help of the dialectical (logical question-and-answer) method, the most complex theological problems and particularly how to reconcile revelation and reason. They tried to discover through science and faith a final proof of God's existence, of the immortality of the soul, and of the truth of individual Church dogmas. In pursuit of their studies, they were driven into opposing directions.

The realists, deriving their inspiration from Plato, believed in the existence of universal essences (beyond conception by the human mind). What is perceived through the senses or comprehended by reason was to them no more than a reflection of the real. In "universals" they saw that which existed in reality.

The nominalists, preferring Aristotle's position to that of Plato, argued that reality lay in the multiplicity of individual objects in the world. They denied the reality of universals, which were to them but names. Instead, they insisted that the human mind cannot conceive of anything but the "particular." Bernard of Clairvaux and Thomas Aquinas (the thirteenth-century philosopher known as the greatest of all schoolmen) were realist thinkers. Roscellinus and Abelard in the twelfth century, and Duns Scotus in the thirteenth, were Nominalists.

THOMAS AQUINAS

Thomas (d. 1274) is most famous for his *Summa Theologica*. A Dominican, preacher, and scholar who was also a poet and writer of hymns, Thomas surveyed the whole field of contemporary knowledge. With authority and logic, he presented thirteenth-century Catholic views of not only faith and Church, but also most other aspects and activities of earlier times and his own. Thus he analyzed the foundations of law, particularly the attitudes of the Ancients and the Christians toward natural law. He investigated the problems of worldly power, of kingship, and of the limits of secular rule. He dealt with economics, with questions of property, fair price, profit, and usury. He examined the question of heresy and its punishment. He discussed dogma. In all his work, he tried to reconcile Aristotelian logic with Catholic tradition and the tenets of St. Augustine and other Church fathers. In a sense, he codified the contemporaneous Catholic views. Thereby he established standards for future scholars, even if, by defining them, he also exposed the views to criticism.

Mysticism

The scholastic and logical trend in theology was counterbalanced by a strong trend toward mysticism. There were elements of mysticism in Thomas's writings and in the works of other great schoolmen, who quite generally maintained that revelation takes precedence over reason and logic. But the true mystics went further. Like their twelfth-century predecessors, they hoped to be able to perceive the superhuman, the divine, and to have communion with it during this life on earth. They felt that in human beings there is a spark of the divine, that, in times of contemplation or ecstasy (when the demands of reason and the preoccupations of daily life are overcome), can provide direct communion with God.

The Church continued to look askance at these mystics, who seemed to advocate communicating with God without the mediation of the Church. Unlike the great scholastic theologians, the Church in general considered reason of little value to faith. Nevertheless, mysticism developed rapidly during the thirteenth century. It reached its climax toward the end of the century with Meister Eckhart (d. 1327) in Germany. In Italy, Francis of Assisi and his successor, St. Bonaventura, were outstanding representatives of mysticism.

Architecture

It is to be expected that an age so imbued with religious fervor, so devoted to old and new paths of learning, so active, so contemplative, and so inspiring to individual genius, would naturally bring forth great works of art. One of the crowning achievements of the thirteenth century was the Gothic cathedral, which embodied the noblest aspirations of the age. Through pointed arches, which gradually replaced Romanesque roundness, through perpendicular structure that emphasized height rather than massiveness,

through flying buttresses (tall masonry of the outside walls of a church) and tall spires, the attention of the worshiper was directed away from this world and upward toward heaven. As symbols of the thirteenth-century Church, the cathedrals combined unity and multiplicity.

The construction of the cathedrals was made possible by the growing wealth of Western towns and by great collective efforts. Architects (the names of few of them are known today) proved masters of building techniques. Some of the cathedrals were under construction for several centuries. Plans and styles changed and mixed. As in Romanesque churches, beautiful sculptures to adorn the outside and inside walls related to the illiterate churchgoer stories of the Bible and mythological tales, or depicted kings and queens, churchmen, and noblemen. But frescoes, which often embellished Romanesque churches, were rare, for Gothic churches had little wall space. Instead, huge stained-glass windows were placed between the mighty pillars that supported a high roof. The devotion of the artists to their work and the spirit of sacredness that guided them have found their lasting expression in the masterpieces of Gothic art.

The Gothic style originated in France and spread to most countries north of the Alps. South of the Alps, particularly in Italy, it did not become as well established as in the north. The Gothic style was also used for secular buildings, city halls, and burghers' homes. It was reflected in various arts and crafts—in painting, miniatures, tapestries, and everyday utensils such as swords, chairs, doorknobs, and clothing.

Literature

Although it has been said that the cathedral was the chief artistic expression of the thirteenth century, lasting works of literature were also produced, notwithstanding widespread illiteracy even among the upper classes. In addition to many theological books written by schoolmen, the literature of the age included numerous scientific and legal treatises. Some of the most beautiful of Church hymns were composed, such as the "Stabat mater" of Jacopone da Todi and the "Dies irae" of Thomas of Celano. For Church literature, Latin remained the dominant language. But for other types of literature the vernacular was used more and more frequently.

Among the secular works created (in their final form) during the thirteenth century were Wolfram von Eschenbach's *Parsifal*, Gottfried von Strassburg's *Tristan and Isolde* (which surpassed Chrétien de Troyes' model), the Icelandic *Edda* of Snorri Sturluson, the French *Roman de la Rose*, new *chansons de geste*, and the Spanish *Cid*. There were also prose tales of chivalry and of ancient heroic deeds, chronicles of past and contemporary events, and travel accounts.

Besides Church literature, traditional songs, epics, and learned treatises, there were many works of poetry and prose, which were composed in a lighter vein: romances, fables, and stories, sung or told by students and

professional entertainers. They carried themes and traditions from place to place and thus contributed to a broad cultural exchange. Their productions were sometimes original, sometimes imitative. Often they merely ridiculed earlier traditions. Finally, the drama, long neglected as an art form, made its reappearance. So-called miracle and mystery plays were written; they were performed at certain times of the year in the marketplaces in front of cathedrals.

The thirteenth century contributed a wealth of cultural achievements rarely equaled in the history of Western civilization. Government by law matured, the arbitrary power of the lords diminished, bureaucracies strengthened, and towns gained in social and economic influence. Technological advances benefited agriculture and shaped the military, which, as armament depended increasingly on wealth, in turn led to a redistribution of power. The Church found new vigor not only through efficient administration but particularly through a new revival of faith, as proved by the life of outstanding figures such as St. Francis and the activities of monastic orders all over Europe. Scholasticism, while remaining embedded in the religious beliefs of the time, opened the way to doubt and investigation and thereby to radical changes in outlook. Artistic achievements in architecture, particularly Gothic cathedrals and town houses, have seldom been equaled. Lyrics, epics, and chronicles, often adorned by illuminations and illustrations, have retained their inspiration to this day. In many ways, the thirteenth century was, indeed, the climax of the Middle Ages.

Selected Readings

Artz, Frederick B. *The Mind of the Middle Ages: An Historical Survey,* A.D. *1200–1500* (1980)

Birt, David. *The Medieval Village* (1974)

Burrow, John A. *Medieval Writers and Their Work: Middle English Literature, 1100–1500* (1982)

Chaunu, P. *European Expansion from the Thirteenth to the Fifteenth Century* (1978)

Gies, Joseph, and Frances Gies. *Marriage and Family in the Middle Ages* (1987)

Godfrey, J. *1204: The Unholy Crusade* (1980)

Herlihy, David. *Medieval Households* (1985)

Kantorowicz, Ernst. *Frederick II* (1931)

Labarge, Margaret. *Medieval Travellers* (1983)

Murray, Alexander. *Reason and Society in the Middle Ages* (1978)

Postan, M. M. *Medieval Trade and Finance* (1973)

Rörig, Fritz. *The Medieval Town* (1967)

Ross, James B., and Mary M. McLaughlin. *The Portable Medieval Reader* (1977)

Russel, Jeffrey B. *Witchcraft in the Middle Ages* (1984)

Scammell, G. V. *The World Encompassed: The First European Maritime Empires, ca. 800–1650* (1981)

Tillman, H. *Pope Innocent III* (1980)

Walsh, James J. *The Thirteenth Greatest of Centuries* (1909)

17

The Eve of the Renaissance (1275 –1350)

1302	Papal Bull: *Unam Sanctam*
	Convocation of States General in France
	Rebellions of Townspeople in Flanders
1307–1314	Destruction of Order of Templars in France
1308	Death of Duns Scotus
1309–1377	"Babylonian Captivity" of the Church (Avignon)
1314	Scottish Victory over English at Bannockburn
1321	Death of Dante
1326	Death of Turkish Sultan Osman
1327	Death of Meister Eckhart
1328–1350	Reign of Philip VI Valois in France
1337	Death of Giotto
1337–1453	Hundred Years' War between France and England
1338	Diet of Rense regulating Imperial Elections in Germany
1340	English King Edward III claims throne of France
1343	Artisan rebellions in Florence
1346	Defeat of the French at Crécy
1347–1378	Reign of Emperor Charles IV
1348	Outbreak of the Black Death
ca. 1350	Death of William of Ockham

The Renaissance—that great age of outstanding human achievement that marked the transition from medieval to modern times—is dated by historians from approximately the year 1350. The period preceding it, from about 1275 to 1350, is one of the most contradictory in history. Countries that had advanced farthest on the road to the idea of a national state and to central government were thrown back into anarchy. Others that had promoted the idea of universal Christian government had to give up this ideal, yet found no other to take its place. The papacy, which had raised its pretensions to the highest level, found itself falling into the depth of the Babylonian Captivity in Avignon and into ensuing schism. Reason and faith, so recently wedded by the greatest of thinkers, demonstrated the irreconcilability of their positions. Faithful Christians and churchmen who attempted Church reforms along lines successfully followed by earlier reformers found themselves accused of treason and heresy. The unity of Western culture to the extent to which it had existed previously was undermined. If generalizations are difficult for any period in history, they become utterly impossible for that of the eve of the Renaissance.

DISINTEGRATION OF THE MEDIEVAL SYSTEM

In 1270, the eighth and last major crusade had taken place. It had gotten no farther than Tunisia and had brought the death of the French king Louis IX. A chapter in world history closed. As a "result" of the crusades, many noblemen had perished and others had been impoverished. This had led to a strengthening of royal power, to at least a partial cessation of the petty feuds that had disturbed peace and reduced prosperity, and to a social leveling process such as results generally from great wars. During and after the crusades, peasants saw opportunities for breaking some of the feudal chains that had tied them, as serfs, to their lords. Connections with the Moslem world promoted the growth of towns, trade, and worldly thought and affected the Church adversely. Faith diminished. Weakened by huge expenditures, frustrated idealism, and failure to carry the crusades to a successful conclusion, the Church lost prestige and authority.

Whatever influence may be attributed to the crusades, innumerable other factors, some traceable but others beyond the reach of historical investigation, contributed to the social and cultural changes. The crusades spanned a

period of nearly two hundred years (1095–1291); the world around 1300, naturally, looked different from the world of 1100.

The Papacy

Toward the end of the thirteenth century, the Church found itself apparently at the peak of worldly power. Imperial might had been broken, and everywhere papal authority was recognized as supreme. Yet underlying trends were unfavorable. Secular forces had either taken over or had claimed many of the functions that had traditionally been those of the Church. The crusading spirit had spent itself and could not be revived, despite vigorous attempts by Rome. The Moslems had made new inroads on the Christian world. Orthodox and Catholic areas were as divided as at the beginning of the crusades. Indeed, the Latin Empire of Constantinople, which had been founded to reestablish Christian unity under the popes, had fallen. Negotiations at two councils, held in 1245 and 1274 in Lyons, brought out old dissensions rather than a new will for unification.

BONIFACE VIII

In the face of existing trends, Boniface VIII, an arrogant and selfish man who became pope in 1294 and whose personal conduct as a churchman was not beyond suspicion, should have exercised the greatest restraint. Instead, in Rome, he antagonized the nobility, particularly the powerful family of the Colonnas, by filling offices with members of his own family. Abroad, he challenged the rights of kings to tax the clergy. He used various penalties (such as excommunication) to defeat political antagonists. He displayed both greed for revenues and lust for power; he sought to extend papal control by investing the Roman see with additional legal and administrative rights. In 1300, he declared a "jubilee year," but used this mainly for mercenary purposes by securing donations and funds from pilgrims coming to Rome. He reached the climax of papal pretensions when in 1302 he issued a bull, a decree, entitled *Unam Sanctam*, in which he not only asserted full papal jurisdictional rights over the clergy but also put forward general claims to supreme authority in secular as well as spiritual matters.

Perhaps this bull did not add anything new to views long held by the Church, but its wording and timing became Boniface's undoing. It was specifically directed against the French monarchy. Philip IV, king of France, as well as the English king Edward I and other princes, vigorously rejected Boniface's claims. Philip quickly called together representatives of the various estates of his realms and secured from them authorization for his own jurisdiction over clerics. Then he and other rulers accused the pope of various misdemeanors and summoned him before a council. Agents were sent out to bring Boniface, by force if necessary, before the council. Although this objective could not be carried out (despite an assault on the pope and his arrest in the town of Anagni) the papal position received an irreparable blow. Boniface himself died soon afterward.

AVIGNON

The early fourteenth century thus witnessed the collapse of the papal status as envisioned by Gregory VII or Innocent III. Within a few years of Boniface's death, the French king had secured the election of a French pope. This pope did not even take up his seat in Rome. Instead he chose to reside just across the French border in Avignon, on the Rhone.

Thus began the Babylonian Captivity of the popes (a reference to the Jewish exile in Babylonia under Nebuchadnezzar). It was to last for seventy years. In Avignon, the popes became rather subservient to French interests, and the popes' international standing was lost. Too often they displayed extravagance and love of luxury. Enormous sums were needed not only to finance the Church's proper tasks of teaching and charity but also to satisfy political and personal demands and to maintain armies in the field for the purpose of the recovery of the papal states in Italy. This need for money, in turn, increased the attention paid to administrative affairs. It led to sacrifices of moral standards and of spiritual authority. Opposition grew within the Church as well as from without, giving the Empire and the various kingdoms opportunities for greater self-assertion.

The Empire

Even before the fall of Boniface VIII and the Babylonian Captivity of the Church, the Empire had begun to revive. In 1273, the election of Rudolf of Hapsburg (who came not from one of the great ducal families but from a family of petty princes) as emperor ended the interregnum. This period of lawlessness and political disintegration was terminated.

RUDOLF OF HAPSBURG

The new emperor was a man of moderation and considerable ability. He knew how to keep peace in his realm, checkmate nobles who routinely robbed travelers in their lands, the original so-called robber barons, and regain dignity and authority for the office of emperor. He extended his own territorial possessions, adding Austria to his other holdings. Finally he became strong enough to reassert imperial rights in Italy as well.

But he did not become strong enough to introduce an efficient central government. Nor could he change the precedent that emperors had to be elected. This system served to perpetuate the power of the German princes, who, at the time of an election, could impose conditions of their own and thereby keep imperial authority weak.

As a result, after Rudolf's death, the development of political power in Germany continued along lines different from those in most Western countries. Rulers from various houses (Hapsburg, Bavaria, and Luxembourg) followed each other in the imperial office. Each paid primary attention to enlarging, through war or marriage, his own *Hausmacht*—that is, the

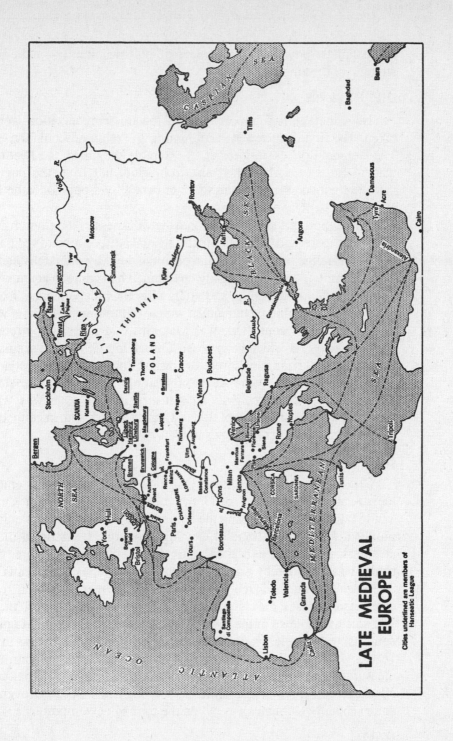

LATE MEDIEVAL
EUROPE

Cities underlined are members of
Hanseatic League

landholdings, power, and influence of his own family—rather than the strength of the empire.

DIET OF RENSE

Nevertheless, two important steps toward reorganization were undertaken. The first occurred in 1338, during the reign of Louis the Bavarian. The German princes declared at an assembly they held, the Diet of Rense, that an emperor derived his rank from God, not from the pope. It was therefore unnecessary for him to be crowned by a pope once he had been duly elected in Germany.

This important step reflected both the weakness of the Church during the Avignon papacy and the change in the general attitude toward secular offices. With the decline of feudalism, the positions held by monarchs had steadily gained in importance. Even many churchmen had come to acknowledge the divine origin of kingship and therewith its independence from papal authority. Among these churchmen were two prominent thinkers who came to live at Louis's court. One was Marsilius of Padua, who wrote a book, *Defensor pacis*, in which he opposed Church interference in secular affairs. Secular affairs, he insisted, were the responsibility of the Christian peoples and of the emperors, who had a Christian obligation toward their subjects and should defend peace even against a pope. The other was William of Ockham, who insisted on abolition of Church abuses and, in connection with this, wished to restrict the popes to their spiritual duties.

GOLDEN BULL

The second step toward reorganization of the Empire was embodied in the so-called Golden Bull of 1356, promulgated by Emperor Charles IV. While falling short of making the emperorship hereditary, this edict at least provided for a new method of electing emperors. It restricted the right of election to seven princes of the Empire, four of them secular, three ecclesiastical. The seven thereby gained the most important positions in all Germany. Their lands were declared indivisible, so that the eldest son (or, in the ecclesiastical cases, the clerical successor) would always inherit them intact. The electoral college of the seven was supplemented by a diet (a parliament comprising high clergy, noblemen, and representatives of the towns, and vested with legislative powers), and later by an imperial law court. By these measures the Empire was prevented from falling apart. Internal wars were checked, central authority was increased along with that of the seven electors, and eventually Germany was put on the road to new importance.

ITALY

After the interregnum, imperial influence in Italy declined. Italy gradually reverted to its previous division into three distinct parts: Sicily and the south, the papal states, and central and northern Italy.

In Sicily and the south, the French under Charles of Anjou had established themselves after the end of the Hohenstaufens. But they could not long maintain their status. Provoked by the brutality of Charles's forces, his financial demands, and his ambitious plans for expansion at the cost of the Byzantine Empire, the outraged Sicilians revolted. In the "Sicilian Vespers" uprising in 1282, they massacred the French garrison. Spanish princes from Aragon then took possession of Sicily; the Anjous were confined to southern Italy.

In the papal states, the popes and Roman nobility fought over control—a struggle solved essentially in favor of the latter, when the popes moved to Avignon.

In the central parts and the north, numerous individual city-states emerged. Most of them recognized the vague overlordship of the emperor. But they chose their own governments, whether Ghibelline, as parties sympathizing with the Hohenstaufen (or Ghibelline) tradition and often allied with the merchant class were called, or Guelph, who, since the times of the Guelphs Henry the Lion and Otto IV, had generally promoted the patrician and the papal causes. Often real power came into the hands of despots who seized the government illegally.

SWITZERLAND

Very special conditions developed in Switzerland, the small area that controlled a number of major Alpine passes and thereby formed the most important link within the Empire between Germany and Italy. Much of this area belonged to the Hapsburgs, and their governors administered it harshly. Early in the fourteenth century, when the peasants and a number of dissatisfied noblemen staged a successful revolt, Hapsburg domination was virtually abolished in central Switzerland. Connected with the revolt is the myth of *Wilhelm Tell*. A confederation of districts (cantons) was established. Through a common diet, it gained a measure of self-government unknown in other contemporary countries with a predominantly agricultural economy. Progressive laws sharply reduced the service obligations of the peasant population.

France

The death of St. Louis in 1270 did not interrupt the growth and consolidation of the monarchy in France. His son Philip III proved inefficient and unsuccessful in foreign as well as domestic affairs. But he did succeed in retaining most of the royal prerogatives. He greatly increased his royal domain by acquiring considerable additional territories through shrewd diplomacy and marriage alliances with wealthy families. His successor, Philip IV, "the Fair," pursued similar policies.

REIGN OF PHILIP IV

Philip IV was an able man, though of questionable character. Unlike most of the other kings during this era, he realized the power of money and did everything possible to strengthen his treasury. He reorganized the financial system, increased taxes, and confiscated the wealth of the Jews. He promoted the growth of towns and instituted a consultative assembly, called the Estates General, which included representatives from towns and country seats along with the clergy and nobility. It resembled the English Parliament. He made use of the Estates General not only as a means of gaining the support of wealthy townspeople for his financial policies, but also as a political instrument. With their help, he gained the right to tax the French clergy, notwithstanding the protests of Boniface VIII.

In foreign affairs, though Philip failed to conquer Flanders, he succeeded in seizing territory in Burgundy. He likewise succeeded in annexing parts of southern France after driving out the Knights Templars, who had established themselves there when the Holy Land was reconquered by the Turks. Under the pretext that they had neglected their duties, concentrated on the administration of their lands rather than defense, occupied themselves with banking activities, led a life of luxury, and were even guilty of heresy, Philip, greedy for their wealth and their position as international financiers, attacked them, crushed them, and had some fifty of them burned at the stake.

GROWING TENSIONS

Philip Augustus, St. Louis, and Philip IV had concentrated authority and wealth in the hands of the French king. They had acquired many new domains and had enlarged the functions of the court and the king's bureaucracy. They had broadened the activities of this bureaucracy, which served as the chief tax-collecting agent but was independent of the feudal hierarchy. All this strengthened the royal position and provoked jealousy and resistance.

In particular, the great vassals were antagonized. They battled this trend, though unsuccessfully, and thus in 1346 lost their right to coin money, in 1349 their right to levy troops of their own, and in 1357 the right to wage private wars. They were determined to prevent any further increase of royal authority. In imitation of the king's procedures, they themselves began to annex the lands of minor vassals and to organize bureaucracies. The townspeople, too, turned against the crown when they realized that the king's bureaucrats had assumed such broad functions that the king could use them to deprive the people of their traditional liberties. Under these circumstances, the conflicts between the king and the several estates became more acute each year. During the reign of Philip VI (1328–1350), they led to disaster. In 1337 the intermittent war with England was resumed, and the crown found itself without the necessary support.

OUTBREAK OF THE HUNDRED YEARS' WAR

The immediate cause for the resumption of hostilities was the decision of Philip VI to confiscate Aquitaine. A pretext for this decision was easily furnished. The English king Edward III (who held Aquitaine as a fief of the French king) had procrastinated in rendering due homage to his overlord and had otherwise neglected his feudal obligations. The struggle over the act of homage was one of long standing. In the time of Edward III such an act was, indeed, almost obsolete. But larger issues between France and England were at stake.

There were grave dissensions over the borders of Aquitaine, and—still more important—issues of an economic nature entered into the question. The wine trade of Aquitaine and the wool trade of Flanders with their profits for the French and English merchants were affected. The action of the French king led to a war that was to last for more than a century and became known as the Hundred Years' War (1337–1453).

At first, skillful French diplomacy, papal intervention, and lack of money and resulting bankruptcy on the English side aggravated the English position. But Edward succeeded in countering the dangers by imposing a boycott on Flanders. He thereby deprived the Flemish artisans of their livelihood and thus created social unrest in this French territory. He followed up his advantage by laying claim, in 1340, to the French crown, which, he insisted, was lawfully his on the basis of marriage and inheritance rights. As a result, a division in the allegiance of the French vassals occurred. Gradually the position of Edward improved. In 1346 he scored a great military victory at Crécy. Dismounting their cavalry and depending mainly on infantry and archers equipped with the unchivalric longbow, the English succeeded in defeating the French, who persisted in their antiquated feudal strategy. In the same year, the English took the harbor of Calais.

French losses led to peace negotiations, but when no settlement was reached, new English expeditions, often supported by dissatisfied French nobles, were equipped. Under the leadership of Edward's oldest son, the so-called Black Prince, the south of France was plundered. These disasters, combined with the pestilence of the Black Death, which had begun to ravage France in 1348, further diminished the French military potential. In 1356, at Poitiers, the French forces were again sharply defeated. Their king, John, was taken prisoner. Not until 1360 could he be ransomed, and then only at a huge cost in money, territory, and royal authority. Thus the first period of the Hundred Years' War had ended in disaster for France.

England

Political trends in England subsequent to 1275 were similar to those in France. In England, as in France, the authority of the king expanded. The powers of numerous royal officials to control national finance, law, and administration multiplied. The English Parliament, analogous to the Estates

General in France, became important and influential as the king's advisory body. After the outbreak of the Hundred Years' War, however, the political evolution of England began to differ increasingly from that of France.

EDWARD I

The transition period from 1275 to 1350 began with the reign of Edward I. Edward had to face political problems quite similar to those confronting his contemporary rival, Philip IV of France. In trying to solve them he relied, like the French king, on a steadily growing bureaucracy. In order to reduce the power of the nobility, Edward subjected many lords to inquests. He deprived them of illegally acquired landholdings and privileges and restricted their authority. At the same time, he reorganized the judicial institutions of the country by increasing the number of local courts, extending the jury system, and providing stricter royal supervision over the judiciary. New statutes based on existing common law gave prevailing legal practices a more precise and binding form.

The expansionist policies of Edward I appealed to a slowly growing nationalistic sentiment among the upper classes of the population. The English forces subjected Wales and even conquered Scotland. (After Edward's death, however, in the decisive battle at Bannockburn in 1314, the Scots under Robert Bruce regained their independence.)

PARLIAMENT

The evolution of Parliament was perhaps the most significant development of the period from 1275 to 1350. Gradually this assembly of the various estates replaced the *curia regis* of former English kings.

Parliament in England differed in many respects from the French Estates General. It was not merely a law court and an advisory body, but rather an assembly of delegates representing the diverse propertied groups of the population. It conveyed to the government the wishes of these groups (including those of the "commoners") on a variety of matters. It made its voice heard on the subject of taxation, particularly whenever taxes beyond customary limits were proposed. It even carried weight in the drafting of laws and the settlement of grievances against royal officialdom. In 1295, the so-called Model Parliament was convoked, and thereafter Parliament functioned as a permanent institution.

During the reigns of the successors of Edward I—that is to say, under Edward II (1307–1327) and especially during the long reign (1327–1377) of Edward III—the influence of Parliament increased. Both kings depended upon its cooperation, as they were hard pressed financially owing to the expenditures and debts incurred by Edward I. Neither of them possessed the necessary astuteness to establish leadership.

Edward III, in particular, showed little ability to retain control over Parliament. Interested in duplicating the exploits of earlier feudal knights, he had little understanding of the social changes that accompanied the transfer of power from the numerous vassals to the wealthy lords, squires, and burghers. Moreover, his absence from the country on military campaigns (the Hundred Years' War broke out during his reign) permitted Parliament to expand the scope of its activity.

At this time the two Houses (the House of Lords, with its hereditary peerage and the higher clergy, and the House of Commons, with its knights of the shires and wealthy burghers) no longer functioned as one indivisible body, as they had during the reign of Edward I. Instead, they got into the habit of discussing the respective problems separately. Soon the House of Lords dealt mainly with judicial matters and concentrated on its traditional task of advising the King. The House of Commons devoted its attention to taxation and trade, later extending its scope to political issues and questions of war and peace. As the reign of Edward III drew to a close, the two Houses had achieved their permanent status as an indispensable part of the English government.

Eastern Europe

The imperial and constitutional developments in fourteenth-century central and western Europe, which foreshadowed the decline of feudalism, had no parallels in eastern Europe.

CENTRAL EASTERN EUROPE

In Prussia, Livonia, Lithuania, Poland, and Hungary, political and economic feudalism based on agriculture and landholding persisted. Industries failed to develop on any large scale, and social stratification was not appreciably modified. Living standards were lower than in the West, and cultural contributions were relatively minor. Much of the area of central eastern Europe was torn by internal strife, for the divisions between Orthodox Slavs, Catholic Slavs, Germans, and Baltic (particularly the pagan Lithuanian) peoples were strong. A powerful commonwealth was nowhere established.

RUSSIA

The situation in Russia differed from that of her neighbors. Although the country remained subject to Mongol rule and was divided into numerous principalities (such as Novgorod, Moscow, Tver, and Smolensk), a nation of great significance began slowly to emerge. Gradually, Muscovy came to assume the role of leading principality.

Government. The city of Moscow became the seat of the Russian Metropolitan. The grand dukes of Moscow won a prominent role among the Russian princes. The grand dukes, being shrewd businessmen, catered to the Tartars (whom they served as tax collectors) and amassed wealth, which

enabled them to wield more power. Under their autocratic government, a feudal system such as had long prevailed in the West failed to develop.

Social Conditions. Most of the people lived in villages under various kinds of collective systems. The institution of serfdom as known in the West was hardly seen. Rarely did the nobility hold "fiefs" in exchange for service; a relationship based on honor such as was embodied in the Western concept of vassalage was not found in Russia. Towns and trade in most of the country were insignificant. What little trade there was consisted chiefly of local business in agricultural products —grain, wax, and honey. Inasmuch as trade was to a large extent controlled by the nobility and the monasteries, the basic conditions for the development of a middle class, a bourgeoisie, were lacking.

Towns. Only the towns of western Russia had an active class of burghers. The most prominent of these towns was Novgorod, which owed its importance to its geographic location near the Baltic Sea. Novgorod became the leading exchange market for the chief Russian export products of timber, furs, wax, and honey. It constituted a republic in which the princes had little influence; and an assembly (*veche*) of freemen decided governmental policies under an oligarchic charter.

Turkey

During the fourteenth century Turkey was added to the roster of European states. Early in that century a great new conqueror, the Turk Osman (d. 1326), led the Moslems against the Eastern Roman Empire. He seized all the Asiatic possessions of Byzantium and thus breached the walls protecting Europe in the East. In 1353 the Turks crossed into Europe and quickly conquered Gallipoli. They took large numbers of Christian boys from their parents and trained them as Turkish soldiers (the so-called Janissaries). Thus strengthened, they seized large parts of the Balkans. Although a century of intermittent warfare was to precede their conquest of Constantinople, they had already become a threat to the West comparable to the menace of the Huns, Arabs, and Tartars in earlier centuries.

ECONOMIC AND SOCIAL CONDITIONS AND THE ARTS

The effects of the crusades were widespread, not only upon the political but also upon the social and cultural sectors of Western civilization. Contacts with the Moslem world stimulated the intellectual life of the West—par-

ticularly in the development of the sciences, such as geography, astronomy, history, and medicine. New products and skills reached Europe, transforming Western ways and standards of living.

Yet, as in the political, so in the social and cultural spheres, innumerable other factors contributed to the changes that occurred. By the end of the thirteenth century new patterns of thought and societal structure, differing from those typifying the feudal Middle Ages, had become evident. The capitalist, the banker, the merchant, indeed the townspeople as a group—all the members of the so-called Third Estate—had gained political and social influence. They owed this gain not to the power of the sword but to the power of wealth. Furthermore wealth came to consist of movable goods and money as well as land, which had constituted the chief capital of the nobleman. The Third Estate, even though it remained a small minority for centuries to come, introduced new standards of morality and new patterns of behavior. Soon, the members of the nobility and clergy modified their own attitudes and activities to make allowance for this new development. Yet many old established traditions and customs survived and were also partly adopted by the Third Estate.

Business Organization

The outstanding characteristic of economic enterprise during the first half of the fourteenth century was its infinite variety. Land still provided by far the most important source of income. But in some areas trade and industry had become dominant factors. New pre-capitalistic enterprises existed side by side with the old established enterprises of skilled craftsmen. The concept of a "just price" was slowly undermined. "Just price" was the concept that a producer or a merchant should ask no more for his wares than was justified by the cost of his materials and the value of his labor, plus a moderate profit, irrespective of the market value of the merchandise. Likewise the view that the lending of capital did not entitle the owner to a reward in the form of interest was undermined. Even the Church, which had condemned all interest taking as usury, began to allow exceptions.

Corporations were formed. Originally they lasted only for the duration of one specific enterprise. Later, in some instances, they became permanent institutions designed to perpetuate themselves for the sake of carrying on successive business ventures. The actual management of a corporation was often in the hands of one investor, or perhaps some hired manager. The other participants, who did not obtain their rewards by contributing services, merely invested capital and received a profit—if the business made a profit.

FORMS OF ENTERPRISE IN ITALY

Italy pioneered in working out new forms of business enterprise. In that country double-entry bookkeeping, letters of credit facilitating exchange, stable currencies (e.g., the Florentine gold florin), and insurance organizations were introduced. Kings and popes stimulated economic growth by

investing in enterprises using these new facilities and methods. The new practices of the Italian townspeople spread northward to cities in Flanders, Holland, Germany, England, and France.

FORMS OF ENTERPRISE IN NORTHERN EUROPE

Though not as progressive as in Italy, business enterprise in European towns north of the Alps also prospered and expanded. The main northern contributions to economic development were the organization of great fairs and the establishment of important mining industries.

Fairs were not new to Europe; they had long been outstanding examples of northern entrepreneurial spirit. The best-known fairs had been those held in the Champagne region of France, where Oriental and southern European goods had been exchanged for the products of northern Europe. These fairs had declined in importance by the turn of the fourteenth century, but others, especially those in Frankfurt and in Scania (Denmark), replaced them as centers of trade. They contributed significantly to business expansion.

Even more beneficial to business ventures in the north was the notable increase in mining and related manufacturing. Raw materials and metals, in both of which the Orient and Italy were lacking, were increasingly made available.

THE HANSEATIC LEAGUE

Some of these activities were sponsored by kings and princes. But most of them were carried on by merchants—most successfully by the members of the Hanseatic League. This association eventually enrolled merchants from as many as seventy-two German towns under the leadership of Lübeck. Although it was rather conservative in point of view, its large size and far-reaching influence constituted an altogether new factor in trade and commerce.

It was during the twelfth century that the north German merchants had developed a new type of ship, the cog, which was capable of navigating in stormy waters too risky for other types of vessels. After founding the League they had achieved a nearly monopolistic control of the herring fisheries. Then they had become active in mining. They had interested themselves in the rich mines in central Germany—especially the salt mines, for salt was needed in the herring trade. Early in the thirteenth century, they had begun to develop Swedish and Norwegian mining resources, especially iron and copper.

Meeting regularly in diets to discuss problems of common concern, the Hanseatic merchants had achieved a degree of cooperation with one another unknown in the strongly competitive Mediterranean area. As a result of their activities, the balance of trade in northern Europe, not unlike that of southern Europe, swung more and more in favor of the West. Additionally, the balance of power shifted so that from that time on Europe had less to fear from eastern invaders.

Agricultural Organization

As usual, agricultural changes were slower in coming than those in trade and industry. Yet in agriculture, too, the late thirteenth and early fourteenth centuries brought numerous innovations. In some regions, to be sure, rather primitive, traditional methods of exploiting landed wealth continued. But in other regions such as England, many estates, having been cut down in size, either had to be cultivated more intensively or had to be rendered suitable for the production of more profitable crops. In England, increased wool production led to the building of a textile industry. Despite the inferior quality of the English woven goods as compared with those of Flanders, the English producers had by the middle of the fourteenth century overtaken their competitors. Flemish artisans were lured to England. In other countries, other economic shifts occurred. Thus grain production shifted eastward and slowly brought Prussia, Poland, and Livonia to the fore.

Social Organization

Necessarily, in those regions where business and agriculture underwent reorganization, the status of the various classes of the population changed. Whereas in the twelfth and thirteenth centuries the serfs had made considerable progress and had attained increasing independence, progress in this direction came to a standstill in the fourteenth century. When production for industry expanded, the nobility saw an advantage in having compulsory labor at their disposal. As a result, no longer did the practice spread of commuting labor services of peasants for money payments.

This slowdown in the emancipation of the serfs was at first confined to those regions where urbanization was rapid. But in rural areas as well, social relationships changed markedly. The gap between the living standards of the noble and the peasant widened. In the towns, likewise, the economic and social conditions changed. Differences between the wealthy burgher and the poor artisan or unskilled laborer increased.

Military Organization

Changes in social relationships were accompanied by changes in power relationships. Weapons with superior firepower had been developed after the formula for making gunpowder had become widely known. Weapons like the cannon (hand firearms were to follow later) rendered obsolete the defenses of the typical castle and the traditional combat tactics of the knights. Since few noblemen possessed the means to produce, buy, and use such new weapons, military control continued to pass into the hands of those who could do so: kings, princes, and towns. These hired mercenary soldiers, fighters who served for monetary wages and did not care about chivalry. Armed with the new weapons, such soldiers could easily defeat those who continued to rely on personal prowess. Frequently they joined in bands under a *condottiere* or leader who made war his business and lent the services of the whole group to the highest bidder.

Besides changing the existing power relationships, this new type of military organization gave an impetus to many industries. It necessitated the expansion of iron production and stimulated rapid progress in inventions and military techniques. It even influenced styles of architecture, as, for example, in the construction of fortresses, towers, and castles.

CULTURAL CLIMATE

Simultaneously with military, technical, and economic changes came a new self-consciousness and self-reliance in intellectual and ideological matters. Early in the fourteenth century, scholastic arguments about the problems occupying the great minds of the two preceding centuries tended to end up in sterile disputes. Such controversies were gradually replaced by new interests. The nominalist point of view, which had emphasized that reality lay in the objects of this world and not in universal ideas and which was reinforced by the intensive study of natural events, gained prestige at the expense of realism. Canon or Church law as well as civil and common law were given ever-increasing attention. In England, Germany, and France, important legal codes were compiled, taking into consideration the results of the renewed studies of Roman legal thought and the *Corpus juris civilis* of Justinian.

POLITICS

Attitudes toward political institutions also changed, as demonstrated not only by Marsilius of Padua, William of Ockham, and other advocates of imperial rights, but also by lawyers and writers in the Western kingdoms. Older Church authorities had often considered the necessity for political organization as evidence of man's sinfulness. Political institutions now came to be regarded instead as inherently just, designed to promote the rights of the individual and necessary for the evolution of a society based on mutual obligations.

FINE ARTS

The fine arts, too, reflected new perspectives. In the small area comprising the region of Florence, Siena, and Pisa in Italy, an artistic center of lasting influence emerged. Painters and sculptors in this region were leaders in the emancipation of the arts from scholastic attitudes. They liberated themselves from the patterns set by the Byzantine and Gothic styles. Although deeply imbued with a Christian spirit, they emphasized a new naturalistic approach in their work, thus paving the way for the ideals of the Renaissance. Great painters like Cimabue (d. 1302), Giotto (d. 1337), and Duccio (d. 1339) appeared in Siena and Florence. The latter two masters in particular concentrated on a more realistic representation of nature than had their predecessors. They studied perspective and anatomy and also interested themselves in depicting everyday life experiences. Nevertheless, they never lost their sensitivity to sacred values, nor did they allow their naturalism to over-

shadow their primary objective of expressing the deepest emotions and aspirations of humans. With them a new age began.

Communications and Travel

In the large area that the German Empire and the Roman Church comprised, communications were difficult. This applied even to smaller kingdoms and still more to outlying parts of Europe, such as England, Scotland, Scandinavia, Finland, and Russia. Roads were bad and the means of transportation slow. Transport by ship depended upon season and weather. This meant weeks, months, and years of absence for the travelers. Generally, women took over the management of households during such times. News took a long time to reach people. In addition, there were barriers—a lack of bridges and ferries, impassable river fords during flood times, toll stations—and also the dangers from robbers. Temporary hindrances also resulted when epidemics occurred in one region or the other. Even the *lingua franca*, the Latin language, did not serve in the later Middle Ages as in earlier times, for in some countries it had to give way to regional languages.

Nevertheless, contacts between all parts of the West remained lively. Millions of the faithful continued to move back and forth on pilgrimages; others traveled from northern to southern countries, from Christian to Mohammedan regions. More numerous artists and artisans served distant courts and town councils. More wandering scholars visited far-off schools and royal courts. Their contributions became ever more welcome. As trade became more lively, merchants, who carried their wares with them, moved in increasing numbers across the continent. Thus, notwithstanding disasters like epidemics, famines, and climate changes, and even despite political differentiation, exchanges of goods and ideas increased. Partly owing to urbanization and colonization of the East, much social change occurred, and change brought diversity, foreshadowing trends of the coming Renaissance.

Dante

At this crossroad of Western civilization there now appeared one of its greatest figures, the Italian poet Dante (d. 1321). He may be regarded as either the last great man of the Middle Ages or the first of the new age. His literary work, which included grave political treatises and exquisite sonnets, reached its apex in his masterpiece, the *Divine Comedy*. In this grandiose poem, Dante describes his journey through Hell, Purgatory, and Paradise and expounds the philosophical views and moral tenets of his age. He renders stern judgment on his contemporaries and on many preceding generations—their moral character, aspirations, achievements, and failures. In a survey of immense scope, depth, and beauty, he thus created a summary of an era that was slowly approaching its end.

*P*olitical successes of the Roman Catholic Church in the thirteenth century were not long lasting. By the beginning of the new century, the papacy was being ruined by excessive ambitions, which culminated in the pope's claiming supreme authority over all worldly and Church affairs in Europe, and this led to political humiliation, followed by exile. The popes were forced to leave Rome, and the Babylonian Captivity began. Papal authority was undermined. Rulers in Germany, France, and England no longer allowed papal interference in the affairs of state within their realms. Royal authority was thereby strengthened in large parts of Europe—even though in England and France it met with reverses during the ruinous Hundred Years' War. The influence of the nobility, whom the popes had often played out against the kings, was reduced, and the bureaucracies of the kings gained in power. Towns, which had assembled wealth and now emancipated themselves from feudal ties, supported the kings.

Economic developments likewise entered a new stage. In agricultural life little was changed, but enterprises in commerce, mining, and industry altered the economic picture. Ventures overseas in the Baltic and Mediterranean areas expanded, and the growing exchange of goods between East and West benefited not only the great ports but also inland towns. New forms of economic organization appeared.

A new age was likewise introduced in cultural affairs. It found expression in a more naturalistic style, which manifested itself in painting, sculptures and design.

Selected Readings

Guenee, B. *States and Rulers in Later Medieval Europe* (1985)

Hamilton, B. *The Medieval Inquisition* (1981)

Hillgarth, J. N. *The Spanish Kingdom, 1250–1516* (1978)

Huizanga, Johan. *The Waning of the Middle Ages: A Study of the Forms of Life, Thought and Art in France and the Netherlands in the Fourteenth and Fifteenth Centuries* (1919)

Kirchner, Walther. *History of Russia* (1976)

Lane, F. C. *Venice: A Maritime Republic* (1973)

Larner, J. *Italy in the Age of Dante and Petrarch, 1216–1380* (1980)

MacKay, A. *Spain in the Middle Ages: From Frontier to Empire, 1000–1500* (1977)

Myers, A. R. *England in the Later Middle Ages* (1952)

Oakley, Francis. *The Western Church in the Later Middle Ages* (1985)

Renouard, Y. *The Avignon Papacy, 1305–1403* (1970)

18

The Early Renaissance (1350 –1453)

1353	Turks cross Straits and invade Europe
	Statute of Praemunire in England
1356	Defeat of French at Poitiers
	"Golden Bull" issued by Emperor Charles IV
1357	Turks conquer Adrianople
1358	Outbreak of Jacquerie in France
	Death of Casimir the Great of Poland
1374	Death of Petrarch
1375	Death of Boccaccio
1378	Uprisings in Florence ("Ciompi")
1380	Defeat of Tartars on the Don River
	Defeat of Genoa by Venice
1381	Beginning of revolts of peasants and Lollards in England
1384	Death of Wycliffe
1386	Federation of Poland and Lithuania
1397	Union of Kalmar between Denmark, Norway, and Sweden
1399–1413	Reign of Henry IV (Lancaster) in England
1400	Death of Chaucer
1409	John Huss, rector of the University of Prague
	Council of Pisa
1410	Defeat of Teutonic Knights at Tannenberg
1414–1418	Council of Constance

1415 Huss burned at Stake

Defeat of French at Agincourt

1417 End of Schism in Catholic Church; Pope Martin V elected

1420–1436 Hussite Wars

1426 Death of Hubert van Eyck

1428 Death of Masaccio

1429 St. Joan: siege of Orléans raised

1430 Death of Andrei Rublev

1431 St. Joan burned at Stake

1431–1449 Council of Basel

1434–1464 Cosimo de Medici, ruler in Florence

1438–1439 Council of Ferrara-Florence

1438 Pragmatic sanction in France; rights of the Gallican Church asserted

Death of Louis the Great of Hungary

1440 *Platonic Academy* founded in Florence

1440–1452 Introduction of printing with movable type (Gutenberg)

1450–1466 Francesco Sforza, ruler in Milan

1453 Capture of Constantinople by the Turks

1453 End of Hundred Years' War; English surrender at Bordeaux

In 1348, a terrible bubonic plague known as the "Black Death" swept over Europe. Like the Crusades, the Black Death has been held responsible—and perhaps with better justification—for numerous social and cultural changes that subsequently occurred. The Black Death was a single event, not a movement spanning two hundred years. It was a sudden terrible event, whose consequences are to a certain extent measurable. It killed from one-tenth to one-quarter of the populations of many European areas, ravaging western Europe more severely than eastern Europe.

The resulting manpower shortages contributed to emancipation movements of agricultural laborers, to rebellions in the towns, to changes in power relationships between countries, and to changes in social habits and mores. Class stratification became, at least temporarily, less rigid. The Black Death influenced scientific endeavors, philosophy, outlook on life, and art.

It induced in many people a feeling of gloom and pessimism, a fear of God's wrath. This mood was expressed in art and literature—for example, in the numerous artistic representations of the "Dance of Death" or in morality plays like "Everyman." It gave others a new thirst for life, imbued them with defiance of religious tenets, and whetted their desire for worldly pleasures.

On the other hand, artistic representations also included classical pagan topics and very worldly books such as Boccaccio's Decameron.

It should be noted, however, that many of the changes occurring subsequent to the outbreak of the Black Death (the plague reappeared periodically later in the century) were underway long before the first epidemic and that the plague occurred during a period of religious doubt, of political upheaval, of artistic reevaluation, and of economic expansion.

THE STATES OF EUROPE

Unlike the marvelous artistic and scholarly developments during the first half of the Renaissance (which means approximately the hundred years following the first outbreak of the Black Death), the political scene between 1350 and 1453 contained little of special interest. Political theory and practice in the Empire, in Italy, and in the western European kingdoms followed along lines laid down earlier. Within the German Empire, each individual component territory consolidated its power in opposition to imperial authority. Italy brought the city-states to full flowering. France and England devoted much of their energy to the Hundred Years' War. The various Iberian kingdoms continued to fight the Moslems and to expand their overseas possessions. Only in the north and east did innovations of special historical interest occur. In the Baltic region, two great unions of states were created; and in the Balkans, the Eastern Roman Empire came to an end when the Turks captured Constantinople.

The Empire

Reorganization in 1356 helped to preserve the Empire but failed to strengthen its central authority. The weak emperors who succeeded Charles IV insisted on continuing the policy of increasing their family holdings at the expense of broad imperial or national aims. Good chances for restoring the imperial prestige were lost when Sigismund (Charles's younger son, who was emperor from 1411 to 1437), was called upon to convene a Church council. Like a second Constantine, he was to preside over it. But he failed to exploit the situation in favor of the Empire when his chief rivals, the popes, were in no position to thwart him. Although the council under his guidance reestablished Christian unity, he gained neither abroad nor in Germany the prestige his role could have given him.

After his death began the long uninterrupted rule of the House of Hapsburg, which was to last until the end of the Empire in 1806. The Hapsburgs restored stability to the imperial office, but central authority remained in a weakened condition. The Diet and the Imperial Law Court lost through inactivity what little prestige they had retained. Foreign powers seized some of the German border areas. Political planning and determined action were confined to the courts of the territorial princes and the governments of the great imperial cities. It was thus through local, rather than central, imperial efforts that the basis for a prosperous economic development was laid, which characterized many industrial regions of fifteenth-century Germany.

Italy

The decline of central imperial authority was most sharply felt in Italy. The country remained divided, with largely contrasting institutions in its various parts. Sicily and southern Italy continued under Aragonese rule; they stagnated politically and economically. So did the papal states, which, during the popes' residence in Avignon, were also torn by party strife that brought misery to all the population. The north continued to develop the city-states and acknowledge imperial overlordship but actually achieved independence.

Many of the city-states flourished. Local governments remained republican in form. Only in Venice, with its elected doge, did the republican form have meaning. Actual power in Venice was exercised by a council of the wealthiest merchants. After the conclusive defeat of the Genoese, who had been their greatest trade rivals, a period of abundant prosperity for supporters of the ruling factions began (and of great misery for all opponents).

In other city-states, quasi-democratic or republican institutions paved the way for despots or tyrants. Some of them were recruited from among the condottiere, the leaders of mercenary troops, others from the ranks of the merchants or financiers, and still others from the landed nobility. These dictators depended upon three sources for their power: first, their own wealth; second, the services of mercenary armies; and third, support from the lower strata of the population, to whose wishes they catered. They often ruled wisely, even though many were arbitrary and demagogic. The exercise of power frequently became a family affair: in Milan, first the Visconti, then the Sforzas gained control; in Mantua, it was the Gonzagas; in Ferrara, the Estes; in Florence, the Medici; and in Urbino, the Montefeltres.

France

Throughout the first century of the Renaissance, most of the creative forces of France were absorbed by the Hundred Years' War with England. Early in the fifteenth century, there was an artistic revival inspired by the Renaissance in the Netherlands and Italy, but few achievements mark other

facets of French life. Many badly needed governmental, military, and financial reforms were delayed. Moreover, while King John (d. 1364) was in captivity in England, peasant revolts (the *Jacqueries*) shook the country. When these had been subdued, the incompetent kings who succeeded to the throne attempted to institute reforms. But new campaigns against England interrupted all progress.

Then a struggle for power developed between the reigning family of Valois, which had succeeded the Capetians in 1328, and the dukes of Burgundy, vassals of the French king who had acquired a number of territories (besides Burgundy) and eventually obtained Flanders by marriage. The dukes thus attained greater power than the kings, whose authority and rights they challenged. From time to time in the ensuing civil wars, they did not hesitate to join the English side or to resort to the assassination of their enemies. Finally the French kings suffered another bitter defeat at Agincourt (1415), a defeat that, within another dozen years, led to the loss of half of France to England.

At this point, when England's forces were overextended and a desperate spirit of resistance was awakened among the French, a turning point came. What actually occurred seemed a "miracle." A young peasant girl from Lorraine, Joan of Arc, came forward to report that voices from heaven had told her she had been chosen to save France. Arousing latent national sentiments and inspiring the soldiers, she succeeded in reviving the courage and loyalty of the French. The army rallied to win its first great military and psychological victory by raising the siege of Orléans, a strategic town on the Loire that English troops had surrounded. This victory made it possible for large areas in France to be liberated. Rheims was retaken, and the eldest son of the last king, the Dauphin Charles, was finally crowned King Charles VII.

Joan had fulfilled her mission. Soon thereafter she fell into the hands of the British, who handed her over to trial by a court of the Inquisition. Inasmuch as Charles did nothing to save her, she was burned at the stake. But the impetus that she had given to the French cause carried France through to victory. In 1435, Burgundy renounced its alliance with Britain; the English were repeatedly defeated in battle. When the war came to an end in 1453, they had been ejected from the mainland, retaining only the harbor town of Calais.

England

Even during the period of continued victories over the French, England experienced disturbances similar to those that racked France. In England, too, the plight of the lower classes was so grave that revolts of the peasants occurred late in the fourteenth century. When, as in France, the rebel peasants were brutally subdued, rebellions of some of the powerful lords continued to keep the country in turmoil. In vain, young Richard II, grandson of Edward III, tried to strengthen his royal authority at the expense of the unruly high

nobility and Parliament. The rebels, under the leadership of Henry of Lancaster, deposed Richard in 1399 and crowned Lancaster Henry IV.

Thereafter the great lords dominated Parliament and controlled state policies. Disunited as they were, however, they merely intensified the misery of the populace. The economic and social progress of the previous era was endangered. Trade decreased and prices fell. A cultural revival initiated at the close of the fourteenth century came to a sudden end. Moreover, during the second quarter of the fifteenth century, with final defeat in war against France, new disturbances marked the reign of Henry VI (1422–1467). But Parliament, subservient though it may have been to whosoever held the real power, survived. It continued to give a measure of stability to English institutions through its influence on taxation and law.

Scandinavia and Poland

No lasting contributions to the political institutions of Europe were made by the Scandinavian countries or Poland. However, two interesting political unions were concluded: one between Denmark-Norway and Sweden-Finland, and the other between Poland and Lithuania. In both cases, military and economic factors induced these countries to sign treaties of unification intended to create a new balance of power in the Baltic area, where the balance had previously favored the German Hanseatic League and the Teutonic Knights.

SCANDINAVIA

The dependence of the Hanseatic League's prosperity upon trade in the Baltic made it necessary for the Hanse to protect its position by building up its navy. This led in 1361 to wars with Denmark, which dominated the "Sound" (the Straits leading from the North Sea to the Baltic Sea) and therefore controlled the northern European seaway linking east and west. In 1370, the Hanse defeated Denmark. The subsequent peace treaty at Stralsund guaranteed continuance of the Hanse's monopolistic position in east-west trade.

Thereafter the Hanse reached the climax of its power and prosperity. Hanse merchants rivaled the great Venetian and Genoese houses in importance. They provided the northern countries with vital commodities, particularly salt. They contributed to the internal development of the various Baltic and North Sea countries—especially Sweden and Norway, with their iron and copper mines.

Yet jealousy of Hanseatic military and economic power induced the three Scandinavian countries to reconcile their own differences, improve their economic collaboration, and form a union (the Union of Kalmar, 1397). They failed to achieve their objectives, though, because nationalistic antipathies and Danish-Swedish territorial rivalries persisted. The Union did not succeed in reestablishing the leading position that Scandinavia, and especially Denmark, had held before 1200.

POLAND

A union of a different kind was formed in 1386 when Grand Duke Jagiello of Lithuania married Jadwiga, last surviving princess of the reigning house of Poland. During the reign of King Casimir the Great (d. 1370), Poland had succeeded in attaining a measure of internal consolidation. A licentious nobility was held in check, and a new law code was worked out. At Cracow a university was founded. Farm production increased and, as in the West, towns and their burghers gained in wealth and power.

Economic factors were thus a major force in the plans for union; Poland's steadily growing agricultural production needed export markets. This stimulated a drive for direct access to the Black and Baltic seas on which Lithuania bordered. Moreover, dynastic, religious, and strategic objectives could be served. The grand dukes of Lithuania, becoming kings of Poland, could win greater prestige in Europe. Poland might be enabled to convert pagan Lithuania to Catholicism. While eliminating competition between themselves, both nations could gain a more powerful position vis-à-vis the Russians to the east and the Teutonic Knights ruling Prussia in the west. In fact, they soon launched an attack on the Teutonic Knights, upon whom they inflicted a decisive defeat at Tannenberg (1410). Thereafter the new commonwealth (which, incidentally, benefited the Poles more than the Lithuanians) became an important power.

Russia

Of more lasting strength, however, was the commonwealth Muscovy began to build during the late fourteenth and the fifteenth centuries. By 1380, Grand Duke Dimitri of Moscow felt strong enough to challenge his overlords, the Tartars. He attacked and defeated them in the Battle of the Don. This victory was unprofitable, as it coincided with a revival of Tartar strength under the famous Tamerlane, who took bitter revenge on the Russians. Moscow itself was captured and burned.

But the resistance of the Muscovites increased their prestige among the various Russian principalities. A number of internal reforms carried out by Dimitri and his successors also contributed to the strengthening of the political leadership of Muscovy. Greater political stability was gained by instituting the rule of primogeniture for succession to the throne of the grand dukes. The influence of the high nobility, the *boyars*, was reduced. Muscovy's laws and suzerainty were extended to neighboring areas. National feeling was strengthened by the Church, which had played a leading role in the resistance movement against the Tartars.

In addition to Muscovy, the principality of Novgorod flourished. Its trade with the Hanse in hemp, wax, furs, and timber in exchange for salt, herring, textiles, and wine from the West gave it unequaled economic importance. Even in the fine arts, remarkable achievements came out of Novgorod, reaching their climax in the works of the great icon painter Rublev.

Turkey

In the mid-fifteenth century, the developing patterns of eastern as well as western European policies were modified as a result of the military successes achieved by the Turks. Late in the fourteenth century, the progress of the Ottoman Turks had been temporarily halted by defeat at the hands of Tamerlane, who had attacked them, as he had attacked the Russians, from the rear. But the Turks, recovering from the losses inflicted upon them, then resumed their advance in Europe. Under Mohammed II (d. 1481), they decisively defeated (in 1444) those Christian nations in the Balkans that had not yet been subdued. They then turned against Constantinople and, after a fierce siege, conquered the valiantly defended city (1453). The last Byzantine emperor was killed in battle. After a thousand years of existence, the Eastern Roman Empire ceased to be. Many historians consider this event so important that instead of dating the beginning of modern times from the discovery of America or from the Reformation, they date it from the fall of Constantinople.

CHURCH AND SOCIETY

During the first century of the Renaissance the Western world's political evolution did not make substantial visible strides. However, Church life and the structure of society underwent many modifications. The attention devoted by Renaissance people to secular affairs changed their ways of life and thought. Not that the average person, or even the outstanding genius, became irreligious; on the contrary, transcendental beliefs continued to keep a firm hold on most people. But nature and worldy aims were not regarded as temptations of the flesh, nor as impediments to salvation, to the same degree that they had been so regarded during earlier medieval periods. More tolerance was displayed toward economic pursuits, naturalism in art, and reason as a guide in life. The study of pagan classical antiquity and scientific investigations of nature was promoted. The Church itself did not escape a measure of secularization.

Avignon

After 1350, the Church, like each of its members, was increasingly exposed to the impact of the new ideas. The popes continued to reside in Avignon and to occupy themselves largely with secular and administrative affairs. They concerned themselves with questions of law, jurisdiction, and politics, as well as financial measures: extra tithes in addition to the customary one-tenth, special donations and fines, confiscation of the property

of heretics, and offers of *indulgences,* by which believers were promised remission of punishment in the afterlife for their sins. They performed many functions outside the proper scope of Church activities, even some that were contrary to Church regulations. These included the sale of Church offices, exploitation of the tourist and pilgrim trade, speculation in real estate, and mercantile and banking activities.

The Great Schism

All this violated the consciences of faithful Catholics as much as it antagonized worldly lords. It provided material for criticism and unbelief. Fearful of losing his authority and disturbed by attacks from within the Church, Pope Gregory XI tried in 1377 to reestablish the papal residence in Rome. He returned there but died within a year. His successor, Urban VI, through lack of moderation in his attempts to inaugurate drastic reforms, antagonized the cardinals. They turned against him and created a new, more serious crisis by electing another pope. This pope, Clement VII, took up his residence in Avignon.

Now the Church had two heads; the *Great Schism* had begun. The split involved all parts of the Church organization. It brought papal authority to its lowest point, divided the nations on the basis of their adherence (for political reasons) to one or the other pope, and delayed urgently needed spiritual reform work.

Reform Movements

Necessarily, opposition to the Church hierarchy grew. With the spread of interest in science, art, and classical literature, it is not surprising that opposition came from people interested in secular affairs. But it came also from those multitudes of believers who had retained their faith in the fundamental obligations of Christians. Noting the secular preoccupations of the Church hierarchy, many churchmen spoke out courageously and vigorously.

WYCLIFFE AND HUSS

The most important advocates of reform were John Wycliffe in England and John Huss in central Europe, in Bohemia. They followed in the footsteps of Marsilius of Padua and William of Ockham, both of whom had recommended clear distinctions between spiritual and secular duties and, as adherents to the nominalist trends, had advocated separation of the realms of faith and reason. Both Wycliffe and Huss also followed the example of Marsilius and Ockham in condemning the claims of the Church to secular possessions. They went even farther by assailing some of the dogmas of the Church.

Wycliffe (d. 1384) challenged the views of the Church on various parts of its dogma and the doctrine of salvation. Like later reformers, he emphasized the Bible rather than Church tradition and translated parts of the Bible into the vernacular. John Huss (d. 1415), a professor at the University

of Prague who was influenced by Wycliffe's teachings, spread similar ideas about both the duties and the dogma of the Church. In particular, Huss condemned the existing system of indulgences.

MYSTICS

Not all advocates of reform went so far as Wycliffe and Huss, both of whom were eventually accused of heresy. The majority sought a purification of Church life and organization rather than a revision of dogma. Among them were many mystics. In Italy, the spirit of mysticism was kept alive by the spiritual Franciscans and by individuals such as St. Catherine of Siena (d. 1380) and her followers. In Germany and the Low Countries, the teachings of Meister Eckhart inspired Johannes Tauler (d. 1361) and, in the next century, Thomas à Kempis (d. 1471).

As earnest and devoted Christians, the mystics, instead of concentrating on criticism, emphasized the positive aspects of an invigorated spiritual life. As always, they advocated the individual's direct relationship to God and worked for a return to a pure Christian life free of worldly ambitions. Mystic trends spread also to Flagellants, Beguines, and other new, rather loosely organized "orders," which flourished especially in the Netherlands and which practiced a Christian way of life that was in many respects in harmony with the wishes of the reformers.

Conciliar Movement

In the face of such trends, the Church finally undertook steps to set its house in order. The initiative came not from the popes but from lesser members of the hierarchy. A series of councils, the first of which was held in 1409, were convened to develop a program with three objectives: restitution of faith, reestablishment of unity, and reform of morals.

COUNCILS OF PISA AND CONSTANCE

The first council took place at Pisa. This initial attempt failed. Instead of solving problems, it aggravated the situation. A new pope was elected who, although chosen to replace the two reigning popes, merely became a third one. A second council was thereupon called by the German emperor Sigismund, who thus reasserted the supreme authority of the early emperors. This council (at Constance, 1414–1418) was successful in solving one issue—that of schism. All claimants to the papal see were deposed. There was general recognition of a new pope, Martin V, who took up his residence in Rome.

The remaining issues, however, were not solved. Secular trends had become too firmly implanted, and "heresies" had spread too widely. When questions of faith and reform were taken up and Huss was summoned before the council, the assembled authorities refused him an adequate hearing. Even though he had come under a guarantee of safe conduct, they had him burned at the stake.

COUNCILS OF PAVIA AND BASEL

New councils were convened—at Pavia in 1423 and at Basel in 1431. By that time, the popes were more immediately concerned with reasserting their leadership in the Church and their supremacy over the councils than with dogmatic and moral issues. Taking advantage of the diverging interests of the various nations in regard to these questions, they succeeded in prolonging the discussions until 1438. By then, victory was theirs. Soon thereafter, notwithstanding continued resistance of many members of the council, a papal bull confirmed the monarchical principle in the Church.

COUNCIL OF FERRARA-FLORENCE

One more council was held in 1438 in Ferrara and in 1439 resumed in Florence. It too made no progress with reform. Instead, it concerned itself largely with the reunion of the Western and Eastern Churches, split since 1054. Hard pressed by attacking Turks, the emperor in Byzantium had appealed to the West for help. He and the patriarch of Constantinople personally traveled to Florence. The strategic moment to reestablish papal domination in the East seemed to have arrived. Nevertheless, although an agreement was reached, the persistent opposition, especially that of the Russian Church, prevented its execution. With the fall of Constantinople a few years later, the chief incentive for the Eastern Church to submit to Western demands was gone.

OUTCOME OF THE CONCILIAR MOVEMENT

Thus ended the Conciliar Movement. It had restored Western unity under the popes, but the failure to solve the problems of faith and reform continued to endanger the structure of the Church. A deep social and economic split between lower and higher clergy remained, likewise a deep religious and cultural split between a reform party and a politically minded hierarchy. The gulf between Church aims and national aims widened.

Educational institutions, especially the universities, emancipated themselves from Church guidance. The secular trends of the Renaissance were but imperfectly reconciled with Christian tradition.

Two outstanding scholars, the French Dominican Jean Gerson (d. 1429) and the German bishop Nicholas of Cusa (d. 1464), one of the most learned men of the age (who had observed "that all human knowledge is learned ignorance"), advocated reconciliation. Cusa explained that God and the world "complement each other in the same way as motion and rest." But their appeals to Christian unity in a purified Church had only limited success; secular trends soon took precedence.

State-Church Issues

During the course of the Babylonian Captivity of the Church, the Schism, and the Conciliar Movement, secular princes found many opportunities to further the emancipation of secular rule from interference by the Roman see.

The action of the German princes at the Diet of Rense regarding elimination of papal rights at elections of emperors, supported as it was by Church reformers like Marsilius and Ockham, had set an example that was followed by other nations.

In 1351, England published the Statute of Provisors, which forbade papal appointments to English benefices. In 1353 the Statute of Praemunire prohibited appeals, without royal consent, from local ecclesiastical courts to courts outside of England. In 1438, France issued the Pragmatic Sanction, which similarly provided for the right of the king to exercise Church jurisdiction and to nominate high clerics.The Empire soon thereafter passed additional ordinances. The Spanish, by acting as champions of Catholicism, succeeded in making the papacy so dependent upon their support that they actually gained still greater liberties. Even popular movements, such as revolts of the lower classes which occurred in Italy, France, England, and Bohemia, showed a change in the relationship of Church and state. They demonstrated how deeply the lives and views of the peoples had begun to be influenced by national aspirations.

Societal Changes

The questioning of so many fundamental values and the disruption of accustomed political and economic life resulted inevitably in an accelerated transformation of the prevalent class structure. Perhaps the lowest classes, whose revolts proved to be premature, were less affected than the upper strata of society.

In Italy, earlier than elsewhere, the hereditary nobility lost its former place and mixed with a merchant aristocracy. Soon the newly formed class surpassed the old feudal nobility in refinement of manners and took over certain activities formerly reserved for the nobility. The middle group or burghers (consisting of smaller merchants and artisans) was likewise strongly affected. Since this group lacked the wealth required for industrial development, it sank to a low economic level. It lost much of its former independence and many of its members had to work for wages.

In the towns north of the Alps, it took longer for the wealth of the rich merchants to challenge the power of birthright. Moreover, the guilds were stronger there than in Italy. They retained political influence and control of production and trade. But wherever very rich merchants made their appearance, as in southern Germany, eastern France, Flanders, England, and the Baltic ports, social changes did not substantially differ from those in the south.

In rural areas, societal changes were fewer. Only in Italy was a new element introduced when prosperous townspeople began to supplant or supplement the landowning feudal lord by buying estates. This meant a challenge to former class concepts. It gained for the rich townspeople not

only the economic advantages but also the prestige that the nobility had derived from possession of land.

In northern countries too the burghers invested in landed property, though not on a scale that could endanger the status of the nobility. Nevertheless, in the north, rural society displayed new features. The owners of manors and the other lords began to enjoy imported luxuries as well as the products of an advanced European economy. They rapidly devoted more attention to their pre-capitalistic business enterprises.

On the other hand, the condition of the peasant deteriorated. The movement toward emancipation from serfdom came almost to a standstill. The lords, anxious to retain their serfs to work the mines and attend to other commercial enterprises, discontinued the practice of commuting compulsory labor services into money payments.

Economic Changes

Despite population losses following the outbreak of the Black Death and despite the trend toward lower prices in many parts of Europe during the late Middle Ages, production and trade increased. Capital formation took place rapidly, but capital came to be concentrated in comparatively few hands. The few who possessed it seldom attempted to specialize in any particular branch of industry or trade. Notwithstanding enormous risks, they invested in a great variety of enterprises. They often participated in many ventures: banking, money lending and exchange, mining, manufacturing, trading, exporting and importing, buying and selling real estate, building, and dealing in works of art. Some even took on lucrative public offices, such as tax collecting for popes or secular rulers.

Historians call this period an age of *mercantile capitalism*. As the narrow concepts of the feudal nobility, the standards of the Christian Church regarding interest taking, and the restrictive tendencies of guilds were gradually left behind, the way was opened for a measure of capitalistic activity. Kings as well as Italian despots saw their advantage in it, for the sake both of reducing the power of the nobility and of acquiring wealth and luxuries. They supported the merchant capitalists against the upper and lower classes.

Subsequent scientific discoveries accelerated the transformation of the economy. Technical improvements were introduced in the mining industry, in milling processes, in the manufacture of textile goods, in shipbuilding, in occupations such as the distillation of salt from sea water, and in agriculture. A higher standard of living resulted.

Social Revolts

The transition from a feudal economy to mercantile capitalism was a drastic change that did not occur without some violence. All groups of the population became involved: clergy, nobility, townspeople, peasantry. From all sides came urgent demands. Attacks on any one dominant group—Church, monarchs, feudal lords, or guilds—engulfed all. Many disturbances

originated with the noblemen. Highway robbers and other members of the declining nobility participated in them, perhaps unaware of the underlying social trends that would irrevocably deprive them of their former positions.

More important, however, were the revolts of the lower classes. In France they came to a climax in 1358 in the Jacqueries. Faced during the Hundred Years' War by ruined crops and ever-increasing demands of their lords, and hoping to derive some advantage from a general disaster, the peasants asked for better laws and more equitable justice. They demanded personal freedom and a reduction in their service obligations. Joined by townspeople who had been similarly damaged by war and burdensome taxation, they began to attack the nobles and to burn their castles. It required the extreme exertions of the government, which had been weakened by war with England, to subdue the revolt.

Other uprisings, feeding on social grievances, occurred in numerous towns. Common workers rose against the wealthy in Florence in 1378. Similar uprisings followed in other Italian cities, in Paris and London, in southern Germany, and in towns of the Netherlands.

During the last two decades of the fourteenth century and throughout the fifteenth, the situation continued to deteriorate as religious reformers added their share to the general discontent. Thus in 1381 Wycliffe's followers, the Lollards, participated in a rebellion similar to the Jacqueries of France. Under the leadership of Wat Tyler in London, peasants and city workers rebelled, demanding economic improvements for the lower classes and broader use of parliamentary power on their behalf. Their revolt shared the fate of the Jacqueries.

In Bohemia, the Hussites staged a series of revolts, which spread far into adjacent imperial lands. The Hussites, like the Lollards, were both heretics and rebels. Czech nationalism gave their religious and social demands a special character and turned their revolts into extremely devastating wars. Still other outbreaks occurred in Spain and elsewhere. Not until the end of the Renaissance—and only after the great Reformation of the sixteenth century was over—was a comparatively stable social order reestablished.

SCHOLARSHIP AND ARTS

There have been times, as in early Roman history, so lacking in great cultural achievements that the interest of the historian in them has centered chiefly around political, constitutional, and social developments. During the

late fourteenth and the fifteenth centuries, however, cultural events occurred that had far greater meaning for the future than the contemporary political or military events such as the various institutional modifications or the Hundred Years' War. These cultural events occurred in the central region which constituted the focal point of medieval civilization. They extended from the Low Countries throughout the Empire, western and southern Germany, Burgundy, and Italy down to Florence, Siena, and Rome.

From this area spread the Renaissance—the mightiest and most meaningful of all the movements of the time. The Renaissance, an age of "rebirth" of interest in classical antiquity, spanned about two hundred years, approximately 1350 to 1550, and marked the age of transition from medieval to modern culture. It was distinguished by a spirit of confidence in human achievements and possibilities. It meant an extension of secular activities, of ambition and competition. It showed a joyful love for worldly attractions, for the beauty of nature. It brought towering achievements in art and redirected thought toward rational objectives characteristic of classical antiquity. It was an age of reform.

Humanism

Basic to the cultural achievements of the Renaissance was the philosophy and attitude of *humanism*, as developed in Italy. Humanism meant occupation with "things human" as opposed to transcendental questions and problems of the "other world." Humanism emphasized the "dignity" of the individual and sought the full development of each person's personality. It took as its guideposts, not the thoughts and metaphysical speculations of the great medieval philosophers, but those of the classical authors. Humanists therefore studied with renewed fervor the works of antiquity—chiefly those of Latin authors (such as their cherished Cicero), which they preferred to the works of the Greeks.

Their pursuits necessitated careful investigations of source material, based on thorough linguistic knowledge. Owing to their zeal, numerous ancient texts were rediscovered. Humanistic attitudes were soon adopted also by leading thinkers. In opposition to scholastics, with their overly subtle dialectics, they applied the methods of classical scholarship to the writings of the Church fathers and rethought Christian theological problems. Christian humanism supplemented classical humanism.

ITALIAN HUMANISM

At the beginning of the era of humanism and the Renaissance stands the great Italian poet Petrarch (d. 1374). He personified the new spirit. Despite sincere allegiance to the great medieval tradition, he interested himself in the affairs of nature and everything human. A famous letter of his describing his excursion on a mountain, Mont Ventoux, symbolizes this interest. Although St. Augustine had once warned in his writings against the temptations of nature and external beauty, and although Petrarch carried a copy of

Augustine's book along on his trip and reread it, he opened his eyes to the world surrounding him and reported the delights of his ascent of Mont Ventoux. Indeed, some historians have dated the beginnings of the Renaissance from Petrarch's venture.

Secular interests similar to those of Petrarch animated his friend Boccaccio (d. 1375). Boccaccio's great accomplishment was that he evoked the interest of his contemporaries in the heritage of ancient times. Unlike Petrarch, who knew some Latin but no Greek, Boccaccio devoted most of the attention of his mature years to classical studies and to composition in Latin and Greek.

The two authors were followed by a long list of other distinguished humanists, including Poggio (d. 1459), who combined literary interests with studies of nature and with scientific occupations. Another was Lorenzo Valla (d. 1457), who was led by his source studies to attack the authenticity of the so-called Donation of Constantine, on which the popes based the legal title to their sovereignty in Rome. But so deeply were humanistic tendencies by then embedded, even at the papal court, that, notwithstanding his challenging work, Valla was appointed a papal secretary. At about the same time, Aeneas Silvio Piccolomini (the future Pope Pius II) gained fame for works of a secular character, including a geography.

Everywhere, humanism marked Italian cultural life. A Platonic academy was founded in Florence, which attracted famous Greek scholars, especially some of those forced to flee from the Turks. Princes, cardinals, tyrants, and wealthy burghers vied for the honor of engaging the services of scholars and becoming patrons for artists, writers, and musicians.

GERMAN AND NORTHERN HUMANISM

From Italy, humanism spread northward across the Alps. Its flowering there came in the sixteenth century, but some humanistic trends became evident already in the fifteenth. Obstacles to humanism were greater in the north, since scholastic traditions were still alive and vigorous. Moreover, superstitious beliefs were stronger. Works such as *The Witches' Hammer*, dealing with witchcraft, found a wide public. Interest in astrology and magical arts was widespread.

Yet in the north, too, classical studies were gradually taken up. A modern spirit made itself felt. Biblical scholarship improved, and humanism permeated modes of thinking and writing. The mathematician, astronomer, and classical scholar Johann Müller, known as Regiomontanus (d. 1476), exemplified the growing importance of humanism. Awareness of natural surroundings was reflected in the publication of numerous books on mathematics, astronomy, cosmogony, and geography. At the courts of the princes, particularly at the imperial court and that of the dukes of Burgundy, but also at the courts of lesser nobles and in the houses of wealthy merchants,

the taste for classical and humanistic studies grew. Wealth was used to promote humanistic endeavors.

Renaissance Learning

The spirit of free inquiry characteristic of humanism and the Renaissance brought many results. Intellectual leadership shifted from the universities, whose standards declined with the degeneration of scholasticism, to individual scholars who had no affiliation with institutions controlled by the Church. The University of Paris, once the pride of the Western world, no longer provided much stimulus. Italian and English universities likewise failed to retain their former greatness. The German universities, more recently founded, had greater vitality, but they did not fill the place left vacant by the others.

It was through individual efforts that studies of the Greek heritage were broadened. Latin, corrupted for centuries, regained some of its classical beauty. Libraries were compiled by secular and ecclesiastical princes and by other wealthy private persons in all parts of Europe. Literary and artistic treasures were collected.

Education was given more attention. Many schools were founded, especially north of the Alps, and literacy became more common. The traditional curriculum of the seven arts was gradually augmented to include studies of classical languages, law, science, and manners. Less importance was attached to dialectics and grammar. Prominent scholars like Vittorino da Feltre set new perspectives in learning. Thousands of humanistic students—men and women—came especially to Italy. Owing to its ancient heritage and its contemporary achievements, Italy passed through a period rivaling the days of ancient Rome.

Literature

Humanistic tendencies led to the spread of scientific and other scholarly activities beyond the Church and the universities. They necessitated schooling for larger numbers of people, and the written word gained a far greater significance than it had possessed in earlier medieval times. Literature gradually took over the central role in intellectual endeavors, as evidenced in an abundance of works. In the second half of the fourteenth century, Petrarch published his *Sonnets*. Boccaccio wrote the *Decameron*, a classic that, through its entertaining stories, reflects general human concerns as well as life in late medieval Italian society. Both of these works were composed in the vernacular.

In France, Germany, and England, too, secular writings were enjoyed by widening circles. Stories of chivalry became popular, not merely among courtiers—people who were in attendance at the courts of princes—but also among the bourgeoisie, who amplified and transformed them. Numerous chronicles were compiled. Histories were written, such as that by Froissart (d. 1410), who described the early phases of the Hundred Years' War. In

England the allegorical poem *Piers the Plowman* (attributed to William Langland) was composed. It is outstanding among the literature of the time inasmuch as it occupies itself with economic, religious, and moral problems of the lower classes. Toward the end of the fourteenth century, Chaucer wrote the *Canterbury Tales*. Not merely did this work constitute an artistic achievement. It also provided a realistic, brilliant, and yet charitable study of human nature, of virtue and vice in the innumerous aspects.

Literary works of the fifteenth century lack much of the imagination of those in the fourteenth. The output was extremely large. But much of it, especially in Italy, was dry and stilted, designed to imitate the classical style. The authors often took up pagan mythological themes, yet the numerous allusions to Latin writers could appeal only to those trained in the "sophisticated" taste of the time. Exceptional was the poetry of Francois Villon (d. 1463), whose poetic gift, delight in life, and insight into the realities of the human condition infused his creations with the spark of originality and sincere emotion. On the whole, literature in the north, as expressed in legends, poems, songs, and miracle and morality plays, all of which had a background of folklore, was more spontaneous than the aesthetic, refined writings of Italy.

Art and Architecture

The greatest glory of the Renaissance was its art—painting, sculpture, and architecture. No description can give an adequate impression of the lasting beauty created by the great masters; these works of art must be enjoyed directly. Individuals of genius constituted the source of Renaissance greatness. A society appreciative of beauty, allowing artists to develop their own individual and many-sided personalities, and receptive to the works created by them, supported their endeavors.

ITALIAN ART

In Italy, no longer did Florence and the central Italian region stand alone in producing great works of art. Its example spread to Rome, Milan, Venice—everywhere. Outstanding among the Italian painters were Fra Angelico (d. 1455), Masaccio (d. 1428), Fra Filippo Lippi (d. 1469), and Gozzoli (d. 1497); among the sculptors, the della Robbia family, Ghiberti (d. 1455), Donatello (d. 1466), and Verrocchio (d. 1488); among the architects, Brunelleschi (d. 1446).

While devoting themselves to religious as well as worldly subjects, they combined classical beauty and simplicity with some medieval Gothic elements. They imbued these with the spirit of the Renaissance and their own aesthetic feelings. They paid increasing attention to a realistic representation of nature and daily life, in which they took joy. They attached new importance to observation, to what their senses told them. Through the study of anatomy, perspective, and light and shadow, the foremost painters improved

the desired rendering of naturalistic features. They painted on canvas as well as on wood or walls (frescoes); they used chemically perfected pigments.

In architecture, the great masters applied new and daring building techniques. Nevertheless, it was not through their technique but through their inspiration, imagination, and workmanship that they achieved masterpieces enduring in human history.

NORTHERN ART

The northern countries followed closely the example set in Italy; Germany and the Netherlands produced achievements worthy of the age. A late flowering of the Gothic style was evident. The great trading towns with their rich merchants took pride in adorning their surroundings with marvelous buildings. Wood carving was brought to a perfection unknown in Italy (which lacked timber). Carved and painted altars and statues beautified thousands of small country churches as well as great cathedrals. Another branch of artistic work, the woodcut (which was used for illustrations in books), was also more highly developed in the north than in Italy.

The themes of the northern artists were less secular than those of the Italians. Lacking some of the joyful spirit of the south, the northern artists persisted to a large extent in the pessimistic mood of earlier times. Many works centered around death and the dangers of worldliness and sin. They called people to repentance rather than to indulgence in worldly affairs and their enjoyment.

As to northern painting, a Renaissance style can be traced earliest in the Netherlands—particularly Brabant and Flanders, two provinces that in the fifteenth century formed part of the Burgundian realm. Closely connected economically with the great Italian ports in the Mediterranean area as well as with the Hanseatic towns on the Baltic, the cities of the Netherlands had become centers of a prosperous burgher society. Their accumulated wealth was invested in daring commercial enterprises, in luxurious living, and in imposing works of art. It was there that painters flourished, like the brothers van Eyck (d. 1426 and 1441) and Roger van der Weyden (d. 1464). Their loving devotion to every part, every detail of nature and human creations, and the intensity and simplicity of their presentation, combined with deep religious feeling, give an unparalleled appeal to their works. In many technical aspects, the Netherland masters became teachers of all of Europe, including Italy.

Music

It was the Netherlands that also made special contributions in the field of music. Church chants and secular songs, cultivated by cathedral choirs, artisan guilds, students, and performers at the courts of princes, flourished during the fifteenth century in many regions of northern Europe. The Netherlands broke with tradition in instrumental and vocal music. They introduced innovations in choral singing when developing the art of the canon (or round)

and contributed to the evolution of the polyphonic style. It was from there that some of the finest composers came, including Dufay (d. 1474). It was Netherland masters who influenced most parts of Europe.

The Printing Press

At the very end of the first half of the Renaissance, at almost the same moment when Constantinople fell, another event of fundamental importance occurred: the development of the printing press with movable type by the German printer Johann Gutenberg (d. 1468). He also introduced the use of type made of lead instead of wood. The first work printed on movable type by Gutenberg was a marvelous illuminated edition of the Bible. Other fine publications followed. Soon the Gutenberg press in Mainz was supplemented by the Aldine press of Manuzio in Venice and other presses. It is difficult to overestimate the significance that scholarship and the written word were to assume owing to Gutenberg's invention. In exquisite editions coming from Italy, the works of the classical authors and their thoughts appeared and were made accessible to widening circles. Often they replaced a preoccupation with the Bible and sacred texts. Accepted ideas as well as challenging ones could be spread to all parts of Western civilization. Information could reach ever larger parts of the populations, and the ability to read assumed unanticipated importance. The entire cultural climate and social structure of the Western world were changed.

*F*ollowing *the Babylonian Captivity and the Schism, the papacy could not regain that leadership to which it had long aspired. Emperors, kings, and dukes emancipated themselves steadily from Rome's influence. They occupied themselves with the growth and rule of their own realms. Political and military power became concentrated in their hands.*

Production increased, as did commerce and banking. Secular affairs captured the minds of many scholars, philosophers, and writers who centered attention on humanistic endeavors. The invention of the printing press made possible the spread of new ideas. Otherworldliness had to yield a place in art to naturalness. The challenges created by this emphasis on worldly affairs brought about an enhanced status of the wealthy burghers and new hardships for peasants and lower segments of the town populations. Behind a glorious flowering in learning and the arts, misery was widespread, and revolts followed hard on the heels of the new age.

Selected Readings

Armstrong, C. A. J. *England, France and Burgundy in the Fifteenth Century* (1983)
Berenson, Bernard. *Italian Painters of the Renaissance* (1980)
Bertelli, Sergio, et al. *The Courts of the Italian Renaissance* (1986)
Bowsky, William M., ed. *The Black Death: A Turning Point in History?* (1978)
Burckhardt, Jacob. *The Civilization of the Renaissance in Italy* (1980)

Cassirer, Ernst, et al. *The Renaissance Philosophy of Man* (1956)

Chamberlain, E. R. *Everyday Life in Renaissance Times* (1980)

Crowder, C. M. D. *Unity, Heresy and Reform, 1378–1403* (1970)

Du Boulay, F. R. H. *Germany in the Later Middle Ages* (1983)

Durant, Will. *The Renaissance: A History of Civilization in Italy from 1304–1576 A.D.* (1953)

Fowler, K. *The Age of Plantagenet and Valois* (1967)

Hale, John Rigby. *A Concise Encyclopedia of the Italian Renaissance* (1986)

Hay, Denys. *The Italian Renaissance in Its Historical Background* (1977)

Kaminsky, H. *A History of the Hussite Revolution* (1967)

Lopez, Robert S., and J. W. Raymond. *Medieval Travel in the Mediterranean World* (1955)

Nichol, D. M. *The End of the Byzantine Empire* (1979)

Ortigo, Iris. *The Merchant of Prato* (1957)

Perroy, E. *The Hundred Years' War* (1965)

Ross, James B., and Mary M. McLaughlin, eds. *The Portable Renaissance Reader* (1958)

19

On the Threshold of the Modern Age (1453–1492)

1454	Peace of Lodi: balance of power in Italy
1455	Death of Ghiberti and Fra Angelico
1455–1483	Wars of the Roses in England
1458–1490	Reign of Matthias Corvinus in Hungary
1458–1464	Reign of Pope Pius II (Aeneas Silvio Piccolomini)
1460	Death of Prince Henry the Navigator
1461–1483	Reign of Louis XI of France
1462–1505	Reign of Ivan the Great of Muscovy
1464	Death of Nicholas of Cusa
1466	Death of Donatello
	Peace of Thorn between Teutonic Knights and Poland
1469–1492	Rule of Lorenzo il Magnifico of Medici in Florence
1471	Death of Thomas à Kempis
1477	Death of Charles the Bold of Burgundy; marriage of Mary of Burgundy and Maximilian of Hapsburg
1478	Establishment of the Spanish Inquisition
1479	Union of Aragon and Castile under Ferdinand and Isabella
1480	End of Tartar rule in Russia
1485	Richard III of England killed; Henry VII (Tudor) becomes king
1487	Diaz rounds Cape of Good Hope
1492	Columbus Discovers America

*T*he forty years that elapsed between the capture of Constantinople by the Turks and the discovery of America—the last forty years of the Middle Ages—are remarkable for the beauty and vigor that mark European civilization. Italy, Germany, and the Netherlands continued to produce works of art unsurpassed in other ages. Botticelli (d. 1510), Verrocchio (d. 1488), Leonardo da Vinci (d. 1519) are just a few names that illustrate Italian accomplishments in painting and sculpture, while Memling (d. 1494), Schongauer (d. 1491), and Riemenschneider (d. 1521) are among the many names of great artists in the Netherlands and Germany. The composer Okeghem (d. 1492) was outstanding in the field of music. Pico della Mirandola (d. 1494), a man of universal interests and far-reaching ability, a classical scholar and an accomplished writer, and Marsilio Ficino brought Italian humanism to perhaps its finest stage. No new aspect of civilization was, however, introduced by these men. Perhaps none was called for, as long as what had been evolved during the early Renaissance showed so much vitality and continued to bring forth so many distinguished accomplishments.

It was different, though, with regard to the political and economic situation of the Western world. Disruptive forces had triumphed between the middle of the fourteenth and the middle of the fifteenth centuries. The time for reconstruction had come. Increasing national pride in various countries of Europe provides the background against which this reconstruction must be viewed.

WESTERN EUROPE

Two aspects characterize the political conditions in Western Europe toward the end of the Middle Ages: the national state idea, which meant the triumph of loyalty to the nation over the previously prevailing ideal of Christian unity; and the monarchical idea, which meant the triumph of royal power over feudal nobility.

Spain and Portugal

The most spectacular developments took place on the Iberian peninsula. From comparative insignificance, Spain and Portugal emerged to become, within less than twenty-five years, the foremost powers of the Western world. For more than a hundred years, Portugal, Castile, and Aragon had explored the seas. They had extended their rule over territories beyond the seas —eastward to the Balearic Islands, Sardinia, Sicily, and Naples, and even to parts of Greece; westward to the Azores and the Canary Islands; and, under the sponsorship of the Portuguese Prince Henry the Navigator (d. 1460), also

southward along the African coast as far as the equator. At home, all three countries had in an unrelenting struggle put an end to the unruly behavior of the nobility. Their rulers, supported by the Church (which, in turn, received aid from them), had gradually gained in strength.

During the last part of the fifteenth century, this long and slow evolution led to a sudden climax, marked by three great events: (1) the marriage, in 1469, between Ferdinand of Aragon and Isabella of Castile, which led to a unification of these two kingdoms and therewith to the establishment of modern Spain; (2) the success of Portuguese and Spanish discoverers—of Diaz, who in 1486 reached the Cape of Good Hope at the southern tip of Africa, of the Genoese Columbus, who served the Spanish monarchs and in 1492 landed in America, and of Vasco da Gama, who in 1498 reached India by sailing around the Cape of Good Hope; and (3) the liquidation in 1492 of the kingdom of Granada, last of the seven-hundred-year-old possessions of the Moslems in Spain. In order to forestall future dangers from the south, the Spaniards expelled most of the Moslems and Jews living there. The Inquisition was used to convert by force those who stayed and to establish uniformity in the newborn empire.

France

For France, the chief problem after the end of the Hundred Years' War consisted in the reestablishment of effective government and of its place among the European nations. Its victory over England meant more than mere territorial gains. It meant that France's feudal age, which had brought about the involvements with the English, was over. The country remained divided, owing to the independent position of the dukes of Burgundy. Regional differences, especially between north and south, remained strong. Yet a national spirit triumphed. The king, rather than the nobility or the Estates General, became its representative. France entered the modern age early.

At the beginning of this age stood the cruel and cunning figure of Louis XI (1461–1483), a most remarkable and capable ruler. He had the good fortune of seeing his chief rival, Charles the Bold, brilliant duke of Burgundy, defeated and, in 1477, killed during an attempt to extend Burgundy's rule into Switzerland. After Charles's death, the rich Netherlands, a part of the Burgundian realms coveted by Louis, escaped him because Charles's daughter and heiress, Mary, married the German prince Maximilian. But Louis refrained from going to war over this issue and instead devoted his attention to pursuing French internal reforms.

He established a nearly absolute rule. The country was cleared of roaming and pillaging soldiers and brigands. The army was reduced and subjected to strict control. Supreme jurisdiction was monopolized by the court. The treasury was rebuilt through extreme thriftiness. Royal domains were expanded at the cost of the remaining nobles, among whom the king shrewdly sowed discord. The administration, confined to the hands of

appointees of the king, was subjected to a previously unknown, extremely careful personal supervision.

England

England emerged from the Hundred Years' War in a more precarious position than France. Not only had it lost its Continental possessions except for Calais, but royal power was seriously undermined. Parliament, which continued to function and which exercised increasing control over the bureaucracy, veered in its actions in accordance with the changing fortunes of the great lords who fought for control of the government. The loot brought back by the English from France and Flanders was soon exhausted. Returning soldiers accustomed to pillaging and lacking employment made the whole land insecure.

The situation worsened when war broke out between two contending branches of the royal house (York and Lancaster), the so-called Wars of the Roses. In its course, both sides stained themselves with the ugliest acts of brutality, murder, and betrayal. Not until 1485 did the almost three-decade-long conflict end with the Battle of Bosworth Field. The last York king, Richard III, was killed. He had been a capable administrator who understood the trends of the times, the importance of the burghers, and the need for adjustment to new economic and international conditions. But political acts of treachery cost him his throne and life.

His successor was Henry VII, of the House of Tudor. Cunning and parsimonious like Louis XI of France, he regained power and authority for the crown. Peace returned. The abuses of protectionism, bribery, and nepotism were reduced. The country was gradually opened to new economic prosperity and to the arts of peace.

The Netherlands

Emphasis on trade and the emergence of a mercantile-capitalistic society particularly benefited the Netherlands. Despite their small size, the Low Countries had for a long time played a prominent role in the European economy, owing to the favorable location of their harbors and the importance of the Flemish textile industries. After the decline of Bruges toward the end of the fourteenth century, Antwerp had become one of Europe's greatest commercial centers. Lively connections extended from there to Venice, Milan, and Florence, to Nürnberg, Augsburg, and Frankfurt, to Paris and Lyons, to London, Hull, and Bristol, and especially to the Hanseatic ports of Hamburg, Lübeck, and Danzig. Under the rule of the ambitious and luxury-loving Burgundian dukes, the Low Countries further improved their position.

By the dawn of the modern age, Dutch ships were leaders in the northern east-west trade route. Dutch merchants were among the richest of Europe. Dutch towns rivaled the Italian towns not only in business enterprise but also in style of living, in arts and music, and in the development of a refined Renaissance society.

CENTRAL AND EASTERN EUROPE

The circumstances that altered the political patterns in western European countries did not have an equally strong effect on central and eastern Europe. Germany, Italy, Scandinavia, and Poland continued along more traditional lines and did not yet enter the modern age that western Europe approached. Russia could only begin to chart a national policy after it had gained independence from Tartar domination in 1480. Moreover, economic dislocations (caused by rising prices and depreciation of money) and the resulting social upheavals, which characterized the western European economy in the second half of the fifteenth century, also affected central and eastern Europe. These difficulties were not counterbalanced by the advantages that nations on the Atlantic seaboard enjoyed.

The Empire

In Germany, expansion of mining and industry and pursuit of traditional trade objectives kept economic activity for the time being at a comparatively high level. Great banking enterprises were built up in southern Germany. Masterful craftsmanship distinguished the goods produced in many towns (such as Nürnberg). The ventures of the Hanseatic merchants still proved lucrative. Cultural interests also broadened. But conservatism among merchants and craftsmen prevented a timely conversion to modern methods, especially in the north. Competition from Dutch ships reduced the share of the Hanseatic League in the Baltic trade. Guilds and other medieval institutions slowed the growth of that type of business organization that proved successful and suitable for modern developments.

Moreover, political conditions remained unfavorable. Not centralization, but decentralization made headway. The electoral and other princes, as well as individual free imperial towns, jealously watched over their old-fashioned liberties. An emperor, Frederick III (d. 1493), ruled who lacked the qualities needed for his office. His was, unfortunately for Germany, the longest rule of any emperor. During his reign, internal strife continued. Foreign enemies infringed on the Empire's borders, and at one time the emperor had to give up even his own capital, Vienna. Only one political achievement can be traced to Frederick's reign, an achievement intended to increase the wealth and power of his family. It turned out to add enormous prestige also to the Empire as a whole and to lay the basis for an unexpected restoration of Germany's leading position: the marriage of Frederick's son Maximilian to Mary, heiress of Burgundy. Through this marriage the rich Netherlands was added to the Hapsburg possessions.

Italy

The extraordinary evolution of the city-state, which Italy had witnessed since the end of the crusades, reached its peak during the last decades of the Middle Ages. Yet the years of Venice's greatness (except for Renaissance art, which flourished in Venice later than in other parts of Italy) were nearing their climax. For conservatism in business methods was as strong in Venice as among Hanse merchants. The effects of the reorientation of overseas as well as of continental trade and trade routes reduced Venice's prominence. But other cities, Milan and especially Florence, only then attained the full glory of their development.

Tyrants continued to direct affairs through wealth, demagoguery, and intrigues. Though their methods were often divorced from accepted standards of Christian ethics, they were successful where wisdom and moderation prevailed. All of Europe was to learn from the examples they set—whether from a Sigismondo Malatesta of Rimini (d. 1467), who failed because he relied on mere force and artful display, or from a Giovanni de Medici (d. 1427) in Florence and his heirs Cosimo (d. 1469) and Lorenzo the Magnificent (d. 1492), who succeeded because a sober sense of reality directed their actions.

As a "modern" entrepreneur as well as a politician, Giovanni had risen to the eminent position from which he could direct Florence's fate. While keeping up a pretense of popular control and adroitly managing public opinion, the Medici house directed the government unofficially for almost a century. Under its patronage, the arts flourished, as well as business. In external affairs, the Medici exploited the rivalries of neighboring city-states, of the papacy, and of outside interests of German emperors and, later, of the French kings. They supported a system of balance of power. This enabled the various Italian city-states, and especially Florence itself, to preserve their independence of the large powers.

Other parts of Italy, where city-states and the system of despots did not prevail, were less prosperous and set few examples. Southern Italy (under the Aragonese) and the papal states continued to stagnate, politically and economically, although Rome became a center of humanism and of Renaissance art.

Eastern Europe

The Renaissance spirit spread from Italy and Germany eastward to Poland-Lithuania. Close cultural connections between this area and the West had long existed. The common Catholic faith had constituted a link. Thousands of German artisans had settled in Poland and, through their skills and habits, had fertilized the civilization of numerous towns. Unlike the situation in Poland, however, almost no reflection of Renaissance culture can be traced in Orthodox Russia. Cultural achievements there were scarce.

POLAND-LITHUANIA

In the last part of the Middle Ages, Poland reaped the benefits of its union with Lithuania. In 1466, at Thorn, it could impose on the Teutonic Knights a peace that forced the Order to cede parts of western Prussia and to recognize Polish overlordship. Poland thereby became, at least for a while, Catholic Europe's eastern bulwark against Russian expansion—just as Hungary under its able king Matthias Corvinus (d. 1490) served after Constantinople's fall as a buffer against the Turks. The powerful German Hanse town of Danzig, which controlled the exit to the Baltic Sea and therewith the key to Poland's increasingly important grain trade, began to orient itself toward Poland. It retained, though, its German connections and its traditional German liberties.

Unfortunately, social progress in Poland did not equal the country's political advance. A thin but important stratum of society was produced that was receptive to, if not very creative in, Renaissance scholarship and art. But this stratum, composed of a rich and luxury-loving nobility, an extravagant and arrogant clerical hierarchy, and a small merchant aristocracy, was faced by a large illiterate, destitute lower nobility, by poor, unlearned country priests, and by a miserable and oppressed peasantry and town proletariat. These masses gained as little from political conquests as from the economic benefits brought by the expansion of the Polish grain market.

RUSSIA

At the end of the Middle Ages, Muscovy was ruled by Tsar Ivan the Great (1462–1505). Under him, the basis for Russia's future greatness was laid. Gradually, he incorporated one neighboring principality after another. He also seized the great port of Novgorod, whose trade was, however, ruined by the expulsion of the Hanse merchants. He asserted his authority over Church and nobility, carried out clerical reforms, and had a new law code drafted. Through marriage with a Byzantine princess, he raised the prestige of his country. Through invitations to foreign craftsmen, doctors, and merchants, he introduced Western skills and techniques. He improved the military strength and the wealth of his country. After putting an end to what was still left of Tartar control and suzerainty, he entered into diplomatic relations with Western powers.

Nevertheless, Russia continued to develop along lines different from those of the Western world. Townsmen gained little influence. Wealth remained concentrated in the hands of tsar, Church, and high nobility—all of whom maintained numerous economic monopolies. Serfdom, which decreased in the West, was extended in Russia. The monarchical structure there showed more similarity to Oriental despotism than to Western concepts.

SOCIETY ON THE EVE OF THE MODERN AGE

If during the past two centuries of our own modern times scientific and technical inventions have, throughout the whole world, wrought rapid and radical changes in the established patterns of life, nothing comparable happened in the course of the Middle Ages. Most people lived at the end of medieval times as they had for a thousand years—as tillers of the soil and laborers in town and country. Hard manual labor characterized daily life, interrupted mainly by numerous religious holidays. But since their bodies were usually weakened by hunger and hardships, working hours were short. Relief was also found through entertainments, with jugglers and musicians at festivals and fairs. Yet the population had increased. Around 1500, the German empire may have comprised some thirteen million people, while kingdoms and duchies comprised fewer. England, for instance, had less than five million people.

Decline of Feudalism

Feudalism and manorial organization, though varying according to region, no longer affected daily life to the same extent as before. Castles and walls afforded less and less security, a development that had begun slowly in the thirteenth century. Gunpowder and cannons had reduced their usefulness. Chivalry among the nobles and the knights died out. Royal authority and bureaucratic administrations as well as law courts restricted the rights of nobles.

With power depending increasingly on wealth, the nobles and landlords had to seek income by working their estates "for the market" rather than for sustenance only. To the peasants, the decline of feudalism meant little. Their lot remained hard and possibly even worsened. The growing market economy and the use by the lords of a migrating landless proletariat meant that peasants lost part of that security that they had possessed under the old feudal system.

As a result, movement to the towns accelerated. By 1500, perhaps up to one fifth of the population lived in towns and enjoyed improved conditions. Cultural life there was vigorous. Besides ever more elaborate festivals, pageants, parades, and spectacles with music and dancing, scholarly and artistic enjoyments gave variety to the days of otherwise hard-working artisans as well as of the town proletariat, the rulers, and the town officials.

Health and Hygiene

Medical care had changed but little since ancient times. Although some people reached their eighties and nineties, the average life expectancy was invariably low—perhaps somewhere in the thirties—owing to infant mortality, childbirth fatalities, famines, warfare, feuds, and epidemics such as the plague, malaria, and cholera.

Trial-and-error methods had brought some advances. More hygienic water systems and fountains and disposal facilities were installed in some regions. In Germany, in towns such as Lübeck, Erfurt, and Nürnberg, foreign visitors commented on their advantages and perfection. Other measures were taken elsewhere. A system of quarantine was introduced in Ragusa (Dalmatia) and enforced on ships from the Orient, which meant that they had to stay for forty (*quaranta*) days in isolation before unloading. Doctors could not help much, whether the patients were noblemen in their palaces or peasants in their huts. The diet of the former, though generally more plentiful, was probably still less healthy than that of the latter. Faith and belief in a better afterlife may have helped to relieve pain or at least to make it bearable.

Women

The position of women had somewhat changed: The spread of the cult of Mary at the beginning of the millennium was symbolic. Women of the upper classes of society received a better education. Some were found in universities, while some were prominent at the courts of dukes and kings and as protectors of the arts. When men were away on military expeditions, on campaigns that may have lasted for years, women administered and controlled the households and, later, managed businesses. Yet their legal status remained essentially unchanged, subordinate to men. The Salic law, which excluded them from succession to the throne, prevailed in most countries. But their effective role was considerable. In peasant households, much of the burden fell on women. They had to contribute to economic needs through their labor in the fields and by spinning and weaving, not only for domestic use but also for entrepreneurs in the towns. Convents for nuns possessed large areas of land, to which they attended with no less skill than the monks in the monasteries. Often abbesses wielded considerable political influence.

As a rule, women married early. They were expected to lead chaste lives, an expectation not necessarily fulfilled, just as was the case with men, who indulged in many extramarital affairs and kept mistresses and sometimes slave girls, whom they had brought from the East. Prostitution was common.

Insurrections

Under the circumstances, dissatisfaction was widespread. Revolts, fueled by increasing attention to worldly affairs, followed. They occurred in the countryside as well as in towns, where strict rules enacted by guilds contributed to the unrest. In Italy, they especially shook Venice, Florence, and Rome. Germany and the Netherlands, France, England, Scandinavia, Poland, and Bohemia were similarly affected. Concessions were often made, but they brought at best temporary relief to the poorer sections of the population.

Finance

If up to Renaissance times power had rested in the hands of those who wielded the sword, it gradually shifted into the hands of those who possessed wealth. Wealth, possessions, and money were needed for warfare as for

peaceful pursuits—for hiring soldiers and mercenaries, who came to decide battles, as well as for agriculture, commerce, and government. Upon wealth depended the large ventures, such as the expeditions around the African Cape or to America. These, along with trade in Mediterranean and Baltic waters, called for larger, faster, and more strongly built ships and for substantial investments.

As a result, banking, finance, and a money economy developed vigorously and increasingly undermined existing Church regulations against usury and interest taking. Better business methods, including double-entry bookkeeping, were more widely in use. Skillful entrepreneurs emerged. Outstanding among them were the Datini, Strozzi, and Medici families in Italy, the Jacques Coeur and Lyonnaise bankers in France, the Fuggers and Welsers in Germany. Others appeared particularly in the Netherlands, which, earlier than others and more successfully, adopted Italian business methods.

But the financial resources were used mainly for trade and only to a limited degree stimulated production. They caused difficulties insofar as they led to serious price fluctuations and inflation. They were as yet insufficient to replace prevailing barter transactions, which, unlike in later times, remained the principal method of exchange in daily life.

It was in such an atmosphere that the great Spanish and Portuguese expeditions to unknown parts of the world were undertaken. This brought the expansion of Western civilization to all parts of the globe and marks in history the dividing line between the customary classifications Middle Ages and modern times.

The transition from medieval to modern times was, of course, almost unnoticeable to the generation that lived through it. Like generations of all ages, people at the time were only vaguely aware of the changes, and uncertain of the direction of existing trends. They felt the continuity more than the break. But in retrospect, the new aspects are evident. By 1500, the Western world possessed little of that unity that Roman traditions and Christian heritage had given to life and thought in the High Middle Ages.

An individualistic spirit prevailed, which expressed itself in the business ventures of enterprising merchants and the breakdown of the feudal class structure; in the growth of national feelings and the diversity of legal developments; in the challenge to traditional religious ideas and the spread of a scientific attitude toward nature; in the scholarly investigations of classical antiquity and the adoption of new standards for artistic creations; and most of all in the widening of the horizon of Western people. In the new age the West was to expand its activities beyond the borders known in the Middle Ages and to embrace—and dominate—all of the globe.

With that first voyage of Columbus, the world of Western civilization expanded. From then on, it comprised the whole of the globe. At the beginning of the Middle Ages, the horizon of Western people had encompassed scarcely more than the lands extending around the Mediterranean Sea and from the Atlantic to the Rhine; in the High Middle Ages, it had at best embraced the Old World—from the Atlantic Ocean to China and India. Driving and striving Westerners, as they emerged in Renaissance times, made it their objective not only to know, but also to dominate, the globe.

Their beliefs and attitudes were adjusted to the new task. They were no longer those that they had held at the beginning of the Middle Ages. Then they had been in search of unity—of the unity of Christendom. Now, as the Middle Ages waned, they cherished national and cultural diversity, and they would soon also cherish religious diversity. Then their faith had constituted a link between them and all who shared it; those who were outside of it were their enemies. Now their enemies changed; they came to be those who belonged to other nations, and there were many nations.

The personal relationship that had tied them to family or lord had broken down. They thought of themselves more often as individuals than as members of a community, church, social class, profession, or guild, all of which were hallowed by tradition. The feudal world had meant a certain order, an ideal order, which, to be sure, had seldom existed in practice.

Renaissance ideology had disrupted the feudal world without providing a new sense of order. Rational belief, based on observation of nature and its works, superseded faith and superstition. Western man and woman stood alone, facing the world—and often their God—alone, without the comforts that an all-enveloping social structure and a dogma could offer. What had been built during a thousand years was crumbling. Liberation from bonds and the attainment of individual freedom beckoned. A new reality challenged old beliefs.

Selected Readings

Aston, Margaret. *The Fifteenth Century: The Prospect of Europe* (1968)

Brinton, Crane. *Ideas and Men: The Story of Western Thought* (1963)

Cardini, Franco. *Europe, 1492: Portrait of a Continent Five Hundred Years Ago* (1989)

Contamine, Philippe. *War in the Middle Ages* (1984)

Morison, Samuel Eliot. *The European Discovery of America: The Southern Voyages, 1492–1616* (1974)

Schevill, Ferdinand. *The Medici* (1949)

Appendix

Table 1: Some Memorable Rulers, Statesmen, Scholars, and Artists

B.C.	Greek and Hellenic			Roman		Various
	Rulers and Statesmen	Scholars and Poets	Artists	Rulers and Statesmen	Scholars and Poets	
IX Century		Homer Hesiod				
VIII Century				(Romulus)		Isaiah
VII Century	Draco (Lycurgus)	Aleaeus Sappho				
VI Century	Solon Peisistratus Cleisthenes	Anacreon Anaximander Thales Pythagoras		Tarquin Superbus		Jeremiah Zoroaster Confucius Lao-tse Buddha
V Century	Miltiades Aristides Themistocles Cimon Pericles Alcibiades	Pindar Herodotus Aeschylus Sophocles Euripides Thucydides Socrates Anaxagoras Empedocles Heraclitus	Phidias			
IV Century	Dionysius I of Syracuse Epaminondas Philip II Alexander the Great	Plato Aristotle Hippocrates Democritus Euclid	Praxiteles			

Some Memorable Rulers, Statesmen, Scholars, and Artists (cont'd)

	Greek and Hellenic		Roman		Various
III Century	Epicurus Zeno (Stoic) Archimedes	Ptolemy I Seleucus Pyrrhus		Scipio the Elder	Hannibal
II Century	Polybius		Terence Plautus	Cato the Elder Tiberius and Gaius Gracchus	
I Century			Catullus Cicero Lucretius Horace Vergil	Marius Sulla Pompey Caesar Antony	
A.D.					
I Century			Ovid Livy Seneca	Tiberius Nero Vespasian	Apostles
II Century	Ptolemy Plutarch Galen		Tacitus Juvenal Suetonius	Trajan Hadrian Marcus Aurelius	
III Century			Ulpian	Aurelian Diocletian	Origen Tertullian Cyprian
IV Century				Constantine Julian the Apostate Theodosius	Eusebius John Chrysostom St. Anthony St. Basil

Table 2: Some Memorable Churchmen, Scholars, and Artists

A.D.	Theology—Philosophy, Science, History	Literature	Painting, Book Ilustration	Architecture, Sculpture	Music
V Century	St. Augustine St. Jerome St. Patrick				
VI Century	Boethius Gregory of Tours				
VII Century	Isidore of Seville				
VIII Century	Bede Paul the Deacon	(*Beowulf*)			
IX Century	Alcuin Einhard Strabo Johannes Scotus		(*Carolingian* Renaissance)		
X Century	Gerbert of Rheims		(*Ottonian* Renaissance)		(Musical Notation)
XI Century	Gregory VII Lanfranc Anselm of Canterbury / Avicenna (Arab) Roscellinus	(*Chanson de Roland*)	(*Romanesque* Style)	(*Romanesque* Style)	
XII Century	St. Bernard Abélard Hugh of St. Victor Joachim of Flores / Otto von Freising Ordericus Vitalis Edrisi (Arab) Averröes (Arab) Maimonides (Jew) William of Malmesbury	Chrétien de Troyes Bertran de Born (Troubadour) (*Nibelungenlied*)	(*Romanesque* Style)		

Some Memorable Churchmen, Scholars, and Artists (*cont'd*)

A.D.	Theology—Philosophy, Science, History	Literature	Painting, Book Illustration	Architecture, Sculpture	Music
XIII Century	St. Francis, St. Dominick, Innocent III, Albertus Magnus, St. Thomas Villehardouin, Saxo Grammaticus, Matthew Paris, Roger Bacon	Walther von der Vogelweide, Wolfram von Eschenbach, Gottfried von Strassburg	*(Gothic Style)* Cimabue	*(Gothic Style)* Niccolo Pisano	Thomas of Celano, Jacopone da Todi
XIV Century	Master Eckhart, Wycliffe Marsilius of Padua, William of Occam	Dante, Boccaccio, Petrarch, William Langland, Chaucer	*(Gothic Style)* *(Early Renaissance Style)* Duccio, Giotto	Giovanni Pisano	
XV Century	Huss, Thomas à Kempis Ibn Khaldun (Arab), Froissart, Nicolas of Cusa, Johann Müller, Regiomontanus	François Villon, Gutenberg (Printer)	*(Renaissance)* Masaccio, Fra Angelico, Botticelli, Leonardo, della Robbia, van Eyck, Memling, Rublev (Russian Icons)	Ghiberti, Donatello, Brunelleschi, Verrochio	Dufay

Table 3: Some Memorable Rulers

A.D.	Germanic Kingdoms / France	Germany Holy Roman Empire	England	Eastern Europe	Popes	Various
V Century	Alaric (Visigoths)				Leo the Great	
VI Century	Theodoric (Ostrogoths) Clovis (Franks)			Justinian (East Rome)	Gregory the Great	
VII Century	Pepin of Heristal (Franks)					
VIII Century	Charles Martel (Franks) Pepin the Short (Franks)			Leo the Isaurian (East Rome)		
IX Century	Charlemagne		Alfred the Great		Leo III	Harun al-Rashid (Arabs)
X Century	France: Hugh Capet	(House of Saxony) Otto the Great		St. Vladimir (Russia)		
XI Century		(House of Franconia) Henry III Henry IV	Canute the Great William the Conqueror	Yaroslav the Wise (Russia) Boleslav the Bold (Poland) St. Stephen (Hungary)	Gregory VII	
XII Century	Louis VI	(House of Hohenstaufen) Frederick I Barbarossa Henry VI	Henry II	Vladimir II (Russia)	Alexander III	Saladin (Turks)

Some Memorable Rulers (*cont'd*)

A.D.	Germanic Kingdoms		England	Eastern Europe	Popes	Various
XIII Century	Frederick II Rudolf of *Hapsburg*	Philip II Augustus St. Louis	Edward I	Alexander Nevsky (Muscovy)	Innocent III Boniface VIII	Genghis Khan (Tartars)
XIV Century	Charles IV	Philip IV Philip VI of *Valois*	Edward III	Jagiello (Lithuania) Dimitri Donskoy (Muscovy)		Tamerlane (Tartars)
XV Century	Maximilian I of *Hapsburg*	Louis XI Charles VIII	Henry IV (*Lancaster*) Richard III (*York*) Henry VII (*Tudor*)	Matthias Corvinus (Hungary) Ivan the Great (Russia)	Martin V Pius II Sixtus IV	Ferdinand and Isabella (Spain) Lorenzo de Medici

Index